PERFORMING CONVERSION

Conversions
Series Editors: Paul Yachnin and Bronwen Wilson

Available Titles
Ovidian Transversions: 'Iphis and Ianthe', 1350–1650
Valerie Traub, Patricia Badir and Peggy McCracken

Performing Conversion: Cities, Theatre and Early Modern Transformations
José R. Jouve Martín and Stephen Wittek

Visit our website at: www.edinburghuniversitypress.com/series/CONV

PERFORMING CONVERSION

CITIES, THEATRE AND
EARLY MODERN TRANSFORMATIONS

Edited by José R. Jouve Martín
and Stephen Wittek

EDINBURGH
University Press

Edinburgh University Press is one of the leading university presses in
the UK. We publish academic books and journals in our selected subject
areas across the humanities and social sciences, combining cutting-edge
scholarship with high editorial and production values to produce academic
works of lasting importance. For more information visit our website:
edinburghuniversitypress.com

Edinburgh University Press Ltd
The Tun – Holyrood Road, 12(2f) Jackson's Entry, Edinburgh EH8 8PJ

First published in hardback by Edinburgh University Press 2021

Typeset in 10/12.5 Sabon by
Servis Filmsetting Ltd, Stockport, Cheshire,
and printed and bound by CPI Group (UK) Ltd, Croydon, CR0 4YY

A CIP record for this book is available from the British Library

ISBN 978 1 4744 8272 1 (hardback)
ISBN 978 1 4744 8273 8 (paperback)
ISBN 978 1 4744 8274 5 (webready PDF)
ISBN 978 1 4744 8275 2 (epub)

CONTENTS

CONTENTS

ACKNOWLEDGEMENTS

It is a pleasure to extend our sincere thanks to the general editors of the Edinburgh University Press Conversions series, Paul Yachnin and Bronwen Wilson, for their enthusiastic encouragement and sage guidance. Many thanks also to Eden Glasman and Pierce Williams for help with proofreading, and to our families for their never-ending love and patience. We could not have done it without you! Funding and institutional support for this volume was made available by the Social Sciences and Humanities Research Council of Canada (SSHRC), the Department of English at Carnegie Mellon University, and the Department of Languages, Literatures, and Cultures at McGill University.

SERIES EDITORS' PREFACE

Conversion is a strange thing. It is something confected from natural, material and corporeal kinds of transformations that in turn transforms the multiform becomings of all kinds of matter and living creatures. Stone becomes sand by the movement of water, and sand becomes glass in the heat of fire. And animal and human bodies metamorphose in a host of ways. Early modern Europeans seem to have believed that bear cubs, shapeless at birth, were literally licked into shape by their mothers.

But conversion is also a particular case of transformation: it is both a force and a response to a force; it describes being pulled or directed toward a new kind of being. Bodies and matter change in themselves; conversion reaches out from the phenomenon of transformation to radiate change across the temporal and spatial character of the world itself.

Neither the route nor the momentum of conversion follows a straight path. For conversion is enabled, hindered, orchestrated and resisted by elemental, environmental, material, institutional, social and bodily demands and desires, which render the process open and subject to reversals and reorientations. Its itineraries cannot easily be traced, nor its effects measured. Its temporal and spatial dimensions are inevitably intertwined – its pasts, presents and futures arrested and accelerated. To confront conversion in its historical and phenomenal permutations therefore entails exploring how these experiences, sensations and transmutations are materialised in cultural forms and in human bodies – through imagination, narration,

performance, violence, experimentation, social structures and institutional apparatuses.

Augustine's account of his conversion is a critical instance of narrative's potential to convey the temporal and spatial dynamics of conversion, together with its anticipatory and ineluctable character. He tells the story of his life differently because of the revelatory experience in the garden. All his wanderings, fallings, sufferings become necessary parts of a narrative leading up to the time-shaping child's cry of 'tolle lege [pick it up and read]' and his reading of the passage from Romans. 'For instantly,' Augustine reports, 'as the sentence ended, there was infused in my heart something like the light of full certainty and all the gloom of doubt vanished away.' The moment of conversion changes him by transforming his past into wanderings away from and then back to his true home. It also fashions his future life into an evangelical mission oriented around a polestar dialogic relationship with God – a relationship where speaking with God and being seen by God guarantees Augustine's substantial meaning and value. His retelling shows how conversion is able to organise time into a meaningful dwelling place in relation to the moment of turning, which for the convert, is toward a higher order of being.

The Conversions series sets out to explore the efflorescence of various forms of conversion and their social, corporeal and material integuments as they played out across early modernity. As recent work on the distributed nature of human thinking and feeling confirms, humans are never alone on the pathways of conversion (or alone with the divine). Movement toward, or away from, modes and expressions of self-realisation, salvation or ensoulment unfold in ecologies that include politics, law, religious practice, the arts and the material, corporeal and natural realms.

From 1492, which saw the last battle of the Reconquista and the start of conversional war against the First Peoples of the Americas, up to 1656, when Baruch Spinoza, one of foundational thinkers of secular modernity, was cast out of the Jewish community of Amsterdam, Europe and the new worlds that the Europeans were coming to know emerged as a vast theatre of conversion. The process of conversion in early modernity was manifested in institutional, bodily and artistic practices, and it permeated a multiplicity of cultural forms and technologies. These material and subjective transformations were of a piece with geopolitical reorientations that issued from oceanic journeys and from evolving relations with Islamic dominions and other civilisations. Encounters with ancient, indigenous and unfamiliar worlds gave impetus to the rethinking and translation of forms of knowledge and languages; to the conversion, sometimes violent, of built and natural environments; to gender and sexual metamorphoses; to ethnic, religious and social performances; and to the reimagining of God.

The history of the Reconquista, the conquest and conversion of the Americas,

the back-and-forth changes of the national church in England, and the French Wars of Religion show us that conversion was not only an often winding pathway toward the realisation of self and soul. It also became in this period a sublime weapon of war and instrument of domination. The First Peoples of the Americas, the Jews of Spain and the Catholics of England, among many others, were compelled to convert by violence and threats of violence. They seldom found themselves free to find their own way toward fulfilment or salvation. But conversion also became in the period a surprisingly potent instrument of resistance to the power of the state or the Church, a way for subjects such as Bartolomé de las Casas, Anne Askew or Martin Luther to stand out against the powerful and even to begin to create new conversional publics.

Individually, the volumes in the Conversions series will address important matters in original ways – matters such as how the politics of conversion developed inside Europe and across an increasingly globalised world, how Ovidian 'transversions' – conversions in the realm of gender and sexuality – were themselves transformed by a host of writers and artists in England and France, how the crisis of conversion created Shakespeare's theatre, how Europeans invented scores of new, purpose-built 'conversion machines' and how the performance of conversion reimagined the space and the social character of cities in Europe and the Americas. Each volume in the series will bring forward cutting-edge work in particular disciplines or interdisciplinary fields, and all the volumes will also set out to be of interest and value to readers outside those particular disciplines or sets of disciplines. Together, the volumes in the series will undertake to tell a new story about early modernity and will explore how conversion in its multiple forms, including as a way of thinking about historical change, brought about the transformations that made the world modern.

Bronwen Wilson and Paul Yachnin

CONTRIBUTORS

Iain Fenlon is Professor of Historical Musicology in the University of Cambridge, a Fellow of King's College, and Chairman of the Faculty of Music. Most of his writing has been concerned with the social and cultural history of music in Renaissance Italy. His books include a two-volume study, *Music and Patronage in Sixteenth-Century Mantua* (Cambridge University Press, 1980, 1982), a monograph on the early Italian madrigal (with James Haar), and *Music, Print and Culture in Early Sixteenth-Century Italy* (The Panizzi Lectures, British Library, 1994). In the course of his career he has been affiliated to a number of other academic institutions including Harvard University, All Souls College, Oxford, New College Oxford, the École Normale Supérieure, Paris, and the University of Bologna. His most recent books are *The Ceremonial City: History, Memory and Myth in Renaissance Venice* (Yale University Press, 2007), and *Piazza San Marco* (Harvard University Press, 2009).

Elke Huwiler is an Assistant Professor in the Department of German Literature at the University of Amsterdam. She also teaches in the Department of Literary Studies and Media and Culture. She wrote her dissertation on Radio Drama and is currently doing research in the field of Historical Performance Studies.

José R. Jouve Martín is Professor of Hispanic Studies and Chair of the Department of Languages, Literatures, and Cultures at McGill University. He is the author of the books *Esclavos de la ciudad letrada* (IEP, 2005) and *The*

Black Doctors of Colonial Lima: Science, Race, and Writing in Colonial and Early Republican Peru (McGill-Queens University Press, 2014). He has co-edited the volumes *La constitución del Barroco hispano-transatlántico* (with Renée Soulodre-LaFrance; Special Issue of *Revista canadiense de estudios hispánicos* 33.1, 2008), *Del barroco al neobarroco: realidades y transferencias culturales* (with J. Pérez-Magallón and R. de la Fuente Ballesteros; Universitas Castellae, 2011), *Contemporary Debates in Ecology, Culture and Society in Latin America* (with Marianne Schmink; Special Issue of *Latin American Research Review* 46, 2011), and *Políticas y mercados culturales en América Latina* (with Victor Vich; Special Issue of *Latin American Research Review* 49, 2013).

José-Juan López-Portillo is Assistant Professor of International History at the Centro de Investigación y Docencia Económicas (CIDE) in Mexico City. He works on the first globalisation that occurred from the fifteenth to the seventeenth centuries. He is the author of *Another Jerusalem: Political Legitimacy and Courtly Government in the Kingdom of New Spain 1535-1568* (Brill, 2017). He edited and wrote an introduction for a volume in the Variorum series, *The Expansion of Latin Europe, 1000-1500* (Ashgate, 2014). He is currently working on a general *History of the Spanish Empire* for I. B. Tauris.

Angela Vanhaelen is Associate Professor in the Department of Art History and Communication Studies at McGill University. She is the author of *The Wake of Iconoclasm: Painting the Church in the Dutch Republic* (Penn State University Press, 2012), which was awarded the 2013 Roland H. Bainton Book Prize by Sixteenth Century Society and Conference. She is also author of *Comic Print and Theatre in Early Modern Amsterdam: Gender, Childhood and the City* (Ashgate, 2003). She has recently co-edited (with Joseph Ward) the volume *Making Space Public in Early Modern Europe. Performance, Geography, Privacy* (Routledge, 2012). She is co-editor (with Bronwen Wilson) of a special issue of the journal *Art History*, 'The Erotics of Looking: Materiality, Solicitation and Netherlandish Visual Culture' (November 2012) and has published articles in journals such as *Art Bulletin, Oxford Art Journal, De Zeventiende Eeuw, Art History* and *RES: Journal of Anthropology and Aesthetics*.

Stephen Wittek is Assistant Professor of Literature at Carnegie Mellon University in Pittsburgh. His research focuses on the media of conversion and the early modern English stage. He is the author of *The Media Players: Shakespeare, Middleton, Jonson, and the Idea of News* (University of Michigan Press, 2015). Other projects of note include a new edition of *The Merchant of Venice* for Internet Shakespeare Editions (co-edited with Janelle Jenstad) and

the digital humanities project, DREaM, a database that indexes 44,000+ early modern texts, thus making long-neglected material more amenable for use with large-scale analytical tools (with Stéfan Sinclair and Matt Milner).

Paul Yachnin is Tomlinson Professor of Shakespeare Studies at McGill University. He has served as President of the Shakespeare Association of America (2009–10). From 2005 to 2010, he directed the Making Publics (MaPs) project. From 2013 to 2019, he directed the Early Modern Conversions project. Among his publications are the books, *Stage-Wrights* (University of Pennsylvania Press, 1997) and *The Culture of Playgoing in Early Modern England* (with Anthony Dawson; Cambridge University Press, 2001), editions of *Richard II* (Oxford University Press, 2011) and *The Tempest* (https://internetshakespeare. uvic.ca/Library/Texts/Tmp/); and six edited books, including *Making Publics in Early Modern Europe* (with Bronwen Wilson; Routledge, 2010) and *Forms of Association* (with Marlene Eberhart; University of Massachusetts Press, 2015). His book-in-progress, *Making Publics in Shakespeare's Playhouse*, is under contract with Edinburgh University Press. With Bronwen Wilson, he is editing *Conversion Machines in Early Modern Europe: Apparatus, Artifice, Body*, a volume from the Conversions project. His ideas and the ideas of his MaPs colleagues about the social life of art were featured on the CBC Radio IDEAS series, 'The Origins of the Modern Public'. A recent area of interest is higher education practice and policy, with publications in *Policy Options*, *University Affairs* and *Humanities*, and projects, including the TRaCE Project, involving twenty-four Canadian universities.

INTRODUCTION:
CONVERSION, CITIES AND THEATRE
IN THE EARLY MODERN WORLD

José R. Jouve Martín and Stephen Wittek

On the morning of 3 February 1631, the people of Lima awoke to discover that their main square had been transformed overnight into an elaborate allegory of the city of Troy. In addition to offering an unprecedented dramatic spectacle, this remarkable feat of civic theatricality provided a fitting metaphor for the multiple transformations experienced by the city in the century that followed its founding by Francisco Pizarro in 1535.[1] As the entrance to the fabled riches of Potosí (and also the primary site of export), Lima had quickly become a central colonial outpost of the Spanish empire, boasting a level of opulence and grandeur that rivalled that of Mexico City and many other cities in the Iberian Peninsula itself. Most notably, its many churches and monasteries spoke of the exuberance of its religious life, a testament to the efforts applied to the forced conversion of the populations of the former Inca Empire and of the singular role of the city in spreading Catholicism on the global stage.[2] In addition to these institutions, Lima was also home to one of the earliest universities in all of the Americas, a centre of learning where one could study theology, philosophy, Latin, Greek and the *Lengua general del Inca* or Quechua. By casting the city as a Homeric *polis*, the organisers of the Trojan allegory underlined the 'civilising' role bestowed by its religious and cultural infrastructure, and suggested a stark contrast to the larger Indigenous hinterland.

At first glance, the grandiose, allegorical tribute to the civilising force of Spanish culture and religious conversion appeared to be the work of learned elites. However, to the surprise of observers who congregated in the *plaza*

mayor that morning, the visionaries responsible for the overnight transforma-
tion of the colonial city turned out to be Afro-Peruvians classified as *mulatos*,
the mixed-race descendants of former slaves who had arrived in Lima by the
thousands in the previous decades.[3] The *mulatos'* staging of the story of the
Fall of Troy took place as part of the celebrations that the viceregal authorities
had organised to honour the birth of Prince Baltasar Carlos, Philip IV's son
and heir to the throne of Spain.[4] For three days, the *mulatos* played the roles
of Achilles, Agamemnon, Priam, Hector, Ulysses and other classical heroes.
Armed with shields bearing poems in praise of the newborn prince, they
entertained the enraptured crowd with mock battles based on the Homeric
epic. For the closing finale on the final day, they brought a wooden horse into
the centre of the plaza and proceeded to re-enact the Trojan defeat. When the
performance was complete, they made stirring proclamations of their loyalty
to the prince and exited the square in a courtly procession, proudly bearing a
portrait of the king. According to colonial chroniclers, none of the many other
events and representations linked to the prince's birth had come even close to
the artful complexity of the spectacle devised by the *mulatos*. By all accounts,
the radical transformation of the city square – and the corresponding transfor-
mation of the Afro-Peruvian performers – left a profound and lasting impres-
sion on the community overall.

The Trojan allegory in the *plaza mayor* exemplifies the ability of early
modern theatre to create spaces where elites and subalterns alike could pub-
licly experiment with ideas, identities and politics pertaining to religious
conversion. With the help of the Trojan production, spectators reimagined
themselves as the citizens of a classical *polis* rather than the inhabitants of a
capital thousands of miles away from the main cultural centres of Western
Europe. More importantly, by presenting themselves as Greeks and Trojans,
the *mulatos* were able to make a striking claim about their cultural author-
ity and their place in society. Rather than the mere descendants of slaves,
they now appeared as the sophisticated products of a successful programme
of conversion, and as the legitimate inheritors of an esteemed cultural tradi-
tion. Of course, the transformation of the city square was only temporary and
imaginary, but the argument it made about the power of conversion to trans-
form the city and the people had a potent impact on public discourse. As the
city chronicler Antonio Suardo put it in his account of the event, theirs 'have
been the most admired festivities that have ever taken place in this kingdom,
due to the splendor of their attire as well as their disposition'.[5] Without the
representational powers of theatre, the *mulatos* could not have expressed such
a radically provocative and complex argument, or received the same level of
public approbation.

This book considers various ways that theatricality contributed to the
exploration of conversional experiences, arguments and concepts in large

urban centres throughout early modernity (c.1500–1700). As demonstrated by the example from Lima, theatrical representation and conversional thinking came together in a variety of unprecedented combinations in the period, a development that derived in part from major changes in the social, intellectual and economic fabric of the Western world during the fifteenth and sixteenth centuries. In large urban centres such as Lima, London and Amsterdam, new opportunities for social mobility facilitated the perception that one's place in society hinged on the roles individuals played in the larger drama of everyday life.[6] Moreover, at the international level, wars of religion compelled individuals, communities, cities and countries to switch their political allegiances and religious beliefs on an unprecedented scale. While churches continued to provide a fundamental forum for explaining these changes, early modern publics found in theatre a space for a more playful, dialogical approach that fictionalised the conversional anxieties of the day in a massive anthology of stories about transformation. By the same token, theatre also offered a novel way of making sense of the changes that people underwent as a result of the disruptions and dislocations brought by diverse, world-shaking phenomena – from colonial expansion, to increasing courtly governance, to the unexpected rise of prices in various European countries. In theatrical productions that played out in classrooms, civic squares, commercial playhouses and multiple other locations, drama reformulated complex changes into transformational narratives that could be understood and *felt* by audience members of widely different social backgrounds.

The question at the core of *Performing Conversion* concerns the ability of theatre to model, interrogate, inspire, condition and constitute conversional experience within the special representational space of the stage. In chapters that range across the methodologies of literary studies, performance studies, history and art history, the contributing authors focus on different urban spaces, such as squares, playhouses, streets and labyrinths, and on early modern cities such as London, Venice, Madrid, Amsterdam, Zürich and Mexico City. Collectively, these chapters develop a wide-ranging investigation of the role that the creation and representation of drama had on the experience of conversion, while also considering the influence of theatre and theatrical practice on other forms of knowledge, spirituality and action. In the course of this investigation, the volume develops a picture of theatre as a space for the active reimagining of religious identity as well as the various other categories of political and social identity that might pertain to conversional change. This approach extends the work of Peter Lake and Michael Questier, who have described the theatre as 'a sort of playpen in which participants could adopt and lay aside, ventriloquise and caricature, try on for size, test and discard a whole variety of subject positions, claims to cultural authority, arguments and counter-arguments about legitimacy and power'.[7] In analyses that apply

this perspective to theatre as well as related forms of theatricality in urban spaces, this volume suggests that the theatrical 'playpen' was in fact a place where some very serious social work could occur, a place where a great variety of identity options could become apparent, and the prospect that one might change (or pretend to change) one's identity could seem vividly possible. We note that, even in its most basic forms, theatre required engagement with multiple, nested and fluctuating identities (for example, an actor on a stage might become a Jew, a Moor, a Puritan or a Jesuit). Moreover, at the level of narrative, it involved innumerable disguise plots and other gestures toward the distinction between appearance and reality, providing a unique register for the epistemological problems that characterise conversional discourse in early modernity.

<div align="center">CONVERSION</div>

In order to fully appreciate the contribution of drama to early modern conversional thinking, however, one must come to terms with the irreducible ambiguity at the core of conversional concepts, and acknowledge that the period featured a multiplicity of fluctuating, diverse and competing models of conversion deriving from the long history of religious conversion in the West. For example, in some cases, conversion was the result of territorial expansion and open warfare, as during the Arab conquest of Northern Africa and the Iberian Peninsula. Other times, it was the (not necessarily peaceful) outcome of social and political crises that took place internally over longer periods – the rise of Christianity in the Roman Empire is a key example. In yet other cases, it was a protracted and deeply personal journey that culminated in a sudden revelation (a model famously exemplified by St Augustine), or a less gradual process motivated not so much by faith or conviction, but by economic, social or political circumstances that warranted such action. Of course, there were also a great number of cases where conversion was not a matter of personal agency at all, but a form of coercion, an external imposition inflicted upon political subjects in a single stroke, as when Bishop Severus forced the conversion of the Jewish community of Minorca in the fourth century, thereby creating a template for similar events in other parts of the Mediterranean.[8] Although there are significant areas of overlap among these various conversional models, a definitive, universal description of what conversion 'is' or 'is not' remains tantalisingly out of reach – and for good reason. As Karl Frederick Morrison has noted, conversional concepts are essentially metaphorical, and the history of conversion is 'a history of metaphorical analysis' whereby abstract, ambiguous notions of change become socially plausible and meaningful.[9] In other words: conversion works, not despite ambiguity, but because of it.

On a similar point, it is also important to recognise that the ambiguity of conversion was a central problem for the early moderns and a key catalyst for

the deluge of conversional activity that dominated and defined the period: as people sought to confirm their own conversions and the conversions of others, the practices, debates and theories codifying conversional experience began to multiply in an exponential fashion. To study conversion in the early modern period, then, is to study a genuinely complex, dynamic congeries of divergent ideas and phenomena that do not fit comfortably within a singular definition.

By offering a broad overview of the ways in which theatre enabled early moderns to experience, experiment with and make sense of conversion, the following chapters help to provide perspective on the evolution of conversional thinking, and also help to explain the social dynamics underlying conversion in the present era. As developments such as the Reformation and the Counter-Reformation played out, the theatrics of conversion became an increasingly central aspect of identity-formation, not only at the level of individual self-definition, but also at the level of international politics. Consider, for example, Queen Christina of Sweden's spectacular entry to Rome following her conversion to Catholicism, or Henry IV of France's dramatic renouncement of Protestantism and subsequent ascension to the French throne.[10] Given the speed with which the conversion of individuals and communities could take place, not to mention the considerable benefits it could yield, it is not surprising that questions of authenticity and sincerity became a central focus of scrutiny and debate. Faced with the ontological and epistemological impossibility of definitively proving the interior dimension of conversion one way or another, individuals had to find ways to make and judge conversional claims based on exterior significations such as dress, bodily practices, rituals, dietary customs, forms of speech and myriad other ways of communicating the fundamental message of conversion: 'this person used to be an x, but is now a y'.

CITIES

Cities were especially given to theatricality because they had the economic capacity to support a professional class of cultural producers and because they tended to cultivate a densely populated, culturally heterogeneous environment where issues of identity, social performance and conversion became especially apparent and important. Under the auspices of these new social and economic conditions, opportunities for social mobility increasingly depended on one's ability to perform according to various 'roles' in the larger drama of everyday life. Moreover, with the rise of urban planning and the proliferation of forms for multisensorial, performative representation, the early modern city became something like a stage itself: intensely protean, oriented toward display, openly solicitous of attention and conducive to conversional imagining.

To illustrate the co-productive relation between cities, theatricality and conversion, Iain Fenlon begins this volume by drawing attention to the transformation of civic and religious spaces that took place between the late

sixteenth and early seventeenth centuries (Chapter 1). His primary example is the Piazza San Marco in Venice, a masterpiece of civic planning that incorporated geometrically structured perspective views deriving from the work of Leon Battista Alberti and other Renaissance theorists. As Fenlon points out, public activity in the period was characterised by the rise of urban culture and the reconfiguration of urban space, not only to accommodate a growing population, but also to facilitate the emerging conversional theatrics of Church and State, which made use of urban spaces for the purpose of political and religious indoctrination. Accordingly, squares such as the Piazza San Marco became open-air sites for sophisticated theatrical displays designed, not for a simple aggregation of individuals, but for a public.[11] In the course of facilitating public discourse and public consciousness, the squares also provided a remarkably effective space for making the social reality of conversion manifest.

In addition to city squares, the period also saw the rise of a great variety of recreational spaces that forged a similar sort of relation between theatricality and conversional thinking. Angela Vanhaelen offers an excellent case in point in her analysis of Amsterdam's *Doolhoven*, or labyrinths (Chapter 2). Nestled in the heart of the city, the *Doolhoven* provided a unique multisensorial experience that included fountains, mechanical statues and other marvels of the time. Although the attractions were primarily secular, they borrowed their basic concept and design from similar structures at medieval cathedrals, where one's progression through a labyrinth served as an allegory for progression toward spiritual transformation.[12] Upon exiting the labyrinthine cityscape of early modern Amsterdam proper, *Doolhoven* attendees encountered another, more pleasurable, system of tangled passageways that provided strange surprises, opportunities for thoughtful reflection and a brief respite from the pressures of everyday life in the bustling urban metropolis.

Beyond the orbit of designated pubic space, the interplay between cities, theatricality and conversion could also become manifest – in a more diffuse manner – in exclusive or semi-private spaces, such as classrooms and private studies. For an illustrative example of how this dynamic could operate, consider the rhetorical textbooks of Fernández Salazar, which are the subject of José-Juan López-Portillo's analysis (Chapter 3). While Franciscan missionary theatre advocated the transformation of colonial Mexico City into a New Jerusalem that would herald the second coming of Christ, Cervantes de Salazar's curriculum promoted an alternative dramaturgy of conversion based on the principles of early modern humanism. Following the example of Juan Luis Vives, his textbooks sought to train students, not only by reading, but also by performing didactic dialogues, with the objective of instilling a fully embodied sense of what it meant to think and present oneself as the product of a humanist education. Thus, by performing rhetorical exchanges centred on conversional transformation, subjects also contributed to the conversion of a

city. As in Lima, Venice and Amsterdam, and many other cities in the period, the growth of urban culture in Mexico City progressed in accordance with an emphasis on theatricality and conversional thinking.

THEATRE

As early modern cities became increasingly able to sustain companies of professional players, theatre began to spread out into purpose-built facilities that attracted large crowds on a regular basis. In London, these facilities included open-air amphitheatres, such as the Globe, alongside smaller indoor venues, such as the Blackfriars Playhouse. As Stephen Wittek points out in his analysis of Dekker and Middleton's *The Honest Whore* (Chapter 4), London's theatres attracted 'an audience that included the full spectrum of London citizenry: apprentices, shopkeepers, guildsmen, housewives, foreigners, artisans, professionals, ambassadors, labourers and courtiers, all crowded together in a dense network of shared cognitive experience'.[13] Crucially, the discursive situation constituted by this heterogeneous collection of onlookers was not passive or unidirectional, but intensely dialogic. In addition to simply seeing actors and their fellow spectators, people went to the theatre to be seen – and to feel seen. These factors facilitated an unprecedented 'exercise in collective imagining' that allowed for a multisensorial understanding of the transformations of men and women and of the world around them, both secular and religious.[14]

Thus, with the rise of a theatrical industry, the inhabitants of early modern cities were able to access a more playful, dialogical alternative to the conversional discourse of the religious establishment, which generally tended toward polemic, didacticism and orthodoxy. In an analysis of how this dynamic played out in the Spanish Golden Age (Chapter 5), José R. Jouve Martín shows how dramatists such as Lope de Vega and Calderón de la Barca enacted religious debates amongst Catholics, Protestants, Jews, Muslims and Pagans, and personated celebrity converts such as Saint Augustine and Queen Christina of Sweden. In Madrid and other parts of the Spanish Empire, audiences attended these plays in droves, but not necessarily for purposes of religious instruction. Rather, the key to the drama's appeal hinged on the ability of dramatists to balance piety with a probing exploration of conversional issues, spectacular stage effects, and multiple storylines that almost never failed to include romantic – and sometimes even tacitly sexual – subplots.

This ability to combine serious thinking with broad appeal is indicative of the interpretive openness that made theatre an extremely effective, but also extremely provocative, vehicle for conversional thinking. As Elke Huwiler demonstrates in her analysis of drama and conversion in the Swiss cities of Zürich, Berne and Lucerne (Chapter 6), the challenge of integrating theatre into a religious landscape often included the thorny difficulty of controlling the meaning – and more importantly, the perceived meaning – of dramatic

representations. Despite dramatists' careful attempts to avoid controversy, Swiss audiences regularly inferred an immoral or sacrilegious underlying intention, obliging censors on both sides of the religious divide to keep a sharp eye out for the possibility that a subversive message might lurk behind the guise of polysemic uncertainty, which was an inherent aspect of the medium. Ultimately then, the challenge that theatrical culture posed to traditional orthodoxies consisted not merely in the content of productions, but also in the very nature of the form itself.

By recognising the challenge that forms of theatrical representation brought to bear on practices of interpretation, one can begin to discern a symbiotic relationship between theatre, conversion and urban environments. That is to say, while cities provided a set of socioeconomic conditions that were especially conducive to theatricality, the spaces of theatrical production correspondingly provided a powerful set of things to think with, a toolkit for understanding and living in the city that significantly reorganised processes of memory, perception and identity-formation. In his analysis of Middleton's *A Chaste Maid in Cheapside* (Chapter 7), Paul Yachnin refers to this co-productive relationship between conversion, theatre and cities as a 'conversional economy':

> Theatre opened new pathways between the City of God and the Earthly City, between the domains of conversion and economy, so that playgoers might begin to think in far more complex ways about their lives in the metropolis of London, a city that was a centre of religious controversy and change and also a centre of bustling commerce that happened to feature a newborn entertainment industry, a burgeoning field of the creation and consumption of print and performance that was at once artistically and socially creative.[15]

Viewed through the lens of theatrical representation, the subtle inter-relation between identity-formation, performance and the environment became much easier to perceive. Conversion appeared not only as a process of introspection and self-discovery, but also as a series of material transactions that allowed – or forced – human beings into different social, economic and spiritual states. These transactions were not simply the result of a cynical attempt to turn the tide in pursuit of an unscrupulous benefit (be it social or economic): they were also a way to navigate the processes of conversion itself, the many passageways and alleys that linked the Earthly City to the City of God.

As noted above, the purpose of this book is not to propose a unified theory of conversion, or even to articulate a multi-purpose definition of conversion, but to provide perspective on the centrality and variety of conversional discourse in early modernity, and to bring the relation between conversional discourse, theatricality and cities into close view. Although religion plays an important role in the pages that follow, the authors are at pains to demonstrate

that conversion was not always exclusively – or even primarily – a religious phenomenon, and that factors such as material culture, performance, economics and the physical environment were absolutely central to conversional experience. Simply put, our contention is that conversion is not reducible to a single phenomenon or definition. Rather, it is a constellation of experiences, discourses and material contexts. On a similar note, despite a geographical scope that stretches from London to Lima, the volume does not set out to provide a comprehensive or encyclopedic account of conversional practices, cities or theatrical cultures. Rather, we offer readers a brisk, meandering tour of select sites that collectively make important, underlying trends easier to see. Taking a cue from Michel de Certeau's famous description of 'walking in the city', the objective of our tour is not to look down at these cities as if from above, but to experience them from street level, focusing on specific aspects while inevitably disregarding others.[16]

Finally, in addition to offering a new perspective on the development of conversional phenomena in early modernity, it is our hope that this volume will also help to improve understanding of how conversion functions in the twenty-first century. With this goal in mind, Stephen Wittek closes the volume by considering affinities between conversional practices in early modernity and the present era, with particular focus on the forced conversion of Aboriginal children in Canadian residential schools, the so-called 'conversion therapies' purporting to 'cure' lesbian, gay, bisexual, transgender and queer (LGBTQ) people and the conversions imposed on Jews by entrenched structures of anti-Semitism (Coda). In readings of three twenty-first-century plays that explore these issues, Wittek emphasises the unique ability of drama to analyse and critique the performative nature of conversional social practices. His analysis asserts the centrality of dramatic and social performance to the ongoing evolution of conversional phenomena, drawing lines of connection between the theatrical representations explored in the preceding chapters and similar offerings in our own age.

Notes

1. The description of the staging of the Fall of Troy is found in the works *Diario de Lima* by Juan Antonio Suardo, a narration of the most important events that took place in the capital of Peru between 1629 and 1639, and the book by Captain Rodrigo de Carvajal y Robles entitled *Fiestas que celebró la ciudad de los Reyes del Perú al nacimiento del serenísimo Príncipe don Baltasar Carlos de Austria*. Further information about these two chroniclers and their description of the events can be found in Jouve Martín, 'Public Ceremonies and Mulatto Identity in Viceregal Lima', pp. 179–201.
2. From the late sixteenth century to the mid-seventeenth century, the city of Lima played a fundamental role in the religious imagination of the Spanish empire as illustrated by the multiple canonisations and processes of beatification of city residents that were initiated at that time. For a description of the religious life of

the city at the time, see Jouve Martín, 'En olor de santidad', pp. 181–98. Also of interest is Van Deusen, *Embodying the Sacred*.

3. The census taken in 1636 by the Viceroy of Peru Marquis of Chinchón, under whose authority the festivities in honour of Prince Baltasar Carlos took place, showed that Lima had a total of 10,758 Spaniards, 13,620 individuals classified as blacks and 861 as mulattos (Bowser, *The African Slave in Colonial Peru*, p. 341). The Indigenous population of Lima had been moved in 1590 to the nearby town of Santiago del Cercado, situated in the outskirts of the city. See also Jouve Martín, 'Public Ceremonies and Mulatto Identity in Viceregal Lima', p. 185.

4. The mulattos of Lima were allowed to organise themselves into a guild in the late 1620s, which also explains their presence in the celebrations at hand alongside other colonial guilds. While most colonial guilds were organised following a professional criterion, the mulattos' guild was primarily conceived along racial lines. For more information see Bowser, *The African Slave in Colonial Peru*, p. 306. See also Jouve Martín, 'Public Ceremonies and Mulatto Identity in Viceregal Lima', p. 188.

5. Suardo, *Diario de Lima*, I, p. 141 [our translation].

6. Social mobility was far from a uniform experience and varied wildly from one territory to the next. However, changes were noticeable in major urban centres and some parts of the countryside. For a discussion of this topic in early modern Europe see Collins, 'Geographic and Social Mobility in Early-Modern France', pp. 563–77; Stone, 'Social Mobility in England, 1500–1700', pp. 16–55; and Casey's *Early Modern Spain: A Social History*, pp. 111–37. Especially of interest for an overview of the subject in comparative perspective is the chapter that Henry Kamen devotes to the 'middle elite' in *Early Modern European Society*, pp. 95–116.

7. Lake and Questier, *The Antichrist's Lewd Hat*, p. xxxi.

8. See Bradbury, *Severus of Minorca – Letter on the Conversion of the Jews*, pp. 1–4.

9. Morrison, *Understanding Conversion*, p. 2.

10. See Åkerman, *Queen Christina of Sweden and her Circle*, pp. 196–233; Wolfe, *The Conversion of Henri IV*, pp. 139ff.

11. For a discussion on the emergence of publics and the transformation of urban space in early modern Europe see Eberhart and Yachnin, *Forms of Association: Making Publics in Early Modern Europe*. Also of interest is Vanhaelen and Ward, *Making Space Public in Early Modern Europe: Performance, Geography, Privacy*.

12. See Compton, *Understanding the Labyrinth*, pp. 103–61. Also of interest is Bandiera, *The Medieval Labyrinth Ritual and Performance*, pp. 17–23. A comprehensive review of the academic literature related to the semiotic and ritualistic conceptions of the labyrinth can be found in Rhodes and Rudebock's *Bibliography of Studies Related to Labyrinth Research*.

13. Wittek, 'Conversional Thinking and the London Stage', in this volume, p. 96.

14. Wittek, 'Conversional Thinking and the London Stage', in this volume, p. 96.

15. Yachnin, 'Conversional Economies: Thomas Middleton's *Chaste Maid in Cheapside*', in this volume, p. 159.

16. De Certeau, 'Walking in the City', pp. 156–7.

WORKS CITED

Åkerman, S., *Queen Christina of Sweden and Her Circle: The Transformation of a Seventeenth-Century Philosophical Libertine* (Leiden: Brill, 1991).

Bandiera, N. A., *The Medieval Labyrinth Ritual and Performance: A Grounded Theory Study of Liminality and Spiritual Experience*, PhD diss. (Austin: The University of Texas at Austin, 2006).

Bowser, F. P., *The African Slave in Colonial Peru, 1524–1650* (Stanford: Stanford University Press, 1974).

Bradbury, S., *Severus of Minorca – Letter on the Conversion of the Jews* (Oxford: Clarendon Press, 2004).

Casey, J., *Early Modern Spain: A Social History* (London: Routledge, 1999).

Carvajal y Robles, Rodrigo, *Fiestas que celebró la ciudad de los Reyes del Perú al nacimiento del serenísimo Príncipe don Baltasar Carlos de Austria* (Lima: Jerónimo de Contreras, 1632).

Collins, J. B., 'Geographic and Social Mobility in Early-Modern France', *Journal of Social History* 24:3 (1991), pp. 563–77.

Compton, V., *Understanding the Labyrinth as Transformative Site, Symbol, and Technology: An Arts-Informed Inquiry*, PhD diss. (Toronto: University of Toronto, 2007).

De Certeau, M., 'Walking in the City', in Simon During (ed.), *The Cultural Studies Reader* (London: Routledge, 1993), pp. 156–63.

Eberhart, M. and P. E. Yachnin (eds), *Forms of Association: Making Publics in Early Modern Europe* (Amherst: University of Massachusetts Press, 2015).

Jouve Martín, J. R., 'En Olor De Santidad: Hagiografía, Cultos Locales Y Escritura Religiosa En Lima, Siglo XVII', *Colonial Latin American Review* 13.2 (2004), pp. 181–98.

Jouve Martín, J. R., 'Public Ceremonies and Mulatto Identity in Viceregal Lima: A Colonial Reenactment of the Fall of Troy (1631)', *Colonial Latin American Review* 16:2 (2007), pp. 179–201.

Kamen, H., *Early Modern European Society* (London: Routledge, 2000).

Lake, P. and M. C. Questier, *The Antichrist's Lewd Hat: Protestants, Papists and Players in Post-Reformation England* (New Haven: Yale University Press, 2002).

Morrison, K. F., *Understanding Conversion* (Charlottesville: Virginia University Press, 1992).

Rhodes, J. and D. Rudebock, *Bibliography of Studies Related to Labyrinth Research*, <https://zdi1.zd-cms.com/cms/res/files/382/Bibliography_ of_ Studies_ Related_ to_ Labyrinth_Research_.pdf_517K.pdf> (last accessed 21 April 2020).

Stone, L., 'Social Mobility in England, 1500–1700', *Past and Present* 33:1 (1966), pp. 16–55.

Suardo, J. A., *Diario de Lima, 1629–1639*, ed. R. Vargas Ugarte, 2 vols (Lima: C. Vásquez, 1936).

Van Deusen, N. E., *Embodying the Sacred: Women Mystics in Seventeenth-Century Lima* (Durham: Duke University Press, 2017).

Vanhaelen, A. and J. P. Ward (eds), *Making Space Public in Early Modern Europe: Performance, Geography, Privacy* (London: Routledge, 2013).

Wolfe, M., *The Conversion of Henri IV: Politics, Power and Religious Belief in Early Modern France* (Cambridge, MA: Harvard University Press, 1993).

I

VENICE: THE CONVERTED CITY

Iain Fenlon

For most historians, the term 'conversion' refers to religious phenomena. These certainly occupy the central focus of the argument in what follows, where they will be considered within the geographically specific socio-cultural context of Venice during the late sixteenth and early seventeenth centuries, a period that is traditionally portrayed as the final instalment of a Golden Age, characterised in artistic terms by the late works of Veronese (d.1588), Titian (d.1576), and Palladio (d.1580). Endlessly celebrated in traditional histories, this heroic panorama of cultural achievement needs to be tempered by consideration of the lasting effects upon the Venetian mentality of the crises produced by the war of Cyprus. As some thoughtful contemporaries realised, the impact of these significant threats to the city's sense of security and well-being – which were then almost immediately followed by the devastating plague of 1575–7 in which one third of its inhabitants perished – could not be successfully disguised by the elaborate celebrations, unparalleled in recent Venetian practice, that greeted the news from Lepanto in 1571, and the visit of Henry III of France three years later.

The relentless advance of Islam, as it seemed at the time, is central to understanding Venetian religious discourse in these years. So too is the polemic over an appropriate governmental reaction to heresy, which has to be broadly defined to include different categories of perceived enemies of the state, including Protestants and Jews, among others. In this context, negotiations with Rome over the activities of the Inquisition were viewed in some patrician

circles as inimical to the Republic's self-image as the 'home of liberty'; identified by Petrarch, this trope had reverberated throughout the intervening centuries as a vital component of the 'Myth of Venice'.

In this sense, the response to 'heretics and infidels' from both without and within the state involved a refashioning of Venetian identity in which Catholicism was not merely reaffirmed but dramatically and radically redirected. In one of the largest and arguably the most cosmopolitan cities in Europe, the heightened sense of civic and devotional piety that resulted from official initiatives was not as monolithic as its constant reiteration at the hands of both the ecclesiastical and secular authorities might seem to imply. With its wide network of commercial relationships and central position within the international book trade, religious life in Venice was constantly animated by its contacts with outside alternatives, particularly from north of the Alps, much to the consternation of the Papacy and the Holy Office. In other words, as its political and economic power declined and its overseas empire diminished (Cyprus was never recovered, for all the celebratory noise generated by Lepanto), Venice was deliberately redefined by an alliance of secular and religious authorities as the ultimate holy and apostolic city in the Augustinian sense, equivalent in its importance to Rome itself. This process of change was not gradually imposed, but rather dynamically pursued during the second, third and fourth decades of the seventeenth century, decades which came to experience the strength of this sense of 'conversion' in the classic definition of the word, as a constituting turning point, or change in direction.

Traditional discussions of religious change often feature either a grass-roots movement based upon the ideas of a single personality or group of activists, or a top-down procedure principally driven by governmental authorities. Within this framework, rituals, literary works, practical texts and the arts have traditionally been seen as modes of propaganda, and their audiences as passive recipients. While the presence of such stabilising and legitimising effects cannot be denied, the transformative potential of popularisation has often been underestimated in such discussions. Successful popularisation rested much less upon actual normative expertise, but rather constituted an authority in its own right, even if quite distant from the dogmatic or systematic ideas that it attempted to popularise. New groups of experts and skills, and new sites of communication were established in the course of this development, as can be seen in the example of Giovanni Tiepolo during his time as Patriarch of Venice. As his case also makes clear, modifications of popular rituals, both civic and religious, are one arena in which these strategies of conversion can be observed in some detail. It is here, in the liturgical, musical and ritual elaborations of the renewal of relics, which Tiepolo clearly saw as a vital weapon in the armoury of change, that the discussion can begin.

1.

More than any other city in the Italian peninsular outside Rome, early modern Venice was densely populated with Christian relics. Printed hagiographic guidebooks such as the twelve books of Pietro de Natali's *Catalogus sanctorum*, written by a fourteenth-century Venetian Bishop of Jesolo and printed in both an accessible quarto format and in a handsome folio version for scholarly use, describe for the benefit of the erudite and pious visitor the rich variety of relics that could be venerated in the churches of the city.[1] The movement of relics to people rather than the reverse, achieved through the process of *translatio*, was a prominent feature of the medieval church.[2] From the eighth century onwards, competition to acquire the most prestigious saintly remains, often by unscrupulous means, was intense. Monks raided churches, merchants plundered tombs and relic-hunters scoured the catacombs. Far from being considered a crime, the thefts necessary to create the extensive and lucrative relic market were sanctioned by all parties to the transaction, from the Pope to the institutions and individuals who received them.[3] One of the most important transferrals of relics to Venice occurred at the end of the twelfth century, when the body of St Stephen was transported to the Benedictine monastery on the island of San Giorgio Maggiore. Its presence there gave rise to an annual procession, which took the form of an official ducal procession (*andata*) in which the Doge and Senate and the whole official celebratory machine crossed the lagoon on Christmas Day to celebrate Vespers, before returning the next day for the celebration of Mass on St Stephen's Day.[4] The involvement of Venice in the Fourth Crusade had given it a distinct advantage in the traffic of significant remains from Asia Minor, and the establishment of the Latin Kingdom converted the tide of fresh arrivals into a flood until its collapse in 1261. Among them were those of St Nicholas, the patron saint of sailors, and the military saint, George, who together with St Mark constitute the traditional triumvirate of Venetian saintly protectors. All three of them appear in the legend of the fisherman and the ring, probably of fourteenth-century origin, which completed the Venetian appropriation of the Evangelist inaugurated by the *translatio*.[5]

The arm of St George, one of the most prized relics in the treasury of the Basilica, was brought back to Venice in 1204; later it was joined by the leg of the saint, triumphantly carried from Scutari, near Constantinople, by Christian refugees at the end of the fifteenth century.[6] Meanwhile, the head of the saint was acquired by a captain in the Venetian navy and added to the collection of San Giorgio Maggiore in 1462.[7] To this already significant presence, another relic was donated to the Scuola di San Giorgio degli Schiavoni, founded by some 200 immigrants from Dalmatia in the middle of the fifteenth century who venerated St George as one of their patrons. Dalmatians had been prominent

in the Venetian struggle against the Turks in the Adriatic, and their veneration of the dragon-slaying military saint carried a richly resonant contemporary significance.[8] Of the nine canvasses painted by Carpaccio for the Scuola, three related to the life of St George as recounted in the Golden Legend.[9]

Possession of the relic of St Nicholas was a more contentious matter, since it was contested by both the citizens of Bari, who claimed to have acquired them in the eleventh century, and the Venetians who allegedly removed them during a raid in the twelfth.[10] Their importance as a symbol of the religious domination of the Adriatic is underlined by the geopolitical significance of the church of San Nicolò on the Lido, the site of official rituals of state from the Middle Ages onwards. Ducal elections and investitures took place there before being transferred to San Marco, and the annual benediction of the Adriatic, which later grew into the Ascension Day ceremony of the marriage of the sea, was enacted nearby, within the confines of the lagoon.[11] Above all there was St Mark, whose body, according to the legend of the *translatio*, had been brought to Venice from Alexandria by two Venetian merchants, and was interred under the High Altar in the Basilica.[12] There it functioned as the ultimate site of sacral power bestowed through the concept of 'praesentia', the notion that, although in heaven, in some powerful and effective sense the saint was 'present'. It was at this precise spot that intercession took place and pardon was received for the sins of the city, and that good reigned and evil was exorcised, through the agency of the Doge, St Mark's representative on earth.[13]

Writing in the early seventeenth century, Giovanni Botero claimed that in no other city could so many complete relics of saints be found.[14] Visitors such as Philippe de Commynes observed in 1495 that Venice 'is the most reverend city that I have ever seen in ecclesiastical matters',[15] while the eccentric Englishman Thomas Coryate, who followed him over a century later, described it as 'the Jerusalem of Christendome'.[16] For both Venetians and foreign visitors alike, this impressive patrimony and the devotional practices that surrounded it were a tangible demonstration of the special character of a city that was so frequently represented as divinely protected. In the course of the sixteenth century, few saints were canonised by the Church,[17] and only a small number of new relics arrived in the city; among them was the skull of St Titus, hastily transferred from Crete before the Venetians abandoned the island during the Turkish occupation.

Nonetheless, and perhaps in compensation, a significant campaign of refurbishment of existing relics took place in the years after Trent. One of the most important of these occurred in 1617, when five important reliquaries, including samples of the Precious Blood and fragments of the True Cross, were rediscovered hidden behind a marble panel in the sanctuary of San Marco.[18] Giovanni Tiepolo, the indefatigable *Primicerio* of St Mark's Basilica and a strong advocate of Tridentine policy in relation to the worship of relics, now ordered that

a procession around the Piazza be held so that they could be displayed and venerated. It was in something of the same spirit that the *Procuratori de supra*, who were ultimately responsible for the Basilica and its treasures, resolved to restore and rehouse the prized icon of the Madonna Nicopeia, one of a large number of ritual objects, including reliquaries, gold chalices, enamelled book covers, and icons, which the Venetians had acquired as booty following the fall of Constantinople in 1204.[19] There it had been venerated as the Virgin Hodegatria; it was not until the seventeenth century that the icon was assigned the name of Nicopeia ('victory bringing') by the Venetians, in the belief that this small lightweight panel had brought success to those who had carried it in battle in Asia Minor, and would bring similar good fortune to the Republic.[20]

The origins of an early-seventeenth-century resurgence of devotion to both Christ and the Virgin, the two most potent protectors of Venice, which was also accompanied by a re-energised interest in the worship of relics, the cult of the rosary and devotion to a number of local saints, was a direct product of the crises of the middle decades of the century. In essence its roots stretch even further back, to the years when the Venetian sense of security and well-being suffered the seismic shock generated by the War of the League of Cambrai and the traumatic defeat of the Republic at the battle of Agnadello in 1509, a disastrous military humiliation which prompted Machiavelli to famously note that in one day, the Venetians had

> lost the state which they acquired during many years with infinite expense. Although they have recently gained some of it back, they have regained neither their reputation nor their strength, and so live at the mercy of others, like all the other Italian rulers.[21]

In the subsequent transition from a militant power to one constrained by the Hapsburg presence, Venice refashioned itself as a city of peace and harmonious existence, a process influenced by political theorists including Gasparo Contarini.[22] However, the central idea of the perfection of Venetian political institutions, outlined in Contarini's authoritative text *De magistratibus et republica Venetorum*, was to be severely tested during the middle decades of the century.

2.

Following his appointment in 1566, the Papal Nuncio to Venice, Giovanni Antonio Fachinetti, frequently appealed to the government to put down heresy, invoking both Christian duty and *ragion di stato* in the process. In grand rhetorical style, he often emphasised the vulnerability of the Republic to 'the sedition and discord that heresy brings', while drawing on the familiar metaphor of religious dissent as a disease more terrible in its effects on the body politic than any outbreak of plague.[23] Failure to act would only provoke

divine retribution. While the suppression of heresy was Fachinetti's main aim, it inevitably became intertwined with that of Pius V, the militantly reformist pope who had been elected in January of the same year, to cement an alliance between the Papacy, Venice and Spain in order to mount a new crusade against the Ottoman Empire. Until 1572, when Pius died, and Fachinetti (later to be elected as Innocent IX) was recalled, both pursued these twin objectives with determination.[24]

Events were to move in their favour. Following the death of Suleiman the Magnificent in September 1566 and the transfer of power to the new sultan, Selim, Venetian fears for the safety of Cyprus intensified. The island, which was the last Christian stronghold in the Muslim East and had been under the control of the Republic for eighty years, was highly prized for its symbolic value, its strategic importance and its produce.[25] These concerns soon turned into harsh reality when the Ottoman forces landed on the island in July 1570. The fall of Famagosta to the enemy, followed by the failures of the Christian fleet during the winter, increased the pressure on the loose alliance of Spain, Venice and the Papacy to establish a formal agreement to combine forces in the struggle against the Turks.[26] Finally signed in May 1571, the articles that established the Holy League as a *foedus perpetuum* was agreed and celebrated by the Venetians later in the summer in a carefully managed piece of state ceremonial.[27] With the campaign of the Holy League against the Turks in full swing, Facchinetti returned to his traditional argument, now giving it a new emphasis:

> Private persons examine their consciences and seek to placate the Lord God when they are admonished by his scourges. This Republic should do the same. Well knowing that it is really God and not the Turk who is making war upon us, they should carefully reflect upon the question, 'why should the Majesty of God think itself offended by this state?'[28]

In this formulation, the danger posed by the Ottoman galleys became an expression of Divine displeasure, even vengeance, and the threat to Venetian security could only be overcome were the Republic to be in a condition of high moral perfection, a condition which necessarily excluded any gestures of leniency towards infidels and heretics. When victory for the fleets of the Holy League came at Lepanto on 7 October 1571, the moral health of the Venetians was inevitably adduced as one of the reasons for their success, at least by the citizens of the Republic. Perhaps inevitably, in view of the difficulties which had accompanied the formation of the League the previous year, the Spanish claimed that the heroism of Don Juan had been decisive, while the Venetians praised the firepower of their galliasses. Equally inevitably, the most common explanatory theme among all members of the League centred on the role of Divine providence. Pietro Buccio's oration, one of a number

that were delivered publicly, attributed even the mechanics of the battle to God's intervention. The ships of the League had triumphed, he wrote, because the wind changed in their favour at the crucial juncture, a sure sign of Divine Justice, while the fact that the Turks had clearly underestimated the size of the opposing fleet could only be attributed to Divine Goodness.[29] The theme of Lepanto as Christ's Victory runs through Celio Magno's play with music, *Il trionfo di Christo*, given in the ducal palace before the Doge and Senate on St Stephen's Day in 1572, which elaborates the *topos* of the Venetians as a divinely protected people through whose courage the Infidel had been punished.[30] The ubiquitousness of this idea is neatly illustrated by the anonymous pamphlet of poetic paraphrases of the Psalms, 'accommodate', according to the title page, 'per render gratie a Dio della vittoria donata al Christianesimo contra Turchi'.[31] Here, within a central decorative frame, the Lion of St Mark is shown being guided by the hand of God. Every conceivable ingenuity was deployed by Venetian poets and printers to exploit the Christian theme. In one commentary on the 'Pater Noster' 'in lingua rustica', the prayer itself is intertwined with celebratory observations on the victory, and paraphrases of the Psalms and other well-known prayers are common in the Lepanto literature.[32]

For some Roman commentators, the victory was the direct outcome of Papal wisdom, a theme elaborated in Giorgio Vasari's frescoes illustrating the triumphs of the Papacy in the Sala Regia in the Vatican, as well as the funerary monument of Pius V in the Sistine Chapel of Santa Maria Maggiore.[33] As early as the Consistory of May 1571, which had ratified the articles of the Holy League, Pius V had attributed the successful conclusion of the discussions to the power of divine protection, and in consequence had projected the League's military campaign as a divinely ordained Christian crusade on historical lines, pursued through the agency of Papal guidance, and achieved through the heroism of the Papal Commander, Marcantonio Colonna. Contemporary codes of chivalry required the nobility to fight crusades as and when they were required. An important part of the Pope's conception, this was taken up by commentators such as Orazio Toscanella, who argued that it was a Christian duty to reclaim the Holy Land, the birthplace of Adam and Christ, from the Turks. The spread of Islam was a great danger. The Holy League should overcome their differences and, sustained by their common love of Christ, should take up arms and drive the Turks back to their own lands, just as Alexander the Great had done with Darius, Xerxes with the Athenians, and Hannibal with the Romans. The alternative was bloodshed, misery and death.[34]

In terms of traditional Venetian practices, it was inevitable that the victory at Lepanto would be marked by an expansion of the Venetian civic liturgy in order to accommodate an annual celebration. The main vehicle for this was a St Giustina, Virgin and Martyr, on whose feast day the victory had taken place. A minor figure in the Roman calendar, she had always been more

significant in a Venetian context, since her relics are preserved in the Paduan church of the Benedictine monastery which bears her name, where they had been reinterred in the crypt of the attached Basilica in 1562.[35] The reburial of her remains together with her association with Lepanto elevated Giustina to a position of major importance within the official articulation of the myth of Venice. An annual *andata*, ordered by the Doge and Senate, starting from San Marco and then processing to the church and convent of Santa Giustina in the north of the city, took place for the first time in 1572.[36] Mass was celebrated and coins, popularly known as *giustine*, were presented to the nuns by the Doge, after which the *andata*, chanting litanies as it went, returned to the Piazza.[37] The *andata* to Santa Giustina joined together a liturgical celebration of a great naval victory with a civic procession and parade in which government officials, clergy and citizens all participated in a public representation of a harmonious political order. It also provided the state with an occasion to honour a local saint, to commemorate the Venetian victims of war, and to annually identify a common enemy who remained uncomfortably lodged in the Venetian consciousness while strengthening social cohesion through communal displays of piety and patriotism. Through such means the Venetians were constantly reminded of the unity of Church and State, placed under the patronage of St Mark and guided by his representative on earth. From a position of comparative obscurity in the Venetian ritual calendar, St Giustina was now indissolubly wedded to the crucial process of divine intervention which had secured the victory, and throughout the 1570s and beyond, her newly acquired significance was frequently expressed in a wide range of plays, verse, paintings, music and sculpture.[38] The title page of Paolo Paruta's funeral oration in honour of the Venetian dead shows the saint supported by two lions with the affirmation 'In te Domine speravi' around the decorative frame.[39] Above the gateway of the Arsenal, symbol and source of Venetian naval power, St Giustina's statue by Gerolamo Campagna was raised in 1578, together with an explanatory inscription in Latin, 'VICTORIAE NAVALIS MONVMENTVM', and the date, M.D.L.XXI.

Veneration of St Giustina was just one of a number of religious practices through which the Venetians recalled and celebrated Lepanto in later years; another was the increased attention paid to the already established devotion of the Rosary. Although a Rosary Confraternity had been founded in Venice at the end of the fifteenth century shortly after the Dominican cult had been established in Cologne, it was only in the last quarter of the sixteenth century that it greatly increased in popularity, largely as a result of papal changes to the liturgy, which anchored it to the annual commemoration of the victory.[40] Initially it was Pius V who instituted 7 October as the feast of Our Lady of Victory by adding the text and chants of 'Auxiliarum Christianorum' to the Litany of Loreto; the connection between the victory and the Rosary was then

further consolidated by his successor, Gregory XIII, who in 1573 designated the first Sunday in October as the Feast of the Rosary.[41] The fresh lease of life which these changes brought to the devotion was particularly strong in Venice and the Veneto. At the Dominican church of S. S. Giovanni e Paolo in Venice, the Scuola del Rosario, whose membership seems to have largely consisted of wealthy merchants, raised the considerable resources necessary to transform the gothic chapel of St Dominic on the north side of the church into a shrine dedicated to the Rosary. Designed by Alessandro Vittoria, this contained a rich collection of commemorative paintings.[42] The longevity of the association of the Rosary with Lepanto is illustrated by the chapel of the Rosary Confraternity in the Dominican church of Santa Corona in Vicenza, which was decorated with frescoes showing the battle by Alessandro Maganza and assistants in 1613–21. As late as the eighteenth century, the Cathedral in Bassano was redecorated with celebratory scenes in which Lepanto and the Rosary are associated.[43]

The euphoria generated by Lepanto, and by the celebrations which marked the visit of Henry III, 'Rex Christianissimus Francorum' three years later, was soon to be dispelled by the arrival of the plague in 1575.[44] Official insistence on the efficacy of prayer, piety and penitence induced an intense atmosphere of collective devotion and communal expiation during the two years that it stalked through the city, carrying off one quarter of the Venetian population in its wake.[45] There are plenty of recorded instances of communal action during these years. In the summer of 1576, on the feast of San Rocco, with the epidemic raging, a large crowd gathered in front of the church. Each of the seventy Venetian parishes was represented by a delegation made up of ordinary parishioners, *cittadini* and patricians, the three estates which made up Venetian society. Led by a priest carrying a cross, these groups formed a procession of atonement which, as it walked, recited prayers and chanted litanies.[46] In their encouragement of traditional public demonstrations of devotion and repentance as one of the main weapons to combat the plague, the ecclesiastical authorities ran contrary to certain medical opinions which were wary of free public association, believing it only to encourage the spread of the disease. More traditional approaches were also in evidence when two distinguished physicians from Padua, Girolamo Capodivacca and Girolamo Mercuriale, were officially invited to give their opinions about the cause of the epidemic and to recommend courses of action. At first they were welcomed as saviours (flattering comparisons with Saints Cosmas and Damian were made as they courageously ministered to the afflicted), but admiration rapidly turned to delusion as the disease continued unabated and the mortality rate increased.[47] Following tradition, the Patriarch of Venice strongly advocated that processions be held throughout the city, to be accompanied by prayers and sung litanies.[48] There was widespread acceptance of the traditional belief that all

pestilence was a sign of divine wrath, a form of retribution delivered upon a sinful nation. The only recourse was prayer and repentance, and in the public sphere, processions and the worship of relics were considered to be fundamental antidotes. In the gradual process by which the Venetians redefined themselves as a peaceable nation, and their city as the crucible of Christian values in a reformed Catholic world, the plague of 1575–7 was a defining experience.

<div align="center">3.</div>

When the Florentine architect Jacopo Sansovino died in Venice in 1570, his ambitious project to remodel the Piazza San Marco along classical lines was left unfinished.[49] Largely promoted by Doge Andrea Gritti as the main focus of an even more substantial urban scheme following the defeat at Agnadello in 1509 and the consequent loss of Venetian prestige, it had been planned in an attempt to restore confidence in the city as a great commercial centre, flourishing once again under the benign administration of a model republican regime administered with justice and wisdom. In this scheme of things, the refashioned Piazza was to have enhanced symbolic power as the most prominent feature of a spectacular large-scale *renovatio urbis*, in which Venice was transformed into a peace-loving state which offered a new model of how a centre of political, religious, intellectual and artistic life could be constructed.[50] Sansovino's design involved a radical architectural renewal of the Piazza and its surrounding buildings, in order to impart an appropriate sense of splendour, modernity, magnificence and *auctoritas*.[51] This was achieved by superimposing classicising details that recalled ancient Rome upon the existing Byzantine elements of the square, in a conscious attempt to realise, in architectural terms, the Myth of Venice, the concept of the city as the perfect Republic, unwalled and yet unconquered for a thousand years, ruled for the benefit of all its citizens by a benevolent patrician class.[52] In essence, the result represents a courageous reinterpretation, on a magisterial scale, of the plan of the ancient Roman forum as described by Vitruvius.[53] Finally completed in the late seventeenth century, Piazza San Marco is the most spectacular example anywhere in early modern Italy of the transformation of urban space in order to reinforce claims to power through the appropriation of a classicising language.[54]

In the years after the final session of the Council of Trent, there was a noticeable increase in the importance of the piazza and its surrounding buildings as the *locus* of public devotional activity. While the veneration of relics took on a heightened significance, this was not merely because of their importance in the new spiritual order, but also because the disquieting events of the final decades of the century made appeals for divine assistance all the more urgent. The severe epidemic of bubonic plague which gripped the city in 1575–7 only intensified Venetian recourse to the traditional protectors of the Republic. In September 1576, after a fierce summer which had seen the plague at its worst,

the Senate decreed that the Doge, accompanied by the high officers of state, should process around the Piazza on three successive days. On the first the Blessed Sacrament was carried, on the second the Basilica's relic of the True Cross and on the third the Madonna Nicopeia.[55] As they made their way around the Piazza, double-choir litanies were sung by the choir of the Basilica. In this way, the intercession was sought not only of the Communion of Saints, but also of Christ and the Virgin, two major protectors of the city.[56] In the spate of relic renovation which took place in the early seventeenth century, devotion to both was renewed and amplified.

Through her long-standing association with the foundation of the city itself, which according to legend had taken place on the Feast of the Annunciation, the Virgin had always played a significant role in the Venetian consciousness. Both the Annunciation and the Feast of the Assumption were marked as great civic celebrations with strong political significance.[57] A long tradition of Marian veneration goes back at least to the foundation of the Cathedral in Torcello, dedicated to St Maria Assunta, and by the middle of the fifteenth century, when the first patriarch of Venice, Lorenzo Giustiniani, actively promoted the devotion of the Immaculate Conception, there were some twenty-one churches in the city dedicated to the Virgin. The week-long *Feste delle Marie*, then celebrated at the church of Santa Maria Formosa, was claimed by a fifteenth-century chronicler to date back to a tenth-century commemoration of a Venetian victory over pirates. Other sources relate that the annual *andata* which replaced it was established because the victory had taken place on the Feast of the Purification.[58] The intimate association between Mary and the government of the Republic is powerfully expressed in Guariento di Arpo's majestic large-scale detached fresco of the Coronation of the Virgin, which originally decorated the Maggior Consiglio, in the Ducal Palace.[59] By the end of the sixteenth century, about one third of the major Marian celebrations in the Venetian calendar had acquired state connotations, usually through association with important military or naval victories. These developments only served to intensify the role of the Virgin in the inextricably linked rituals of civic and devotional practice; so too did the annual blessing of the Adriatic on the feast of the Ascension, which had grown into a complex ceremony in which Venice was symbolically remarried to the sea.[60]

Throughout Italy, the image of the Virgin was to be found everywhere, from the home to the street to the church.[61] The private life of the early modern Venetian home was not merely secular, but was thoroughly permeated by devotional activity.[62] Often flanked by candlesticks, *madonnieri* and other images of the Virgin constituted the focal point for contemplation.[63] Lower down the social scale, cheap woodcuts of the Virgin and Child, nailed to the wall or glued to doors, served a similar purpose.[64] It was in front of these shrines that prayers were said, and litanies and hymns such as the 'Salve Regina' were sung.

Through such rituals, a part of daily life in even the most modest homes, the devotional practices of the parish church, the *campo* and the *calle*, were fused into a seamless sequence of song and prayer. In the public realm, the most venerated of all images of the Virgin was the Madonna Nicopeia, who was said to be efficacious in times of peril.

This legend had been current at least since the middle of the sixteenth century, when Giovanni Battista Ramusio wrote that the Nicopeia was 'venerated with great reverence and devotion here in the church of San Marco, and is carried in procession during times of war and plague, and to pray for rain and good weather', and claimed that it had been used as a palladium by the Byzantine emperor Alexius V Ducas.[65] The claim is almost certainly false; neither the medieval inventories of the treasury of the Basilica, nor chroniclers such as Andrea Dandolo mention the Nicopeia.[66] Nonetheless, since at least the fifteenth century the icon had been processionally carried around the Piazza, protected by a white baldachin and accompanied by lighted candles whenever the city was under threat from disease, famine or war.[67] During the plague of 1474 the icon was carried around the square on the orders of the Senate, accompanied by all the Venetian clergy and religious orders, the six *scuole grandi*, and the flagellant confraternities who processed while singing.[68] The cult of the Nicopeia may have become more important after 1503, when the vast open portal at the south-western corner of San Marco, where the Aniketos relief of the Virgin and Chid was embedded in the wall, was closed off to create a burial chapel for Cardinal Battista Zen.[69] Some years later the Venetian chronicler Marin Sanudo recorded that psalms accompanied by instruments were sung before the Nicopeia, displayed in front of the Basilica, in celebration of the French victory over the Old Swiss Confederation at Marignano in September 1515.[70] Set against the magisterial background of the western façade of San Marco, where it was overseen by the Four Horses from Constantinople and other spoils from the Fourth Crusade, this moment of veneration made claims not only upon the redemptive power of the icon, but also upon the Venetian sense of history and identity.

Until the second half of the sixteenth century, the Madonna Nicopeia had been kept in the upper sacristy of San Marco, but in August the *Procuratori di supra* ordered that the icon be moved to the chapel of St Isidore, where a mass was to be celebrated in its honour every Saturday. Significantly, the text of their deliberation still speaks only of 'l'immagine della Beata e Gloriosa Vergine' rather than the 'Madonna Nicopeia',[71] and the intention was clearly to elevate its status. Shortly after the 'miraculous' rediscovery of the relics of the Precious Blood and the True Cross, the Procurators decided to draw up a scheme for the restoration and embellishment of the icon with gold, silver and precious stones; this clearly formed part of an integrated initiative designed to heighten the visibility of some of the most important cult objects in the

Basilica. Giovanni Tiepolo, who had been instrumental in orchestrating the celebrations for the rediscovery of the relics in May 1617, now publicised the history and efficacy of the Nicopeia in a treatise which reiterated the legend that the icon had been painted by St Luke.[72] This was to claim the Nicopeia as the original version of the much-copied Virgin Hodegetria, brought in the fifth century from Jerusalem to Constantinople, where it was kept in the Hodegon monastery. There, paraded through the streets of the capital while litanies were sung, it was venerated for its miraculous powers, before being appropriated as war booty and brought back to Venice. The Procurators now determined to give the Nicopeia both increased exposure and status by transferring it from the chapel of S. Ididoro to a specially reconstructed altar designed by a local architect, Tomasso Contin.[73]

Contin was commissioned to design two matching altars situated immediately to the west of the iconostasis. The one on the north side of the crossing, next to the High Altar, was reserved for the Madonna Nicopeia, displayed for the first time in its history on its own altar in the spiritual heart of the Basilica; the matching altar on the south side was dedicated to the Holy Sacrament. These changes in devotional practice were clearly influenced by the teachings of Trent. The debate over the Eucharist had been one of the most bitterly contested theological arguments of the Protestant Reformation. The Catholic position, articulated during the thirteenth session of the Council, affirmed the dogma of transubstantiation and led to a new insistence on the display and veneration of the consecrated host. This can be seen in the increasing elaboration with which the devotion of the Quarant'ore was invested, particularly in Rome.[74] The installation of Sacrament chapels in Venetian churches was not new either.[75] Writing in 1515, Sanudo recorded a procession through the parish of San Cassiano on Good Friday, in which the *Scuola del santissimo sacramento* escorted the Eucharist with sixteen large candles and four hundred torches.[76] Every parish in the city supported a confraternity of this kind, whose principal function was to maintain the altar in the sacrament chapel, to adorn it with paintings and statues, to accompany the Eucharist when it was carried in procession during Holy Week, and to sustain sick or dying members of the confraternity. Through their collective patronage, the confraternities were responsible for a number of important artistic commissions on Eucharistic themes, notably by Tintoretto and his workshop, who made such work something of a speciality.[77]

In the following decades, the altar of the Madonna Nicopeia became the focus of both new and rejuvenated traditional ritual practices, particularly during moments of crisis. Displayed for all to see in Contin's new arrangement, the Nicopeia was now publicly worshipped as a potent protectress of Venice itself; in front of her image, prayers were said and litanies sung.[78] As in previous times, it was the Nicopeia that was carried around the Piazza in times of

plague and war. While both the restoration of the Madonna Nicopeia and the construction of Contin's chapel were clearly in keeping with Tridentine teaching, these initiatives also reflect the more general increase in Marian devotion, and in particular the veneration of relics, that are such a feature of the religious life of Venice during the early decades of the seventeenth century. The character of urban piety in this period is typified by the 1617 procession, which took place on the feast of the *Inventione St Crucis*.

Members of the six Venetian *scuole grandi*, the wealthiest charitable confraternities of the city, walked in the procession, as did representatives of a number of Venetian parish churches who carried portable platforms decorated with statues and other images. The nine congregations of secular priests, who traditionally participated in official ceremonies such as funerals of the Doge, intoned the 'Te Deum', a traditional expression of communal religious exaltation.[79] Together with the *scuole grandi*, the presence of the *scuole piccoli* (which catered for the artisanal classes) as well as a contingent of nuns and monks from the monasteries of the city symbolised the ecclesiastical structure of the city, and emphasised the indissolubility of religious and civic values by fusing together the political and devotional dimensions of public life.[80] The procession was halted at three moments so that the relics could be more easily worshipped by the crowds; at these junctures the choir of the Basilica, under the direction of its recently appointed *maestro di cappella* Claudio Monteverdi, performed a setting of a text in praise of the Precious Blood. In a letter the following year, Monteverdi refers to the requirement for him to perform music for the *Inventione*, when

> the Most Holy Blood will be displayed, and I shall have to be ready with a concerted Mass, and motets for the entire day, in as much as it will be displayed throughout that day on an altar in the middle of St Mark's [Basilica], set up high especially.[81]

Monteverdi composed two settings of 'Adoremus te, Christe', a text specified in the liturgy for Vespers on feast days associated with the *Inventione*.[82] Published just a few years later, these rather old-fashioned pieces, which rely for their effect on bold, dignified statements for different groupings of voices, are well suited to outside performance.[83] Yet more music was provided later on in the procession by four singers, placed directly in front of the relics, who intoned the litany of the saints. The overall effect of the 1617 procession was that of a kaleidoscopic sequence of colours, sounds and smells, as the different elements of the spectacle passed before the onlookers. For its part, the crowd responded with prayers, cries for divine assistance and devotional gestures, adding their voices to the simple hymns and litanies sung by the participants. As with so many of the civic and devotional rituals that took place in Piazza San Marco, a form of dialogue between participants and spectators took place,

articulated by shared texts and familiar music. Through these means, an event of major significance in the spiritual life of the Basilica, which involved the rehabilitation of cult objects of great devotional and civic importance, was able to touch the lives of ordinary Venetians. While some participated in the procession itself, enfranchised to do so through membership of a *scuola* or parish, everyone in the Piazza was able to be involved in the event, if only at a distance from the relics themselves. Although the central dramatic actions were witnessed only by a privileged elite, despite the different perceptions that this produced, the total effect was that of a sequence of actions in which ritually conceived performances were communally sanctioned at various levels of involvement.

The model for the 1617 procession was the annual Corpus Christi procession, the Eucharistic festivity par excellence, in which the participants, including those setting out on the pilgrimage to the Holy Land, walked around the Piazza San Marco under a long white canopy with, at the centre of the action, the host itself. According to an early fifteenth-century decree from the Senate, which established the procession in the Venetian ritual calendar, the monstrance was to be protected by a baldachin carried by four members of the patrician class, 'in reverence for Our Lord, Jesus Christ, and in honour of the Fatherland'.[84] This sets the tone for what became the most telling example of state appropriation of a major public festivity of the church year, celebrated throughout Catholic Europe, for an adroit amalgam of political and devotional motives. The diary of Arendt Willemsz, a barber from Delft who stayed in Venice en route to the Holy Land in 1525, and who walked in the Corpus Christi procession together with a contingent of his fellow pilgrims before setting sail, observed that groups from the *scuole grandi* 'remained kneeling before the holy sacrament, singing hymns'.[85] As with the Corpus Christi festivity, the 1617 procession was deliberately devised to unite both protagonists and onlookers in a common experience that simultaneously evoked both the universally Christian and the specifically Venetian.

The discovery of the relics of the True Cross and the Holy Blood constituted a significant addition to the Basilica's possession of relics associated with the Passion of Christ. Although pieces of the cross were worshipped throughout Catholic Europe, a number of those in Venice were held in particularly high regard. One of the relics in San Marco was said to have an impeccable provenance, having been taken from the entire cross which, according to legend, St Helena had transported to Constantinople; from there, the Venetians had removed a sliver in the aftermath of the Fourth Crusade.[86] Another prestigious fragment was brought to Venice by Cardinal Bessarion, who donated it to the Scuola Grande della Carità in 1462. By then it had been embedded, together with a piece of Christ's tunic, in a spectacular staurotheke divided into four chambers made of rock crystal and inserted into an elaborate gilt filigree

frame embellished with enamels showing the Passion. The significance of the Bessarion reliquary is underlined by its appearance in a number of portraits of the Cardinal based on a lost original by Gentile Bellini, as well as on the painted doors of the tabernacle which once enclosed it, where Bessarion is shown in prayer together with two members of the Carità.[87] The most famous of all Venetian relics of the True Cross was presented by Philippe de Mézières, Grand Chancellor of Cyprus, to the Scuola di San Giovanni Evangelista in 1369. It is shown in a number of panels from the cycle painted for its *albergo* by Gentile Bellini, including the well-known *Procession in Piazza San Marco*, where it is shown being solemnly carried around the square.[88]

A strong sense of the *respublica Christiana*, an integrated state of mind in which a strong attachment to both church and state overlapped to the point of indissolubility, had long been a feature of the Venetian mentality, carefully fostered by both the ecclesiastical and civic authorities. But as the official reaction to the plague of 1575–7, which culminated in the decision to build the votive church of the Redentore and to institute an annual *andata* to it so powerfully demonstrates, it was in the decades after Trent that the Piazza San Marco, and the Basilica to which it was umbilically connected, were increasingly brought into play as the central space for the assertion of new emphases. This gathering sense of renewal, while based on tradition and encouraged by the gradual acceptance of the policies of the Catholic Reformation, was fostered and developed by Giovanni Tiepolo, *Primicerio* of San Marco (1603–19) and Patriarch of Venice (1619–31). An unkempt and ascetic churchman, he was an exceptional pastoral figure who devoted his personal fortune to the restoration of many churches and altars in the city, including the interior of San Pietro di Castello, the Cathedral of Venice and the church of Santa Lucia.[89] Tiepolo's preoccupation with relics, which was thrown into high relief over the 1617 discoveries and the rehabilitation of the Madonna Nicopeia, is symptomatic of the tone not only of his own piety, but also of the religious temper of early seventeenth-century Venice.[90] These concerns emerge from descriptions of the solemn ceremonies, attended by the Doge and the Signoria, that marked the decision to build the votive church of Santa Maria della Salute in thanksgiving for the cessation of the plague of 1630–1. While this ritual, performed by the head of the Venetian polity in the presence of the senior members of the government, emphasised the official nature of the vow proclaimed by the Doge, the central role of the Madonna Nicopeia, which was carried through the Piazza, underlined its important status. The procession was the first of many held throughout the following months; the Nicopeia was carried in all of them.[91] In a lengthy treatise, in effect a *summa* of the literature on divine chastisement, Tiepolo attributed the end of the plague to Venetian attachment to the Virgin on the one hand, and to the intercession of St Sergius and the recently beatified Lorenzo Giustiniani on the other, a characteristic emphasis

upon the importance of local saints.[92] In the course of some three decades, through his actions and his voluminous writings, Tiepolo transformed the nature of Venetian public worship, and helped to secure a further formulation of the Myth of Venice in which it became the City of God.[93]

NOTES

1. Natalibus, *Catalogus sanctorum et gestorum eorum ex diversis voluminibus collectus*, n.p.; Gallo, 'Reliquie e reliquari veneziani', pp. 187–204.
2. Brown, *The Cult of the Saints*, pp. 88–9.
3. Geary, *Furta sacra*, especially pp. 44–55.
4. Cooper, *Palladio's Venice*, pp. 229–57.
5. Tramontin, 'Realtà e leggenda nei racconti marciani veneti', pp. 35–58; Muir, *Civic Ritual*, pp. 88–90; Fenlon, *The Ceremonial City*, pp. 32–3.
6. Hahnloser, *Il tesoro di San Marco*, II, pp. 162–3, 183–4.
7. Setton, 'St. Georges Head', pp. 1–12.
8. Moore, *The Architecture of the Christian Holy Land*.
9. Fortini Brown, *Venetian Narrative Painting in the Age of Carpaccio*, pp. 69–70, 209–14.
10. Geary, *Furta sacra*, pp. 94–103.
11. Muir, *Civic Ritual*, pp. 119–34; Fenlon, *The Ceremonial City*, pp. 43–4.
12. Fenlon, *The Ceremonial City*, pp. 9–49
13. Brown, *The Cult of the Saints*, pp. 86–127; Dale, 'Stolen Property', pp. 205–15; Fenlon, *The Ceremonial City*, pp. 49–61.
14. Botero, *Relatione della republica venetiana*, p. 105.
15. Kinser, *The Memoirs of Philippe de Commynes*, p. 162.
16. Coryate, *Coryat's crudities*, p. 184.
17. Burke, 'How to be a Counter-Reformation Saint', pp. 48–62.
18. The principal sources are Vergaro, *Breve descrittione del sacro thesoro ... figura nella della retra dietro*; Vergaro, *Breve descrittione del sacro tesoro delle reliquie ritrovate nel santuario della Chiesa Ducale di San Marco, & honorate con solenne processione a 28 di Maggio del 1617*; Vergaro, *Racconto dell'apparato et solennità*; Tiepolo, *Trattato delle santissime reliquie*; Suriano, *Breve descrittione del sacro thesoro delle reliquie, ritrovate nel santuario della Chiesa Ducale di San Marco, & honorate con solenne processione a 28 di Maggio del 1617*. See Pincus, 'Christian Relics and the Body Politic', pp. 39–57.
19. Tramontin, 'Influsso orientale', I, pp. 817–20. For those that remain in the treasury see Gallo, *Il tesoro di San Marco e la sua storia*, and Hahnloser, *Il tesoro di San Marco*.
20. The term seems to have been used for the first time by Querini in his *Relatione dell'imagine Nicopeias che si ritrova in Venetian nella Ducale di San*. To avoid confusion, I have used the traditional description throughout this essay.
21. Machiavelli, *Istorie fiorentine*, p. 29 (my translation).
22. Gleason, 'Confronting New Realities, pp. 168–84.
23. Pullan, *The Jews of Europe*, p. 20.
24. For Fachinetti see Martin, *Venice's Hidden Enemies*, pp. 183–5.
25. Paruta, *Della Guerra di Cipro*, pp. 5–6.
26. Setton, *The Papacy*, IV, 97–1044; Fenlon, *The Ceremonial City*, pp. 158–66.
27. Gombrich, 'Celebrations in Venice', pp. 62–8; Fenlon, *The Ceremonial City*, pp. 167–9.
28. Pullan, *The Jews of Europe*, pp. 20–1.

29. Buccio, *Oratione sopra la vittoria christiana*, ff. 4v–5r.
30. Magno, *Il trionfo di Christo*; Fenlon, *The Ceremonial City*, pp. 273–6.
31. Anon., *Parafrasi poetica sopra alcuni salmi di David*, title page.
32. Anon., *Discorso sopra il Pater Noster in lingua rustica*, n.p.
33. Herz, 'The Sistine and Pauline Tombs', pp. 241–62; Fenlon, *The Ceremonial City*, pp. 301–3.
34. Toscanella, *Essortatione ai Cristiani contra il Turco*, n.p.
35. Tramontin, *Culto dei santi*, pp. 223–4.
36. For the *andata* to Giustina see Tramontin, *Culto dei santi*, pp. 223–4; Urban, *Processioni e feste dogali*, pp. 129–32.
37. Illustrated in Papadopoli, *La monete di Venezia*, II, pp. 311, 318–22, table 1–2.
38. Fenlon, *The Ceremonial City*, pp. 276–80, 293–300, 303–7.
39. Paruta, *Oratione funebre*, n.p.
40. Niero, 'La mariegola', pp. 324–36; Niero, 'Ancora sull'origine del Rosario', pp. 465–78.
41. Molmenti, *Sebastiano Venier*, pp. 131–2.
42. Fenlon, *The Ceremonial City*, pp. 281–5; the chapel and its contents were destroyed in a fire in August 1867.
43. Bordignon Favero, 'La "Santa Lega"', pp. 220–31.
44. For the visit of Henry III see Fenlon, *The Ceremonial City*, pp. 193–215.
45. Preto, *Peste e società a Venezia*, n.p.; Palmer, 'L'azione della Repubblica di Venezia', pp. 103–10; Fenlon, *The Ceremonial City*, pp. 217–29.
46. Fenlon, *The Ceremonial City*, p. 225.
47. Preto, *Peste e società*, p. 49.
48. For the texts see Castello, *Liber sacerdotalis*, n.p.
49. Tafuri, *Jacopo Sansovino e l'architettura del '500 a Venezia*, n.p.; Howard, *Jacopo Sansovino*, n.p.; Morresi, *Piazza San Marco*, n.p.; Morresi, *Jacopo Sansovino*, n.p.; Fenlon, *Piazza San Marco*, n.p.
50. Tafuri, 'Renovatio urbis', and some of the individual chapters in Tafuri, *Venezia e il Rinascimento*; Gleason, 'Confronting New Realities'.
51. Calabi, 'Il rinnovamento urbano', vol. 5, pp. 101–63.
52. Fasoli, 'Nascità di un mito', pp. 445–79; Gaeta, 'Alcune considerationi sul mito di Venezia', pp. 58–75. Artistic expression of various aspects of the Myth are discussed in Rosand, *Myths of Venice*.
53. D'Evelyn, *Venice and Vitrivius*, n.p.
54. Canniffe, *The Politics of the Piazza*, pp. 103–6.
55. For the rubrics and texts of processions 'in tempore pestis' see Anon., *Litaniae secundum consuetudinem ducalis ecclesiae Sancti Marci*.
56. Wills, *Venice: Lion City*, pp. 195–233.
57. Rosand, *Myths of Venice*, pp. 12–16.
58. Sansovino, *Venetia città nobilissima*, pp. 493–5; Muir, *Civic Ritual*, pp. 135–56; and for the place of these traditions within the broader panorama of Venetian Marian devotions see Musolino, 'Culto Mariano', pp. 256–60 and Devaney, 'Competing Spectacles', pp. 107–25.
59. Sinding-Larsen and Kuhn, *Christ in the Council Hall*, pp. 45–56; Wolters, *Storia e politica*, pp. 93–135; Martindale, 'The Venetian Sala del Gran Consiglio', pp. 76–124.
60. Muir, *Civic Ritual*, pp. 119–34; Fenlon, *The Ceremonial City*, pp. 43–4.
61. Muir, 'The Virgin on the Street Corner', pp. 25–40.
62. Morse 'Creating Sacred Space'; Cooper, 'Devotion', pp. 190–203.
63. Kasl, 'Holy Households', pp. 59–89; Morse, 'Creating Sacred Space', pp. 159–63, 165–70.

64. Pon, *A Painted Icon*, pp. 46–50.
65. Ramusio, *Delle navigationi et viaggi*.
66. Schultz, 'Die Nicopeia in San Marco', pp. 483–4.
67. Moravia, *Panegirico nella translazioni*, f. 5v.
68. For the text see Fenlon, *The Ceremonial City*, p. 227.
69. Nelson, 'The Aniketo Icon', pp. 91–111, especially pp. 104–6.
70. Sanudo, *I diarii*, XXI, col. 130.
71. Gallo, *Il tesoro di San Marco e la sua storia*, p. 148.
72. Tiepolo, *Trattato dell' imagine della Gloriosa Vergine dipinta da San Luca*, n.p.
73. For Contin see Hopkins, *Baldassare Longhena*, pp. 135–6.
74. Weil, 'The Devotion of the Forty Hours', pp. 218–48.
75. Cope, *The Venetian Chapel*, p. 2.
76. Sanudo, *I diarii*.
77. Cope, *The Venetian Chapel*, n.p.; Hills, 'Piety and Patronage', pp. 30–43; Wills, *Venice: Lion City*, pp. 195–206.
78. Moore, '"Venezia favorita di Maria"', pp. 299–355.
79. These details are taken from Vergaro, *Racconto dell'apparato et solennità*, and the same author's *Breve descrittione del sacro thesoro*.
80. Fenlon, *The Ceremonial City*, pp. 134–8.
81. Monteverdi, Letter of 21 April 1618, to Prince Vincenzo Gonzaga in Mantua; see Stevens, *The Letters of Claudio Monteverdi*, pp. 138–9.
82. Anon., 'Adoremus te, Christe et benedicimus tibi quia per sanguinem tuum pretiosum redimisti mundum. Miserere nobis'. It is possible that Monteverdi's settings were performed in 1617.
83. Bianchi, *Libro primo de motetti*, n.p.
84. Fenlon, *The Ceremonial City*, p. 125.
85. Fenlon, 'Strangers in Paradise', pp. 32–4.
86. Gallo, *Il tesoro di San Marco e la sua storia*, pp. 12, 276.
87. Fortini Brown, *Venetian Narrative Painting*, pp. 272–9; Lobowsky, 'Per l'iconografia del Cardinal Bessarione', pp. 287–94. The tabernacle doors, which have been dated to *c.*1472–3, are now in The National Gallery, London (NG 6590).
88. Fortini Brown, *Venetian Narrative Painting*, pp. 144–50, 233–4.
89. Sansovino, *Venetia città nobilissima*, pp. 6–19, 140–4; Walberg, 'The Pastoral Writings', pp. 193–224.
90. For Tiepolo see Cozzi, 'Note su Giovanni Tiepolo', pp. 121–50; Logan, *The Venetian Upper Clergy*, pp. 332–74.
91. Hopkins, *Santa Maria Della Salute*, pp. 4–5, 162–3.
92. Tiepolo, *Dell'ira di Dio*, n.p.; see Logan, *The Venetian Upper Clergy*, pp. 354–62.
93. Walberg, 'Patriarch Giovanni Tiepolo', pp. 233–52.

Works Cited

Anon., *Parafrasi poetica sopra alcuni salmi di David molto accomodati per render grazie a Dio della vittoria donata al christianesimo e contra a' Turchi* (Venice: Giorgio Angelieri, 1571).
Anon., *Discorso sopra il Pater Noster in lingua rustica, per la vittoria de Christiani contra Turchi* (n.p., n.d).
Anon., *Litaniae secundum consuetudinem ducalis ecclesiae Sancti Marci* (Venice: Pinelliana, 1719).
Anon., 'Adoremus te, Christe et benedicimus tibi quia per sanguinem tuum pretiosum redimisti mundum. Miserere nobis'.

Bianchi, G. C., *Libro primo de motetti* (Venice: B. Magni, 1620).

Bordignon Favero, E., 'La "Santa Lega" contro il Turco e il rinnovamento del Duomo di Bassano: Volpato, Meyring e la "Madonna del Rosario"', *Studi veneziani* XI (1986), pp. 207–31.

Botero, G., *Relatione della republica venetiana con un discorso intorno allo stato della chiesa* (Venice: Giorgio Varisco, 1605).

Brown, P., *The Cult of the Saints: Its Rise and Function in Late Antiquity* (Chicago: University of Chicago Press, 1981).

Buccio, P., *Oratione sopra la vittoria christiana contra Turchi ottenuta l'anno felicissimo MCLXXI* (Venice: Domenico de'Franceschi, 1571).

Burke, P., 'How to be a Counter-Reformation Saint', in P. Burke (ed.), *The Historical Anthropology of Early Modern Italy: Essays on Perception and Communication* (Cambridge and New York: Cambridge University Press, 1987), pp. 48–62.

Calabi, D., 'Il rinnovamento urbano del primo Cinquecento', in A. Tenenti and U. Tucci (eds), *Storia di Venezia dalle origini alla caduta della serenissima*, vol. 5 (Rome: Istituto della enciclopedia italiana, 1996), pp. 101–63.

Canniffe, E., *The Politics of the Piazza: The History and Meaning of the Italian Square* (Aldershot: Ashgate Publishing Ltd, 2008).

Castello, A. da, *Liber sacerdotalis* (Venice: Sessa and de Ravanis, 1523).

Contarini, G., *De magistratibus et republica Venetorum* (Paris: Vascosani, 1543).

Cooper, D., 'Devotion', in M. Ajmar-Wollheim and F. Dennis (eds), *At Home in Renaissance Italy*, exh. cat. (London: Victoria and Albert Museum, 2006), pp. 190–203.

Cooper, T. E., *Palladio's Venice: Architecture and Society in a Renaissance Republic* (New Haven and London: Yale University Press, 205).

Cope, M. E., *The Venetian Chapel of the Sacrament in the Sixteenth Century* (New York and London: Garland, 1979).

Coryate, T., *Coryat's crudities hastily gobbled up in five moneths travels in France, Savoy, Italy, Rhetia* (London: William Stansby, 1611).

Cozzi, G., 'Note su Giovanni Tiepolo, primicerio di San Marco e patriarca di Venezia: l'unità ideale della chiesa veneta', in B. Bertoli (ed.), *Chiesa, società, stato a Venezia: miscellanea di studi in onore di Silvio Tramontin* (Venice: Studium Cattolico Veneziano, 1994), pp. 121–50.

Dale, T. E. A., 'Stolen Property: St. Mark's First Venetian Tomb and the Politics of Communal Memory', in E. Valdez del Alamo and C. Stamatis Pendergast (eds), *Memory and the Medieval Tomb* (Aldershot: Ashgate Publishing Ltd, 2000), pp. 205–15.

Devaney, T., 'Competing Spectacles in the Venetian "Festa delle Marie"', *Viator* 39 (2008), pp. 107–25.

D'Evelyn, M. M., *Venice and Vitrivius: Reading Venice with Daniele Barbaro and Andrea Palladio* (New Haven and London: Yale University Press, 2010).

Fasoli, G., 'Nascità di un mito', *Studi in onore di Gioacchino Volpe*, vol. 1 (Florence: Sansoni, 1958), pp. 445–79.

Fenlon, I., 'Strangers in Paradise: Dutchmen in Venice in 1525', in I. Fenlon (ed.), *Music and Culture in Late Renaissance Italy* (Oxford: Oxford University Press, 2002), pp. 24–43.

Fenlon, I., *The Ceremonial City: History, Memory and Myth in Renaissance Venice* (New Haven and London: Yale University Press, 2007).

Fenlon, I., *Piazza San Marco* (London: Profile Books, 2009).

Fortini Brown, P., *Venetian Narrative Painting in the Age of Carpaccio* (New Haven and London: Yale University Press, 1988).

Gaeta, F., 'Alcune considerationi sul mito di Venezia', *Bibliothèque d'humanisme et renaissance* 23 (1961), pp. 58–75.

Gallo, R., *Il tesoro di San Marco e la sua storia* (Venice and Rome: Instituto per la Collaborazione Culturale, 1967).

Gallo, R., 'Reliquie e reliquari veneziani', *Rivista di Venezia* XIII (1934), pp. 187–204.

Geary, P. J., *Furta sacra: Thefts of Relics in the Central Middle Ages*, 2nd revised edition (Princeton: Princeton University Press, 1990).

Gleason, E. G., 'Confronting New Realities: Venice and the Peace of Bologna, 1530', in D. Romano (ed.), *Venice Reconsidered: The History and Civilization of an Italian City-State, 1297–1797* (Baltimore: Johns Hopkins University Press, 2000), pp. 169–84.

Gombrich, E. H., 'Celebrations in Venice of the Holy League and of the Victory of Lepanto', in *Studies in Renaissance and Baroque Art Presented to Anthony Blunt on his Sixtieth Birthday* (London: Phaidon, 1967), pp. 62–8.

Hahnloser, H. R., *Il tesoro di San Marco*, 2 vols (Florence: Sansoni, 1971).

Herz, A., 'The Sistine and Pauline Tombs: Documents of the Counter-Reformation', *Storia dell'arte* 43 (1981), pp. 241–62.

Hills, P., 'Piety and Patronage in Cinquecento Venice: Tinoretto and the Scuole del Sacramento', *Art and History* 6 (1983), pp. 30–43.

Hopkins, A., *Santa Maria Della Salute: Architecture and Ceremony in Baroque Venice* (Cambridge: Cambridge University Press, 2000).

Hopkins, A., *Baldassare Longhena 1597–1682* (Milan: Electa, 2006).

Howard, D., *Jacopo Sansovino: Architecture and Patronage in Renaissance Venice* (New Haven and London: Yale University Press, 1975).

Kasl, R., 'Holy Households: Art and Devotion in Renaissance Venice', in R. Kasl (ed.), *Giovanni Bellini and the Art of Devotion* (Indianapolis: Indianapolis Museum of Art, 2004), pp. 59–89.

Kinser, S. (ed.), *The Memoirs of Philippe de Commynes*, trans. I. Caseaux (Columbia, SC: University of South Carolina Press, 1973).

Lobowsky, L., 'Per l'iconografia del Cardinal Bessarione', in G. Fiaccadori, A. Cuna and S. Ricci (eds), *Bessarione e l'umanesimo* (Naples: Vivarium, 1994), pp. 285–95.

Logan, O., *The Venetian Upper Clergy in the 16th and Early 17th Centuries: A Study in Religious Culture* (Lewiston, NY: Edwin Mellen Press, 1996).

Machiavelli, N., *Istorie fiorentine* (Florence: Felice Le Monnier, 1857).

Magno, C., *Il trionfo di Christo contra Turchi* (Venice: Onofrio Farri, 1571).

Martin, J. J., *Venice's Hidden Enemies: Italian Heretics in a Renaissance City* (Berkeley and Los Angeles: University of California Press, 1993).

Martindale, A., 'The Venetian Sala del Gran Consiglio and its Fourteenth-Century Decoration', *The Antiquaries Journal* 73 (1993), pp. 76–124.

Molmenti, P., *Sebastiano Venier dopo la battaglia di Lepanto* (Venice: Nuovo Archivo Veneto, 1915).

Moore, J., '"Venezia favorita di Maria": Music for the Madonna Nicopeia and Santa Maria della Salute', *Journal of the American Musicological Society* XXXVII (1984), pp. 299–355.

Moore, K. B., *The Architecture of the Christian Holy Land: Reception from Late Antiquity through the Renaissance* (Cambridge: Cambridge University Press, 2017).

Moravia, G., *Panegirico nella translazioni dell'imagine della chiesa di S. Marco* (Venice, 1618).

Morresi, M., *Piazza San Marco: istituzioni, poteri e architettura a Venezia nel primo Cinquecento* (Milan: Electa, 1999).

Morresi, M., *Jacopo Sansovino* (Milan: Electa, 2000).

Morse, M. A., 'Creating Sacred Space: The Religious Visual Culture of the Renaissance Venetian Casa', *Renaissance Studies* 21:2 (2007), pp. 151–84.

Muir, E., *Civic Ritual in Renaissance Venice* (Princeton: Princeton University Press, 1981).

Muir, E., 'The Virgin on the Street Corner: The Place of the Sacred in Italian Cities', in S. Ozment (ed.), *Religion and Culture in the Renaissance and Reformation* (Kirksville, MO: Sixteenth Century Journal Publishers, 1989), pp. 25–40.

Musolino, G., 'Culto Mariano', in S. Tramontin (ed.), *Culto dei santi a Venezia* (Venice: Studium Cattolico Veneziano, 1965), pp. 256–60.

Natalibus, P. de, *Catalogus sanctorum et gestorum eorum ex diversis voluminibus collectus* (Vicenza: Rigo di Ca Zeno, 1493).

Nelson, R. S., 'The Aniketo Icon and the Display of Relics in the Decoration of San Marco', in H. Maguire and R. S. Nelson (eds), *San Marco, Byzantium and the Myths of Venice* (Washington, DC: Dumbarton Oaks Research Library and Collection, 2010), pp. 91–111.

Niero, A., 'La mariegola della più antica scuola del rosario di Venezia', *Rivista di storia della chiesa in Italia* 15 (1961), pp. 324–36.

Niero, A., 'Ancora sull'origine del Rosario a Venezia e sulla sua iconografia', *Rivista di storia della chiesa in Italia* 17 (1974), pp. 465–78.

Palmer, R., 'L'azione della Repubblica di Venezia nel controllo della peste: lo sviluppo della politica governativa', in *Venezia e la peste, 1348–1797* (Venice: Marsilio, 1980), pp. 103–10.

Papadopoli, N., *La monete di Venezia*, 4 vols (Venice: 1893–1919).

Paruta, P., *Oratione funebre in laude de' morti nella vittoriosa battaglia contra Turchi a Curzolari*, ed. G. B. Valiero (Venice: B. Zaltiero, 1572).

Paruta, P., *Della Guerra di Cipro*. Second part of *Historia Venetiana parte secunda*. 2 parts in one volume (Venice: Domenico Nicolini, 1605).

Pincus, D., 'Christian Relics and the Body Politic: A Thirteenth-Century Relief Plaque in the Church of San Marco', in D. Rosand (ed.), *Interpretazioni veneziane: studi di storia dell'arte in onore di Michelangelo Muraro* (Venice: Arsenale, 1984), pp. 39–57.

Pon, L., *A Painted Icon in Early Modern Italy: Forli's Madonna of the Fire* (Cambridge: Cambridge University Press, 2015).

Preto, P., *Peste e società a Venezia, 1576*, 2nd edn (Vicenza: Neri Pozza, 1984).

Pullan, B., *The Jews of Europe and the Inquisition of Venice, 1550–1670* (Totowa, NJ: Barnes and Noble, 1983).

Querini, C., *Relatione dell'imagine Nicopeias che si ritrova in Venetian nella Ducale di San Marco* (Venice: Pinelli, 1645).

Ramusio, G. B., *Delle navigationi et viaggi* (Venice: De Giunti, 1559).

Rosand, D., *Myths of Venice: The Figuration of State* (Chapel Hill and London: University of North Carolina Press, 2001).

Sansovino, F., *Venetia città nobilissima et singolare* (Venice: Curti, 1663).

Sanudo, M., *I diarii*, R. Fulin et al. (eds), 58 vols (Venice: Visentini, 1879–1903).

Schultz, M., 'Die Nicopeia in San Marco. Zur Geschichte und zum Typ einer Ikone', *Byzintinische Zeitschrift* 91 (1998), pp. 475–501.

Setton, K. M., 'St. Georges Head', *Speculum* 48 (1973), pp. 1–12.

Setton, K. M., *The Papacy and the Levant 1204–1571*, 4 vols (Philadelphia: Philadelphia American Philosophical Society, 1976–84).

Sinding-Larsen, S. and A. Kuhn, *Christ in the Council Hall: Studies in the Religious Iconography of the Venetian Republic* (Rome: L'erma di Bretschneider, 1974).

Stevens, D. (trans.), *The Letters of Claudio Monteverdi*, revised edition (Oxford: Clarendon Press, 1995).

Suriano, A., *Breve descrittione del sacro thesoro delle reliquie, ritrovate nel santuario della Chiesa Ducale di San Marco, & honorate con solenne processione a 28 di Maggio del 1617* (Venice: Pinelli, 1617).

Tafuri, M., *Jacopo Sansovino e l'architettura del '500 a Venezia*, 2nd edn (Padua: Marsilio, 1972).

Tafuri, M., *'Renovatio urbis': Venezia nell'età di Andrea Gritti, 1523–1538* (Rome: Officina Ed., 1984).

Tafuri, M. (ed.), *Venezia e il Rinascimento: religione, scienza, architettura* (Turin: Einaudi, 1985), translated as *Venice and the Renaissance* (Cambridge, MA and London: MIT Press, 1989).

Tiepolo, G., *Trattato delle santissime reliquie, ultimamente ritrovate nel santuario della chiesa di San Marco* (Venice: Pinelli, 1617).

Tiepolo, G., *Trattato dell' imagine della Gloriosa Vergine dipinta da San Luca. Conservata già da molti secoli nella Ducal Chiesa di San Marco della Città di Venezia* (Venice: Alessandro Polo, 1618).

Tiepolo, G., *Dell'ira di Dio e de' flagella e calamità che per essa vengono al mondo* (Venice: Sarzina, 1632).

Toscanella, O., *Essortatione ai Cristiani contra il Turco* (Venice: Sigismondo Bordogna & Francesco Patriani, 1572).

Tramontin, S. (ed.), *Culto dei santi a Venezia* (Venice: Studium Cattolico Veneziano, 1965).

Tramontin, S. 'Realtà e leggenda nei racconti marciani veneti', *Studi veneziani* 12 (1970), 35–58.

Tramontin, S. 'Influsso orientale nel culto dei santi a Venezia fino al secolo XV', in A. Pertusi (ed.), *Venezia e il Levante fino al secolo XV*, vol. 1 (Florence: L. Olschki, 1973), pp. 801–20.

Urban, L., *Processioni e feste dogali: Venetia est mundus* (Vicenza: Neri Pozza, 1998).

Vergaro, G. C., *Breve descrittione del sacro thesoro . . . figura nella della retra dietro la quale si e ritrovato con le altre reliquie, il Preciossimo Sangue che nel giorno della Santissimo Croce si espone* (Venice: Pinelli, 1617).

Vergaro, G. C., *Breve descrittione del sacro tesoro delle reliquie ritrovate nel santuario della Chiesa Ducale di San Marco, & honorate con solenne processione a 28 di Maggio del 1617* (Venice, 1617).

Vergaro, G. C., *Racconto dell'apparato et solennità fatta nella ducal chiesa di San Marci di Venetia con l'occasione dell'inventione & espositione del Sangue Pretiossimo del costato di Christo, del latte del Beata Vergine, con altre santissime reliquie il 28 Maggio 1617* (Venice: Pinelli, 1617).

Walberg, D., 'The Pastoral Writings and Sacred Art Patronage of Patriarch Giovanni Tiepolo (1619–1631). A Preliminary Investigation', *Studi veneziani* LXII–LXIV (2011), pp. 193–224.

Walberg, D., 'Patriarch Giovanni Tiepolo and the Search for Religious Identity in the Waning of the Renaissance', in B. Paul (ed.), *Celebrazione e autocritica. La serenissima e la ricerca dell' identità veneziana del tardo Cinquecento* (Venice: Viella, 2014), pp. 233–52.

Weil, M. S., 'The Devotion of the Forty Hours and Roman Baroque Illusions', *Journal of the Warburg and Courtauld Institutes* 37 (1974), pp. 218–48.

Wills, G., *Venice: Lion City: The Religion of Empire* (New York: Simon & Schuster, 2001).

Wolters, W. *Storia e politica nei dipinti di Palazzo Ducale: Aspetti dell'autocelebrazione della Repubblica di Venezia nel Cinquecento* (Venice: Arsenale, 1987).

2

TURNINGS: MOTION AND EMOTION IN THE LABYRINTHS OF EARLY MODERN AMSTERDAM

Angela Vanhaelen

Something extraordinary in the soundscape of early modern Amsterdam disrupts the pedestrian's quotidian passage along city streets. The sudden blast of trumpets, pipes and drums arrests passers-by near the corner of Prinsengracht and Looiersgracht.[1] Above a portal there, an inscription mimicking the voice of a showman orders: 'Don't just stand in front of this door, walk in'.[2] Pausing at this threshold, the passer-by hears the promise of attractions within: the play of a fountain, organ music, laughter and chatter, as well as tinny bleatings and chirpings punctuated by the chiming of bells and startled screams that mingle the tinkling of delight with something that sounds like terror. According to the inscription, this place is called *doolhof*, or labyrinth. Those who interrupted their everyday expeditions in order to satisfy their curiosity would have passed through the portal into the spacious terrace of a tavern. Shaded by trees, it offered places to sit and enjoy glasses of wine or beer. A typical visit might then begin with a drink or two. Printed guidebooks were on sale; the visitor could peruse one to get an overview (Figure 2.1). The title page pictures an intriguing hedge maze. Its text directs appreciation to the courtyard's large sculptural fountain group of Bacchus and Ariadne, billed as one of the main attractions. In addition, it promises various artful moving works driven by clockwork, and the lively and life-sized statues of famed kings and princes of the century. All of this and more was to be seen in the *Oude Doolhof* (Old Labyrinth) of Amsterdam, where 'more and more improvements are made yearly'. Visitors thus discovered themselves in an art park and pub: a pleasure garden filled with unusual sculptural works.[3]

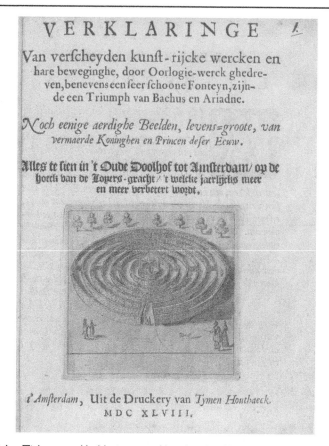

Figure 2.1 Title page, *Verklaringe van Verscheyden Kunst-Rijcke Wercken en hare Beweginghe* (Amsterdam: Tymen Houthaeck, 1648), University of Amsterdam Library (UvA) Special Collections, OTM O 62–2613.

Amsterdam boasted five inns called *Doolhof*, most of which included labyrinths, fountains and moving mechanical statues. The idea of using inns as semi-public, semi-private exhibition sites for innovative arts seems to have been the brainchild of Amsterdam's political and intellectual elite. Vincent Coster, the first proprietor of the *Oude Doolhof*, held the civic office of municipal wine assayer; his uncle had served as a leading burgomaster. Antonia Cloeck, who ran the *Franse Doolhof*, also hailed from the regent class: her grandparents were the burgomaster C. P. Hooft and Anna Blaeu, of the renowned publishing and map-making family; moreover, her uncle was the playwright P. C. Hooft, who was a founder of the Dutch Academy in 1617. Jan Theunisz, proprietor of a similar type of inn, was a scholar who taught at Leiden University and at the Dutch Academy. The Academy was conceived as a cultural and academic

centre, with the aim of offering vernacular public instruction in both the arts and sciences; it was 'meant for the edification and amusement of everyone'.[4] Repeated condemnations by Reformed church leaders resulted in its closure in 1619. The *Doolhof* inns, first established in the early 1620s, seem to have reprised the aims of the short-lived Academy. These were private businesses where pleasurable public exposure to the arts and sciences could evade religious censure. As the city expanded into a global trading hub, the *Doolhoven* were advertised as places where local and international visitors could wonder at Amsterdam's marvellous inventions.[5]

Exhibition sites are liminal spaces. They transport people from the prosaic rhythms of everyday life into the realm of ritual. Typically there is a prescribed route and by following it visitors animate a narrative, which aims to transform them, usually by instilling particular social and political values.[6] The labyrinth is an especially fitting architectural structure for this, in the sense that it too is designed to move and change those who follow its ritualised routes. To this day, many museums are experienced as compressed labyrinthine spaces that take us from artwork to artwork along a twisting course that weaves back and forth through the building's inner rooms. The designed itinerary highlights the most valued works as the scripted movement unfolds with maximum impact.[7] At the *Oude Doolhof*, many of the exhibited works were connected to Ovid's account of the Cretan labyrinth. Indeed, if we think of the *Oude Doolhof* as an early modern theme park, then the theme of this art park was metamorphosis.

The role of the various artworks arranged along the specified route was not just to represent or tell the story of the Cretan labyrinth. As we'll see, they reactivated it in powerful ways – putting it into motion through the affective involvement of participants. The fountains, automata and mechanical devices encountered at the *Oude Doolhof* were surprising works set up to startle viewers with unanticipated sounds and movements; and the labyrinth was an ever-changing bodily experience that created conditions of sensory dislocation and visual uncertainty. These garden courtyards thus engaged visitors in multi-sensorial interactions: confounding maze, spraying water, organ music and Bacchic conviviality together enhanced the collective force of a gathering of moving artworks so strikingly lifelike that they appeared to come alive. This type of embodied, sensuous and emotive engagement calls for a particular methodological approach, one that considers the impact of the work of art on its viewers. Indeed, Dutch art theorists of the period advised that every effective artwork should possess a moving quality called *beweeglijkheid*, a term that designates the moving and transformational powers of the work.[8] Skilful art was transformative because it was performative: it could stir the passions of viewers by appealing to all of their senses, accordingly soliciting physical and emotive involvement with artworks that were coextensive with the world. By persuading beholders that depicted figures could move, breath

and speak, a moving image could consume its beholders, immersing them in an illusory experience. As the art theorist Franciscus Junius wrote, a successful work of art was performative: it should affect us 'not otherwise than if wee were present, and saw not the counterfeited image but the reall performance of the thing'.[9] The moving image thus generates a performative aesthetic: spectators do not engage in aloof observation of erudite iconography or optical effects, but become intensely interconnected with the work. Ultimately, the aim of *beweeglijkheid* – used to designate both motion and emotion – was to move viewers to action: a truly compelling artwork could provoke a change in ethical outlook. The *Doolhoven*, then, can be understood as sites of conversion, urban pleasure parks that aimed to delight, instruct and transform.

The suggested itinerary through the site, which is laid out in the guidebook, helps us to understand its transformative potential. The first work that visitors encountered at the *Oude Doolhof* was the 'beautiful fountain of the Triumph of Bacchus and Ariadne' (Figure 2.2). Situated in the tavern yard before the entrance to the maze, it was a fitting transitional work – Bacchus for the enjoyment of the drinkers; Ariadne to guide the maze-treaders. While the Bacchus fountain is in many ways an appropriate introductory work for the site, it does pose a narrative challenge. To start with Bacchus and Ariadne is to begin at the end of the story of the Cretan labyrinth. After slaying Ariadne's half brother the Minotaur, and solving the maze with the help of her clew of thread, Theseus callously abandons Ariadne on the island of Naxos where she is rescued by Bacchus. This unwinding of the narrative in reverse offers, perhaps, a clue for deciphering this enigmatic exhibition site: the logic of the planned route is reversal. Like a maze, the story of the labyrinth contains many twists and sudden reversals of fortune. The theoretical term used by Dutch playwrights and artists to designate such turnings was *staetveranderinge*, or a change of state.[10] A *staetveranderinge* is filled with the potential of transformation. As the most dramatic moment in a performance or a picture, its emotive charge has the power to deeply move the audience and thus to effect a change in their inner state. By condensing Ariadne's abandonment and rescue, the fountain sculpture presents a number of turnings and multiple psychological states. It artfully compresses all of this motion and emotion together so that the larger narrative could be apprehended as if in the moving blink of an eye – what the art theorists called an *oogenblikkige beweeging*. This is where an artwork differs from theatre or history. Whereas the performed or published story unfolds over time, the work of art captures a single loaded moment in which the full impact of the narrative is distilled.[11] The effect on the viewer is not unlike drinking a concentrated draught of liquor.

According to the guidebooks, the fountain evokes the moment in which Ariadne wakes in confusion to discover that Theseus has sailed away without her. Expecting her lover, she sees instead the god Bacchus arriving in the midst

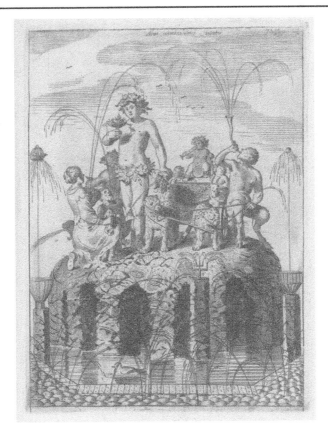

Figure 2.2 'Triumph of Bacchus and Ariadne' in *Verklaringe van Verscheyden Kunst-Rijcke Wercken en hare Beweginghe* (Amsterdam: Tymen Houthaeck, 1648), University of Amsterdam Library (UvA) Special Collections, OTM O 62–2613.

of a storm with his wild retinue of satyrs, bacchantes, putti and leopards. In the moment depicted, Ariadne – keeper of the labyrinth's secrets and the holder of its thread – knows that she has lost her way. The *Doolhof* guidebooks cite a poem by Dutch playwright Jan Vos, which evokes Ariadne's reaction to this shocking *staetveranderinge* by describing facial movements: 'her mouth is laughing still, but the eye begins to weep'.[12] The face of a statue normally is frozen in expression, but the fountain's play of water animates immobile stone. A smiling face appears to weep as water drips from its eyes, conveying conflicting emotions. Spurting and flowing water constantly alters stone surfaces, invigorating the figures and conveying the motion and emotion of this charged transitional moment. Laughing and weeping, Ariadne moves between past and future desires.

The guidebooks discuss the iconography of the fountain and provide a

moralising gloss, warning that although Ariadne's despair turned to desire in Bacchus's embrace, her passion ultimately led to death as she was later slain by the goddess Diana for not guarding her maidenhood.[13] As visitors in the tavern courtyard contemplated the visual and narrative complexities of this work, perhaps forming moral conclusions with guidebooks or drinks in hand, they unwittingly activated another set of waterworks. Trick fountains, installed under the pavement around the sculptural group, would suddenly spurt up jets of water, soaking those who stood there. The English baronet and Member of Parliament, Sir William Brereton, visited the *Oude Doolhof* in 1634. He later wrote about it and noted with prurient delight that 'those who stood within a circle, and near unto the rails, were well washed: a woman well washed under her clothes once or twice'.[14] Others also asserted how comical and pleasurable it was to see curious women and young girls surprised by cold water spraying up their skirts: they scream and they 'hop about like new-born calves', declared Tobias van Domselaer, who included a long description in his civic history of Amsterdam.[15] The water trick, in other words, transformed unwitting spectators into fledgling Minotaurs, whose cavorting was part-human, part-bovine. The fountains did not single out female victims, of course. Male writers don't recount their own unguarded reactions and undignified movements, although their libidinous observations do reveal how passions were stirred.

The sudden sensational shock of water on flesh prompts unthinking physical reactions and heightened emotions – starts and shrieks of surprise, mocking and embarrassed laughter, possibly drunken lasciviousness. The Bacchus and Ariadne fountain thus did not simply represent a moralised mythic history; it activated multiple Dionysian aspects of the exhibition site by triggering unrestrained bodily impulses, intensifying sensations and arousing passions. Overcome by drunkenness, licentiousness and sensuality, the cavorting, screeching and guffawing spectators – like Ariadne – were initiated into Bacchus's rowdy retinue. They become bacchante through the uninhibited behaviour stimulated by the fountain. As the Dutch classicist Daniel Heinsius emphasised in his poem *Ode to Bacchus*, the god of wine was a loosener of limbs: 'he unbinds our senses and understanding, and devours our cares'.[16] A fluid release of body and mind was activated by the pranking waterworks, freeing visitors from conventions of civility and the constraints of proper public manners. This Bacchic work thus affects the visitor like heady wine. Francis Bacon also wrote about Bacchus in *The Wisdom of the Ancients*, where he concludes: 'of all things known to mortals, wine is the most powerful and effectual for exciting and inflaming passions of all kinds'.[17]

When Brereton and Domselaer's descriptions of the *Oude Doolhof* waterworks are considered together with commentary about the powers of Bacchus, it seems that the Triumph of Bacchus and Ariadne fountain was imbued with the power to affect visitors so that they experienced and performed the various

metamorphoses that occur in the tale of Bacchus and Ariadne. They become like Ariadne: passions are aroused as troubles dissipate in the cheerful imbibing of wine and submission to Bacchus. Assaulted by the trick waterworks, visitors capered like noisy bacchantes and in the process of hopping about 'like new-born calves', they might see themselves and others as satyrs or even Minotaurs – part-human, part-beast. The ritual performance prescribed by this strange exhibition site thus began with a release of the passions, an unleashing of the inner beast. Visitors were now prepared for the next part of the route: entrance into the labyrinth.

Translated literally, a *doolhof* is a wandering courtyard – a bounded space that encompasses the possibility of straying endlessly along crooked paths. There is an element of madness or *dolheid*: the maze incites wandering and wondering; it puts you in motion and in error (especially if you are drunk). Enclosed by high green hedge walls, errant ramblers in the *doolhof* encounter multiple paths that dead end or fork, forcing them to double back or choose another way, becoming disoriented in the process. Vision becomes an especially unreliable guide in a series of frustrating encounters with multiple impasses and blind alleys. You may hear sounds, voices, footsteps, but sonic cues also won't help you find the way. You can't wholly perceive or fully comprehend the maze when you are inside it. The confusion of losing yourself in the dizzying labyrinth is akin to inebriation. The maze, as Bernard Tschumi has pointed out, affects sense before reason.[18] Like the Bacchus fountain, it is an unpredictable and crafty art form that heightens awareness of embodied experience by demanding physical participation. Part-architectural, part-sculptural, this dynamic art form is not experienced as a static container or as a separate crafted object, but as immersion in ever-changing mobile and emotive spatial practices.

Following from the Bacchic excesses of the tavern yard, the confusion of mazy wandering was intensified by the layout of the exhibition site. The ritual itinerary unfolded with ever-increasing sensory disorientation. Spatially, this was experienced as constriction. Visitors were lured from the streets into a noisy enclosed square where their senses were assaulted by the liquid refreshments of cunning Bacchus. Then (for a small admission fee), they entered a second courtyard to be entrapped by the tight constraints of the tricky maze. The deeper they went into the labyrinth, the more difficult it became to get out again. Sensations intensify with ensnarement. Pleasure mingles with panic, delight with dismay; each step is an exercise in paradox. Perhaps the Dutch poet, politician and gardener Jacob Cats had this sort of maze in mind when he wrote in 1625 of a bittersweet *doolhof* that was both pleasant and terrifying, 'a garden full of fearful joy and a thousand strange blows'.[19] An oft-repeated dictum was that the labyrinth was like sensual pleasure or voluptuous worldliness: seductively easy to enter into, but the deeper in you go, the more difficult

it is to get out. As one emblematist put it: 'So to vaine pleasures it is ease to go / But to returne again it is not so'.[20]

The experience of intense confusion and entrapment is particularly heightened when confronted with choices between multiple paths, and the Amsterdam *Doolhoven* are the first known civic labyrinths that were multicursal.[21] Previous public labyrinths, such as the ones designed for churches and town halls, were unicursal: there was a single path and by conforming to it, the seeker was led to the centre in a contemplative quest for truth, self, God.[22] In the multicursal maze, by contrast, there is no secure knowledge of a predetermined way, and the wanderer must make trial-and-error decisions based only on partial sensory experience. A space of intense sensation and affect, the labyrinth must be negotiated with the body. By confounding information received by the senses, it prompts awareness of the limitations and the failings of sensate knowledge even as it forces reliance upon it. The body is affected by the space, compelled to feel its way through the passageways offered; and the body affects the space, putting it into motion by activating its various possibilities. In a maze, you can't separate yourself – physically or cognitively – from your environment. Following from the pleasures of the Bacchic courtyard, the constrictions of the maze might initially feel like a sensual embrace. But with each false turn and every failed attempt to find the way, frustrated maze-walkers may begin to feel that they are caught in the serpentine coils of original sin. Voluptuous worldliness is easy to enter into, but difficult to exit. By trapping, isolating and alienating, the maze forces the wanderer to discover the interior labyrinth of the self, and within it a devouring beast.

Arriving finally at the centre of the *Oude Doolhof* maze, the wayfarer was confronted with another affecting sculptural group: Theseus battling the Minotaur, the man–bull that fed on the blood of those who penetrated the labyrinth's hidden heart. Plutarch described this monster as: 'A mingled form and hybrid birth of monstrous shape / Two different natures, man and bull, were joined in him'.[23] These statues do not survive, and the only extant image is a small print on the title page of one of the guidebooks (Figure 2.3). The booklet states that the statues were larger than life sized, and Domselaer's civic history casually notes that some dead bodies lay strewn about them.[24] Death is at the centre, but it is not the end. In a labyrinthine move, the Theseus and Minotaur sculpture is a terminal point that diverts and redirects travellers, doubling back to origins by situating the Amsterdam *doolhof* as a creative reinvention of the ancient Cretan labyrinth. Its distinctive multicursal structure and the physical lived time of confused wandering are re-evaluated as a recurrence of the original labyrinth.[25] This potent reanimation of an ancient form was harnessed to larger civic narratives, as maze-walkers in Amsterdam activated a passageway to one of the city's mythic origins: the founding of republican Athens by the citizen-hero Theseus.[26]

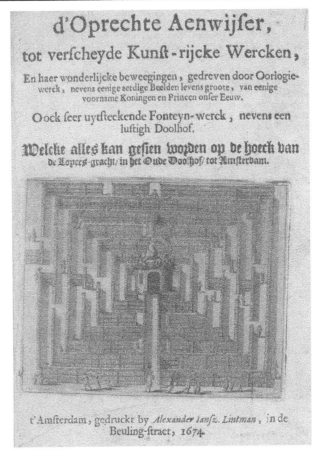

Figure 2.3 Title page, Jan Vos, *D'Oprechte Aenwijser* (Amsterdam: Alexander Iansz. Lintman, 1674), University of Amsterdam Library (UvA) Special Collections, OTM O 62–2616.

The commentary on Ovid's *Metamorphoses* by Dutch artist and writer, Karel van Mander, includes an explanation of the labyrinth story that emphasises the exemplary heroism of Theseus. Van Mander describes the Cretan labyrinth as irrational and beastly, a place of fleshly lust. One can lose oneself in the multicursal maze, and for Van Mander, the danger lurking at its heart was not so much death, but the possibility of being transformed into a Minotaur, of becoming man–beast. He describes the potential of the labyrinth to change men into brutes by making them move and behave on the basis of bodily sensations and appetites. Rewriting the myth along the lines of Christian morality, he urges readers to conquer their fleshly, sinful, beastly, irrational natures. They should strive to become like Theseus, who unravelled the labyrinth,

slayed the monster, and followed 'the straight path of reason'.[27] This is the right path for the model citizen: to emerge from the labyrinth a transformed subject, in control of the self, the beast and the city. The labyrinth thus described is a site of perpetual conflict, a field of opposing forces. Following from the Bacchic courtyard, the labyrinth challenged roaming spectators to become intensely aware of bodily sensations and passions, to confront their own beastly natures, and then, ideally, to overcome their carnal impulses and conquer the beast within.

The relevance of the myth of Theseus and the labyrinth for Amsterdam had been brought forward by one of the city's foremost playwrights and leading citizens, P. C. Hooft. The son of a wealthy Amsterdam burgomaster (and, as noted, uncle of one of the *Doolhof* proprietors), Hooft was sent on a tour of several French and Italian cities as a young man, and returned inspired to develop vernacular classicism in his home city. The first theatre play that he composed after returning from his travels was *Theseus and Ariadne*. Written in 1601, the work appeared in print in 1614 with a second edition in 1628.[28] During these decades, it was performed multiple times by the Amsterdam Chamber of Rhetoric, *De Egelantier*.[29] This civic society was the centre of literary production before the founding of the Dutch Academy by Hooft and a small group of others, who broke from *De Egelantier* in 1617. *De Egelantier* was conceived as 'a school of the mother tongue, open to anybody, without exceptions'.[30] Its activities centred on the writing, recitation and performance of plays and poetry, and the staging of *tableaux vivants* at public festivities and civic competitions. It was open to all citizens and drew its membership mainly from the broad middle classes, including many artists and skilled craftsmen. Notably, it also included many members of the civic government, and thus had the semi-official public role of deliberately crafting a cultural politics for the city. As literary scholar Marijke Spies has argued, the main aim of *De Egelantier* was to create urban harmony.[31] The Neostoic philosophy of Justus Lipsius provided a non-confessional moral foundation that de-emphasised religious differences and controversies. In addition to Calvinists, the society included a number of prominent Roman Catholics, Mennonites and members of other confessional groups. It deliberately avoided dogma or zealotry, which was seen as disruptive to urban life. The aim was to heal the divisive religious, political – and artistic – conflicts of the Revolt and to generate civic accord through performance, entertainment and creativity.[32] The Amsterdam *Doolhoven*, as I'm arguing, were designed along very similar lines.

Hooft's particular aim for *De Egelantier*, and later the Dutch Academy, was to advance a new kind of Dutch classicism, reviving ancient forms in the vernacular and making them accessible for the betterment of the urban popula-tion. The foreword of *Theseus and Ariadne* declares that the play was written for 'the honour of the fatherland and our mother tongue'.[33] The emphasis

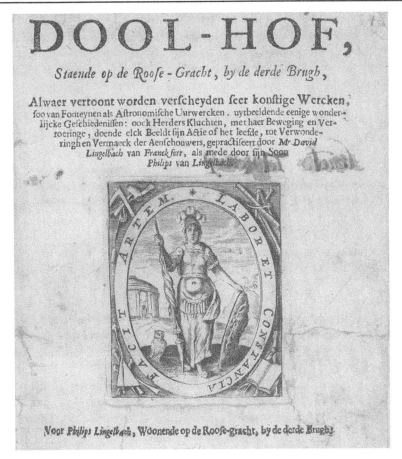

Figure 2.4 Title page, Crispijn van de Passe, *Dool-hof, Staende Op de Roose-Gracht* (Amsterdam: voor Philips Lingelbach, 1660), University of Amsterdam Library (UvA) Special Collections, OTM O 60–2758.

is the heroism of Theseus. Like Van Mander, Hooft represents Theseus as a Stoic hero, a republican civic leader who overcomes passion and irrationality for the greater good of the community. Indeed, the tenets of Neostoicism offered a means of cultivating civic order. The title page of a *Doolhof* pamphlet points in this direction (Figure 2.4). Athena, goddess of wisdom, craft and civic defence, is ringed with the text: *Facit, Artem, Labor et Constancia*.[34] The phrase *Labor et Constancia* calls up Justus Lipsius's pivotal treatise *De Constantia*, first published in 1583.[35] Described as a 'practical guide to the art of living', *De Constantia* was an international bestseller. Lipsius's career was disrupted by the violence and uncertainty of war, making him keenly aware of the inescapability of public evils. Moving from place to place in a futile

quest for peace, the scholar came to realise that he could not escape troubles. War is experienced as turmoil within the self. Drawing on Roman Stoicism, the *De Constantia* counsels that while you can't change worldly events, you can change yourself. Only the cultivation of immovable strength of mind will calm the inner chaos that results when passions are stirred by external events.[36] Neostoicism promised equanimity to self-disciplining subjects who, instead of being continuously buffeted by immediate sensations and perceptions, could learn to meet every situation with constancy, dignity and self-control.[37] The desired state is *apatheia* – to be without pathos, suffering or passion.

De Constantia was extremely influential in the Dutch cities, where it was taken up as a model for public life. By encouraging individuals to assume active responsibility for the cultivation of the self, Neostoicism fostered a new relation between private people and political structures. The ethics of responsible citizenship especially meant that individuals could define themselves as denizens rather than victims of the state and the *polis*.[38] Not surprisingly, Lipsius names Theseus as exemplar: 'For whoever listens to reason has tamed the desires and the riotous impulses ... and he is safe from losing his way in the labyrinths of this life, if he follows it as the thread of Theseus.'[39] The world is a labyrinth and we are lost in it if unruly passions are not tamed. The Amsterdam labyrinth parks therefore seem designed as a sort of Neostoic training ground: by immersing visitors in multiple moving and sensual experiences, they created opportunities to battle against strong passions and cultivate constancy. To be caught in the labyrinth of life is to be entangled in troubles and buffeted by fortune and changing circumstances. Prudence, faith and fortitude are needed to negotiate its many trials. Like exemplary Theseus, the maze-treader has to master the confusions, wild emotions and sensory distractions of life's maze. Successful maze-warriors must fight to achieve inner calm – only by governing the self can you defeat the maze.[40] In a republican city (like Athens and like Amsterdam), all citizens must become stoic leaders: by achieving mastery of themselves, they secure civic harmony.

Indeed, the first public multicursal mazes may have emerged in early seventeenth-century Amsterdam because the reform of subjects and the reform of civic life were very much intertwined during this period of intensive urban growth. The Dutch cities founded innovative disciplinary programmes whose aims were in part derived from the principles of the treatise 'Boeven-tucht', or 'The Discipline of Misbehaviour', written in 1587 by Dirck Volkertzoon Coornhert, a literary figure and artist who was influential for *De Egelantier*. Coornhert addressed pressing social problems of his day. His treatise explains that the displacements of war and religious discord were bringing legions of migrants into the ever-expanding Dutch cities. Masses of them, according to Coornhert, were idle layabouts, indigents who were turning to crime. Houses of correction were proposed as a productive solution to this urban disorder.

Amsterdam's city fathers put Coornhert's recommendations into practice and established two workhouses, one for men and another for women, in the late 1590s. P. C. Hooft's father, the burgomaster C. P. Hooft, was in fact one of the founders of these new civic institutions. Interestingly, the tax revenues paid by Amsterdam innkeepers for liquor licences were an important source of funding for the *Spinhuis*, so there was a direct connection between the tavern and the house of correction.[41] If sellers of drink contributed to social ills, they also paid to help make society well again.

The purpose of the workhouses was to detain prostitutes, beggars and other criminals and teach them productive work, thus training them to make industrious contributions to public life.[42] The women incarcerated at the *Spinhuis* accordingly were set to the tasks of spinning, weaving, sewing and lacemaking. Above the portal of the *Spinhuis* is a verse by P. C. Hooft, which succinctly addresses this method of reform: 'Don't be afraid, for I exact no vengeance for wrong but force you to be good. My hand is stern but my heart is kind.'[43] Another inscription states that the *Spinhuis* was founded to teach indigent girls and women not to take the crooked way – the *doolwegh* – of begging and idleness.[44] At the *Spinhuis*, then, the forced labour of spinning produced a sort of Ariadne's thread, which would guide wayward women to the right way. As Van Mander explained, Ariadne's thread is a 'straight thread of reasonableness, to come from the confused ways of this world into the path of righteousness'.[45]

Labour and confinement tame the inner beast. Coornhert likened the 'urban scum' to savage bears and wolves – their depraved nature makes them like dangerous wild animals who must be disciplined and made useful for the greater advantage and convenience of society.[46] The portal of the men's workhouse, the *Rasphuis*, includes a Latin inscription from Seneca: 'Tis valour's part to subdue what all men fear'.[47] The message is evident: if urban miscreants refused to modify their beastly behaviour by their own volition, they would be punished, trained and reformed by these municipal institutions. Civic harmony depended on the inner transformation of each resident. The ideal of self-mastery takes a subtle turn here; good citizens do not just tame the beast within the self – they also dominate it in others. While certainly more heavy-handed, the aims of the prisons were surprisingly similar to those of the *Doolhoven*. Recall that the Cretan labyrinth was a place of incarceration for the Minotaur, a beastly human. Like a prison, the labyrinth contains chaos. Both structures detain people in a bounded space, where they are confronted with their own failings. In each place, the labour of getting out of confinement requires the effort of gaining control of the self – of recognising and training the inner beast. The contrast to the workhouses instructively highlights what was distinctive about the *Doolhof* programme of urban reform: it seductively used aesthetic pleasure and sensation as forms of discipline.

The vernacular classicism of early seventeenth-century theatre and of the *Oude Doolhof* amusement park accordingly extended the virtues of Neostoicism beyond the ruling elite with the aim of educating and reforming as many as possible. The experience of walking the *doolhof* actuated this civic promise. Like the Bacchus fountain, the form of the maze and its central sculpture brought narrative content to life. In order to conquer the labyrinth, wayfaring visitors had to become like Theseus. The initiation rite of solving the maze turned wanderers away from reliance on faulty human senses, feelings and perceptions. It forced them to examine their choices, and to consider whether they were guided by passions and sensations or by calm, godly reason – the thread of Theseus. By performing Theseus's actions and partaking in his courage, maze-walkers ideally would prevail in the sobering trial of the labyrinth, an arduous process filled with multiple turnings, which would convert them into better citizens. Of course, such a conversion is never completed, for if life is a labyrinth, then the final victory only comes at the very end. One of the *Doolhof* guidebooks quips that as in the maze, so in life: everyone wanders as long as he can, until he drops into the grave.[48] Life, thus understood, is an ongoing process of tangling with monsters in an impossible quest to establish calm, undisturbed reason within the self and the city.

Having confronted their own inner beasts within the maze, peripatetic spectators were now prepared for the next part of the itinerary: entry into the sculpture gallery. The publicity materials tend to approach the exhibited artworks somewhat obliquely. One of the guidebooks, for instance, addresses 'art loving and tasteful spectators', stating that although we read of ingenious ancient masters who made extremely subtle works, the Greeks and Romans never saw anything like the clever artificial inventions displayed here. Through art, these things stir and move as if they have life in them. Yes, they even make noises: singing and almost speaking.[49] The next part of the ritual exhibition route thus shifts focus to another aspect of Ovid's tale, for the ingenious ancient master most often credited with the invention of living, moving artworks is Daedalus, the crafty artificer of antiquity.[50] Renowned as the inventor of clever devices including the wooden cow used by Queen Pasiphaë to mate with the Cretan bull, and maker of the original labyrinth, built to imprison the monster born of this bestiality, Daedalus was famously punished for his transgressive ingenuity when imprisoned by King Minos in the very labyrinth that he had so cunningly designed. Daedalic arts do not follow a straight path. Like their creator, who fashioned wings to fly from imprisonment in the labyrinth, Daedalic works are elusive; they deviate, transgress and resist containment. Plato wrote of Daedalus's creations:

> If no one ties them down, [they] run away and escape. If tied, they stay where they are put. If you have one of his works untethered, it is not

worth much; it gives you the slip like a runaway slave. But a tethered specimen is very valuable, for they are magnificent creatures.[51]

The truant works Plato describes are automata, self-moving mechanical figures. Daedalus is said to have fashioned dancing figures for Ariadne and set them in motion to guard the entrance of the labyrinth.[52]

Doolhof publicity traded on the powers of these ingenious artworks, especially their capability to pull people into their sway. One of the posters promises prospective visitors 'many fine secrets',[53] and a mood of suspenseful revelation is created by the peripatetic space itself. The maze unravels as a thread, pulling exiting visitors along a path to a door that opens directly into a large building. Inside, there were rows of tiered seating facing a curtained stage. After paying an admission price of one *stuiver*, roughly equivalent to the cost of two tankards of beer, spectators found their places. The curtain was raised and the shows began. At designated times the anticipated spectacle of lifelike motion began to play.[54] The shows consisted of three kinds of automata: mechanical clocks, moving mechanical pictures and androids. Each in turn was explained and set in motion by a showman. On a raised stage behind the automata was a row of life-sized historical figures in wax. The shows were accompanied by commentary and music, and a number of the automata made sounds.

The moving pictures were intricate works in which clock mechanisms drove the bodily movements and gestures of small costumed figures in architectural settings. Familiar stories unfolded in a series of moving sequential scenes. In the *Oude Doolhof*, there were three of these moving mechanical picture shows. One performed the Old Testament story of the Queen of Sheba's visit to King Solomon. Another staged a popular pastoral episode derived from a play by P. C. Hooft in which the Persian princess Granida encounters her lover, the shepherd Daiphilo.[55] A third presented the tale of Semiramis, the legendary Assyrian Queen who orders the assassination of her husband. There were also comic scenarios, such as an animated scene of seven wives fighting for a man's pair of pants (Figure 2.5). The sculpture gallery accordingly was a complex pictorial and narrative space where the use of clock mechanisms activated visual imagery, animating it so that it apparently came to life.

The most powerfully lifelike of the displayed automata were the androids. The earliest of these human-like figures was an *Oude Doolhof* automaton named Jochemus (Figure 2.6).[56] Naming personifies the machine, thematising its agency and integrating it into the social world. The guidebook claims that Jochemus could play a variety of tunes on his bagpipe, and that his head, eyes and hands all moved 'as if he lived'. He is very artfully put together, the pamphlet states, and the Master's work is hidden inside.[57] This phrase, 'Master's work', could refer to the Daedalic artist who made the android, but also implies the work of God, raising questions about what activates the

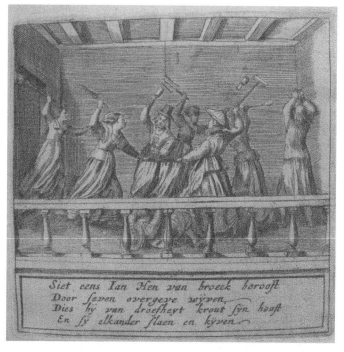

Figure 2.5 'Seven Wives fighting for a Man's Pair of Pants' in Crispijn van de Passe, *Den Nieuwen en Vermaeckelijcken Dool-hof, Staende op de Roose-Gracht* (Amsterdam: voor David Lingelbach, 1648), University of Amsterdam Library (UvA) Special Collections, OTM: O 63–7272.

moving body. The bagpipes externalise the functioning of imagined lungs. The invisible life force of breath or *pneuma* appears to pulsate from the lips into the pipes to inflate the sack, endowing Jochemus with interiority. The machine performs as a living being and the viewer experiences Jochemus's vivid lifelikeness as if it (or he) were human. The effect is more than just the illusion of life: Jochemus appears to function like the workings and processes of nature. Automata move at the limits of artistic practice; these moving images stop just short of realising the artistic ideal of achieving life.[58]

Like Van Mander, Francis Bacon wrote insightful commentary on Ovid's account of the Cretan labyrinth. Notably, Bacon calls Daedalus a 'most ingenious but execrable artist'. He disparages the legendary inventor for putting his extraordinary mechanical skill – his 'destructive genius' – to ill uses, both in the conception of the bestial Minotaur and in the invention of cunning mechanical devices. The story of Daedalus is an important founding myth of technology. Ovid's suggestive description of the inventor evokes what was to become a central concern in the early modern period: 'And turning his mind

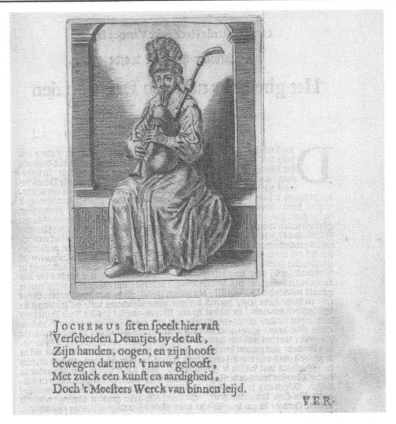

Figure 2.6 'Jochemus' in *Verklaringe van Verscheyden Kunst-Rijcke Wercken en hare Beweginghe* (Amsterdam: Dan. Davidsz. Mansvelt, 1657), University of Amsterdam Library (UvA) Special Collections, OTM O 62–2615

toward unknown arts, he transformed nature'. For both Van Mander and Bacon, Daedalic innovation was a dangerous art. Experimentation with new technologies allowed human ingenuity to create new forms not found in nature – like the labyrinth, the Minotaur and the automaton. The moral of the tale of Daedalus was clear: human ingenuity can go too far, and when the artist's god-like creativity or his lively creations attempted to vie with the power and majesty of God, they had to be curtailed.[59]

Bacon forcefully asserted that although humanity was indebted to the mechanical arts, which were an 'ornament of civic society', the same arsenal supplied instruments of lust, brutality and death. He names guns and engines of war as examples of wicked inventions that far exceeded 'the cruelty and barbarity of the Minotaur himself'. Asserting that the mechanical arts are always prohibited and always retained in the city, Bacon concluded: 'Unlawful arts

are persecuted by Minos, that is, by laws, which prohibit and forbid their use among the people; but notwithstanding this, they are hid, concealed, retained and everywhere find reception and skulking-places.' The Amsterdam labyrinth gardens were just such skulking-places, a means to display forbidden arts that were also ornaments of civic society. By containing, protecting and displaying mechanical inventions, these innovative exhibition sites facilitated the controlled social assimilation of ambiguous art forms.

In the manner of all Daedalic art, however, these cunning works could break out of their confinement. Bacon wrote of Daedalus: 'he always found refuge and a means of escaping', and the same is true of the Daedalic arts. Like 'runaway slaves', they could dart off along unforeseen paths. For Bacon, the machinations of automata were analogous to those of a labyrinth:

> The labyrinth contains a beautiful allegory, representing the nature of the mechanic arts in general; for all ingenious and accurate mechanical inventions may be conceived as a labyrinth, which, by reason of their subtlety, intricacy, crossing and interfering with one another, and the apparent resemblances they have among themselves, scarce any power of the judgement can unravel and distinguish; so that they are only to be understood and traced by the clue of experience. For mechanical arts have an ambiguous or double use, and serve as well to produce as to prevent mischief and destruction; so that their virtue almost destroys or unwinds itself. [60]

This comparison between the labyrinth and the mechanical arts is twofold. First, both are extremely complex and intricate human-made works, best deciphered by experience rather than detached judgement. Moreover, their prospective social impact is equivocal and cannot be judiciously controlled. Like the labyrinth (and, we might add, the Bacchus fountain), these inventions paradoxically proffered civil benefits, but with a great deal of ambiguity, so that public virtue and public mischief were wound together, an entanglement both risky and necessary.

The potentially transgressive autonomy of the automaton accordingly was constrained by strategic techniques of display. Many of the works mechanically mimic the powers of passion run amok. The violent comic scenario of seven women fighting for a man's trousers, for instance, pictures the 'battle for the pants', a long-established comic trope in which passion – pictured as an uncontrolled female force – goes on a rampage (Figure 2.5).[61] With this in mind, we notice that many of the automata enact scenes in which empowered women are on top. The Persian princess Granida chooses the shepherd Daiphilo as her lover; the Queen of Sheba approaches King Solomon as an equal; the Assyrian Queen Semiramis orders an assassin (a knife-wielding automaton) to murder her husband. If we trace a literary source for this particular story, a possibility

is Boccaccio's *Famous Women*, which describes Semiramis as the very embodiment of female inconstancy who committed acts 'more beastly than human'.[62] Passion, inconstancy and beastliness might also have been associated with the ethnic alterity of the costumed mechanical figures. As we have glimpsed in passing, many of the automata are portrayed as Jewish, Persian, Greek, African or Assyrian. When the impassioned automaton is feminised or exoticised, its performance conflates with the perception that certain groups were especially vulnerable to the riotous impulses of the passions. In this way, these automata exhibit attempts to untangle reason and unreason, separating out women and foreigners as being particularly prone to unruly behaviour, and, like the machine, in need of control. While these displays were open to all, they could serve to reinforce the relative standing of diverse individuals within the community by mockingly associating uncivil behaviour with those already excluded from full participation in civic life.

The paradox of these striking displays, however, is that powerful emotions – anger, fear, desire, bloodlust – are expressed by measured, repetitive, mechanical bodily movements. Unlike the human subject, the well-run machine can and does behave with complete constancy. The automaton is not buffeted about by every passing event; and it wholly lacks the understanding to respond spontaneously to the labyrinthine difficulties and contingencies of life. Animate yet lifeless, the android is not vulnerable as mortals are: it is never moved by either the pains or the pleasures of passions and sensations. It is only moved by clockwork. While devoid of emotion, these unfeeling apparatuses do, however, have the power to arouse human passions. If, as I have argued, the visitors' experiences with the waterworks and the maze generated intense awareness of human beastliness, then the startling works in the automata gallery prompted spectators to consider opposite extremes of behaviour: the complete, machine-like constancy of perfect *apatheia*. In so doing, the route through this exhibition site moved viewers to compare themselves to both the beast and the machine.

Such claims resonate with the views of René Descartes, who once lived within easy walking distance of the Amsterdam *Doolhoven*.[63] Descartes famously coined the term *bête machine* – beast machine – to argue that animals and automata both lack the human capacity to use words or signs to convey thoughts. Although they can do many things with greater perfection than us, and can imitate movements which indicate the passions, they do not act from knowledge or reason.[64] The beast machine is an artful configuration that moves on its own according to mechanistic principles; it is not driven by an intelligent mind or soul.[65] By pinpointing what distinguished the human from the animal and the machine, Descartes was able to extend the beast machine analogy to certain aspects of the human body, especially involuntary movements not motivated by the mind.

Descartes described the display of automata in terms of their capacity to prompt a spontaneous and passionate first reaction, which is followed by a reasoning response:

> After having stirred wonder in you by exhibiting to you machines, extremely powerful, very strange and rare automata, visual appearances seemingly real and in postures the subtlest that artificers can devise, I will then uncover the secret devices on which they rest and these are so simple that you will no longer be tempted to feel wonder regarding any product of human devising.[66]

For Descartes, automata displays initially aroused wonder, but this was based only on partial sensory information. The physical impact of such wondrous displays was thus similar to that of the trick fountain and the confounding maze – involuntary and moving. Informed technological explanation – the uncovering of secret devices – would necessarily dispel wonder and accordingly move the viewer from feeling to thinking. With its mysteries eviscerated, the automaton could be exposed as a human-made device that was clever, but not powerfully rare or wonderful. Thus understood, it does not hold sway over thoughtful human viewers but is a work of mechanical ingenuity, a compelling puzzle to be solved by the intelligent beholder.

While Descartes may have disparaged the deceptiveness of 'seemingly real' automata that affected sense before reason, his comments concurrently betray technology's unsettling powers of wonder.[67] The automata's performative illusions – their *beweeglijkheid* – prompted physical reactions. They were designed to elicit involuntary starts and gasps of astonishment and surprise, making people feel before compelling them to think. Descartes described this condition in *The Passions of the Soul*. In his passages on wonder, the philosopher considered both the beneficial and harmful effects of this powerful passion. The social benefit of wonder is that it usefully stimulates scientific curiosity. The main way to induce wonder is with novel objects, particularly if displayed in a manner that is surprising or unexpected. However, the strength and power of a sudden surprise can cause excessive wonder, which the philosopher terms astonishment. Astonishment is always bad, as it 'can entirely block or pervert the use of reason'. The cure for astonishment, advises Descartes, is to repeatedly encounter unusual things. By attaining a special state of reflection and attention, the viewer can closely examine the object that seems strange, learning more about it and dispelling its mysterious powers.[68]

The *Doolhof* amusement parks were sites that provided a controlled environment where visitors were immersed in their interactions with surprising and highly innovative works of art that were cleverly designed to trick and ensnare, and to move them both emotively and physically. Indeed, the artworks behaved like the dangerous beasts that find asylum within a labyrinth:

unleashing their powers, they attacked wandering visitors along the prescribed route with 'a thousand strange blows', provoking struggles in which spectators battled to outwit lively artworks and to overcome the strong passions they aroused. Heinsius wrote that affective theatre performances were a 'wrestling school of the passions',[69] and I would contend that this was the function of the *Doolhoven* as well. The Neostoic prescription was that people needed diligent exercise to learn how to master their instinctive passionate responses to stirring works of art. The stronger the initial reaction, the better. The process of self-mastery involves fighting against formidable antagonists. The artworks along the prescribed itinerary of the *Doolhoven* both unleashed and contained the passions; these sites thus served as a training ground to combat these forces. What was really being put on display, therefore, was human behaviour and its extremes. By following the prescribed itinerary through the exhibition site, visitors experienced how a person with very little reason resembles a beast, which is driven by senses and passions; and how a person without passions or stirrings is like a machine, which moves but does not feel or think. This type of cultural exercise – a sort of initiation rite – was designed to prepare visitors to go back into the city and meet its many disturbing blows armed with equanimity and self-control. The ritual route of these exhibition sites was thus experienced as a surprising reversal: it aroused uninhibited drunken and impassioned behaviour in order to convert it into individual and collective sobriety. While the *Doolhof*'s complex strategies of containment and affective display were designed to order and reform civic life in this manner, this was, of course, an impossible goal. The strategy of both producing and preventing uninhibited behaviour in fact reveals the many contradictions of urban space, which, in the words of Henri Lefebvre, is always 'as prodigal of monstrosities as of promises (that it cannot keep)'.[70]

NOTES

1. Witkamp, *Amsterdam*, pp. 83, 90–1. In his discussion of the *Oude Doolhof*, Witcamp cites a civic by-law of 1629 that prohibited inns with fountains from blasting trumpets, pipes and other noisy instruments to attract customers, indicating that this was a common practice, albeit one that disturbed the neighbours.
2. This may well have been an oral street cry before it was carved in stone. The inscription is transcribed by Vriese, 'Het Oude', p. 270, probably from an undated drawing of the portal in the Amsterdam City Archives.
3. The Amsterdam *Doolhoven* were the first urban labyrinth gardens of this sort in Europe. The city boasted five *Doolhoven*, all set up in the courtyards of inns. The *Oude Doolhof* (Old Maze) was in operation for close to 270 years, from the early 1620s until 1892. In 1626, its proprietor purchased an adjacent garden on Looiersgracht and built a *Nieuwe Doolhof* (New Maze). The *Nieuwe Doolhof* later moved to a larger site on the Rozengracht in 1648 where it remained until 1717. There was also a *Roode Doolhof* near the Regulierspoort from 1630 to 1663, and a *Franse Doolhof* by the St Anthoniespoort from 1637 to 1679. See Vriese, 'Het Nieuwe', pp. 354–7; and Vriese, 'Nog enkele', pp. 82–6.
4. Brandt and Hogendoorn, *German and Dutch Theatre*, p. 349.

5. Fokkens, *Beschrijvinge*, p. 302.
6. See the pioneering work of Duncan, 'Art Museums', pp. 88–103.
7. On the MoMA as a labyrinth, Duncan and Wallach, 'The Museum', pp. 28–51. Also Bann, 'Un retour', pp. 199–216.
8. Weststeijn, *Visible World*, pp. 185–8.
9. Junius, *The Painting*, p. 341. See the important commentary in Weststeijn, 'Between Mind and Body', p. 268.
10. Sluijter, 'Rembrandt's portrayal', pp. 285–306.
11. Weststeijn, *Visible World*, p. 185; the commentary in Massey, 'Reflections on Temporality', p. 187.
12. 'Haer mondt die lachte wel, maer 't oogh dat scheen te huylen'. The line is cited in the guidebook, Anon., *Verklaringe van Verscheyden* (which attributes it to Jan Vos); Spies identifies it as from a poem by Vos that was printed together with P. C. Hooft's play, *Bacchus and Ariadne*. Spies, 'De Amsterdamse Doolhoven', pp. 70–8.
13. Anon., *D'Oprechte Aenwijser*. Sometimes called 'labyrinths of love', hedge mazes symbolised the complexities and ambivalences of eroticism and fertility, themes that recur in the *Doolhoven*. Kern, *Through the Labyrinth*, p. 226.
14. Brereton and Hawkins, *Travels in Holland*, pp. 58–9.
15. 'Die de gapended Vrouw-luyden veeltijts met haar uytspruytende koele water-stralen van onderen als nuchtere Kalveren doen hippelen, dat de ommestaanders vermakelijk is'. Van Domselaer, *Beschryvinge*, p. 309.
16. 'Lyaeus heet ghy meest, om dat ghy kont ontbinden, Ons sinnen en verstant, de sorgen komt verslinden'. Heinsius, *Nederduytsche poemata*, p. 3. See also De Clippel, 'Rough Bacchus', p. 106.
17. Bacon, 'Dionysus', p. 244.
18. Tschumi, *Architecture and Disjunction*, p. 39.
19. 'Een hof vol bange vreucht, en duysent vreemde slagen'. Cats, *Houwelyck*, n.p.; De Jong, *Nature and Art*, p. 126.
20. From Perrière, *Theatre*, as cited and translated in Kern, *Through the Labyrinth*, p. 221.
21. Schaefers and Backer, *Doolhoven en Labyrinten*, pp. 9, 109; Reneman, 'Het "Oude Doolhof"', p. 5.
22. On the contrast between the unicursal and multicursal maze, see Doob, *The Idea*, especially ch. 2. The maze at Chartres Cathedral is the best-known example of the unicursal variant.
23. Plutarch, *Parallel Lives*, vol. I, p. 29. Plutarch claims this passage is a citation taken from Euripedes.
24. Artists sometimes drew on visual representations of centaurs when pictur-ing the Minotaur, which appears to be the case on the title page of the *Oude Doolhof* booklet, Anon., *D'Oprechte Aenwijser*, possibly authored by Jan Vos. Van Domselaer's phrase is: 'zommige gedoode lichame om hem leggende', Van Domselaer, *Beschryvinge*, p. 308.
25. On the relation between dance, ritual, performance and labyrinth patterns, see Kern, *Through the Labyrinth*, pp. 25–7; and Greene, 'Labyrinth Dances', pp. 1403–66.
26. Mazes evoke the establishment of cities, as Theseus emerged to found Athens, with the rescued youth joining him as full-fledged citizens. Kern, *Through the Labyrinth*, pp. 47, 82.
27. Van Mander, *Het Schilder-boeck*, pp. 1062–71.
28. Spies, 'Kunst', pp. 315, 326–7. According to Spies, the play was still being per-formed in 1628.

29. The chamber was named after a flower, the eglantine rose; its motto was '*In liefde bloeiende*' (blossoming/bleeding in love). Schenkeveld, *Dutch Literature*, pp. 11–14.
30. Schenkeveld, *Dutch Literature*, p. 13.
31. Spies, 'Rhetoric and Civic Harmony', pp. 64–5.
32. For instance, one of the group's key leaders, Hendrick Laurensz Spiegel, was Roman Catholic. Spies, 'Kunst', p. 305.
33. Hooft, *Theseus*, p. 40.
34. Allusions to artistry attest to the craftsmanship of the proprietors, David Lingelbach and his son Philips, clockmakers from Frankfurt. De Roever, 'Het Nieuwe Doolhof', pp. 103–12.
35. Lipsius, *On Constancy*. Lipsius's friend and publisher Christophe Plantin took *Labore et Constantia* as the motto for his press; see Voet, *The Golden Compasses*, vol. 1, p. 31.
36. Lipsius, *On Constancy*, pp. 33–6.
37. On the influence of Stoicism and Neostoicism on Descartes, see Dear, 'A Mechanical Microcosm', pp. 60–2, 68; Gaukroger, *Descartes*, p. 29. On the influence of Neostoicism on art theorists, see Weststeijn, *Visible World*, p. 39.
38. Oestreich, *Neostoicism*, p. 13.
39. Lipsius, *On Constancy*, p. 31.
40. Greene, 'Labyrinth Dances', p. 1459.
41. Hell, 'Trade, Transport', p. 744; Sluijter-Seijffert et al., *The Paintings*, pp. 48–9, 208–9.
42. Coornhert, 'Boeven-Tucht', pp. 89–104. On the founding of the workhouses, see Spierenburg, *The Prison Experience*, pp. 44–8.
43. *Schrik niet ik wreek geen quaat maar dwing tot goet / Straf is myn hant maar lieflyk myn gemoet.* The portal was designed by Hendrick de Keyser in 1607, and he requested that Hooft write the verses for it.
44. Dapper, *Historische*, pp. 417–18.
45. Van Mander, *Het Schilder-Boeck*, vol. 2, p. 68.
46. Coornhert, 'Boeven-Tucht', p. 101.
47. Spierenberg, *The Prison Experience*, p. 88. The citation is from Seneca and Miller, *Seneca's Tragedies, Hercules Furens*: 'Virtutis est domare quae cuncti pavent'.
48. 'En dolt zo lang hij kan, tot dat hy dealt in 't Graf'. In the booklet, Anon., *Dool-hof, Staende*, n.p.
49. Anon., *Dool-hof, Staende*, n.p.
50. In France, garden mazes were termed *dédales* or *maisons de Dédalus*. Matthews, *Mazes*, p. 125.
51. Plato, *Meno*, 97: d–e.
52. Price, 'Automata', p. 10.
53. 'Plusieurs beaux secrets'. The poster, *De Fontein in het Oude Doolhof te Amsterdam*, is by Cornelis van Berckenrode. Meijer, 'Het Oude', p. 34.
54. Anon., *Dool-hof, Staende*, n.p.
55. Hooft, *Granida*.
56. Jochemus is first pictured and described in a guidebook that predates 1648. Reneman, 'Het "Oude Doolhof"', p. 76. There is a surviving set of mechanical wooden statues of David and Goliath, *c.*1650, currently displayed in the Amsterdam Museum. Eisma, *David en Goliath*.
57. Anon., *Verklaringe van Treffelijcke*.
58. Summers, 'Pandora's crown', p. 46.
59. Van Hoogstraten, *Inleyding*, pp. 358–60.
60. Bacon, *Moral and Historical Works*, p. 237.

61. On the proverb of the seven women, see Gibson, *Figures of Speech*, ch. 5.
62. Boccaccio, *Famous Women*, p. 23.
63. Scholars have speculated that Descartes' mechanistic theories were influenced by hydraulic automata encountered in the château gardens at Saint-Germain-en-Laye. See Gaukroger, *Descartes*, p. 62. It's likely that Descartes visited the well-publicised Amsterdam *Doolhof* exhibitions and that these also shaped his thinking.
64. Descartes, *Discourse*, pp. 46–7.
65. Descartes argued that the world operated according to mechanistic principles: 'There is a material world machine: or, to put it more forcefully, the world is composed like a machine of matter; or, in material things all causes of motion are the same as in machines built by artifice.' Cited in Maurice and Mayr, *The Clockwork Universe*, p. 3.
66. Cited and translated in Werrett, 'Wonders', p. 141.
67. On wonder and automata, see Marr, '*Gentille Curiosité*', pp. 149–70.
68. Descartes, *Passions*, pp. 20–2.
69. Cited in Heinen, 'Huygens', p. 155.
70. This is in reference to the functions of urban spaces of leisure. Lefebvre, *The Production*, p. 385.

WORKS CITED

Anon., *Dool-hof, Staende Op de Roose-Gracht* (Amsterdam: voor Philips Lingelbach, 1660).
Anon., *Verklaringe van Verscheyden Kunst-Rijcke Wercken en hare Beweginghe* (Amsterdam: Gort, 1668).
Anon., *D'Oprechte Aenwijser, tot Verscheyde Kunst-Rijcke Werken, en haer Wonderlijcke Beweegingen, Gedreven door Oorlogie-Werck ...* (Amsterdam: Alexander Iansz. Lintman, 1674).
Bacon, F., *The Moral and Historical Works of Lord Bacon: Including His Essays, Apophthegms, Wisdom of the Ancients, New Atlantis, and Life of Henry the Seventh* (London: Bell & Daldy, 1873).
Bacon, F., 'Dionysus, or Bacchus', in *The Moral and Historical Works of Lord Bacon Including his Essays, Apophthegms, Wisdom of the Ancients, New Atlantis and the Life of Henry the Seventh* (London: Henry G. Bohn, [1609] 1860), pp. 242–5.
Bann, S., 'Un retour de l'art au jardin. Autour de quelques labyrinthes modernes et postmodernes', in Hervé Brunon (ed.), *Le Jardin comme labyrinthe du monde* (Paris: Louvre, 2008), pp. 199–216.
Boccaccio, *Famous Women* (Cambridge, MA: Harvard University Press, 2001).
Brandt, G. W. and W. Hogendoorn (eds), *German and Dutch Theatre, 1600–1848* (Cambridge: Cambridge University Press, 1993).
Brereton, W. and E. Hawkins, *Travels in Holland, the United Provinces, England, Scotland, and Ireland, 1634–1635* (London: Chetham Society, [1635] 1844).
Cats, J., *Houwelyck, dat is, De gansche gelegtheydt des echten staets* (Middelburgh: Jan Pieterss vande Venne, 1625).
Clippel, K. de, 'Rough Bacchus, Neat Andromeda. Rubens's Mythologies and the meaning of Manner', in C. van de Velde (ed.), *Classical Mythology in the Netherlands in the Age of Renaissance and Baroque* (Leuven: Peeters, 2009), pp. 95–112.
Coornhert, D. V., 'Boeven-Tucht: The Discipline of Misbehaviour or the Means to reduce the number of harmful idlers', trans. W. Freund, R. Deacon and E. Verbaan, *Theoria: A Journal of Social and Political Theory* 56:118 (March 2009), pp. 89–104.

Dapper, O., *Historische Beschryving der Stadt Amsterdam* (Amsterdam: Meurs, 1663).

Dear, P., 'A Mechanical Microcosm: Bodily Passions, Good Manners and Cartesian Mechanism', in C. Lawrence and S. Shapin (eds), *Science Incarnate: Historical Embodiments of Natural Knowledge* (Chicago: University of Chicago Press, 1998), pp. 51–82.

Descartes, R., *A Discourse on the Method of Correctly Conducting One's Reason and Seeking Truth in the Sciences*, trans. and intro. Ian Maclean (Oxford: Oxford University Press, [1637] 2006).

Descartes, R., *The Passions of the Soul: And Other Late Philosophical Writings*, trans. Michael Moriarty (Oxford: Oxford University Press, 2015).

Domselaer, T. van, *Beschryvinge der Stat Amsterdam* (Amsterdam: Marcus Doornik, 1665).

Doob, P., *The Idea of the Labyrinth from Classical Antiquity through the Middle Ages* (Ithaca: Cornell University Press, 1990).

Duncan, C., 'Art Museums and the Ritual of Citizenship', in I. Karp and S. D. Lavine (eds), *Exhibiting Cultures. The Poetics and Politics of Museum Display* (Washington, DC: Smithsonian, 1991), pp. 88–103.

Duncan, C. and A. Wallach, 'The Museum of Modern Art as Late Capitalist Ritual: An Iconographic Analysis', *Marxist Perspectives* 4 (1978), pp. 28–51.

Eisma, M., *David en Goliath met zijn Schilddrager. Een Beeldengroep uit het Oude Doolhof* (Wormer: Inmerc BV, 1996).

Fokkens, M., *Beschrijvinge der wijdt-vermaarde Koop-stadt Amstelredam* (Amsterdam: Marcus Doornik, 1662).

Gaukroger, S., *Descartes: An Intellectual Biography* (Oxford: Clarendon Press, 1995).

Gibson, W. S., *Figures of Speech: Picturing Proverbs in Renaissance Netherlands* (Berkeley: University of California Press, 2010).

Greene, T. M., 'Labyrinth Dances in the French and English Renaissance', *Renaissance Quarterly* 54:1 (2001), pp. 1403–66.

Heinen, U., 'Huygens, Rubens and Medusa: Reflecting the Passions in Paintings, with Some Consideration of Neuroscience in Art History', *Nederlands Kunsthistorisch Jaarboek* 60 (2010), pp. 151–78.

Heinsius, D., *Nederduytsche poemata, dl. 3: Hymnus oft Lof-sanck van Bacchus, Waerin 'tgebruyck ende misbruyck vande Wijn beschreven wort* (Amsterdam: Willem Jansz Blaeu, 1616).

Hell, M., 'Trade, Transport and Storage in Amsterdam Inns (1450–1800)', *Journal of Urban History* 40:4 (2014), pp. 742–61.

Hoogstraten, S. van, *Inleyding tot de Hooge Schoole der Schilderkonst* (Doornspijk: Davaco, [1678] 1969).

Hooft, P. C., *Granida*, L. van Gemert (ed.) (Amsterdam: Amsterdam University Press, [1605] 1998).

Hooft, P. C., *Theseus en Ariadne*, A. J. J. de Witte (ed.) (Zutphen: W. J. Thieme, 1972).

Jong, E. de, *Nature and Art: Dutch Garden and Landscape Architecture, 1650–1740* (Philadelphia: University of Pennsylvania Press, 2000).

Junius, F., *The Painting of the Ancients, in Three Bookes* (London: R. Hodgkinsonne, 1638).

Kern, H., *Through the Labyrinth: Designs and Meanings over 5,000 years* (Munich: Prestel, 2000).

Lefebvre, H., *The Production of Space*, trans. D. Nicholson-Smith (Oxford: Blackwell, 1991).

Lipsius, J., *On Constancy*, ed. and trans. R. V. Young (Tempe Arizona: Arizona Center for Medieval and Renaissance Studies, [1583] 2011).

Mander, K. van, *Het Schilder-boeck*, facsimile of the first edition (Utrecht: Davaco Publishers, [1604] 1969).

Marr, A., 'Gentille Curiosité: Wonder-working and the Culture of Automata in the late Renaissance', in R. J. W. Evans and A. Marr (eds), *Curiosity and Wonder from the Renaissance to the Enlightenment* (Aldershot and Burlington, VT: Ashgate, 2006), pp. 149–70.

Massey, L., 'Reflections on Temporality in Netherlandish Art', in A. Vanhaelen and B. Wilson (eds), *The Erotics of Looking. Early Modern Netherlandish Art* (Oxford: Wiley-Blackwell, 2013), pp. 184–91.

Matthews, W. H., *Mazes and Labyrinths* (New York: Dover Publications, 1970).

Maurice, K. and O. Mayr (eds), *The Clockwork Universe. German Clocks and Automata, 1550–1650* (New York and Washington, DC: N. Watson Academic Publications and Smithsonian Institution, 1980).

Meijer, D. C., 'Het Oude Doolhof te Amsterdam', *Oud-Holland* I (1883), pp. 30–6.

Oestreich, G., *Neostoicism and the Early Modern State*, trans. D. McLintock (Cambridge: Cambridge University Press, 1982).

Perrière, G. de la, *Theatre des bons engins* (Paris: Denis Janot, 1544).

Plato, *Meno*, trans. W. K. C. Guthrie (Ithaca: Cornell University Press, 1941).

Plutarch, *The Parallel Lives*, B. Perrin (ed.) (Cambridge, MA: Harvard University Press, 1914).

Price, D. de Solla, 'Automata and the Origins of Mechanism and Mechanistic Philosophy', *Technology and Culture* 5:1 (Winter 1964), pp. 9–23.

Reneman, H., 'Het "Oude Doolhof" te Amsterdam', PhD diss. (Leiden University, 1975).

Roever, N. de, 'Het Nieuwe Doolhof "In de Oranje Pot" te Amsterdam', *Oud-Holland* VI (1888), pp. 103–12.

Schaefers, F. and A. M. Backer, *Doolhoven en Labyrinten in Nederland: Gids* (Rotterdam: De Hef, 2007).

Schenkeveld, M. A., *Dutch Literature in the Age of Rembrandt* (Amsterdam: John Benjamins, 1991).

Seneca, L. A. and F. J. Miller, *Seneca's Tragedies: With an English Translation by Frank Justus Miller: Hercules Furens, Troades, Medea, Hippolytus, Oedipus* (London: William Heinemann, 1917), p. 41.

Sluijter, E. J., 'Rembrandt's Portrayal of the Passions and Vondel's "staetveranderinge"', *Nederlands Kunsthistorisch Jaarboek* 60 (2010), pp. 285–306.

Sluijter-Seijffert, N., J. M. Kilian and K. Kist, *Cornelis Van Poelenburch, 1594: The Paintings* (Amsterdam: John Benjamins Publishing Company, 2016).

Spierenburg, P., *The Prison Experience. Disciplinary Institutions and their Inmates in Early Modern Europe* (London: Rutgers University Press, 1991).

Spies, M., 'Rhetoric and Civic Harmony in the Dutch Republic of the late 16th and early 17th century', in P. L. Oesterreich (ed.), *Rhetorica Movet* (Leiden: Brill, 1999), pp. 57–68.

Spies, M., 'De Amsterdamse Doolhoven: Populair Cultureel Vermaak in de Zeventiende Eeuw', *Literatuur* 18 (2001), pp. 70–8.

Spies, M., 'Kunst en wetenschappen op de Troon. Culturele hoofdstad, 1578–1713', in W. Frijhoff and M. Prak (eds), *Geschiedenis van Amsterdam. 2:1: Centrum van de Wereld 1578–1650* (Amsterdam: Boom, 2004), pp. 299–383.

Summers, D., 'Pandora's Crown. On Mechanism in Western Art', in P. G. Platt (ed.), *Wonders, Marvels and Monsters in Early Modern Culture* (Newark, DE: University of Delaware Press, 1999), pp. 45–75.

Tschumi, B., *Architecture and Disjunction* (Cambridge, MA: MIT Press, 1994).

Voet, L., *The Golden Compasses. The History of the House of Plantin-Moretus*, 2 vols (London: Routledge & Kegan Paul, 1969–72).

Vriese, J., 'Het Oude Doolhof', *Ons Amsterdam* 16:9 (1964): pp. 268–72.

Vriese, J., 'Het Nieuwe Doolhof', *Ons Amsterdam* 16:12 (1964), pp. 354–7.

Vriese, J., 'Nog enkele Amsterdamse Doolhoven', *Ons Amsterdam* 17:3 (1965), pp. 82–6.

Werrett, S., 'Wonders Never Cease: Descartes's *Météores* and the Rainbow Fountain', *British Journal for the History of Science* 34:2 (2001), pp. 129–47.

Weststeijn, T., *The Visible World. Samuel van Hoogstraten's Art Theory and the Legitimation of Painting in the Dutch Golden Age* (Amsterdam: Amsterdam University Press, 2008).

Weststeijn, T., 'Between Mind and Body: Painting the Inner Movements According to Samuel van Hoogstraten and Franciscus Junius', *Nederlands Kunsthistorisch Jaarboek* 60 (2010), pp. 263–84.

Witkamp, P. H., *Amsterdam in Schetsen* (Amsterdam: G. W. Tielkemeijer, 1869).

3

FRANCISCO CERVANTES DE SALAZAR'S MEXICO CITY IN 1554: A DRAMATURGY OF CONVERSION

José-Juan López-Portillo

INTRODUCTION

Scholarship seemed superfluous to Castilian objectives in the 'New World' during the early years of the sixteenth century. A university education could scarcely have helped those ragged crews of adventurers intent on plundering, conquering or settling the territories they were discovering, or the pious missionaries that followed in their wake to evangelise the Indigenous populations they encountered. However, less than thirty years after Hernán Cortés and his followers captured Mexico City in 1521, the Castilian crown's expectations of its American dominions shifted to such an extent that Francisco Cervantes de Salazar was willing to risk his comfortable prospects as professor of rhetoric at the University of Osuna, Seville, for the uncertain, but animating, promise that practicing his *métier* in distant Mexico City appeared to offer. An invitation from Alonso de Villaseca, a wealthy kinsman who lived there, mitigated some risks of emigration, and rumours that the crown was poised to establish a university in Mexico City made the scholar's long-term prospects seem viable. But in his writings, Cervantes preferred to emphasise other, grander motivations for undertaking such a radical new departure: he believed that through his expertise in rhetoric, he too could serve his sovereign's mission – perhaps even more effectively than the *conquistadores* and friars that preceded him.

Conquest changes the victor's perception of the defeated, from reviling them as alien enemies, to regarding them as dependents, or sometimes partners,

with whom they have become inextricably involved.[1] As Charles V designated those regions of Mesoamerica now under his authority as the Kingdom of New Spain and the latest appendage to his 'composite monarchy',[2] so its *Indios* (as the hemisphere's Indigenous populations were called) became his newest subjects. Meanwhile, the companies of Spaniards that had subdued them, who were already his subjects, were expected to become *pobladores* (settlers) and *vecinos* (citizens) of the new polity rather than rootless and untrustworthy adventurers. To this extent, the crown was eager to fulfil, and to be seen to fulfil, its responsibilities towards its new domains: above all, to extend and uphold Christianity, and to institute good government. One way of achieving these aims was to ensure that those individuals to whom the crown granted authority in New Spain should be worthy of their elevated status in the burgeoning polity.

The crown never denied that Spanish *conquistadores* deserved recognition for their participation in the Conquest; however, after a generation of polemics about the legitimacy of their violent expansion through the New World, its advisors doubted whether they deserved the authority they demanded, as well as whether they would exercise it justly if it was granted to them merely because they were Spanish *conquistadores* rather than *Indio* lords. These doubts sprung from the notion that Spaniards, like other Europeans, were themselves subject, in varying degrees, to the spiritual city of God and the legacy of Rome. What we commonly refer to as the Spanish Empire was properly known as the Habsburg or Catholic Monarchy. Its leaders claimed to be guided by the universal ideals found in Catholicism and, for the secular sphere, in the *exempla* of classical culture, rather than the exclusive worldly interests of Spain. Most official efforts at conversion had thus far focused on evangelising the *Indio* population of New Spain. By founding a university in Mexico City, the crown hoped to transform its Spanish population too. As a rhetorician, Cervantes could envision himself as a guide for a hitherto disordered and undeserving population of Spanish settlers towards civility and political virtue. His own education gave Cervantes confidence in its transformative effects. In the long run, however, the confluence of his ideological expectations with his experience of Mexico City would result in something quite different from what he, or the crown, had originally intended.

EDUCATION AND CONVERSION

Uneducated people are beastly: literally so, according to conventional humanist admonitions of the early sixteenth century. 'Right now, what makes you better than that dog?' a 'Father' asked his rather indignant 'Boy' as the latter played with his canine pet, 'Ruscio', in a dialogue from Vives' *Linguae Latinae Exercitatio* (1539). After all, both the Boy and Ruscio behaved in much the same instinctive way. 'But there is this difference,' the father finally conceded:

'Ruscio cannot become a *homo*: you can, if you wish', although to achieve this transformation, the Boy would have to enter 'the place where beasts go to come back as *homines*', that is '*in ludo litterario*': school.[3]

Vives subscribed to a strand in Western culture that has regarded education as an agent of human fulfilment since Socrates attempted to kindle in his followers a 'philosophical life'. Only those individuals that learned to first identify and then love virtue could control (not abolish) the beastly appetites that threatened to enslave them. Liberated by education, individuals could realise the full potential of their nature: exercising their free will judiciously, acting morally, participating in public life constructively and worshipping piously. *Homines*, therefore, were 'not born, but formed', according to Vives' friend Desiderius Erasmus, while Charles de Bovelles concluded that 'the wise man is he who has made himself human' through education.[4]

Such confident assumptions about the transformative effects of education were one manifestation of an increasingly intense interest during the fifteenth and sixteenth centuries in what we can describe as conversional thinking: the belief that individuals and societies can be purposefully induced to transform their habits and mentalities towards certain ideals. Conversional thinking became a defining feature of the early modern period because it produced a wide range of theories and a variety of attempts to effect individual, societal, aesthetic, religious and ideological change. Movements of religious renewal, which consolidated as the Protestant and Catholic Reformations, and sought, each in their way, a more complete Christianisation of the societies they encompassed, are an obvious manifestation of the renewed confidence in this mentality at the time. So too was the ever-broader prestige of classical learning and the impetus to recover its civic virtues and aesthetic expressions through a process analogous with religious conversion.

Rhetoricians became the standard-bearers of conversion through classical learning in their promotion of the *studia humanitatis*, a curriculum that emphasised the study of Classical Latin and its application to speech and written composition, whose expert practitioners were known as 'humanists'. According to Leonardo Bruni, a prestigious humanist scholar of the early fifteenth century, this formation was best suited to 'perfect and adorn a human being',[5] but a familiarity with the humanist curriculum also offered practical benefits to an individual's public life that justified, in part, the humanists' pretensions about education. The ability to speak or write convincingly was a valuable skill. As Erasmus put it, the *studia humanitatis* was 'not only useful to refine the language of schoolboys, but also to prepare them for life'.[6]

Cervantes began his involvement with this intellectual tradition at the locally prestigious school he attended in his native Toledo in the 1520s and early 1530s, where Alejo Venegas, a humanist scholar, provided him with a thorough grounding in Latin, though no Greek. Afterwards he attended the

University of Salamanca, where he read canon law but failed to graduate. Instead Cervantes chose to apply his learning to practical matters: accepting a position as secretary to Pedro Girón de Loaysa, a jurist and member of the Royal Council of Castile. It was on a diplomatic mission with his employer to Flanders in 1539, however, that the twenty-two-year-old secretary had occasion to meet 'many learned men' including, amongst a coterie of 'Erasmians', Juan Luis Vives himself, who had just completed the *Linguae latinae exercitatio*, ostensibly for the education of Prince Philip, the twelve-year-old heir to the Spanish throne.[7]

The famous scholar and his last work (which would run to over 100 editions throughout Europe) left a deep impression on Cervantes – one made all the more poignant, perhaps, by Vives' sudden death on 6 May 1540, while Cervantes was still in Flanders, and the following death of his employer, Girón de Loaysa, shortly after their return to Spain that October. Invigorated by his experiences abroad, Cervantes began to concentrate once again on academic work, despite resuming secretarial work for the next seven years under Cardinal Loaysa, Girón's kinsman. Amongst other academic work, over the next six years he would focus his attention on Vives and his Spanish disciples, translating the late scholar's *Introductio ad sapientiam* into Castilian and beginning work on the commentaries to the *Linguae latinae exercitatio*, which he would eventually publish in Mexico. The collection of books that Cervantes owned at the time of his death in 1575 (about 520 volumes) were varied, but they attest to his continued adherence to this intellectual tradition throughout his life – even after he joined the clergy in the mid-1550s. It included the usual Latin authors and several works on the *progymnasmata* (exercises with performative elements) that one might expect from a rhetorician, patristic texts from a reader in theology, and most of Vives' *oeuvres*. More unexpectedly we find Greek grammar and vocabulary books, along with Classical Greek authors including Plato and Xenophon (but little Aristotle), and most of Erasmus' works, which he must have kept surreptitiously since, by then, they had formed part the Church's index of prohibited works for a decade and a half.[8]

For Vives, whose ideas had the greatest influence on Cervantes, memory and the ability to speak a language eloquently were fundamental attributes of wisdom, and therefore indispensable agents of education's conversional effects. Language distinguished humans from animals, and individuals that cultivated it were therefore more accomplished humans. Rhetoric was not 'empty verbosity'. It aimed to allow its practitioners both to absorb and to transmit the ideas that words contain through the correct use of language. Vives concluded, in his *De ratione discendi* (1532), that an accomplished orator was therefore qualified to help to shape his commonwealth for the better, since speech, even more than justice, bound society together.[9] Classical Latin was particularly useful in

this regard because it was a language imbued with the wisdom of the exalted generations of Romans that had formed it, and because it continued to be used amongst the erudite. As such it was the only language that could become universal, binding humanity in harmony through mutual understanding.[10]

Erasmus was responsible for refining a related notion that Cervantes found relevant to the final stages of his career in Castile, as well as the needs that his own dialogues would address in New Spain. In his *De civilitate morum puerilium* of 1530, Erasmus reinterpreted the concept of *civilitas*, or civility. His discussion focused on the word's derivation from *civis*, or citizen, and highlighted the incumbent rights and responsibilities towards the rest of society that this exalted status implied.[11] A moral education would curb people's excesses and prompt them, instead, to act 'with civility' for the common good. If more people could attain civility then society would flourish, particularly if this social transformation fostered the creation of a political conversion where a 'true nobility' of virtue, rather than blood, would rise to guide their fellow man.

Erasmian ideas about civility became directly relevant for Cervantes once he took up the position of Professor of Rhetoric at the newly founded University of Osuna. The appointment to this newly established university was not particularly appealing to a man who had served a cardinal and dared to hope thereafter for patronage from the royal family and magnates like Hernán Cortés. Nevertheless, the hitherto secretarial scholar gained some experience in the practice of teaching, and the university's ethos would resonate with his later projects in New Spain. The ideas of the university's founder, Juan Tellez de Girón, fourth Count of Ureña, were clearly influenced by Erasmian notions of civility.[12] The pious Count hoped that his university would edify the many poor students his bursaries supported with a moral education, and inculcate in all students an understanding of the 'rules and regulations governing a Christian Republic', so that they might become its responsible 'citizens'. Ureña's stipulations for achieving this goal included an emphasis on modern scholarship, including, notably, Vives' *Introductio ad sapientie*: the 'catechism of moral education'.[13]

Rhetoric was meant to confer on its best practitioners the capacity to persuade others through eloquence. This ability could be tested in discourses, proclamations, predications and learned disquisitions, and displayed in missives or polemical tracts. It required the deployment of elegant metaphors as well as an arsenal of quotations drawn from those prestigious classical works that composed the common stock of references and allusions shared by cultured society throughout Europe, and through which its members knew one another.[14] The practical importance of demonstrating eloquence before a public induced humanist teachers to develop a variety of techniques that would help to foster the memory of their charges and refine their ability to perform in public.[15] Performance was an obvious means to achieve these ends.

Medieval traditions of didactic performance abounded in Europe. In Spain the *teatro de colegio* was well established in universities such as Salamanca.[16] Humanist circles, however, adapted this tradition towards the performance of dialogues based on classical models. Their use paid homage to the *au fait* Platonic tradition from which they originated, a tradition which from its origins was implicitly dramatic and so chimed with the period's nascent interest in new theatrical expressions. Despite his well-known animadversion towards Athenian drama, Plato evolved his dialectic style of exposition not only from his teacher's 'gadfly-like' interrogation of his fellow citizens in the agora, but also from spoken theatrical 'mimes' originating in Syracuse, which in Plato's native Athens were adapted to become refined spectacles in the intimate setting of the Athenian symposium. The most famous example of this association comes from Xenophon's *Symposium* – a dialogue itself – which portrayed male and female slaves making music, dancing, reciting dialogues and embracing erotically before a leisured group of spectators (including Socrates) who were thereby incited into convivial musings about love and virtue.[17] It was well known that Plato had considered becoming a tragedian in his youth, and according to ancient sources such as Aristotle (who attended his classes) or Diogenes Laertius, Plato's dialogues were normally read aloud by his disciples – despite, they noted, being written in prose rather than poetry.

Marsilio Ficino revived the form in Latin at symposia-like gatherings that he orchestrated at the villas of his Medici patrons.[18] By the later fifteenth century, humanists began to innovate their own type of didactic dialogues, which Alberti believed were 'like a mosaic, bringing together ancient and contemporary wisdom',[19] rather than relying exclusively on ancient texts. This fashion spread and adapted to local circumstances. In England, for example, Sir Thomas More reinvigorated the dramaturgy of the dialogue by adapting its content to the expectations of an early sixteenth-century English audience, while retaining its moral and didactic intention.[20] Rhetoricians favoured the use of performative dialogues and other classroom 'games' – developed from the *progymnasmata* of the ancients – because it forced their students to practice speaking Latin (sometimes referred to as the 'deductive method'). According to Montaigne, for example, 'a child should not so much repeat as act his lesson'.[21] Vives also stressed that listening thoughtfully was an important part of training one's memory. Teachers should therefore conduct their lessons 'with witty and pleasant stories, lively historical narratives ... proverbs, parables, apothegms, astute short precepts, sometimes lively, sometimes grave', so that students would 'drink in willingly, not only the language, but also the wisdom and experience of life as well'.[22] For self-conscious humanists, this emphasis created yet another distinction between themselves and what they regarded as the unenlightened 'inductive didactic' techniques of their old-fashioned 'scholastic' contemporaries, who focused on memorising grammatical rules

and reading texts to themselves.[23] By the first half of the sixteenth century, performance was a common didactic technique, and dialogues were performed routinely throughout European schools and other centres of learning.[24] In Spain, the colloquies of Erasmus were staged publicly in Valencia in 1537, and it became routine to perform Vives' *Linguae latinae exercitatio* at various universities in the same period.[25]

As Cervantes would discover, mendicant communities in New Spain also found performance to be a particularly valuable tool for educating their flock in both Latin and in the tenets of Christianity, for similar reasons as those discussed by the humanists. The friars found it relatively easy to adapt late medieval Spanish traditions of religious and school theatre to suit existing *Indio* performative practices and expectations. Indigenous cultures of New Spain had a long tradition of ritual performances and even analogous forms of edifying dialogues known as the *Huehuetlatolli*, or 'words of the old', that young noblemen memorised and performed as part of their education.[26] In the Amerindian tradition, performers took on the role of 'sacred beings', capable of bringing the world of theatrical fiction into communication with the world of everyday reality:

> The pretend world of the characters and script, which in religious theatre mirrors a world of gods and saints, who to the believers are very real, and the everyday world beyond the stage, from which actors and audience are partially and fleetingly removed. Juxtaposed in this way, these two realities cannot help but enter into dialectical relationship: the world within the theatrical frame is seen in terms of the world outside, and vice versa.[27]

Performing conversion, for the Spanish, was a way of overcoming the apparent 'cultural incommensurability' that separated *Indio* from European culture. So too was learning Latin through performance. The standardised fixedness of Latin, whose terminology referred to a society that no longer existed, made it a viable common point of reference between the living (and therefore varied and fluid) Nahuatl and Castilian languages. *Indio* Latinists like Antonio Valeriano, whom Cervantes would judge as 'in nothing inferior to our own Latinists, highly instructed in the Christian faith and devoted to eloquence',[28] were soon able to translate the vulgate version of the gospels, epistles and sundry other classical texts they found in monastic libraries into their native Nahuatl. The unexpected outcome of the dissemination of Latin amongst the Nahua was not the production of a colonial Latin literature, though its few works are distinguished, but of a Nahuatl literature that was focused on themes of conversion.[29] Such was the initial success of this educational project that some Spanish settlers, few of whom could understand Latin, complained that educated natives were liable to displace them in the crown's preference, particularly with regards to ordination.[30]

NEW SPAIN'S ORIGINAL SIN

Cervantes found the association that humanist scholars made between the transformative potential of education and human fulfilment urgently relevant to the concerns of his new neighbours in Mexico City. Shortly before Cervantes departed for New Spain, the crown felt impelled to convene the so-called Valladolid debates (1550–1) between Fr Bartolomé de Las Casas and the humanist scholar Fr Juan Ginés de Sepulveda, which centred on polemics about the degree of humanity that the New World's Indigenous population possessed.[31] In their present state, the *Indios* seemed ignorant of European standards of civilisation and Christianity. But should the crown regard them like the Boy in Vives' dialogue, capable of learning to become fully civilised and fulfilling their human nature? Or were they more like Ruscio, unable to ever fully liberate themselves entirely from their passions? Unlike Europe, where Vives' blithely humorous dialogue was designed to titillate his readers into taking school seriously, in the New World such questions mattered to the lives of millions as the crown sought to determine the scope of its rights, duties, and the relative status that it should accord to its Spanish and Amerindian subjects there.

The Valladolid debates formed part of broader polemics about Castile's imperial venture in the New World. Notably, Cervantes became acquainted with many of their arguments, and with some of their participants, during his time as secretary to Cardinal García de Loaysa (from 1540 to 1547). De Loaysa was archbishop of Seville and an active member, often president, of the Council of the Indies which sat in that city's *alcázar* (royal palace). Cortés left the greatest impression on the secretarial scholar ever since their first encounter in 1545, during pleasant *soirées* in Valladolid that the old *conquistador* liked to host for noblemen and sages while he waited for the royal court nearby to acknowledge his petitions for redress to the many grievances he felt he had suffered. They would meet again in Seville or at nearby Castilleja de la Cuesta shortly before Cortés died there, isolated, infirm and frustrated, in 1547 – only a few months after Cervantes dedicated the 'completed' *Diálogo de la dignidad del hombre* to him. In doing so, Cervantes may have been after a new patron, but, like other humanist scholars, he also sympathised with Cortés, and would render the *conquistador* as an archetypal 'man of destiny' in his main works. In one dialogue, he called him 'Oh ingenious hero, of a spirit superior to all others, and born only for great enterprises' – against the official line at the time that sought to downplay his merit in the Conquest.[32]

Contact with Cortés reinforced Cervantes' familial and homophilic affinities with the cause of the *criollos* – to use a convenient, if anachronistic, shorthand for Spanish settlers and their offspring, who had been '*acriollados*' (recreated) in their new home, or had actually been born there, becoming, in both

cases, *naturales* (inhabitants) of the land. Despite these affinities, Cervantes was aware of their poor reputation in Castile and, at least in public, shared it. *Criollos* claimed their privileges and status from their own or their ancestors' participation in the Conquest of New Spain (1519–21), but this legacy was tainted. The Castilian crown could not deny that the *conquistadores* had won for it a vast new domain, rich in silver, or that the continued presence of *criollos* in the land sustained royal authority. Nevertheless, many in Castile considered the *conquistadores* to be little better than avaricious renegades who were trying to mask their illegitimate acts of violence on blameless Indigenous populations behind claims of royal service. Consequently, royal authorities prevaricated, for example, as to whether it was just, or even politically expedient, to grant such objectionable *criollos* the sort of lordly autonomy or access to the priesthood they demanded; or whether it would be better to use instead more reliable agents, vetted in Castile – such as university-trained lawyers (*letrados*), noble courtiers, mendicant friars and secular clergy – to conduct the royal administration and religious worship of New Spain even though these latter had not shared the risks and hardships of exploration and conquest. For the *criollos*, the most worrying indication of the crown's disdain for their services in Mesoamerica came in 1542, when the crown promulgated the 'New Laws', which found against the lordly pretensions of the *criollos* in the name of protecting the rights of its *Indio* subjects and exalting the supremacy of the crown over both. In Peru, the *encomenderos* (holders of tributary and proto-lordly rights over portions of the *Indio* population) rose in arms against the legislation, while in New Spain the viceroy suspended its most offensive clauses to avoid similar trouble. The crown agreed to negotiate, and when Cervantes arrived in Mexico during the early 1550s, these disputes were at their most vigorous, both in Castile and the Americas. So polemical was the legacy of the Conquest that by then it had become New Spain's origin myth as a polity, but also its original sin.[33]

Cervantes understood the crown's concern. If Europeans generally judged their own societies to be imperfectly Christian and lacking in virtue and civility, how much greater was the need to convert the burgeoning, varied societies of Castile's American domains, and how enticing the opportunity to get things right, this time, from the start. Cervantes delivered his first public address (now lost) in New Spain to inaugurate the Royal and Pontifical University of Mexico City in 1553, and its theme, so far as we can deduce, was on the need and the possibility of redeeming the *criollos* from 'avarice' to civility.[34] He developed this theme more fully the following year in three didactic dialogues, written in Latin and set in Mexico City. The first, *Academia mexicana*, was set at his new university; then, *Mexicus interior* followed three friends, two locals and a Castilian newcomer, as they explored the centre of the City; finally, *Mexicus exterior* took the same three interlocutors to a vantage point on the summit

of Chapultepec Hill on the outskirts of the City. Cervantes added these dialogues to four others he had written previously in Spain about the games that students played and entitled the seven together as *Ad ludovici vivis, valentini, exercitationem, aliquot dialogi*. In 1554, he attached these *dialogi* to his commentaries on the *Linguae latinae exercitatio* of Vives, to whom he referred in the title of his seven dialogues. The complete volume was printed by Juan Pablos of Mexico City in 1554, and Cervantes dedicated the work to Alonso de Montúfar, who was installed that same year as the city's archbishop.[35]

In the dedication to the *dialogi*, Cervantes expressed the hope that his volume would help his *criollo* students to learn Latin and that, as education spread, 'this New World, previously a seat of the devil and idolatry, now clean of all those stains, will end up converted into the dwelling place of the one and true God'. Since the archdiocese of Mexico City had lain vacant for seven years, Cervantes made play of the opportunity to participate in a grand renewal under the recently arrived archbishop and that he was enthused with 'no less spirit than a soldier when he fights under the command of a valorous and fortunate captain'.[36] One of the characters in *Mexicus exterior* adduces a further intention when he describes Cervantes as

> one of our professors who, in so far as he is able, tries to make sure that our Mexican youth becomes erudite and eloquent so that our illustrious land is not left in darkness, through a lack of writers, which so far have been lacking.[37]

A decade after their publication, in an aside to the unfinished version of a later work known today as the *Crónica de la Nueva España*, Cervantes elaborated on this second intention, claiming that his dialogues intended to extol Mexico City: 'taking advantage of the fact that Latin is so common to all nations, I wanted them to know from me, before anyone else, the city's greatness and majesty'. This earned it the right to remain, as it had been in its gentility, 'the head of this New World . . . after the holy gospel had been promulgated here'.[38]

As Cervantes' makes clear, the *dialogi* were addressing both local and European publics: his students and the broader literate society and administration of New Spain, but also the Castilian crown and the international community of European scholars, whose approval he sought, and whose opinions were influential in determining how the Old World perceived the New. The dialogues would combine the intentions of an educational tract and the rhetorical tradition of the *laus urbis*.[39] The rhetorician's pretentions corresponded to his preconceptions about the effects that the right kind of education could have in transforming individuals and society for the better, as well as to his awareness that conversion lay at the root of polemics about humanity and the legitimacy of the Habsburg Monarchy's authority in the New World. For

Cervantes, education was the best instrument for converting the offspring of once-unrighteous *conquistadores*, the group that he was most interested in redeeming – not only for their own sake, but also to induce them to take up the burden that came with their powerful status: that of converting the rest of the world from Mexico City. Implicitly, the merit that made them worthy of such a responsibility should bestow on these *criollos* greater privileges from the crown than they currently enjoyed. So too their teachers, like Cervantes himself, ought to be considered the champions of New Spain's conversion, for surely, he avers, 'the formation of a soul does not deserve the name of father less than he who has brought them into existence'.[40] The question that remained was how best to impart an education to effect these conversions.

MEXICO CITY DIALOGUES

Cervantes elaborated his dialogues on Mexico City with the understanding that his students would perform them. Such was the pedagogical technique favoured, notably in Salamanca, which served as a model for the University of Mexico, and was used in New Spain both in the *Indio* colleges and as public ceremonial. But Cervantes added to this tradition innovations that his admired Vives propounded. Vives discussed at length the importance of crafting an effective dramaturgy around a didactic dialogue. Performing lessons gave students a memorable dramaturgical context in which to learn their lines and allowed them to embody the didactically crafted characters whose words they were made to recite. Simultaneously, their audiences – normally composed of the performers' classmates and tutors – or the readers of these dialogues, would be exposed to the (hopefully) convincing lessons that the authors of the dialogues had put into the mouths of their characters. Vives intended for student performers to embody characters (roles imposed on the Nahua students we discussed above) and imagine the places where the dialogues were set so that they could appropriate and internalise the dialogue's moral lessons.

In accordance with his own theories, Vives sought to develop his dialogues around a setting that was familiar to his audience, with relatable characters engaged in a dramatic or comic narrative with a memorable moral lesson.[41] The Father's playful repartee with his astonished Boy regarding the distinction between animals and men, set in the familiar context of a family home one leisurely morning, is a good example of what he meant. Another example, which Cervantes obviously had in mind when he composed his Mexico City dialogues, was a colloquy set in Vives' native city of Valencia, whose landscape and Mediterranean warmth Vives so obviously longed for in the chill northern cloisters where he had chosen to unfold his career.[42] The theme of this dialogue was different rules of ball games in various countries, though its best reflections were spurred by particular features of the city of Valencia that the interlocutors encountered on their walk. One of them worked in Paris, for instance,

and had been unable to return to his native city for many years. His memory was revived as he revisited sites that were familiar from his childhood, though he now saw them in the new light shed by his cosmopolitan experience. In his Valencian dialogue, Vives was articulating, dramaturgically – that is, in the imagination rather than experimentally – some advice from Quintilian, who observed that physical locations evoked the memory of events that occurred within them:

> For when we return to a place after considerable absence, we do not merely recognize the place itself, but remember things that we did there, and recall the persons whom we met and even the unuttered thoughts which passed through our minds when we were there before.[43]

Scholars today might describe the effect that Quintilian hoped to create as a 'cognitive ecology', albeit one derived from memory, imagination and performance. Once enacted, the familiarity of the remembered or imagined dramaturgical setting provided an 'ecology' of prompts to the cognition of performer and audience that served as a framework onto which novel ideas could be added and made comprehensible.[44]

Cervantes drew inspiration from Vives and Quintilian when he chose to evoke a mixture of urban space, memory, experience and imagination in his own dialogues. But this strategy, on its own, was impractical in the novel conditions of New Spain. Mexico City tended to astonish European newcomers, but it stirred no memories or associations. After the Conquest that destroyed the city, its ceremonial centre was rebuilt. By the time Cervantes arrived, it was, to use the words of a modern scholar, 'the most perfect city of its day, according to the prevailing [Renaissance] aesthetic'.[45] Its paved, straight, wide avenues, orientated according to specifications of cosmographers like Alonso de Santacruz and flanked by imposing stone buildings of uniform height, corresponded to the advice of Alberti and Vitruvius. We can ascertain that New Spain's first viceroy, Antonio de Mendoza, had these authors in mind as he restructured the cruder urban layout approved by Cortés soon after the Conquest, from his correspondence and a surviving volume of a 1512 edition of Alberti's *de re aedificatoria* that contains his autograph and other annotations, dated 1539.[46] However, few of those who lived in the city were *au fait* with this classical aesthetic, while those in Europe who were might not know that the city embodied it with some success.

Then again, the city was unlike anything Alberti imagined. Its setting on the lake of a highland basin, criss-crossed by canals and 'mountain crowned' – most spectacularly by the snow-capped volcanoes to its south-east – added to its majesty. So too did the fact that it occupied the same spaces as the ceremonial precinct of Tenochtitlan, the imperial *altepetl* (polity) of the Mexica, retaining for it a preponderant place in the imagination of native

Mesoamericans as the *tlalxico* (analogous to the Greek *omphalos*). Until the later 1530s when Mendoza's idealistic urban plans demanded its dismemberment, the Great Pyramid of Tenochtitlan survived, desecrated but structurally intact, 'for memory', as Cortés put it – possibly to be adapted as the bell tower to the nearby cathedral, much like the *giralda* of Seville had once been a minaret. The palatial house of Cortés and the royal palace, where the viceregal administration resided, incorporated the same physical spaces as the palatial complexes of Motecuhzoma II and his father, Axayacatl, respectively. The great square that separated them remained the epicentre of imperial power in Mesoamerica, though now it formed a composite part of the Habsburg monarchy – where its ceremonial was displayed, and its tribute collected and sold at market. Around the Renaissance *trace*, which was inhabited by no more than 10,000 Spaniards and Africans, there lived an estimated 50,000 Mexica in two autonomous districts: San Juan Tenochtitlan and Santiago Tlatelolco. They did not delay long in adapting their own civic centres to the viceregal aesthetic, and all three segments together accounted for the second most populous city in the Castilian Monarchy.[47]

In the grace of its setting, the merit of its history, in its very name, Mexico was unlike any European city that Vives or Quintilian could have had in mind as models. Unable to imitate his teachers in the face of the unprecedented character of the city, Cervantes would have to innovate.[48] Such was the curiosity that Mexico elicited that it would be not merely the setting of the *dialogi* but also their subject matter. In doing so, Cervantes subverted – rather than merely transposing to another city – the example of Vives' Valencian dialogue and its Quintilianist intention: he would have to invent a new cognitive ecology through analogy and description. Conspicuously, he did not choose an archetypal town from the imperial 'homeland', such as Salamanca, Seville or his native Toledo (though he mentions all three as counterpoints), to instil a nostalgic loyalty in his *criollo* audience for Castile, or for some ideal for which those cities stood. Nor did he seek to conjure an image of Rome, Athens or Jerusalem as a sort of 'spiritual landscape rustling with invisible presences' to unite *criollos* and Europeans in reverence for a common 'cultural memory' in opposition to their Mesoamerican environment.[49] His representation of Mexico City was intended neither to conjure past experiences of the city for the imagined characters that populated his dialogues, nor for his audiences. Instead, the author aimed to reveal and simultaneously imbue a new (or previously unacknowledged) ethical meaning to the spaces of the converted capital of New Spain. His primary aim was to teach his students Latin in the classroom, but he also had in mind other audiences: the wider population of the city, the viceregal and ecclesiastical hierarchy in New Spain, the sceptical crown of Castile and the critical intellectuals of Europe (such, after all, was the purpose of writing in Latin). As such, although the dialogues were intended to

be performed in the classroom, they could also guide someone who walked the city in person, or those not present who could explore it through the mind's eye.

In New Spain it was already common for local authors to hail Mexico City's greatness on the basis of its religious (and architectural) conversion: one Franciscan friar called it 'another Jerusalem, mother of provinces and kingdoms', where before the Conquest it had been a wilful 'Babylon full of confusions and evil . . . more does your subjection to the invincible Caesar Charles ennoble and aggrandise you than the tyrannous lordship with which, in the past, you wished to subject everyone else'.[50] Lists of Indigenous governors routinely spanned the period before and after the Conquest without any seeming rupture, and certain wise 'grandfathers and grandmothers' of the pagan Mexica were rendered, in another echo of Jerusalem, as 'prophets' of the land's eventual conversion.[51] Meanwhile, the Mexica cooperated with (and were coerced by) friars and civic authorities to add Christian meaning to their ancestral iconography: the glyph for Tenochtitlan, with its imperial eagle on a fruitful cactus, remained the emblem of Mexico-Tenochtitlan, but if it retained its meanings of aquiline power and rapaciousness of the polity, it also acquired an association with Christian resurrection. This analogy assured the survival and propagation of the symbol in civic ceremonial, architecture and public sculpture. Perhaps the most revealing example is the monolith of an eagle perched over a globe in the city's Franciscan monastery, which symbolised Mexico's rebirth as the capital of a crusading kingdom, with cosmic aspirations.[52] The converted natives also presented themselves as crusading agents of the New Jerusalem: Don Jerónimo del Aguila, Lord of Tacuba, claimed in 1564 to have spent forty years destroying idolatry wherever he found it, often endangering his life, particularly when he served with viceroy Mendoza in suppressing the Mixtón rebellion.[53] Simultaneously, Spanish settlers promoted the legitimising myth that Motecuhzoma II had submitted voluntarily both to the authority of Charles V and to Christian conversion in 1519, only for his wicked kinsmen to 'rise up with the land' and kill him for their own tyrannical motives. The Conquest became a 'pacification of the land'; the *conquistadores* were upholders of Motecuhzoma's legitimate authority against the pretentions of violent rebels, and Cortés was the 'Moses of the New World'.[54]

Cervantes' *dialogi* built on this local tradition in an intellectually sophisticated way that might resonate more readily with European humanists. He began with the newly founded University of Mexico City, which had reconfigured the city's urban landscape and its ends. Early in his first dialogue, *Academia mexicana*, set in the nascent university, Cervantes expressed one of the prejudices that *criollos* feared Castilians held about them through a character named Gutiérrez, who had just arrived from Castile. Upon entering the university and hearing from his local interlocutor, Mesa, that the 'students

are lovers of Minerva and the Muses', he asked pointedly whether 'in a land where greed reigns, can there, by chance, be any place left over for wisdom?'[55] As they peer together into lively classes conducted by able masters of different disciplines (including Cervantes), and pass through corridors bustling with enthusiastic students, it becomes evident that wisdom has indeed overcome greed altogether and turned that discreditable original impulse into virtue and erudition. Convinced, the newcomer avers:

> [T]his Academy of yours, though founded in a region that was previously uncultivated and barbarous, has just been born and yet it already has such beginnings that it won't be long before, in my opinion, New Spain, which used to be renowned until now amongst the other nations for the abundance of its silver, will hence forth be known for the multiplicity of its wise men.[56]

Cervantes' concern for appealing to his various publics is evident. To his *criollo* students and their families in New Spain he emphasised the need to redeem their original sin through education, which offered a path to the sort of moral conversion they needed. He also supplied them with useful quotations from a classical authority to support his claims: 'nothing is so natural to man, as Aristotle points out, than to feel an innate and irresistible inclination to acquire knowledge'.[57] On the other hand, the dialogue seeks to dispel anachronistic Castilian prejudices and to encourage the crown to support the university, which was to be the standard-bearer for New Spain's moral transformation. Indeed, 'many more privileges were due for those that teach so far from their fatherland, and for those that seek to learn amongst the opulence of their families'.[58] Mesa agreed, because

> they will be the first who, with the light of wisdom will chase away the shadow of ignorance that darkened this New World, and in so doing will confirm the *indios* in their faith and worship of God, so that it may be transmitted ever more purely in posterity.[59]

In *Mexicus exterior* and *Mexicus interior*, the character of Alfarus represented the archetypal outsider who served as a proxy for the author's own students, audience or readership, while the knowledgeable locals, Zamora and Zuasus, served as proxies for Cervantes and educated him, and them, about Mexico City. In a refinement of the stock character of the *ingénue*, however, Alfarus made incisive comparisons between Castile and what he experienced, which balanced the degree of authority granted to each interlocutor. Based on alliterative allusions favoured at the time, we can simultaneously identify Alfarus with the new archbishop, Alonso de Montúfar, to whom the dialogues were dedicated. Likewise, Zamora corresponded with Zúmarraga, his deceased predecessor, and Zuazus corresponded with Alonso de Zuazo, a judge and

close friend of Cortés, who held a famous debate with Indigenous noblemen in defence of Christianity in the early 1520s.[60] On this reading, the *dialogi* served to initiate Montúfar in New Spain's virtuous legacy of conversion in order to prepare him for the responsibility of acting as its steward. This format underscored the value of conversation and friendship amongst equals, but added the important reminder that for all the exaltation of Mexico City, the European perspective should not be ignored or undervalued in the American domains of the Habsburg monarchy. According to Zuazo, 'in this way, while we teach [Alfarus] the most notable things [about the city] he will tell us something we might not know, or confirm that which we do', and Zamora replied, with the truism known to all teachers, that 'we never absorb so much as when, teaching someone else, we learn something ourselves'.[61]

With these characters, Cervantes created an urban dramaturgy that rendered the city as a spectacle for those who walked it or read about it. Like all spectacle, it depended on the author's choices about what aesthetic features and routines he chose to present to his audience, and his views on how those features should be interpreted. The dialogues thus sought to repurpose the meaning of space in Mexico City. Thus the viceregal palace, with its elegantly Vitruvian columns and its bustling court, appeared rationally ordered to fulfil their teleological aim of imparting justice and fostering civility; ceremonial processions around the city revealed and encouraged its citizens' piety; the plethora of charitable and religious institutions helped to care for and educate the unfortunate; and the greatness of its square 'which I don't think in either world one could see anything to equal it', surrounded by magnificent buildings and a market the size of all the forums of ancient Rome combined, of which it 'is possible to affirm that they contain everything notable in the world', demonstrated the majesty of the city.[62]

Alfarus was instinctively drawn by the beauty of a particular building, or by the splendour of an avenue that his hosts were intending to show him all along. This natural attraction confirmed both the dictum that the virtuous were drawn to the good and the beautiful and that Mexico City was truly good and beautiful. The city's features were ideal, not only, as Alberti put it in his *de re aedificatoria*, because they 'derived from the first principles of the philosophers',[63] but also because they seemed ideally suited to the city's peculiar needs: the uniform height of its buildings allowed sunshine and ventilation to banish the 'miasma' produced by the lake; their structure reduced the damage that the region's recurrent earthquakes could inflict; the atrium of the convent of San Francisco, with its enormous cross made from the trunk of a once-holy Ahuehuete tree, and its remarkable outdoor chapels, allowed the *Indios* to worship their new Christian God in preferred ancestral ways that served to facilitate their conversion.[64]

An unavoidably embarrassing feature of the city was the relatively humble

scale of its Cathedral compared to its grandiose private and public secular buildings or its splendid monastic institutions. But even this shortcoming served to highlight the sense of a conscious 'before', of which the convert repents, in order to achieve an 'after' that is essential to any narrative of conversion. The interlocutors blamed the former greed of the *conquistadores* for this oversight, and focused on the promise of its correction now that virtue reigned in the city. The question of the Cathedral also reflected Montúfar's stated concern to implement Tridentine mandates for the secular ecclesiastical hierarchy to wrest authority from the (allegedly) overmighty mendicants who, in some cases, were deemed as *alumbrados* for their excessive involvement with Indigenous communities and their disrespect for established imperial hierarchies.[65] Like the Cathedral, there were other features that marked the city's ongoing process of conversion: the rough defensive features of many Spanish houses meant that, according to Alfarus, 'anyone might mistake [these houses] for fortresses', to which Zuazo replied that 'it was convenient to build them thus at first, when there used to be many enemies all around' – implying that they, the once resentful *Indios*, were now converted into friends.

With few exceptions, Cervantes' characters glanced at the *Indio* parts of the city from a distance, in accordance with the author's interest in converting the *criollos* and thus securing their privileges. The exceptions, however, were notable, and they distinguish the *dialogi* from the standard *laus urbis* in that they allowed Cervantes to boast of qualities that were unknown in Europe – that is, the newness of his subject – and to explain why such novelty was good. The seasons had a limited effect on the spring-like balminess of Mexico City and, standing at over 2,000 metres above sea level, its air was famously clear. The highland lake that encompassed it allowed goods to be transported through canals in canoes, so that 'there would be no reason to miss those of Venice'. More importantly, Mexico was the hub of a range of exotic and highly beneficial products: 'Medicines unknown to Hippocrates, Avicenna, Dioscorides and Galen', exclaims Alfaro, who is surprised by their 'strange names'; to which Zuazo replies, 'as ours are to the *Indios*', evincing a protective familiarity, or at least identification, with those acceptable benefits of New Spain's Indigenous cultures that characterised the self-conception of the *criollo*.[66] The proudest boast was the achievement of converting an Indigenous population from alien incivility and paganism to Christian civilisation. Although the process was incomplete, its course so far was a signal of triumph. Even *mestizo* (mixed Indigenous and Spanish, who were often bastards) boys and girls that, as Alfarus' surprise makes clear, were supposed to be an unfamiliar feature of society in Castile, could be redeemed for the commonweal in schools like San Juan: 'nothing is so favourable to a republic as educating its children in this way, so that they may never deviate from the path of virtue'.[67]

Mexicus exterior ends with a Platonic analogy as the three friends ride out of the city, after a 'Lucullan lunch', to climb the spring-bearing hill of Chapultepec on the mainland, where they gain a panoramic view of the city they had just visited piecemeal.[68] The shift in perspective prompts Alfarus' final realisation of the nature and true meaning of Mexico City: 'Oh what great fortune the Spanish arrival has afforded the *Indios*, for they have passed from [pagan] misfortune to their present happiness, and from former servitude to true liberty!' And a little later:

> My God! What a spectacle do I discover from up here; so welcome to the eyes and the soul that with all reason can I declare that both worlds find themselves reduced here and included, so that it is possible to say of Mexico what the Greeks said of man, calling it a *Microcosmos*, or small world.[69]

The conversion of the imperial city of Tenochtitlan combined the virtues of the Old World and the New in Mexico City. It was made new, Cervantes contended, through the combination of the best aspects of the old components. Its novelty was 'an education' for the whole world. As such, and imbued with the zeal of the new convert, Mexico would take its place as the righteous capital of an empire of conversion, extending Christendom to the rest of the hemisphere. The provinces of New Spain were already subjected, and there was hope that the viceroy's planned expedition to Florida would add unprecedentedly bountiful lands to the crown's domains. Zamora pointed out the white shrines and churches on the hills surrounding the lake, including 'Tepeaquilla' or Tepeyac. This was where Zumárraga (represented by Zamora) accepted, before the *Indio* Juan Diego, the Marian apparition under the avocation of Guadalupe, leaving her holy image on the cloak he was using to collect roses and confirming that divine grace animated the earthly city. Significantly, from our perspective, Montúfar would take up and foster Our Lady of Guadalupe's cult as archbishop.

As befits those who have emerged from the Platonic cave to find enlightenment, the *dialogi* end with the interlocutors' reluctance to forgo the panorama in order to return to their obligations in the city, equipped, in the case of Alfarus, with a newfound wisdom. Just as we might imagine, Cervantes' students could find that having finished translating the *dialogi*, they would return home through their city with a better grasp of Latin and a new appreciation for the spaces they were viewing as they walked its streets. They would arrive home converted into fuller *homines* with an understanding of their civic duties and the tools to carry them out, not least in their obligation of furthering the conversion of the New World. If any *criollo* had to act as a guide to newly arrived relatives, friends or dependants from Castile, some of whom could be quite snobby at first, the *dialogi* portrayed this familiar scenario and offered

a useful scheme, complete with erudite quotations, to carry out this task with pride. For Europeans like Alfarus, the progress of the dialogues would reveal the merit and grace of New Spain and induce them to appreciate the glorious mission that was entrusted to its inhabitants.

Cervantes adapted his European, intellectual world in original ways that responded to the polemical context in which he wrote and, in doing so, linked the essentially performative nature of didactic dialogues at the time with a dramaturgy that made Mexico City itself into an engaging *mise en scène*. We still find his intentions particularly accessible precisely because he intended to convey his ideas to different publics by using common points of reference to describe novel things. The dialogues reveal how a rhetorician connected notions of urbanism and education to address the *sui generis* problem of conversion in the context of mid-sixteenth-century New Spain. There is a sense in which the innovations that Cervantes wrought upon the dialogue form create a new cognitive ecology, a set of embodied connections and an ethical microcosm created out of a converted city; writing was akin to a work of art, to making Vives' dialogues modern.

CONCLUSION

It is hard to gauge how successful the *dialogi* were in achieving Cervantes' stated aims during the viceregal period. Only one extant copy of their original print run survives, and its discoverer Joaquín Icazbalceta's doubt over whether this was evidence of its unpopularity or the destructive hands of generations of enthusiastic students remains unanswered. Few authors made reference to his texts in the seventeenth and eighteenth centuries, and those that did focused on his unfinished *Crónica*.[70] We may suppose that as the prestigious founder of the school of rhetoric, his techniques and texts would have set the pattern of a humanist curriculum for years to come, at least until the Jesuits introduced the *modus parisiensis* to the university at the end of the century.[71] Yet Cervantes himself did not teach rhetoric for much longer: within three years of the publication of the *dialogi*, he was ordained, and abandoned rhetoric as a profession in order to graduate in canon law (though he kept Erasmus in his library). He nevertheless remained interested in uncovering the meaning behind public performances and the importance of explaining these to a wider public that had not witnessed them, as evinced in his description of the ceremonies enacted in Mexico City to commemorate Charles V's death: the *Tumulo Imperial de la gran Ciudad de México*, published in 1560. Thereafter, he struggled, with limited success, to ascend the ecclesiastical hierarchy in Mexico City, and never finished writing his Crónica. In that work he would write, when describing his *dialogi*, that the glories of New Spain 'would have gone on increasing greatly, as in other things too, if the viceroy had shown more support'.[72] It was not clear if he meant support for his educational project, or for New Spain more

broadly, or both. But from that doubt, we can surmise another unintended consequence of his efforts: Cervantes had become *acriollado* himself, a *vecino* of Mexico City who combined his own fortunes with those of his adopted land until his death. As he lost interest in converting New Spain through rhetoric, so he sought to establish himself ever more comfortably in the *microcosmos* of Mexico City.

A year after the publication of the *dialogi*, relentless summer rains caused the lake on which Mexico City was built to swell and flood the city disastrously. Such was the destruction, and the imminent threat of its recurrence, that some officials advocated for the relocation of the capital of New Spain to a more practical location on the mainland. Their suggestions were rejected. Instead, the population of the city began to restore it, planning engineering works, based on Indigenous precedents, to try to mitigate the danger of future flooding. Works like the *dialogi* helped to promote and in turn to explain the pride and solidarity Mexico City's inhabitants felt towards their home – ancestral or adopted.

We should categorise the *dialogi* as one manifestation of the *sui generis* culture that developed in New Spain and which sought to make sacred the converted spaces of Mexico City. These efforts succeeded in creating new affective links to the novel polity of its Spanish settlers and to alleviate the alienation that the *Indio* elite at least had felt towards their conquered homeland. Later, the costly conversion of Mexico City's physical appearance and the re-sacralisation of its converted spaces would serve as a template for *Indio* and Spanish elites in other parts of New Spain. As a result, during the sixteenth century, a recognisably Renaissance urban aesthetic spread more assiduously in Mesoamerica than in other parts of the Castilian Monarchy as these elites sought to demonstrate their conformity with the ideals espoused in Mexico City by adapting their own provincial urban centres to reflect them. Since ideals purport to be universal, they are not the exclusive domain of the conquerors – even Europeans at the time, after all, regarded the piety and civility of their culture as degenerate in this period, as shown by the appeal of engaging in a *rinascita* or a *reformatio*. As we see in the *dialogi*, New Spain aimed to embody ideals, rather than replicating the tainted reality of Europe or its Mexica past. The notion of conversion towards these ideals, therefore, presented the inhabitants of New Spain with the opportunity to create society anew under ancient principles. Attached to these ideals, and their confirmation, was the perceived operation of divine grace on the re-sacralised spaces of Mexico City. In a contrast that highlights the success of this ideological project in New Spain, where the process of urban transformation has been described as 'organic', Spanish authorities in Lima during the 1570s were forced to acknowledge their inability to impose on their Indigenous subjects the 'reduction' or 'congregation' of their communities into more recognisably European urban layouts.[73]

The *dialogi* are also, therefore, an early and particularly intellectual example of the literature of '*criollo* patriotism' as it would develop during the viceregal period and inform many aspirations behind Mexican independence movements.[74] Consequently, they have enjoyed a much greater popularity since Mexico's independence, when the explicit ideals they promoted had been left behind, but their implicit pride in the eminence of Mexico City became more relevant than ever. De Icazbalceta republished them for the first time since the sixteenth century in the mid-seventeenth century as part of a remarkable effort to identify, edit and publish 'foundational' texts of Mexican history. Tellingly, his edition was entitled *Mexico in 1554*, and the *dialogi* appeared translated into the national language of Spanish rather than its didactic, international Latin in order 'to disseminate some of Mexico's glories, almost forgotten by its own natives who, in general, show more interest in learning about what is foreign than their own home'.[75] Interest in editing and studying them peaked again at the high point of Mexico's 'revolutionary nationalism' in the 1940s–70s, and again from the 1990s when Mexico began to recast itself as a both an ancient culture with '30 centuries of splendour' and as a crucible of globalisation and when academics began to bemoan the architectural heritage lost to economic 'progress'.[76] Cervantes also achieved the international appreciation for Mexico City that he hoped his *dialogi* would elicit. Its only extant first edition lies in the library of the University of Texas at Austin, and in 1953 that university produced its first English edition in order to commemorate the 400th anniversary of the foundation of the first universities in the Americas (Mexico and Lima).[77] Invasions, revolutions and natural disasters have not managed to undo Cervantes' achievement, and visitors to Mexico City are still drawn, when sightseeing, to follow much the same route as the interlocutors of the *dialogi*.

NOTES

1. Lane Fox, *Alexander the Great*, p. 259.
2. Elliott, 'A Europe of Composite Monarchies', pp. 48–71.
3. Vives, *Linguae Latinae Exercitatio*, II 'Prima salutatio'. For an English translation see Watson, *Tudor School-Boy Life*.
4. Verbekem, 'A Call for Sobriety', pp. 161–73, especially pp. 163–4.
5. Proctor, 'The Studia Humanitatis', p. 814
6. Verbeke, 'A Call for Sobriety', p. 167
7. Marín Ibáñez, 'Juan Luis Vives', pp. 743–59.
8. González González, 'A Humanist in the New World', pp. 251–4.
9. Marín Ibáñez, 'Juan Luis Vives', pp. 743–59.
10. Curtis, 'Advising Monarchs and their Counsellors', pp. 29–53, especially pp. 33–4; Marín Ibáñez, 'Juan Luis Vives', pp. 743–59.
11. Verbeke, 'A Call for Sobriety', p. 165.
12. Bono, *Cultural Diffusion*, p. 2.
13. Ibid., pp. 2–5.
14. Proctor, 'The Studia Humanitatis', pp. 813–18; Swift and Block 'Classical

Rhetoric', pp. 74–83; Abbott, *Rhetoric in the New World*, pp. 33–5; Marín Ibáñez, 'Juan Luis Vives', p. 8.

15. Courtney, *Play, Drama and Thought*, pp. 18–20; Ley, *A Short Introduction*, pp. 12–13.
16. Asenjo, 'Bases y despegue del teatro', p. 48.
17. Bosher, *Theater outside Athens*, pp. 377–8; Puchner, *The Drama of Ideas*, p. 4; Ley, *A Short Introduction*, pp. 12–13.
18. Puchner, *The Drama of Ideas*, pp. 37–9.
19. Bono, *Cultural Diffusion*, p. 52.
20. From his *Libri della famiglia*, bk. II, p. 161, quoted in Bono, *Cultural Diffusion*, p. 52; for general studies of More's 'art of dialogue', see Gordon, 'The Platonic Dramaturgy', pp. 193–215.
21. Courtney, *Play, Drama and Thought*, p. 37.
22. Kress, 'Juan Luis Vives', especially pp. 24–5.
23. Verbeke, 'A Call for Sobriety', p. 166; Breva-Claramonte, *La didactica de las lenguas*, p. 270; Bloemendal and Norland, *Neo-Latin Drama*, p. 331.
24. Courtney, *Play, Drama and Thought*, pp. 13–16; Verbeke, 'A Call for Sobriety', p. 166.
25. Bloemendal and Norland, *Neo-Latin Drama*, p. 567.
26. Abbott, *Rhetoric in the New World*, p. 35 and pp. 50f.
27. Burkhart, *Holy Wednesday*, p. 4.
28. Cervantes de Salazar, *México en 1554*, p. 150.
29. Laird, 'The Teaching of Latin', p. 125.
30. del Paso y Troncoso, *Epistolario de Nueva España*, doc. 233.
31. See, for example, Brading, *The First America*, pp. 79f.
32. González González, 'A Humanist in the New World', p. 240; Sanchis Amat, *Francisco Cervantes de Salazar*, p. 21; Cervantes de Salazar, *México en 1554*, p. 112.
33. López-Portillo, '*Another Jerusalem*', especially pp. 57–8.
34. González Gonzánez, 'De la abundancia de plata a la abundancia de sabios', n.p.
35. Cervantes de Salazar, *Comentaria in Ludovici Vives Exercitationes in Linguae Latinaei*. Throughout I use the Latin-Spanish edition: Cervantes de Salazar, *México en 1554*. The best English translation remains: Cervantes de Salazar, *Life in the Imperial and Loyal City of Mexico*.
36. Cervantes de Salazar, *México en 1554*, pp. 4–5.
37. Ibid., p. 271.
38. Cervantes de Salazar, *Crónica de la Nueva España*, n.p.
39. See, for example, Ruth, *Urban Honor in Spain*, n.p.
40. Cervantes de Salazar, *México en 1554*, p. 30.
41. Swift and Block, 'Classical Rhetoric in Vives' psychology', pp. 76–9; Bloemendal and Norland, *Neo-Latin Drama*, pp. 380, 566.
42. Vives, *Linguae Latinae Exercitatio*, XXII, 'Leges Ludi'.
43. Swift and Block, 'Classical Rhetoric in Vives' Psychology', p. 79.
44. See, for example, Sutton and Tribble, 'Cognitive Ecology', pp. 94–103.
45. Clark, *The Oxford Handbook of Cities in World History*, p. 370.
46. López-Portillo, *Another Jerusalem*, pp. 232f.
47. Kubler, 'Mexican Urbanism in the Sixteenth Century', pp. 160–71, especially p. 162.
48. For a more sanguine view of Vives' influence, see Bono, *Cultural Diffusion*, p. 43.
49. Brown, 'Christianization and Religious Conflict', p. 632.
50. Benavente, *Historia de los Indios de Nueva España*, p. 142.
51. Alberro, *El águila y la cruz*, pp. 67–8.

52. Ibid., p. 60; Benavente, *Historia de los Indios de Nueva España*, bk. 3, ch. 6.
53. Pérez-Rocha and Tena, *La nobleza indígena*, doc. 14, pp. 167–8.
54. Phelan, *The Millennial Kingdom of the Franciscans in the New World*, p. 29.
55. Cervantes de Salazar, *México en 1554*, pp. 20–1.
56. Ibid., p. 50.
57. Ibid., p. 18.
58. Ibid., p. 24.
59. Ibid., p. 24.
60. Martínez Baracs, 'Tepeyac en la conquista de México', pp. 75f.
61. Cervantes de Salazar, *México en 1554*, p. 84.
62. Ibid., especially p. 94.
63. Alberti, *L'Architettura [de re aedificatoria]*, bk. 4, ch. 1, p. 270.
64. Cervantes de Salazar, *México en 1554*, p. 131; see also Abbott, *Rhetoric in the New World*, espescially p. 47 and pp. 50–1.
65. Cervantes de Salazar, *México en 1554*, pp. 113–15.
66. Bono, 'The Contemporary Critics', pp. 65–71.
67. Ibid.
68. Cf. similar intention to De Certeau, 'Walking in the City', pp. 156–63, who has it in the (un-Platonic) reverse order.
69. Cervantes de Salazar, *México en 1554*, p. 279.
70. Sanchiz Amat, 'La recepcion de los dialogos', pp. 43–4.
71. Arróniz, *Teatros y escenarios del Siglo de Oro*, p. 27.
72. Cervantes de Salazar, *Crónica de la Nueva España*, n.p.
73. Gose, 'Converting the Ancestors', pp. 149–50.
74. For '*criollo* patriotism' see Brading, *The First America*, especially pp. 293–314.
75. Cervantes de Salazar, *México en 1554*, XXV; Sanchiz Amat, 'La recepcion de los dialogos', p. 44.
76. Sanchiz Amat, 'La recepcion de los dialogos', pp. 44–6.
77. Ibid., p. 45.

WORKS CITED

Abbott, D. P., *Rhetoric in the New World: Rhetorical Theory and Practice in Colonial Spanish America* (Columbia: University of South Carolina Press, 1996).
Alberro, S., *El águila y la cruz: Orígenes religiosos de la conciencia criolla. México, siglos XVI-XVII* (Mexico: Fondo de Cultira Económica, 1999).
Alberti, L. B., *L'Architettura [de re aedificatoria]* [1485], trans. and intro. Giovanni Orlandi (Milan: Il Polifilo, 1966).
Arróniz, O., *Teatros y escenarios del Siglo de Oro* (Madrid: Gredos, 1977).
Asenjo, J. A., 'Bases y despegue del teatro como instrumento educativo en la Edad Moderna', *TeatrEsco* IV (2010), <http://parnaseo.uv.es/ Ars/teatresco/Revista/Revista4/02_Alonso_julio.pdf> (last accessed 12 February 2018), pp. 29–62.
Benavente, Toribio de, *Historia de los Indios de Nueva España*, Edmundo O'Gorman (ed.) (Mexico: Porrúa, [1542] 1973).
Bloemendal J. and H. Norland, *Neo-Latin Drama in Early Modern Europe: Drama and Theatre in Early Modern Europe* (Leiden: Brill, 2013).
Bono, D. M., 'The Contemporary Critics and the Native American in Colonial New Spain in the Works of Francisco Cervantes de Salazar', *Confluencia* 5:1 (Fall 1989), pp. 65–71.
Bono, D. M., *Cultural Diffusion of Spanish Humanism in New Spain: Francisco Cervantes de Salazar's Diálogo de la dignidad del hombre* (New York: Lang, 1991).

Bosher, K., *Theater outside Athens: Drama in Greek Sicily and South Italy* (Cambridge: Cambridge University Press, 2012).

Brading, D. A., *The First America: The Spanish Monarchy, Creole Patriots and the Liberal State 1492–1866* (Cambridge: Cambridge University Press, 2013).

Breva-Claramonte, M., *La didáctica de las lenguas en el Renacimiento: Juan Luis Vives y Pedro Simón Abril* (Bilbao: Universidad de Deusto, 1994).

Brown, P. 'Christianization and Religious Conflict', in A. Cameron and P. Garnesey (eds), *Cambridge Ancient History*, vol. 12, *The Crisis of Empire*, AD 193–337 (Cambridge: Cambridge University Press, 1998), pp. 632–64.

Burkhart, L. M., *Holy Wednesday: Nahua Drama from Early Colonial Mexico* (Philadelphia: University of Pennsylvania Press, 1996).

Cervantes de Salazar, F., *México en 1554: tres diálogos que Cervantes escribió y publicó en Mexico en dicho año*, ed., trans. and notes J. García Icazbalceta (Mexico: Antigua Librería de Andrade y Morales, [1554] 1875).

Cervantes de Salazar, F., *Life in the Imperial and Loyal City of Mexico in New Spain and the Royal and Pontifical University of Mexico: As Described in the Dialogues for the Study of the Latin Language*, ed. C. E. Castañeda and trans. M. L. Barrett Shepard (Westport: Greenwood, [1554] 1970).

Cervantes de Salazar, F., *Crónica de la Nueva España*, ed. M. Magallón y Cabrera (Madrid: Ediciones Atlas, 1971).

Clark, P. (ed.), *The Oxford Handbook of Cities in World History* (Oxford: Oxford University Press, 2013).

Courtney, R., *Play, Drama and Thought: The Intellectual Background to Dramatic Education* (London: Cassell, 1973).

Curtis, C., 'Advising Monarchs and their Counsellors: Juan Luis Vives on the Emotions, Civil Life and International Relations', *Parergon* 28:2 (2011), pp. 29–53.

De Certeau, M., 'Walking in the City', in S. During (ed.), *The Cultural Studies Reader* (London: Routledge, 1993), pp. 156–63.

Elliott, J. H., 'A Europe of Composite Monarchies', *Past & Present* 137 (1992), pp. 48–71.

González González, E., 'De la abundancia de plata a la abundancia de sabios: La ciudad de México inaugura las lecciones universitarias', *Revista de la Universidad de México* 10661 (July 2003), <http://www.revistadelauniversidad.unam.mx/ojs_ rum/index.php/rum/article/view/15798/17036> (last accessed 19 August 2015).

González González, E., 'A Humanist in the New World: Francisco Cervantes de Salazar (1514–75)', in L. Deitz, T. Kircher and J. Reid (eds), *Neo-Latin and the Humanities Essays in Honour of Charles E. Fantazzi* (Toronto: Centre for Reformation and Renaissance Studies, 2014), pp. 235–58.

Gordon, W. M., 'The Platonic Dramaturgy of Thomas More's Dialogues', *Journal of Medieval and Renaissance Studies* 8 (1978), pp. 193–215.

Gose, P., 'Converting the Ancestors: Indirect Rule, Settlement Consolidation and the Struggle over Burial in Colonial Peru, 1532–1614', in K. Mills and A. Grafton (eds), *Conversion: Old Worlds and New* (Rochester, NY: University of Rochester Press, 2003), pp. 140–74.

Kress, D. M., 'Juan Luis Vives: A Study in Renaissance Theories in Methodology in Foreign Language Instruction', *The Modern Language Journal* 25:1 (October 1940), pp. 19–25.

Kubler, G., 'Mexican Urbanism in the Sixteenth Century', *The Art Bulletin* 24:2 (June 1942), pp. 160–71.

Laird, A., 'The Teaching of Latin to the Native Nobility in Mexico in the Mid-1500s: Contexts, Methods, and Results', in E. P. Archibald, W. Brockliss and Jonathan

Gnoza (eds), *Learning Latin and Greek from Antiquity to the Present* (Cambridge: Cambridge University Press, 2015), pp. 118–35.

Lane Fox, R., *Alexander the Great* (London: Penguin, 1986).

Ley, G., *A Short Introduction to the Ancient Greek Theater: Revised Edition* (University of Chicago Press, 2012).

López-Portillo, J.-J., *'Another Jerusalem': Political Legitimacy and Courtly Government in the Kingdom of New Spain (1535–1568)* (Leiden: Brill, 2017).

Marín Ibáñez, R., 'Juan Luis Vives (1492–1540)', *Prospects: The Quarterly Review of Comparative Education* XXIV:3/4 (1994), pp. 743–59.

Martínez Baracs, R., 'Tepeyac en la conquista de México: problemas historiográficos', in C. Aguilera and I. Arturo Montero García (eds), *Tepeyac. Estudios históricos* (México: Universidad del Tepeyac, 2000), pp. 55–118.

Paso y Troncoso, F. del (ed.), *Epistolario de Nueva España* (México: Antigua Librería Robredo, 1939–42).

Pérez-Rocha, E. and R. Tena (eds), *La nobleza indígena del centro de México después de la conquista* (México: Instituto Nacional de Antropología e Historia, 2000).

Phelan, J., *The Millennial Kingdom of the Franciscans in the New World* (Berkeley: University of California Press, 1970).

Proctor, R. E., 'The Studia Humanitatis: Contemporary Scholarship and Renaissance Ideals', *Renaissance Quarterly* 43:4 (Winter 1990), pp. 813–18.

Puchner, M., *The Drama of Ideas: Platonic Provocations in Theater and Philosophy* (Oxford: Oxford University Press, 2010).

Ruth, J. S., *Urban Honor in Spain: The Laus Urbis from Antiquity through Humanism* (Lewiston, NY: Edwin Mellen, 2011).

Sanchis Amat, V. M., *Francisco Cervantes de Salazar (1518–1575) y la patria del conocimiento: la soledad del humanista en la ciudad de México*, PhD diss. (Alicante: Universidad de Alicante, 2012).

Sanchis Amat, V. M., 'La recepción de los diálogos de México en 1554 de Francisco Cervantes de Salazar: apuntes bibliográficos', *Tiempo y escritura* 28 (January–July 2015), <http://www.academia.edu/21879749/La_recepcion_de_los_dialogos_de_M%C3%A9xico_en_1554_de_Francisco_Cervantes_de_Salazar_apuntes_bibliogr%C3%A1ficos> (last accessed 30 March 2018), pp. 39–54.

Sutton, J. and E. Tribble, 'Cognitive Ecology as a Framework for Shakespearean Studies', *Shakespeare Studies* 39 (2011), pp. 94–103.

Swift, L. J. and S. L. Block, 'Classical Rhetoric in Vives' Psychology', *Journal of the History of Behavioural Science* (January 1974), pp. 74–83.

Verbekem, D., 'A Call for Sobriety: Sixteenth-Century Educationalists and Humanist Conviviality', *Paedagogica Historica: International Journal of the History of Education* 49:2 (2013), pp. 161–73.

Vives, J. L., *Linguae Latinae Exercitatio* (1539).

Watson, F., *Tudor School-Boy Life: The Dialogues of Juan Luis Vives* (London: J. M. Dent & Company, 1908).

4

CONVERSIONAL THINKING AND THE LONDON STAGE

Stephen Wittek

Pierre Hadot famously identified the concept of conversion as 'one of the constitutive notions of Western consciousness and conscience', arguing that,

> in effect, one can represent the whole history of the West as a ceaseless effort at renewal by perfecting the techniques of 'conversion', which is to say the techniques intended to transform human reality, either by bringing it back to its original essence (conversion-return) or by radically modifying it (conversion-mutation).[1]

Although there is certainly a good deal to agree with in Hadot's argument, his historisation also raises some important questions about the ways in which the concept of conversion has evolved and expanded since Greco-Roman antiquity. In particular, it is difficult to see how conversion as we think of it today could have possibly existed in a pre-Christian, polytheistic culture wherein the adoption of a new belief did not necessarily involve an exclusive ideological commitment or a significant shift of identity. Hadot acknowledges this difficulty, but works around it by asserting a prototype for religious conversion in the political conversions espoused by the ancient Greeks and the philosophical conversions described by Plato in *The Republic*.[2] While his historiography, or at the very least his etymology, may very well be correct, it nevertheless seems clear that the idea of conversion took on a fundamentally richer and more profound character when it moved into a Christian context, a context where strict categorisation (you are either an x or a y) necessitated the conceptualisation

of mechanisms for shifting from one category to another. By the same token, one might also note that a conversional intensity or 'ceaseless effort at renewal' in Western thought does not become especially obvious or dominant until the sixteenth century, following the Reformation, the colonisation of the New World, and the rise of sustained contact between previously isolated parts of the globe, developments that made the categorisation of identity (and the possibility of shifting categories) an immediate and pressing source of widespread anxiety and excitement.[3] Regardless of whatever corollary the idea of conversion may have had in antiquity or in the medieval period, it undoubtedly made a significant evolutionary leap in early modernity, an era that one might reasonably think of as an Age of Conversion, or perhaps more precisely, an Age of Conversional Thinking.[4]

This essay begins to build a framework for understanding the relation between conversion and another key structure of early modern thought: theatrical performance. Taking early modern London as a specific focus, my analysis will consider the embeddedness of conversional thinking within the city's concentration of media resources, with particular emphasis on the ability of theatrical affordances to facilitate creative experimentation and critical examination around received categories of identity. The text I will analyse most closely is Dekker and Middleton's *The Honest Whore*, but I hope that much of what I say will apply to the theatrical culture and the broader media environment of early modern London in general. As I hope to show, an invitation to think about conversion in new, deeply personal ways was immanent in the early modern theatre, an emotionally and intellectually fertile space that Peter Lake and Michael Questier have helpfully described as 'a sort of playpen in which participants could adopt and lay aside, ventriloquise and caricature, try on for size, test and discard a whole variety of subject positions, claims to cultural authority, arguments and counter-arguments about legitimacy and power'.[5] This view of theatrical experience suggests that the 'playpen' doubled as a place where some very important social work could occur, a place where a big, difficult problem such as conversion could pique the imaginative curiosity of 3,000 people all at once.[6] In what follows, I will consider how the performance-based identity experiments described by Lake and Questier connect to a wide-ranging meditation on conversion that branched out across Europe and its worlds, beginning with questions of religious conversion, but eventually spreading to multiple categories of human identity. The London stage presents a propitious focus for this line of enquiry, not only because drama naturally brings a critical pressure to bear on the limits and possibilities of identity, but also because the dramatists of the period repeatedly grappled with questions of conversion, applied the structures of conversion to new areas of human experience, and helped to push thought about conversion forward.

Wʜᴀᴛ Wᴇ Tᴀʟᴋ Aʙᴏᴜᴛ Wʜᴇɴ Wᴇ Tᴀʟᴋ ᴀʙᴏᴜᴛ Cᴏɴᴠᴇʀsɪᴏɴ

Before proceeding any further, however, it is necessary to say something about 'conversion', a term that is extraordinarily useful and important precisely because of its capaciousness and resistance to definitional boundaries. Of course, my primary interest is conversion-the-concept, not conversion-the-word, but it is nevertheless instructive to observe the rich and complicated network of valences that the word brought to bear on the concept, not only in English, but also in counterparts from most other major European languages. Figure 4.1 summarises the entry for 'conversion' in the *Oxford English Dictionary*, which organises sixteen usages for the term into three definitional categories: 'I. Turning in position, direction, destination', 'II. Change in character, nature, form, or function' and 'III. Change by substitution of an equivalent in purport or value'. Usages pertaining to identity appear in the second category, which covers religious conversion (8. a.), moral conversion (9) and, more generally, 'the action of turning, or process of being turned, into or to something else' (11. a.). A much fuller sense of these usages comes into view, however, when one begins to read between the definitional borders and browse around neighbouring categories. From the outset, it seems clear that the more abstract concepts of 'conversion' derive shape and force from material examples of movement and process. Thus, in alternative contexts, the word people used most often to designate radical change of identity might have also served to describe the turning back of the sun (3. a.), the solidification of water into ice (11. a.), or the rearrangement of soldiers from files into ranks and fronts (13). There is much more one might say on this point, but for now it will suffice to simply observe that the figurative continuity between the material and abstract meanings opens up a view of how early moderns conceptualised the structure of identity and the processes by which it could change.[7] Conversion-the-word, with all its resonance and flexibility, provided a powerful tool for understanding and articulating the process – or the *idea* of a process – by which a given subject could become someone or something else.

To develop a better understanding of how this idea of a process functioned in early modernity, consider the following list of observations, which will help to bring the conceptual contours of conversion into better focus.

- *The normative conception of conversion entails a movement toward a new, putatively felicitous, state.*
- *Conversion is emotional.*
- *Conversion involves a relation between outward articulations and ostensible interior processes.*
- *Conversion is a form of social negotiation.*

Figure 4.1 A summary of the meanings for 'conversion' that were active in early modernity, adapted from the *OED*. (Source: Nasifoglu, '*Oxford English Dictionary* Study'.)

This list does not attempt to establish a comprehensive definition, nor does it aim to develop an essentialised criterion for qualifying or classifying various instantiations of conversion. Rather, it is an open-ended, and hopefully generative, sketch of some elementary characteristics that become apparent when one considers multiple iterations of conversional thinking across the period.

The first item puts emphasis on personal fulfilment: *The normative conception of conversion entails a movement toward a new, putatively felicitous, state.* To be absolutely clear, I should note that, although 'felicitous' is a common synonym for 'happy', the definitional range of the term also includes a sense of appropriateness, or coherence befitting authenticity. By using the phrase 'putatively felicitous', I intend to underline the crucial distinction between the *expectations normatively attached to conversion* and *incidences of conversion in actuality*, many of which will undoubtedly fail to meet any standard of felicity, however one chooses to define it. The distinction is important because the ascription of felicity to conversion immediately brings some potential exceptions to mind, such as the coercive baptism of Sephardic Jews and Mudéjar Muslims by the Spanish Inquisition. Rather than weighing these examples too heavily, however, I would argue that early modern thought generally dismissed forcible conversion as specious precisely because the use of force implies disregard for the legitimating prerequisite of favourable reception. Then as now, the oxymoronic phrase 'forced conversion' becomes necessary to distinguish between authentic conversions and conversions running counter to individual approval. Tellingly, one rarely (if ever) hears of 'voluntary conversions', not because they never occur, but because an assertion of willing acceptance is already implicit in the word 'conversion' itself, without any requirement for further qualification. These patterns of usage call attention to a deep and abiding assumption that genuine conversion hinges on an attitude of aspiration (or at the very least, positive inclination) toward the projected post-conversional self. At its very core, the idea of conversion is an idea about shifting toward a new, more flourishing and authentic state of being.

However, by arguing that forced conversions subvert the normative conditions of conversional experience, I do not mean to suggest that the idea of conversion implies an entirely voluntary subject. One need look no further than the two great exemplars of conversion in the Western tradition – Paul and Augustine – to realise that the shift toward a converted self does not hinge on intention and action, like a bulb one can switch on or off, but in fact becomes comprehensible primarily in terms of *feeling*, a register that is not contingent on individual volition or conscious control. Thus, item two: *Conversion is emotional.* This observation helps to explain the flurry of epistemological questioning over conversion in early modernity, an intensity that proceeded from the pressing difficulty of knowing for certain if one had truly converted,

and the related difficulty of ascertaining conversion in others. Unlike a marriage, which becomes unquestionably reified through ritual pronouncement, the proof, or truth, of conversion consists first and foremost in a feeling of felicity and an emotional attachment. Early moderns were acutely, even painfully, aware that one could not reliably gauge the reality of conversion in terms of dress, speech or action, all of which could be misleading.[8] Without emotion, or at least an assumption of emotion, the idea of conversion was – and is – devoid of meaning. To be clear, I should add that that this line of argumentation can only really make sense if one recognises emotion, physical sensation and conscious thought as fluid aspects of cognition, rather than discrete categories of human experience.[9] To say that 'conversion is emotional' is not the same as saying that conversion is inherently irrational, or somehow apart from the processes of reason. On the contrary, the present argument regards emotional experience as an indispensable means of thinking and knowing, and as an intellectual force that gives the idea of conversion shape, immediacy, durability and profound weight.[10]

The (always contingent) mechanisms for making a converted self intelligible are the focus of item three: *Conversion involves a relation between outward articulations and ostensible interior processes.* Building on the centrality of felicity and emotion discussed above, this observation registers the implicit assertion of interior action in the outward displays that make the processes of conversion readable for oneself and for others. These displays may include behaviour, speech, practices, temperament, appearance, custom of dress or any other physical manifestation that one understands as work contributing to a conversion process or as an indication that a conversion process has taken place. Regardless of whether they are purportedly *conducive to* or *indicative of* conversion, such articulations gesture toward interiority, toward a shift that occurs beneath a coherent surface. By way of aside, it is worth pointing out that this orientation toward interiority is in fact the key distinction between 'conversion' and related terms such as 'transformation' and 'metamorphosis', designations that typically indicate change on the outside, rather than change on the inside. In certain cases, early modern conversion may have involved an assumption of something similar to the modern notion of a private, dematerialised, unique inner self, but as the scholarship of John Sutton, Gail Paster and others has demonstrated, people in the period were much more likely to understand the inner self in terms of humoral dynamics, or what Sutton describes as the 'nested systems of spirits in the cosmos, the environment, the human body and in inanimate objects, with the animal spirits of medical theory holding a crucial microcosmic position'.[11] This model is profoundly important to an understanding of conversion in early modernity because it suggests that conversional articulations that might otherwise seem purely cosmetic or metaphorical were, for pre-moderns, a pragmatic means of interacting with

a continuity of material processes that connected the most intimate parts of a human self to society, the environment, art and the universe at large. Thus, although the concept of conversion in the period depends fundamentally on emotion, felicity and movement toward personal fulfilment, it would be a mistake to assume that the outward articulations that make the process of change intelligible are merely representational, or conceptually separable from what the core experience of conversion itself actually is.

The final item discloses the political implications of conversional thinking: *Conversion is a form of social negotiation.* This point is central to the plot of *The Honest Whore*, where conversion appears, not only as a process of becoming something better and new, but also as a process of leaving something behind, a process of renegotiating connections to certain social entities, such as family or community, and actively creating new connections, new entities, new categories of identification and new ways of making identity intelligible. Pushing the idea slightly further, one might say that conversion is a process of recreating and improvising around the boundaries of the received or expected social order, often in bold and imaginative ways. As noted above, there is also a strong element of social creativity in the articulations people devise to make a conversion experience publicly manifest. For example, consider the various forms of creative expression that come together in ritual practices, conversion narratives (textual, theatrical, musical and visual), or any of the other myriad ways that converts have found to declare, to themselves and others, 'I was an x, and now I am a y.' By understanding these exercises, not simply as a process of self-definition, but also as a methodology for negotiating and manipulating social relations, one can begin to see the tremendous value in forums such as London's commercial theatre, a uniquely open environment for collectively thinking through the processes, forms, psychology and social dimensions of conversional experience.

The City, Market, Media and Theatre of Conversion

With a conceptual sketch of conversion in place, I will now move to a discussion of the concentration of media resources that made it possible for early modern Londoners to see themselves as conversional beings in public in new ways. Although the specific focus of the present argument is theatre, it is important to acknowledge that the conversional affordances of the London stage were of a piece with the conversional affordances of the city itself, a system that directed energy and attention toward the idea of conversion on a number of fronts. Without risk of anachronism, one might profitably think of seventeenth-century London as a genuinely multimedia environment, a dynamic, discursive system that drew strength from the fluid interoperability of sermons, manuscript newsletters, corantos, pamphlets, broadside ballads, civic pageantry, trials, public executions, verse libels, book burnings and, of

course, commercial theatre. Manifest at almost every level of urban experience, the intensely representational force of the material surround had a radically influential effect on the processes by which Londoners thought about the world, experienced community and conceptualised the horizons of identity.[12]

As background to this point, it is worth noting that the population of the city grew from 50,000 to 225,000 between 1530 and 1605, following a steady influx of rural migrants (such as William Shakespeare) and foreigners from all corners of Europe and beyond, a mix that included servants, merchants, skilled artisans, political figures, intellectuals and entertainers.[13] Thus, in addition to a heightened awareness of discourse circulating in various forums for discussion and debate, everyday life in the city involved an awareness of cultural diversity, or what one might also think of as an awareness of diverse models for defining and understanding a self. In this context of unprecedented heterogeneity, representations pertaining to conversion became a matter of immediate, everyday attention, and an essential implement of the cultural literacy one had to acquire in order to successfully negotiate the social landscape.

Of course, the intense diversity and discursivity of London also owed a great deal to the city's emergence as a major centre of commercial activity and the concomitant emergence of a new culture market and a new class of professional cultural producers. On this point, it is helpful to recall that acting and playwriting did not become viable or even imaginable career options until the final decades of the sixteenth century, following the construction of purpose-built playhouses and the development of a customer base that viewed theatrical performance as goods worth paying for on a regular basis. Before that point, dramatic production was for the most part an irregular, amateur and non-commercial affair. Notably, in the very same decades, the culture market also fostered an explosive increase in the production and sale of popular print products, flooding London with news-sheets, ballads, sermons, dramatic play-texts and pamphlets. A broad understanding of the economic conditions that made these developments possible helps to put a key tenet of the present argument into perspective: if the city was an intensely *multimedia* environment, it was also an intensely *commercial* environment. Insofar as London functioned as a system of affordances for conversional thinking, it also functioned as a system for putting the idea of conversion on sale.

Finally, in addition to the special dynamics of the city, the market, the media and the theatre, one must also take into account the tremendous influence exerted on conversional thinking by state-directed religious upheaval. At the beginning of an essay that links the emergence of 'affective technologies' such as theatre to the emotional violence of the English Reformation(s), Steven Mullaney summarises the epistemic mood of Shakespeare's generation as follows:

If anything were certain in sixteenth-century England, it would be that everything changes, even the immutable; that everything is relative, even the absolute. In the space of a single generation, from 1530 to 1560, there were no fewer than five official state religions, five different and competing monotheisms, incompatible versions of the one god, the one faith, the one truth, the one absolute. What one monarch declared to be sacred and timeless, the next declared to be heresy or worse, in a reformation and counter-reformation by state decree, which was also a family feud, with one Tudor half-sibling divided against another in the name of God. One of the results was a lasting sense of unsettlement; another was a lasting cynicism.[14]

With London in mind, I would venture to add that the Reformation's legacy of unsettlement and cynicism also involved a complementary element of excitement. Although the new era of destabilisation and mutability had an explosive impact on the emotional landscape of the entire nation, it also brought new opportunities to reinvent oneself, especially for young people – and more than half of all Londoners were younger than twenty-five years old.[15] Likewise, insofar as the drama of the period provided a mechanism for feeling and thinking through a new and disorienting paradigm of constant change, it also tended to celebrate change and to prize the capacity for individual reinvention above almost all other attributes.

In other words, as was also the case for multiple other products on offer in London's cultural marketplace, drama traded on the anxiety, confusion and excitement fuelled by the potentiality of conversion. For approximately the same modest sum one might pay for a loaf of bread or a mug of beer, the theatre sold access to a space where the powerless could become powerful, the ugly could become beautiful, and nobodies could become somebodies, a space where all the subtlety and complexity in the idea of conversion could become vividly manifest in the language of dramatic representation. This aspect of theatrical experience was not only present in the many productions that made conversion a central thematic focus in one way or another (as in *The Merchant of Venice*, *A Christian Turn'd Turk* and *The Honest Whore*), but was also an inherent element in the processes by which theatrical space made meaning and shaped structures of attention. Indeed, even in the most basic forms of dramatic representation, engagement requires a spectator to think about identity as mutable, and to confront the possibility that a given identity might shift, multiply or overlap with others: a boy actor plays a girl pretending to be a boy in one performance, and in the next performance he plays a prince pretending to be a priest. As the early moderns were fond of noting, the special mode of attention one had to adopt in order to follow this form of representation was an apt analogue for the skills of discernment one had to learn in

order to negotiate the representational complexities of life in the real world. In the proverbial *theatrum mundi*, or 'world stage', one confronts a dazzling diversity of characters, but the machinations – or truth – behind the outward display remains shrouded in mystery.[16] With the purchase of admission to the early modern theatre, one bought the opportunity to explore a space that modelled all the conversional complexities of the *theatrum mundi*, but did so in a manner that made intractable difficulties safer, more manageable, more articulable, more amenable to critical enquiry, more conducive to emotional expression, more open to playful experimentation and more entertaining.

In a literal sense, the theatre also presented an intense microcosm of London. This point is particularly true for the big, amphitheatre playhouses such as the Globe, which operated according to a business model that required a large, non-exclusive, heterogeneous customer base, and therefore attracted an audience that included the full spectrum of London citizenry: apprentices, shopkeepers, guildsmen, housewives, foreigners, artisans, professionals, ambassadors, labourers and courtiers, all crowded together in a dense network of shared cognitive experience. As anyone who has had the opportunity to visit the present-day reconstruction of the Globe will know, part of the excitement of being a spectator in an open-air, circular playhouse derives from the fun of looking around at, being with and *feeling with* one's fellow spectators. The meaningfulness of this type of experience was especially acute in early modern theatre, which offered an otherwise unavailable opportunity to present oneself in public and participate on an equal basis in a collective, dialectic (rather than didactic), exercise in collective imagining.[17] Notably, although the original Globe was approximately the same size as its modern-day counterpart, the maximum occupancy was double (3,000 as compared to 1,500), so one's sense of being among others was especially intense, even for the elites occupying prestige seats in the upper tiers. Furthermore, all performances always took place in broad daylight, a condition of the discursive situation that significantly enhanced the overall rate and flow of visual communication via channels such as fashion, gesture and facial expression. Of course, these feedback loops for audience self-awareness also had an auditory and physical dimension. For example, consider the feeling of applauding while listening to the collective applause one is helping to create, or the feeling of laughing (or *not* laughing) as the entire assembly erupts in laughter, or the feeling of one's heartbeat as 3,000 people freeze in silence and breathe a sigh of relief, collectively focused on the actions of a single person on stage.[18] Opportunities for emotional interaction along these lines are central to Mullaney's theorisation of the theatre as an 'affective technology', a term that does not refer exclusively to the material apparatus (stage, seating, props, acoustics and so on), but also includes the overall cognitive system – or ecology – that comes together when the building is full of human participants

and a performance is in session.[19] If conversion becomes comprehensible primarily in terms of emotion, as I have suggested above, then theatre provided an ideal instrument for conducting the cognitive and social work that conversional thinking required.

THE CONVERTED CURTEZAN

1 OFFICER
You're changed, you're altered.
CANDIDO
Changed, sir? Why, true, sir. Is change strange? 'Tis not the fashion unless it alter: monarchs turn to beggars, beggars creep into the nests of princes, masters serve their prentices, ladies their servingmen, men turn to women.
1 OFFICER
And women turn to men.
CANDIDO
Ay, and women turn to men. You say true, ha, ha! A mad world, a mad world. (*The Honest Whore*, Scene 13, 139–47)[20]

The change of appearance that the First Officer observes in the above quotation is *not* the result of a conversion. Candido, a respectable linen merchant and a member of the municipal council, has switched clothing with his apprentice and has an expensive white fabric on his (bleeding) head, not because he has converted, but because he is playing a trick on his wife. Nevertheless, by simply uttering the word 'change', the Officer provides occasion for a meditation on conversion that connects to questions at the centre of *The Honest Whore*, an early seventeenth-century comedy by Thomas Dekker and Thomas Middleton. Rather than giving the officer an explanation for his appearance, Candido wittily suggests that changeability is entirely typical of the status quo, an argument that recasts the tensions of conversional culture in terms of a paradox: inconsistency is the new consistency. According to the linen draper's facetious logic, one should not find anything particularly surprising or strange in any given instance of identity change because all categories of identity are regularly subject to radical reversal: kings turn into beggars, beggars turn into kings, masters turn into servants, servants turn into masters, and men turn into women. To underscore the point in performance, the actor playing the role of Candido may have delivered these lines while making a metatheatrical gesture toward the actor playing the role of Candido's wife, an (actual) man who had become a (virtual) woman on stage. On a similar note, the First Officer's following comment about women who 'turn to men' is almost certainly a metatheatrical reference to the scandalous spectacle of female-to-male cross-dressing on the streets of early modern London.[21] Clearly, the 'mad world'

Candido refers to is the city itself, and the madness he celebrates derives from an omnipresent, delightfully theatrical potentiality for conversion.[22]

The conversional axis for *The Honest Whore* is not primarily political (king/subject), social (servant/master), sexual (female/male) or even confessional (Catholic/Protestant), but moral. Bellafront, the titular 'honest whore', turns from prostitution to an 'honest' life, which in this context means a life characterised by conformity within the strictures of idealised early modern femininity. There is a good deal of evidence to suggest that a progression along these lines could count as a conversion in the period, despite the definitional opacity concerning the term 'conversion' itself.[23] But even if there were not a broad body of texts that posit movement into or out of prostitution as an established subset of conversional phenomena, one could still be certain that *The Honest Whore*, in particular, counted as a conversion narrative, if for no other reason than because contemporaries said it did. As shown in Figure 4.2, the Second Quarto edition of the play appeared in print as *The Converted Curtezan*, an alternate title that makes the connection to conversion explicit.[24] With the topic of publication in view, it is worth noting that the First and Second Quartos both appeared in 1604, following what must have been an exceptionally popular production in the same year by Prince Henry's Men at the Fortune Theatre. The publication history also provides evidence of *enduring* popularity: three further quartos appeared in the years 1605, 1615 (or 1616) and 1635 respectively, a record that places *The Honest Whore* among the most-published dramas of the era.[25] In all likelihood, a certain measure of this popularity derived from the titillating subject matter. As Peter Ure has noted, the racy private theatres produced a number of plays involving prostitutes in the early seventeenth century, but *The Honest Whore* was one of the first, if not the very first, to appear at one of the big, public playhouses, venues that attracted a much larger, more diverse audience.[26] It would be a mistake, however, to assume that titillation was the only source of appeal. For contemporary theatregoer Edward Pudsey, the Bellafront plot apparently commanded very little interest, if any at all. Pudsey recorded seventeen quotations from the play in his Commonplace Book, all of which are either folksy aphorisms or witty one-liners, and none of which derive from any of the scenes involving Bellafront, even though she has more lines than any other character in the play.[27] In contrast to Pudsey, the following analysis will focus on Bellafront exclusively, with particular emphasis on the aspects that make her conversion knowable for readers, theatregoers, herself and her fellow characters. Building on these aspects, I will read the play as an extended expression of the question at the very centre of conversional thought: How can one know if a conversion has taken place?

As noted above, the conversional axis for *The Honest Whore* is primarily moral, with abject prostitution at one pole, and idealised chastity at the other.

Figure 4.2 Title page for the Second Quarto of *The Honest Whore*,
featuring the alternate title, *The Converted Curtezan*. The only surviving
copy of the quarto with an extant title page is part of the Bute collection
at the National Library of Scotland. (Source: Re-printed with permission
from the National Library of Scotland.)

However, it is important to recognise that, although the assignation of catego-
ries such as 'moral', 'sexual' or 'political' can provide a helpful framework for
analysis, there is always overlap with other forms of conversion, particularly
religious conversion, which resonates throughout all categories, providing an
implicit structure and tremendous emotional force. So, even though the plot
of *The Honest Whore* traces a primarily moral trajectory, religious gravity is
always present. For example, shortly after her conversion, Bellafront predicts
that her father will welcome her home with joy, 'seeing me new born' (Scene
10, 205), a choice of words that repurposes the New Testament trope of
religious conversion as rebirth.[28] On a similar note, when Mattheo, a former

client, learns that Bellafront has abandoned prostitution, he responds by ironically figuring her departure as an act of apostasy: 'Thou'rt damned for alt'ring thy religion' (Scene 10, 125). Examples such as these foreground the deep embeddedness, not only of religious language, but also of religious *feeling*, in the processes that make a conversion knowable. Bellafront's moral conversion derives shape and emotional energy from a distinctly religious set of pressures: the promise of rebirth on one hand, and the threat of damnation on the other. Toward the end of the play, a more overt and complex example of the same pattern appears in an exchange with Hippolito, the young man who prompts Bellafront to turn chaste. Responding to a suggestion that she might lose resolve and turn back to her former ways, he shows her a human skull, which he refers to as a 'book', and issues the following warning:

> Read this book.
> Ask counsel of this head what's to be done;
> He'll strike it dead that 'tis damnation
> If you turn Turk again. O do it not!
> Though heaven cannot allure you to do well,
> From doing ill let hell fright you. And learn this:
> The soul whose bosom lust did never touch
> Is God's fair bride, and maidens' souls are such;
> The soul that, leaving chastity's white shore,
> Swims in hot sensual streams, is the devil's whore. (Scene 10, 180–9)

Once again, the pressures lending coherence to conversional understanding are intensely emotional: 'let hell fright you'. As in Shakespeare's *Measure for Measure*, Milton's *Comus*, Spenser's *The Faerie Queene* and numerous other literary works from the period, the ideology in the warning posits chastity as a metonymy for spiritual purity – aligned with cleanliness and salvation, and contrasted against disease, filth and death. Moreover, with the phrase 'turn Turk', Hippolito deploys a cant analogy that maps abnegation of chastity onto the process of converting from Christianity to Islam, a formulation that casts unchaste women as treacherous infidels cut off from the civilising influence of European culture.[29] Clearly, the stakes go well beyond moral correctness or personal reputation. Bellafront's sexual conduct has become a matter of eternal life and death, with death chillingly reified onstage by the skull Hippolito forces her to contemplate (undoubtedly an actual human skull in the original production). However, despite the strong religious overtones, *The Honest Whore* is ambiguous to the point of incoherence in terms of confessional doctrine or detail. Following from Hippolito's argument, one might conclude that chastity in and of itself is the sole qualification for salvation. Although his admonishment *sounds* a lot like a sermon, it is markedly light on theological specifics. On a similar note, the play takes place in Milan,

so Catholicism, which many people in England regarded as the ideology of Antichrist, would presumably provide the frame of reference for any religious understanding or instruction. My point, however, is not that doctrinal incoherence makes an important difference, but rather, that the incoherence does not really matter as long as the religious allusions resonate at the level of emotion, which is the dominant register for articulating and recognising conversion.

Bellafront does not appear in *The Honest Whore* until Scene 6, the scene where she meets Hippolito for the first time and begins the process of conversion. In anticipation of her entrance, the dramatists focus on the personal details of her private boudoir, developing a strong sense of intimacy that begins with the stage directions for her servant, Roger:

> Enter Roger with a stool, cushion, looking-glass, and chafing-dish; those being set down, he pulls out of his pocket a vial with white colour in it, and two boxes, one with white, another red, painting. He places all things in order and a candle by them, singing with the ends of old ballads as he does it. At last Bellafront, as he rubs his cheek with the colours, whistles within. (Scene 6, introductory stage direction)

There is something almost cinematic in the observational intentionality of this description, which is extremely rich and lengthy for a stage direction in an early modern dramatic text. By mimicking the actions of his mistress's toilette, Roger guides the audience through a candid tour of the objects and practices that contribute to the construction of her outward façade: the cushion she sits on as she prepares herself in front of the mirror, the various boxes and vials she uses to store cosmetics, and the bits of old song sheets she uses to apply colour. Detail by detail, these revelations push the artificiality of Bellafront's external presentation to the foreground, and mark out a distinction between her private, unadorned self versus the role she performs in connection to her profession. Following Roger's pantomime imitation, Bellafront carries the exposé a step further by performing a sort-of reverse striptease that progresses from a state of half-dress (petticoat, but no gown), through various stages of primping and preparation, all carried out in conjunction with sassy banter ('Where's my ruff and poker, you blockhead?' [Scene 6, 16]). Although the role is not especially complex, it nevertheless involves a marked degree of dimensionality and emotional resonance that goes well beyond typical prostitute roles from other plays of the same era (for comparison, consider the 'Country Wench' in Middleton's *Michaelmas Term*). Bellafront is much more than a loose gown, feathers and a painted face. The dramatists have clearly taken a great deal of care to present the character in a perspective that suggests a strong sense of personhood, and the boy actor who played the role was presumably capable of conveying this aspect persuasively on stage, without descending into farce.[30] As a complement

to the characterological depth, there is also a broad suggestion that, although Bellafront is comfortable in her profession, she has a melancholy sense of dissatisfaction with her present state of being. While she makes her preparations in front of the mirror, she sings 'Down, down, down, down; I fall down, and arise I never shall' (Scene 6, 32–3), signalling an incipient desire to become something other than what she is. In addition to providing strong dramatic appeal, these gestures toward genuine personhood and emotional longing help to lay the necessary groundwork for the turning that plays out as the scene develops. Ultimately, the saliency of the conversion at the centre of the plot hinges entirely on the ability of the drama to present the prospective convert as a compellingly real, feeling person.

As the scene progresses, Mattheo and the other gallants enter with Hippolito, whom they leave with Bellafront in hopes that a sexual dalliance will help him to forget his (supposedly) deceased lover, Infelice. Bellafront's conversion takes place shortly after the gallants have left, at the moment where Hippolito realises he is alone in a brothel with a prostitute.

HIPPOLITO
Pretty fine lodging. I perceive my friend
Is old in your acquaintance.
BELLAFRONT
Troth, sir, he comes
As other gentlemen, to spend spare hours.
If yourself like our roof, such as it is,
Your own acquaintance may be as old as his.
HIPPOLITO
Say I did like, what welcome should I find?
BELLAFRONT
Such as my present fortunes can afford.
HIPPOLITO
But would you let me play Mattheo's part?
BELLAFRONT
What part?
HIPPOLITO
Why, embrace you, dally with you, kiss.
Faith, tell me: will you leave him, and love me?
BELLAFRONT
I am in bonds to no man, sir.
HIPPOLITO
Why then,
You're free for any man; if any, me.
But I must tell you, lady, were you mine,

You should be all mine. I could brook no sharers;
I should be covetous, and sweep up all.
I should be pleasure's usurer; faith, I should.
BELLAFRONT
O fate!
HIPPOLITO
Why sigh you, lady? May I know?
BELLAFRONT
'T has never been my fortune yet to single
Out that one man whose love could fellow mine,
As I have ever wished it. O my stars!
Had I but met with one kind gentleman
That would have purchased sin alone, to himself,
For his own private use, although scarce proper
(Indifferent handsome, meetly legged and thighed),
And my allowance reasonable (i'faith,
According to my body), by my troth
I would have been as true unto his pleasures
Yea, and as loyal to his afternoons,
As ever a poor gentlewoman could be. (Scene 6, 300–28)

Like Paul on the road to Damascus or Augustine in his garden, Bellafront begins to understand herself as the subject of conversion in a moment of intensely felt realisation that comes across involuntarily, but not without a strong degree of willing acceptance. Following a bit of flirtatious banter, the conversional experience takes hold as Hippolito says he would never be content to settle for anything less that sexual exclusivity, a declaration that Bellafront reacts to with the words 'O fate!' (Scene 6, 316), followed by an audible exhalation that Hippolito refers to explicitly in his response: 'Why sigh you, lady? May I know?' (Scene 6, 317). From this point forward, the sassy, bawdy seductress disappears, and a new, stridently earnest figure emerges, a progression marked by a shift from earthy tavern talk ('makes your breath stink like the piss of a fox' [Scene 6, 103]) to high melodrama ('Either love me, / Or cleave my bosom on thy rapier's point' [Scene 6, 500–1]). As a number of critics have pointed out, the conversion depicted in this scene derives primarily from Bellafront's sudden infatuation, and has much less to do with the scathing, 104-line sermon that Hippolito delivers in response to her solemn declarations of love (Scene 6, 364–474).[31] In addition, one might also observe that, insofar as Bellafront falls in love with Hippolito, she also falls in love with the idea of the chaste, monogamous version of herself that Hippolito brings into view ('I would have been as true unto his pleasures ... As ever a poor gentlewoman could be' [Scene 6, 325–7]). With the dawning realisation of the potentiality for a new,

more flourishing way of being, the process of conversion – a process of falling in love – has already begun.

But conversion is difficult to prove. The reality of Bellafront's experience seems certain to Bellafront herself and to the theatrical spectators (and readers) who can judge the authenticity of her emotional engagement from an intimate, critical perspective, but the evidence is far less compelling for the other characters in play, most of whom find the likelihood of a genuine conversion extremely remote, and assume that the outward appearances of change are either frivolous or deliberately deceptive. At the end of Scene 6, Hippolito leaves the brothel unconvinced that his sermon has had any effect, despite Bellafront's aborted suicide and declarations of repentance. As the drama develops, the same basic problem plays out with a variety of Bellafront's former acquaintances, and in each case, basic scepticism wins out over the difficulty of providing compelling outward evidence for an essentially inward claim. For example, at the beginning of Scene 8, the brothel proprietor, Mistress Fingerlock, pays Bellafront a visit with the intention of engaging her services, and receives news from Roger that Bellafront 'is not the whore now that you take her for' (Scene 8, 6), a development he accredits to 'squeamishness' (Scene 8, 18). When Bellafront enters, she is no longer wearing the apparel of her former profession, and has adopted a tone that bears an unmistakable affinity to Hippolito's sermon in Scene 6: 'Hence, thou our sex's monster, poisonous bawd, / Lust's factor, and damnation's orator! / Gossip of hell!' (Scene 9, 36–8). But rather than crediting this obvious change in tone to genuine change, Fingerlock drily suggests that Bellafront's refusal to work is not in fact a choice, but a necessity imposed by disease: 'Marry gup, are you grown so holy, so pure, so honest, with a pox?' (Scene 9, 73–4). In the scene that follows, Bellafront has a similar encounter with Matteo and his band of gallants, who also regard the possibility of her conversion as a flat-out impossibility:

> BELLAFRONT
> O, I pray do, if you be gentlemen;
> I pray depart the house. Beshrew the door
> For being so easily entreated! Faith,
> I lent but little ear unto your talk;
> My mind was busied otherwise, in troth,
> And so your words did unregarded pass.
> Let this suffice: I am not as I was.
> FLUELLO
> 'I am not what I was'! No, I'll be sworn thou art not. For thou wert honest at five, and now thou'rt a punk at fifteen; thou wert yesterday a simple whore, and now thou'rt a cunning cony-catching baggage today. (Scene 9, 35–46)

'I am not as I was' is an iteration of the implicit message in all conversional articulations: 'I was an *x*, and now I am a *y*.' As Fluello demonstrates, the message is always subject to blunt contradiction: 'You are not a *y*, and you can never be anything other than an *x*.' In order to establish stronger social proof of her new disposition, Bellafront seeks out, and eventually manages to acquire, a marriage with Mattheo (her original seducer), thereby reinforcing her avowal of chastity with the legitimating forces of law, ritual and convention. Unlike a conversion, the constitution of a marriage does not hinge on the saliency of a deeply felt commitment. As long as all parties to the ceremony make the requisite statements under the appropriate conditions, the marriage will have a binding social reality, regardless of feelings or behaviours. Crucially, however, *The Honest Whore* does not posit marriage as constitutive of conversion (a proposition Shakespeare considers in *The Merchant of Venice*), but as a mechanism for giving an already-constituted conversion the semblance of social legitimacy – the icing on the cake, and the cardinal condition for a generic comic ending.

So, how can one know if a conversion has taken place? Rather than offering an easy, pre-formulated answer, *The Honest Whore* shows what it takes to fully engage the question, not only by focusing critical attention on the epistemic problems of conversion, but also by summoning the emotional energy necessary to put conversional experience in proper perspective. In accordance with normative conditions, Bellafront's progression toward a new, more felicitous, state proceeds from an effusion of intensely felt realisation that washes over her, not really by choice, and certainly not by force. Crucially, she knows her conversion by feeling it, or more precisely: the emotion that shapes her awareness of conversion is a form of knowledge in and of itself. In order to make the reality of her experience salient for a theatrical audience, the drama necessarily places emphasis on details suggestive of personhood and capacity for genuine feeling. Indeed, if there can be any compelling representation of conversion at all, it can only become manifest in terms of personal, emotional detail. In this respect, London's early modern theatre was an ideal vehicle for conversional thinking. By moving the concept of conversion into a medium that could represent emotional detail in high definition, but could also organise complex abstractions within a critical framework, Dekker, Middleton and their contemporaries made a significant and lasting contribution to a subject of intellectual scrutiny that dominated the period, and has had a profound influence on the culture of modernity.

NOTES

1. Hadot, 'Conversion', p. 1.
2. Ibid., pp. 2–3.
3. Hadot, 'Conversion', p. 1; Marcocci et al., *Space and Conversion in Global Perspective*, p. 3; Mills and Grafton, *Conversion*, pp. xii–xv.

4. On the development of conversional thinking (especially in England), see Questier, *Conversion, Politics and Religion*, pp. 40–75.
5. Lake and Questier, *The Antichrist's Lewd Hat*, p. xxxi.
6. For more on the social work of theatrical experience, see Mullaney, 'Affective Technologies', pp. 71–89; Welch, 'Making Mourning Show', pp. 74–82; Yachnin, 'Performing Publicity', pp. 201–19.
7. For a discussion of the role of metaphor in language and the mind, see Lakoff and Johnson, *Metaphors We Live By*.
8. As Frances Dolan has noted, an adjudicator of conversion 'had no recourse outside of representation . . . there is . . . no definitive cache of physical evidence that could prove, once and for all, who they were and what they were really up to'. Dolan, *Whores of Babylon*, pp. 2–3.
9. A number of theorists have argued against a categorical differentiation between emotion, cognition, reason and sensation. For a good summary, see Reddy, *The Navigation of Feeling*, pp. 14–20.
10. Writing along similar lines, M. Z. Rosaldo has described emotions as 'embodied thoughts . . . steeped with the apprehension that *I am involved*.' Rosaldo, 'Toward an Anthropology of Self and Feeling', p. 143.
11. Sutton, *Philosophy and Memory Traces*, p. 36. See also Paster, *Humoring the Body*; Schoenfeldt, *Bodies and Selves*.
12. For mass media and cognition, see Hoskins, 'From Collective Memory', pp. 278–88.
13. Porter, *Shakespeare's London*, pp. 33–4.
14. Mullaney, 'Affective Technologies', p. 71.
15. Picard, *Elizabeth's London*, p. 89; Pelling, *The Common Lot*, p. 27.
16. On *theatrum mundi*, see Agnew, *Worlds Apart*, pp. 14–16.
17. For a discussion of public making in the early modern theatre, see Wittek, *The Media Players*, pp. 12–17.
18. On alienation in the theatre (for example, *not* laughing while everyone else laughs), see Mullaney, *The Reformation of Emotions*, pp. 76–83.
19. Mullaney, 'Affective Technologies', pp. 81–2. Sutton and Tribble have defined 'cognitive ecologies' as, 'the multidimensional contexts in which we remember, feel, think, sense, communicate, imagine, and act, often collaboratively, on the fly, and in rich ongoing interaction with our environments'. Sutton and Tribble, 'Cognitive Ecology', p. 94. Arguing along similar lines, Andy Clark makes a compelling case for preferring an ecological theory of mind over analytic traditions that adhere to brain-bound biases: 'if we are broadly speaking functionalists about the role of physical organizations in supporting thought, it must be at least possible that the relevant functional wholes should sometimes extend beyond the ancient confines of skin and skull, and include inextricable tangles of feedback, feed-forward and feed-around loops that promiscuously criss-cross the boundaries of brain, body and world'. Clark, 'Material Surrogacy', p. 27.
20. All quotations from *The Honest Whore* derive from Paul Mullholland's edition for *Thomas Middleton: The Collected Works*. Mullholland uses the updated title, *The Patient Man and the Honest Whore*.
21. Jean Howard notes that the prevalence of crossdressing in early modern London is difficult to gauge, but 'given Biblical prohibitions against the practice and their frequent repetition from the pulpit and in the prescriptive literature of the period, one would guess that the number of people who dared walk the streets of London in the clothes of the other sex was limited. Nonetheless, there *are* records of women, in particular, who did so, and who were punished for their audacity; and from at least 1580 to 1620 preachers and polemicists kept up a steady attack on the practice.' Howard, 'Crossdressing', p. 418.

22. In a sense, every city in English Renaissance drama is really just London in thin disguise, but the point is especially true for the version of Milan represented *The Honest Whore*, which somehow includes Bethlem Hospital. The geographical anachronism does not seem to have been a mistake: in *The Honest Whore, Part 2*, it turns out that Milan is also home to Bridewell Prison.
23. There are a number of conversion narratives from the period that feature progressions either away from or toward ideals of feminine chastity. Notable cases in point include Greene, 'The Conversion' and Cranley, *The Converted Courtesan*. For further examples, see Mulholland, 'Introduction', pp. 3–4 and Howard, *Theater of a City*, pp. 129–30.
24. According to speculation by Daalder, the printers used the alternate title in order to make the Second Quarto look like an entirely different publication, a ruse calculated to circumvent restrictions on the maximum number of copies permitted by the Stationers' Company. Notably, however, Daalder also argues that most incidences of variance in the Second Quarto most likely derive from authorial direction: Daalder, 'Introduction'. Howard suggests that use of the word '*Curtezan*' in the alternate title may have been part of an attempt to boost sales by making the play sound more Italian: Howard, 'Civic Institutions', p. 8.
25. Mulholland, 'Introduction', p. 3 and Mulholland, '*The Patient Man and the Honest Whore*: General Textual Introduction', p. 507.
26. Ure, '*Patient Madman*', pp. 20–1.
27. Mulholland, 'Introduction', p. 3.
28. The trope appears in the Geneva Bible three times (John 3: 3, John 3:7 and 1 Peter 1: 22–3).
29. Daalder, *The Honest Whore, Part 1*, IV, i, 1889, note. Notably, a number of Turk-based conversion plays appeared in the first quarter of the seventeenth century. Howard compellingly describes the genre as a masculine counterpart to the prostitute-based conversion plays that appeared around the same time: Howard, *Theater of a City*, pp. 130, 140.
30. For a discussion of the ability of boy actors to play female roles convincingly, see McLuskie, 'The Act', pp. 120–30.
31. Ure, '*Patient Madman*', p. 32; Leggatt, *Citizen Comedy*, p. 114; Daalder, 'Introduction'.

WORKS CITED

Agnew, J., *Worlds Apart: The Market and the Theater in Anglo-American Thought, 1550–1750* (Cambridge: Cambridge University Press, 1986).
Clark, A., 'Material Surrogacy and the Supernatural: Reflections on the Role of Artefacts in "Off-line" Cognition', in L. Malafouris and C. Renfrew (eds), *The Cognitive Life of Things: Recasting the Boundaries of the Mind* (Cambridge: McDonald Institute for Archaeological Research, 2010), pp. 23–8.
Cranley, T., *The Converted Courtesan* (London, 1635).
Daalder, J., 'Introduction', in *The Honest Whore, Part 1*, by T. Dekker and T. Middleton (Victoria: Digital Renaissance Editions, 2015), <http://digitalrenaissance.uvic.ca/Library/Texts/1HW/> (last accessed 21 September 2015).
Daalder, J. (ed.), *The Honest Whore, Part 1*, by T. Dekker and T. Middleton (Victoria: Digital Renaissance Editions, 2015), <http://digitalrenaissance.uvic.ca/Library/Texts/1HW/> (last accessed 21 September 2015).
Dekker, T. and T. Middleton, *The Honest Whore, Part 1*, ed. J. Daalder (Victoria: Digital Renaissance Editions, 2015), <http://digitalrenaissance.uvic.ca/Library/Texts/1HW/> (last accessed 21 September 2015).

Dolan, F., *Whores of Babylon: Catholicism, Gender and Seventeenth-Century Print Culture* (Ithaca: Cornell University Press, 1999).

Geneva Bible, *The Bible Translated According To The Ebrew And Greeke And Conferred With The Best Translations* (London, 1589).

Greene, R., 'The Conversion of an English Courtesan', in *A Disputation between a He Cony-Catcher and a She Cony-Catcher* (London, 1592).

Hadot, P., 'Conversion', trans. A. B. Irvine, <https://aioz.wordpress.com/2010/05/17/pierre-hadot-conversion-translated-by-andrew-irvine/> (last accessed 21 September 2015).

Hoskins, A., 'From Collective Memory to New Memory Ecology', in M. Neiger, O. Meyers and E. Zandberg (eds), *On Media Memory: Collective Memory in a New Media Age* (Houndmills: Palgrave Macmillan, 2011), pp. 278–88.

Howard, J., 'Crossdressing, The Theatre and Gender Struggle in Early Modern England', *Shakespeare Quarterly* 39 (1988), pp. 418–40.

Howard, J., 'Civic Institutions and Precarious Masculinity in Dekker's *The Honest Whore*', *Early Modern Cultural Studies: An Electronic Seminar* 1 (2000), <http://emc.eserver.org/1-1/howard.html> (last accessed 21 September 2015).

Howard, J., *Theater of a City: The Places of London Comedy, 1598–1642* (Philadelphia: University of Pennsylvania Press, 2007).

Lake, P. and M. C. Questier, *The Antichrist's Lewd Hat: Protestants, Papists and Players in Post-Reformation England* (Yale University Press, 2002).

Lakoff, G. and M. Johnson, *Metaphors We Live By* (Chicago: University of Chicago Press, 1980).

Leggatt, A., *Citizen Comedy in the Age of Shakespeare* (Toronto: University of Toronto Press, 1973).

McLuskie, K., 'The Act, the Role and the Actor: Boy Actresses on the Elizabethan Stage', *New Theatre Quarterly* 3 (1987), pp. 120–30.

Marcocci, G., W. de Boer, A. Maldavsky and I. Pavan (eds), *Space and Conversion in Global Perspective* (Leiden: Brill, 2015).

Middleton, T., *Michaelmas Term* (London, 1607).

Mills, K. and A. Grafton (eds), *Conversion: Old Worlds and New* (Rochester, NY: University of Rochester Press, 2003).

Milton, J., *A Mask presented at Ludlow Castle, 1634: on Michelmas night, before the right honorable, Iohn Earl of Bridgewater, Viscount Brackly, Lord President of Wales, and one of His Maiesties most honorable privie council* [*Comus*] (London, 1637).

Mulholland, P., 'Introduction' to *The Patient Man and the Honest Whore*, by T. Dekker and T. Middleton, in Gary Taylor and John Lavagnino (eds), *Thomas Middleton: The Collected Works* (Oxford: Clarendon Press, 2007).

Mulholland, P., '*The Patient Man and the Honest Whore*: General Textual Introduction', in J. Lavagnino and G. Taylor (eds), *Thomas Middleton and Early Modern Textual Culture: A Companion to the Collected Works* (Oxford: Clarendon Press, 2007), pp. 507–28.

Mullaney, S., 'Affective Technologies: Toward an Emotional Logic of the Elizabethan Stage', in M. Floyd-Wilson and G. Sullivan (eds), *Environment and Embodiment in Early Modern England* (Basingstoke: Palgrave Macmillan, 2007), pp. 71–89.

Mullaney, S., *The Reformation of Emotions in the Age of Shakespeare* (Chicago: University of Chicago Press, 2015).

Nasifoglu, Y., '*Oxford English Dictionary* Study', <earlymodernconversions.com/wp-content/uploads/2013/06/OED-research-usage-for- conversion.pdf> (last accessed 21 September 2015).

Paster, G. K., *Humoring the Body: Emotions and the Shakespearean Stage* (Chicago: University of Chicago Press, 2004).

Pelling, M., *The Common Lot: Sickness, Medical Occupations and the Urban Poor in Early Modern England* (London: Longman, 1998).

Picard, L., *Elizabeth's London: Everyday Life in Elizabethan London* (New York: St Martin's, 2004).

Porter, S., *Shakespeare's London: Everyday Life in London 1580–1616* (Stroud: Amberley, 2009).

Pudsey, E., Commonplace Book, Bodleian Library MS. Eng. poet. d. 3. fol. 80.

Questier, M., *Conversion, Politics and Religion in England, 1580–1625* (Cambridge: Cambridge University Press, 1996).

Reddy, W., *The Navigation of Feeling a Framework for the History of Emotions* (Cambridge: Cambridge University Press, 2001).

Rosaldo, M. Z., 'Toward an Anthropology of Self and Feeling', in R. Shweder and R. Levine (eds), *Culture Theory: Essays on Mind, Self and Emotion* (Cambridge: Cambridge University Press, 1984), pp. 137–57.

Schoenfeldt, M., *Bodies and Selves in Early Modern England: Physiology and Inwardness in Spenser, Shakespeare, Herbert and Milton* (Cambridge: Cambridge University Press, 1999).

Shakespeare, W., *The most excellent Historie of the Merchant of Venice* (London, 1600).

Shakespeare, W., *Measure for Measure*. In *Mr. William's Shakespeares Comedies, Histories, & Tragedies* (London, 1623), pp. 63–84.

Spenser, E., *The Faerie Queene* (London, 1596).

Sutton, J., *Philosophy and Memory Traces: Descartes to Connectionism* (Cambridge: Cambridge University Press, 1998).

Sutton, J. and E. Tribble, 'Cognitive Ecology as a Framework for Shakespearean Studies', *Shakespeare Studies* 39 (2011), pp. 94–103.

Ure, P., '*Patient Madman and Honest Whore*: The Middleton-Dekker Oxymoron', *Essays and Studies* 19 (1966), pp. 18–40.

Welch, K., 'Making Mourning Show: *Hamlet* and Affective Public-Making', *Performance Research* 16:2 (2011), pp. 74–82.

Wittek, S., *The Media Players: Shakespeare, Middleton, Jonson and the Idea of News* (Michigan: University of Michigan Press, 2015).

Yachnin, P., 'Performing Publicity', *Shakespeare Bulletin* 28:2 (2010), pp. 201–19.

5

RELIGIOUS DRAMA AND THE POLEMICS OF CONVERSION IN MADRID

José R. Jouve Martín

In 1609, shortly before King Phillip III decreed the forceful expulsion of the Spanish *moriscos*,[1] a satirical play about the life and deeds of the prophet Muhammad was staged in Madrid. Entitled *Vida y muerte del falso profeta Mahoma* (*Life and Death of the False Prophet Mohammed*), and often attributed to the playwright Mira de Amescua, the work drew on a Western tradition of apocryphal stories about the Prophet, intertwining dubious biographical details and false miracles with gallant and romantic subplots in order to portray Muhammad as a fraud.[2] In this comedy, as well as in the play that Rojas Zorrilla would later write on the same subject, the anti-Muslim ideological message was conveyed through a series of monologues in which Mohammad reflects on his own life as well as through the various debates he has with Christian opponents. As González Muñoz has pointed out, both works present Muhammad as an impostor, who is aware of the truth of the Christian religion and deceived his followers – and himself – with the sole purpose of achieving fame and influence.[3]

Despite the play's satirical nature, the Holy Office was afraid that these sorts of works would ultimately serve to spread the message of the enemies of the Church. The Inquisition was also not oblivious either to the gulf that existed between the written texts submitted for its approval and audiences' interpretations of what was actually performed on stage, especially if the plot was of a religious nature.[4] Those who considered theatre a threat to the established order called for Inquisitorial officials to be present on site to take note of the

differences between text and performance. However, unless there were compelling circumstances that forced its intervention, the Holy Office normally contented itself with purging the manuscripts of possible errors and heresies in advance and let its army of informants do the rest. In the case of the play under discussion, the censors required that the original title of the work, *Vida de Mahoma* (*Life of Mohammed*), be amended to clearly denounce Mohammed as an impostor: hence its final title, *Vida y muerte del falso profeta Mahoma*.

Concerns about the difficulty of controlling the representation and reception of these sorts of works proved to be not entirely unjustified. A few years after its premiere, a certain Juan Alonso, a *morisco* exiled in Northern Africa who had converted to Islam and wrote about theology and other aspects of the Morisco predicament, made a surprising reference to the play.[5] Apparently unaware of its satirical intentions and oblivious to its anti-Muslim stance, he praised the play and its author for daring to depict Mohammed's life and miracles on stage in spite of the threat posed by the Inquisition:

> This Spanish poet wrote a play about the miracles of our Holy Prophet that was performed in Madrid and in which Mohammed was depicted as he truly was with his green robes embroidered with stars . . . This fact came to the attention of the Holy Office, over which the Devil himself presides. During one of the functions, which the public attended with much attention and pleasure, both the poet and the actors were taken away. The Inquisition forbade them to continue staging the play and sought to punish the author. He defended himself stating that everything performed on stage was right and faithful to the true scriptures, after which he was asked to remain silent and not to reveal anything about it to anyone.[6]

There is no way to corroborate exactly whether the author of this text had actually witnessed the play or whether he was just reporting what others had told him. However, his words illustrate the complex interplay between text, performance and reception that was characteristic of the polemics of conversion in Early Modern Spanish theatre. This debate would shape Spanish cultural and social life from the fifteenth to the late seventeenth century. It would do so not only for the many crypto-Jews, *moriscos*, *conversos*, black Africans and Indigenous peoples who found themselves at the centre of conversion efforts, but also for many Old Christians, whose local religious practices and beliefs often diverged from Catholic orthodoxy in significant ways. The debate revolved as much around religious dogma as around theological and philosophical questions that were already in the public sphere: Is it possible to convert to another religion? How does conversion take place? What kind of conversions are possible? To what extent can they be empirically and spiritually verified? By whom and through which means? These questions lent

themselves to dramatic experimentation and found a fertile ground in Spanish theatre. They opened the floodgates of vastly different narratives and ideas on the experience and possibility of conversion and its relation to other historical and contemporary events.

Despite its position as the empire's capital, Madrid was a relative late-comer to the polemics of conversion in Spanish theatre. In fact, a fundamental chapter of those polemics had taken place not even in the Iberian Peninsula, but in the Americas where Franciscan missionaries such as Pedro de Gante had first realised the extent to which music and drama could be a benefit to the evangelisation effort. It did not take long for the initial songs and dances to be expanded with textual and theatrical performances similar to those that had been developed in the Iberian Peninsula in the late fifteenth and early sixteenth centuries, but repurposed with the goal of achieving the spiritual, cultural and political conversion of the Indigenous population on a mass scale. A well-known example of these performances was the staging of the *Conquest of Jerusalem* in early colonial Mexico. According to a description by Toribio de Benavente, this production took place in Tlaxcalla in June 1539 to commemorate the Truce of Nice (1538) between Spain and France, which allowed Charles V to focus once again on defeating the Ottoman Turks. The representation was carried out not in the Indigenous settlement itself, but 'in the city which they [the Spaniards] have recently begun to build down below on the plain'.[7] There,

> they left a big and very handsome plaza in the middle, and here they constructed Jerusalem on top of a building that they were erecting for the *cabildo* [town hall] ... Our Lord the Emperor was stationed opposite Jerusalem, to the east and outside of the plaza. To the right of Jerusalem was the camp to be occupied by the army of Spain. Opposite to this was a place prepared for the provinces of New Spain, and in the centre of the plaza was Santa Fe, where the Emperor was to be lodged with his army. All those places were surrounded by walls and painted on the outside to look like stone-work, with their embrasures for cannon, their loopholes and battlements, all very realistic.[8]

It was a striking example of the convergence of urbanism, theatre and conversion. By staging the old city of Jerusalem in the middle of the construction site of the new colonial city and having the Tlaxcalla Indigenous population participate both as spectators and actors, the Spaniards aimed to incorporate Tlaxcallans into the history of salvation as well as to indoctrinate them on the alleged role of the Spanish King in the long awaited second coming of Christ.[9] The religious significance of the whole event was underlined by the remarkable fact that the army of the Tlaxcallans of New Spain was baptised during and as part of the play – and not in fiction, but in reality – thereby blurring the lines between ritual and theatre.

The Sultan brought with him many Turks (these were adult Indians whom they had planned to have baptized) and publicly they asked the Pope to let them be baptized. His Holiness at once ordered a priest to baptize them, and they were actually baptized. Then the Most Blessed Sacrament was removed and the procession went on in order.[10]

It must be noted that, for the Franciscans, baptism was a sacrament that had the immediate metaphysical effect of transforming the individual into a member of the Church, regardless of his or her complete grasping of the revealed doctrine. It was a spiritual transmutation, not an intellectual one. Therefore, the use of theatre and the staging of mass baptisms were seen as legitimate means to achieve the quick conversion of the Indigenous populations, especially considering the shortage of priests.[11] The alleged success of these mass conversions reinforced Franciscan millenarianist ideas and the role of the Franciscan Order in the spiritual conquest of the New World and the Second Coming of Jesus Christ.[12] Not everyone agreed, however. In fact, the unorthodox methods used by the Franciscans to hasten the conversion of the peoples of the New World proved controversial. As Indigenous peoples reverted to their old religious beliefs and practices, the secular Church as well as other religious orders, such as the Dominicans, questioned the Franciscans' methods as inadequate and ineffectual, emphasising instead the importance of teaching and understanding the Word of Christ as the only path to a true and long-lasting conversion of the native populations. As a result of their combined pressure, Pope Paul III issued the Papal Decree *Altitudo divini consilii* on 1 June 1537 to prohibit mass baptisms. However, the Franciscans did not concede defeat on the issue until the ecclesiastical synod of 17 April 1539, which enforced the application of the prohibition. Although performances and mass baptisms did not immediately cease, as illustrated by the staging of the *Conquest of Jerusalem* itself, the successful attack on the Franciscan methods of conversion had far-reaching implications for their evangelical theatre. The representation of the sacraments on stage as well as in other non-liturgical contexts became subject to increased scrutiny by Church authorities in both the Americas and the Iberian Peninsula. Together with the renewed emphasis on interior forms of conversion, rather than purely ritualistic ones, these events led to the decline of this kind of dramaturgy. However, it was not the end of the polemics of conversion in Spanish theatre.

Back on the Peninsula, the situation was, if anything, even more confusing than in the Americas due to the existence of multiple and overlapping conversional situations. These included the forced conversion of the Spanish Jews, the expulsion of the *moriscos* from the King's territories, the threatening expansion of Reformist and Protestant thought, and the spread of heterodox and unsanctioned forms of popular religion. The task of figuring out how to

repurpose theatrical resources in Counter-Reformation Spain fell to an emerging religious order, the Jesuits. Over the following decades, Jesuit drama would endeavour to build on interest in classical theatre and theatrical traditions already present on the Peninsula in order to advance the cause of Catholicism on the global stage without resorting to the questionable dramatic and sacramental tactics practiced by the Franciscans.

The importance that theatre would eventually have for the Jesuits was to a certain extent unexpected. The Society of Jesus was founded in 1534 by Ignatius of Loyola and approved by Pope Paul III in 1540. Its aim was to defend Catholicism against the Protestant heresy and to extend the Christian faith to the four corners of the world through preaching and missionary work. While it could perhaps be argued as Kevin J. Wetmore does that 'Jesuit spirituality is inherently theatrical',[13] theatre as such did not rank very high in the original priorities of a religious order that had adopted a militant and military imaginary as part of its identity. However, it quickly found a space in the schools, colleges and universities created by the Jesuits as part of their efforts to counter the Protestant threat on theological, intellectual and propagandistic grounds.

In 1599, the Order produced the 'Ratio Studiorum', a set of regulatory directives for Jesuit schools that recognised the increasing importance of theatre. In a section devoted to rectors of Jesuit colleges and universities, the Ratio established two rules linked to theatrical performances. Rule thirteen declared that

> tragedies and comedies, which are to be produced only rarely and in Latin, must have a spiritual and edifying theme. Whatever is introduced as an interlude must be in Latin and observe propriety. No female make-up or costume is to be permitted.[14]

Rule sixteen prescribed that plays performed in Jesuit schools should be selected by the Prefect of Studies or other individuals judged competent, and that copies of all literary works 'written and displayed within the college and outside by members of the Society – dialogues, addresses, verses and works of a similar nature – be preserved in the archives' for future consultation.[15] While rule sixteen was scrupulously followed, the same could not be said of rule thirteen. Vernacular languages

> were soon introduced and the number and topics of the representations were expanded to the point that, by the end of the sixteenth century, it was customary to represent Eclogues, Tragedies, Comedies, Sacramental *autos* and *entremeses* dealing with both profane and religious topics in the numerous schools that the Company had in Europe and America.[16]

As a result, the theatrical experimentation initiated by the Franciscans received a decisive new impulse by the Jesuits. In opposition to the Franciscans,

however, Jesuit plays were not created for the purpose of the quick conversion and indoctrination of the (Indigenous) masses. While conscious of its appeal to a wider public, Jesuit theatre was often addressed to the local elites and was intellectually more sophisticated than the drama of the Franciscans. Alongside erudite references to ecclesiastical and theological sources, Jesuit theatre incorporated elements from classical theatre and echoed elements of the new dramaturgy that had emerged in the Iberian Peninsula since the late fifteenth century.

A significant example of this Jesuit 'theatrical Counter-Reformation', as René Fülöp-Miller called it in the 1930s,[17] was the staging of the *Tragedia de San Hermenegildo* (*Tragedy of Saint Hermenegild*) in Seville on 25 January 1590, which coincided with the inauguration of a new Jesuit school designed by famed architect Juan Bautista Villalpando.[18] The play aimed not only to commemorate the canonisation of King Hermenegild, which had taken place just a few years earlier, in 1585, but to honour the city of Seville and its decisive support for 'the construction of this public school devoted to the general study of Human Letters'.[19] The Jesuits had first arrived in Seville in 1554, and their influence grew quickly. By 1579, the Order already had nine schools and over 260 members distributed throughout the province. By 1590, it had become one of the most powerful religious institutions, if not the most powerful, in a city that had benefited extraordinarily from the immense wealth brought from America, making it one of the richest cities in the Iberian Peninsula. Despite its cosmopolitanism, Seville was also a renowned site of Catholic religious orthodoxy, where authorities were especially active in the persecution of anyone suspected of Jewish, *converso* or Reformist sympathies.[20]

As such, the *Tragedia de San Hermenegildo* was a celebration of the Jesuit presence in Seville and a dramatised declaration of their superior religious understanding of the history of Catholicism, especially in contrast to old and new heresies. For their staging of the life of the King of Seville, the play's authors, Hernando de Avila, Juan de Arguijo and Melchor de la Cerda, followed the traditional narrative established by Ambrosio de Morales in his *Coronica General de España*.[21] According to Morales, Hermenegild had converted to Catholicism under the influence of his wife, Ingunda, and with the strong of opposition of his father, King Leovigildo, who demanded that his son renounce his newly acquired faith and surrender his control over Seville. Hermenegildo's refusal led to his imprisonment and martyrdom. According to legend, his spilled blood became the fountain that would eventually lead to the conversion of Spain to Catholicism and, by extension, of the lands of its overseas empire.[22] Between acts, the tragedy included short burlesque plays that represented the defeat of Ignorance and its allies, Sensual Love and Love for Self-Interest, at the hands of Hercules, who as the mythical founder of Seville, throws support behind Science and its two allies, Love for Science and Honorable Love.[23] The combination of popular and learned forms of theatre,

together with the appeal inherent in the staging of the life of a local legendary figure, made the play an unqualified success.[24] Its potential for the Counter-Reformist efforts of Imperial Spain did not go unnoticed, and it was staged 'at some point or another in most Jesuit colleges in and outside the Iberian peninsula in the following decade and throughout the seventeenth century'.[25] It was not only those interested in spreading the word of God who took notice. Among those who understood the aesthetic, theological and philosophical potential of the emerging Jesuit theatre was a new generation of playwrights who found, in the narrow streets of Madrid, a public eager to see the drama of conversion under a new light.

By the end of the sixteenth century, Madrid had been transformed from a relatively small town into the European capital of a global empire. This radical transformation made it the rival of far-more established cities such as Toledo or Seville as the centre of Spanish theatrical life. Religious brotherhoods found a stable source of income in the management of the *corrales*, where plays on religious and secular themes were regularly staged. For their part, playwrights and actors enjoyed unprecedented access to a public willing to pay for this new form of entertainment. Their association with the brotherhoods in charge of the *corrales* did not shield them from the ever-present gaze of the Inquisition, but it helped them to become ingrained in the social and cultural fabric of the city. The definitive establishment of the Spanish Royal Court in the city in 1606 offered new channels for theatrical and para-theatrical activities that greatly benefited those who made a living out of fulfilling the constant demand for new plays and spectacles. As a result, seventeenth-century Madrid became a privileged theatrical space in which to represent the aspirations and social anxieties of imperial Spain. Unsurprisingly, the dilemmas linked to religious and social conversion soon occupied centre stage.

Towering above his contemporaries, the figure of Lope de Vega dominated Madrid's theatrical life at this time. Lope was a careful observer of Jesuit theatre, having studied at the Jesuit Colegio Imperial in Madrid from 1572 to 1574. However, he addressed the problem of conversion from a rather different perspective. While for the Jesuits the purpose of theatre, according to Wetmore, was 'to delight and entertain in order to teach about Catholic doctrine and argue against the Reformation',[26] for Lope de Vega it became an end in itself with its own rules and principles, which he laid out in his *Arte nuevo de hacer comedias* (1609). His aim was to overcome the classical divide between comedy and tragedy and transform theatre from a moralising experience into an entertainment form in which the audience was king. He adhered to these principles in his historical and romantic plays, and also in his plays dealing with religious topics. Rather than shying away from hagiographic and conversional plays, Lope embraced them wholeheartedly, and for good reasons: civil and ecclesiastical authorities looked upon conversional drama

favourably due to its (allegedly) pious content, and the public loved it for the combination of adventure, violence and supernatural references. Once romantic and even comic subplots were added to the mix, the result was a winning combination.

Lope de Vega's plays were heavily ideological, but not as inherently doctrinal and pedagogical in nature as Jesuit drama. His own take on the story of Saint Hermenegild, which he adapted in his play *La mayor corona* (*The Largest Crown*), makes the King of Seville no less a champion of Catholicism and of Spanish national identity than the Jesuit version.[27] However, Lope de Vega stripped the Jesuit *Tragedy of Saint Hermenegild* of its heavily allegorical and intellectualising elements and replaced them with a heavy dose of dramatic (and tacitly sexual) tension. In the Jesuit version of the play, the wife of Hermenegild is of secondary importance to the plot, as was probably to be expected due to the limited role of women in Jesuit theatre. However, in Lope de Vega's *La mayor corona*, the physical and spiritual love between the future saint and his wife is at the centre of fast-paced action that relentlessly moves towards the dramatic final moments of Saint Hermenegild's life, where he is offered the head of his son on a platter before dying as a martyr.[28] In Lope de Vega's play, Hermenegild's conversion derives from the self-evident intellectual superiority of Roman Catholicism and the daring actions and raw emotions of the protagonists. Conversion is presented, not so much as a product of the intellect, but as a product of the passions of the soul. Actions rather than thoughts are the prime movers of affections, and affections are what propels the play's characters to their tragic fates in the end.

Lope de Vega's ability to fuse popular piety and Counter-Reformist propaganda in a coherent – and entertaining – whole found another expression in the plays that he dedicated to Isidore the Laborer, a twelfth-century farmer who became the patron saint of Madrid in 1622. Lope's involvement in the campaign to support Isidore's canonisation –designed to raise the religious and political profile of Spain's new capital – started in 1599, when he published a long poem about the saint's life. A play entitled *San Isidro Labrador de Madrid* (*Saint Isidore the Laborer*) followed almost twenty years later, appearing in print in 1617, coinciding with a critical moment in the canonisation process. Its success combined with the arrival of the news confirming that Isidore had been raised to the altars led to Lope's designation as one of the chroniclers of the festivities that Madrid organised to commemorate the occasion. As part of those festivities, he also wrote, staged and published two sequels to his 1617 play on the life of Saint Isidore: *La niñez de San Isidro* (*The Infancy of Saint Isidore*) and *La juventud de San Isidro* (*The Youth of Saint Isidore*). Due to time restrictions and the demands of the civil and ecclesiastical authorities in charge of the event, these two plays were performed 'on two *medios carros*, just like *autos*', as Elaine Canning has pointed out.[29] It is therefore possible

to consider these works as two acts of one play. Far from an arid doctrinal approach, Lope de Vega's plays on the life of Isidore brought to the stage a lively tale that relied on the many historical anecdotes and local legends that had made him an object of curiosity and intense devotion in Madrid and its surroundings. In the case of Saint Isidore, Lope also managed to include in the plot the romantic (but extremely chaste) relationship between the Saint and his wife, Saint María de la Cabeza, alongside the many supernatural events that dotted the life of this poor but devout peasant. By doing so, Lope's plays on Isidore's life successfully bridged the gulf between popular and orthodox forms of religion as well as between piety and entertainment. In the process, Lope successfully refashioned his own public image from that of an author who had been banned from Madrid in 1588 – accused of libel against his lover Elena Osorio (the 'Filis' of his poems) and her family – to become one of Madrid's most beloved and sought-after sons.[30]

Local stories of devotion and conversion were not the only narratives that attracted Lope's attention. As the foremost dramatic author in the capital of an empire bent on a global conversional project, Lope de Vega was not oblivious to the controversial issue of the conversion to Christianity of non-Western peoples and societies. A case in point was the evangelisation of Japan, a veritable emotional and political rollercoaster as far as conversion was concerned. His interest was spurred by two contemporary events of opposing significance. The first was the arrival of Japanese ambassador Rokuemon Hasekura to Phillip III's Royal Court in 1615 and his public conversion to Roman Catholicism, which attracted considerable curiosity at a time when these kinds of events were readily interpreted as a sign of the imminent triumph of global Catholicism.[31] The second event, offering an almost perfect counterpoint, was the distressing news about the persecution of Dominican missionaries in Japan, and more specifically, the martyrdom suffered in 1617 by Friar Alonso Navarrete and his companions as a result of their evangelisation efforts. Lope de Vega eulogised those who had participated in the 'heroic' conversion of Japan and the Japanese martyrs in his 1618 historical account, *Triunfo de la fe en los reinos del Japón* (*The Triumph of Faith in the Kingdoms of Japan*). The play *Mártires de Japón* (*The Martyrs of Japan*), written around the same time at the request of Friar Navarrete's brother, Pedro Fernández Navarrete, has also been attributed to Lope de Vega, although questions remain as to whether he really was the author of this work. Nevertheless, the fact that he was considered the play's author by his contemporaries shows that Lope de Vega occupied a significant place in the public imaginary of the time and that many considered the drama to be worthy of his pen.[32]

Closer to home, Lope de Vega addressed the difficult problem of the conversion to and from Islam in two earlier works that coincided chronologically with the 1599 royal wedding between Philip III and Margarite of Austria in

Valencia, both of them well-known for their anti-Morisco stance. In his histor-
ical play *Tragedia del rey don Sebastián y bautismo del Príncipe de Marruecos*
(*Tragedy of King Sebastian and Baptism of the Prince of Morocco*), written
between 1595 and 1603, he recounted the story of the 1593 conversion of
Mawlay Sayj, also known as Muley Jeque, son of Abû `Abd Allah Mohammed
al- Mutawakkil, former Sultan of Morocco.[33] After having been deposed by
the Saadi prince Abu Marwan Abd al-Malik, al-Mutawakkil fled to Portugal,
where he joined forces with the young Portuguese King Dom Sebastian, who
in turn dreamt of the conquest and conversion of that kingdom. In 1578, the
decisive battle of Alcazarquivir (Morocco) ended 'in a complete rout of
the Portuguese resulting in the deaths of 20,000 Portuguese troops along with
the deaths of three sovereigns: Sebastian, al-Mutawakkil and Abd al-Malik'.[34]
It also meant that, according to the line of succession, King Philip II became the
new sovereign of Portugal. Lope's *Tragedia del rey don Sebastián y bautismo
del Príncipe de Marruecos* was at the same time a re-enactment of the success-
ful conversion of Muley Jeque (who rejected his dynastic rights in order to
embrace Christianity), a cautionary tale about the political miscalculations of
the Portuguese nobility, and a celebration of Philip II's reign.[35] Lope adopted a
much darker stance when dealing with the problem of the 'failed' conversion of
the Morisco population as illustrated by *Los cautivos de Argel* (*The Captives
of Argel*), a play written around 1599 coinciding with the royal wedding in
Valencia, and while he himself was present in that city. As Natalio Ohanna
has shown, Lope's work is based on the inquisitorial trial and public execution
of a *morisco* named Abdela Alicaxet in 1576, who was burnt at the stake in
Valencia accused of professing the Muslim faith and having joined the pirates
raiding the Spanish coast from Algiers.[36] Similarly, the plot of *Los cautivos
de Argel* revolves around the figure of a Valencian *morisco* named Francisco
who, after meeting with the Berber pirate Dalí, decides to join him and flee
to Algiers. There, he converts to Islam and adopts the name Fuquer, joining
other pirates in attacking the Valencian countryside. In so doing, Lope presents
Francisco/Fuquer as the embodiment of the quintessential *morisco*: both a
wicked traitor willing to help the enemies of Spain and a false Christian whose
conversion cannot be trusted. In essence, this was how the entire Morisco
population came to be seen by those who supported the expulsion, and chiefly
among them the newly wed Spanish monarchs and their *valido*, the Duke of
Lerma. While raiding the region of his birth, Francisco/Fuquer is finally cap-
tured near his hometown and recognised by his countrymen. Confronted with
the enormity of his crime, he abjures his Muslim faith – something the defiant
Abdela Alicaxet never did – before being put to death.

　　While not afraid to use his pen to take a stance on contemporary events
such as those described so far, especially if it could ingratiate him with the
patronage networks of the Spanish court, Lope de Vega usually preferred to

approach the always controversial topic of conversion from the point of view of more established historical figures and narratives. Plays such as *El prodigio de Etiopía* (*The Prodigy from Ethiopia*) – a work on the conversion of a black slave and former bandit who must fight the temptations of his past life in his path to sainthood – and *El Santo negro Rosambuco* (*Rosambuco, the Black Saint*) – a recreation of the life of Saint Benedict of Palermo, a former black pirate who joined the Franciscan order – approached the problem of conversion from a safer historical and political distance.[37] In these works, in which the interplay of race, religion and slavery figures prominently, Lope de Vega explored the individual's ability to convert to Christianity and rise to the highest spiritual state regardless of ethnic origins and social status,[38] a chance that (as we have seen) Lope considered that the Morisco population had been offered, but failed to seize. True to style, Lope de Vega addressed the conversion of these black characters not through a succession of moralising discourses, but through fast-paced actions. The protagonists are brought into contact with natural and supernatural forces that rock their belief systems and then find themselves navigating the intricacies of a social and religious setting that is fundamentally alien to them. As in prior works, Lope de Vega did not fail to include romantic subplots (as illustrated by Juana's scarcely veiled sexual attraction for Rosambuco) as well as comical situations, often racially prejudiced. Not everyone approved, though. Perhaps unsurprisingly, Lope was often accused of using his fertile imagination and poetic licence to distort the facts and true meaning of the conversion stories that he presented on stage. In the case of *El santo negro Rosambuco*, the Spanish critic Menéndez Pelayo claimed – echoing the words of an earlier, eighteenth-century commentator – that the play contained 'more lies than scenes' and that the text was full of 'feigned declamations, false miracles, unworthy pranks, chimeric bravados and, in sum, everything that never happened in the life of the protagonist'.[39]

The above-stated criticism could easily be extended to all or most of Lope de Vega's conversional plays since he certainly altered the established narratives in order to make them conform to the requirements of the stage, to his audiences' social and religious imaginaries, and, when required, even to the desires of his patrons. However, his approach to the problem of conversion was not necessarily oblivious to philosophical conundrums, as his play *Lo fingido verdadero* (*Acting is Believing*), published in 1621, aptly illustrates. In this portrayal of the life of Saint Genesius of Rome, a pagan dramatist and actor who became a martyr and eventually the patron saint of comedians, Lope de Vega explored the limits of conversion and its representation in a manner that recalls the controversies surrounding the evangelical theatre of the Franciscans and anticipates some of Calderón's self-referential dramatic plots. After losing his beloved Marcela to his rival Octavio, Genesius accepts Emperor Diocleciano's request to stage a theatrical piece on the topic of Christian converts. As he

rehearses his part in the play, in which he himself impersonates a pagan who asks to be baptised, he hears an otherworldly voice announcing his future salvation. During the performance, Genesius is baptised by a true angel rather than by the actor who had been charged with that role, a strategy that is itself an echo of the theatre controversies and the sacraments already discussed earlier in this chapter. Furious at being unable to separate fact from fiction by reason and experience alone, the Emperor steps on stage, further blurring fiction and reality, as he cruelly decides to punish Genesius, thereby laying the groundwork for him to become a martyr and a saint.[40]

Philosophical and metatheatrical conundrums aside, Lope de Vega's unconventional, and even playful, treatment of religious figures and topics led him into conflict with the Holy Office. Moralists such as the Jesuit Pedro de Ribadeneyra had condemned the new theatre emerging in Spain at the end of the sixteenth century in the strongest terms possible, accusing it of being fountain and spring of all evils, chair of pestilence, school of incontinence, mill of lust, oven of Babylon, and a festival of demons, among other demeaning epithets borrowed from Saint John Crisostomo.[41] As Urzáiz Tortejada reminds us, the Inquisition had also vigorously persecuted 'the combination of the comic and the sacred in theatre, as well as the excesses that the popular cult to the saints generated'.[42] Lope de Vega would experience this firsthand in 1608 when the Holy Office sequestered his play on the conversion of Saint Augustine, a religious figure to which he felt particularly attached, especially after 1610, when he underwent an inner 'conversion' on the Augustinian model, and initiated a cycle of meditation and repentance, eventually becoming a priest in 1614.[43] His request for the play to be returned so that he could amend those aspects that might have been considered indecent was succinctly denied. His prestige as a dramatist, his general defence of Catholicism and of the Spanish Crown, and the fact that he himself had been named to a sinecure position as a familiar of the Inquisition that same year[44] – and later prosecutor to the Apostolic Chamber – basically guaranteed that he did not have to fear prosecution for whatever faults were found in the text. All of Lope de Vega's fame and other 'virtues' were not enough to save the work, although some scholars have argued that this play might have been the same that was later printed under the title *El divino africano* (*The Divine African*) in 1623.[45]

If Lope dominated the theatrical stage of the early 1600s in Madrid, it was in Pedro Calderón de la Barca's plays and sacramental *autos* that the polemics of conversion found their most fertile ground in the central years of the seventeenth century. Like Lope, Calderón was strongly influenced by Jesuit theatre, having also attended the Jesuit Colegio Imperial in Madrid from which he left to study in Salamanca.[46] Also like his predecessor, Calderón did not shy away from dramatising some of the most significant (and controversial) conversional events of his time. In *La protestación de la fe* (*The Protestation of*

Faith), written in 1656, Calderón dramatised one of the most famous cases of the entire seventeenth century: the Catholic conversion of Queen Christina of Sweden. Born in 1626, Christina was officially proclaimed Queen of Sweden at the age of six following the death of her father at the battle of Lützen, although she did not become the effective ruler of the realm until the age of eighteen. A patron of artists and men of letters, she was one of the most educated women of her time. This 'Minerva of the North', as she was known by her contemporaries, had already stirred considerable controversy with her decision not to marry. She rocked her kingdom – and all of Europe – once again in 1654 when she abdicated the Crown to her cousin Charles Gustav and converted to Catholicism, an action secretly supported by Philip IV of Spain who had sent his ambassador Antonio Pimentel de Prado to counsel her in 1652. After leaving Sweden and spending a brief time in Brussels, Cristina moved to Rome, where she would become known as much for her lavish lifestyle and love affairs as for her support of the arts, being described by Pope Alexander VIII as 'a Queen without a realm, a Christian without faith, and a woman without shame'.[47]

Christina's free spirit and eccentric nature – too free and eccentric for the taste of Philip IV, as it would eventually turn out – was not what captured Calderón's imagination in the sacramental *auto*, *La protestación de la fe*. Written in 1656, this heavily allegorical play begins with a discussion between Wisdom (Catholicism) and Heresy (Protestantism and, more specifically, Lutheranism). Following the advice of Wisdom, Christina becomes acquainted with Saint Augustine's theology, and his ideas on grace and free will, which in turn leads her to question the faith of her ancestors. Waking up from a dream-vision of Philip the Apostle, she receives the providential visit from Catholic Religion and Secular Arm, who were sent by King Philip IV to provide her with political and spiritual aid. With their help, Christina takes the fateful decision to confront Heresy, renouncing both her faith and her kingdom. After Christina 'protests' Catholicism as the only true faith, Heresy is condemned by Wisdom and 'relaxed' to the Secular Arm for punishment.[48] Christina's conversion was to be superbly staged in two chariots: one of them carrying Wisdom adorned with a tiara, a cloak and a triple cross in its hand; in the other was to appear Christina crowned with a laurel wreath and dressed in her own imperial cloak. Catholic Religion would lead both of them to the banquet of the Eucharist where they would sit side by side.[49] Undoubtedly, *La protestación de la fe* was designed as an ecstatic celebration of orthodox Catholicism, but also – in a very Calderonian fashion – an exploration of the limits of royal power, the changes of fortune and conscience, and the extraordinary role of a singular woman in shaping European politics. Unfortunately for Calderón, news of Christina's scandalous life in Rome and of her changing political alliances made the King order the postponement of the play.[50]

A few years later, Calderón turned his attention to yet another famous con-version that seemed to herald – once again – the triumph of global Catholicism. This time it was not a Swedish Queen (nor a Japanese ambassador, as Lope de Vega had witnessed in 1615), but a Muslim prince. Mohammed El Attaz, son of Abdalauhid, King of Fez, had renounced his faith in 1656 to become a Jesuit priest. That such a high-profile figure would convert to Catholicism generated much curiosity in Spain and other parts of Europe. As heir to the throne of Fez, El Attaz had embarked for Mecca in 1651 in order to complete the Hajj before ascending to the throne. However, his ship was captured by the Knights of Saint-Jean near Cap Bon and taken to Malta, where he devoted his days as a captive to the comparative study of Christianity and Islam. Following a mystical revelation, he converted to Catholicism in 1656 despite the ransom paid for his freedom by the Bey of Tunis. He then moved to Italy where, after adopting the Christian name of Baldassarre Loyola de Mandes, he devoted his efforts to the evangelisation of other Muslim captives, eventually achieving his goal of becoming a Jesuit in 1663. His status as a former Muslim prince and his growing fame as a charismatic Christian preacher and proselytiser did not go unnoticed in Rome. The Pope granted his wish to join the diplomatic mission to the court of the Grand Mogol in India that was to depart from Lisbon. However, his dream to participate in the long-awaited conversion of the East with the hope of receiving the gift of martyrdom was cut short. After travelling through France, he arrived in Madrid in 1667, where he died in the Imperial College on 15 September. Legend has it that he still managed to convert a young Muslim while on his deathbed. News of his death spread quickly through Madrid, and the Queen herself supervised the funeral, which was attended by many members of the Royal Court.[51]

Calderón dramatised the life of Mohammed El Attaz in his work *El gran príncipe de Fez* (*The Great Prince of Fez*), which was staged at the Palacio Real de Madrid in 1669. It was certainly not the first play to portray the problem of conversion from and to Islam in the seventeenth century. As discussed at the beginning of this chapter, the life of Muhammad himself had been staged in satirical plays such as those by Mira de Amescua, *Vida y muerte del falso profeta Mahoma* (1609), and Rojas Zorrilla, *El profeta falso Mahoma* (1640).[52] Lope de Vega had also addressed the topic of successful and failed conversions from Islam in at least two of his plays, *Tragedia del rey don Sebastián y bautismo del Príncipe de Marruecos* and *Los cautivos de Argel*, analysed earlier in this essay. Another distinguished author who joined them in presenting the problem of Muslim conversion in his plays, albeit with far less public success, was Miguel de Cervantes. He did so in *Los baños de Argel* (*The Baths of Algiers*), based to a large extent on Cervantes' own experience of captivity in Algiers, and *La Gran Sultana* (*The Wife of the Great Sultan, Doña Catalina de Oviedo*), a comedy that dramatises 'the passion aroused

in an Ottoman Sultan, by Catalina de Oviedo, an exceptionally beautiful harem-slave who has escaped conversion to Islam'[53] and succeeds not only in keeping her Christian faith, but also in becoming Grand Sultana herself by marriage. The interaction between Muslims and Christians also takes centre stage in Cervantes' *El gallardo español* (*The Valiant Spaniard*), published in 1615 as part of *Ocho comedias y ocho entremeses nuevos nunca representados*. However, conversion is of secondary importance in this predominantly epic and chivalric play. The action, which takes place during the 1563 siege of Oran, revolves around the military actions and romantic adventures of Fernando de Saavedra, a Spaniard who falls in love with a Moorish woman (Mora Arlaxa) but ends up marrying a Spanish woman (Margarita), who reveals herself to be his true love. While the protagonists frequently crossdress – even pretending to be of a different gender to achieve their goals – they do not properly 'convert' as illustrated by the fact that their marriages finally take place with members of their own social and religious groups. This is also the case of *La conquista de Jerusalem por Godofre de Bullón* (*The Conquest of Jerusalem by Godfrey of Bouillon*), which has been attributed to Cervantes although doubts remain about his authorship. Based on Tasso's *Gerusalemme Liberata* (1581), this historical play re-enacts the conquest of Jerusalem during the First Crusade interspersing various romantic subplots among the play's Christian and Muslim protagonists.[54] Either through epic, comedy or drama, the conversion of the Muslim 'other' – and the risk of converting to Islam for those Christians who fell prisoners to Muslim forces in the Mediterranean – had already found a space in the *corrales* of Madrid long before Calderón staged the story of Mohammed El Attaz.

In *El gran príncipe de Fez*, Calderón presented Baldassarre's famed conversion, of which Baldassarre himself left us an account, as the result of a series of dialectical and allegorical quarrels between his two inner natures: his Good and Evil Genies.[55] These quarrels start after he reads a passage of the Koran that, despite all his intellectual prowess, he is unable to understand. His Good Genie then leads him to a passage of Pedro de Rivadeneyra's *Vida de San Ignacio de Loyola* (1611) – the same Jesuit who had condemned secular theatre in his *De la tribulación*. In this text, the theologian and moralist narrated the chance encounter between a Muslim and Ignatius of Loyola during the latter's pilgrimage to the monastery of Montserrat as well as the discussion that ensued between them about the mystery of the Immaculate Conception. In Calderón's play, this spiritual revelation is then followed by a series of supernatural events that only a terrorised Mulay Mahomet is able to see. Believing to have been forsaken by the Prophet and unable to explain the extraordinary phenomena happening around him through reason alone, he then invokes the help of the Virgin Mary, who miraculously appears in a cloud and commands him to return to Malta to be baptised.[56] The play ends with Baldassarre's

death, which happens before he is able to achieve his desired martyrdom, nevertheless making him a martyr in spirit.

In typical Counter-Reformation fashion, Calderón presented conversion as a process of doubt and self-discovery aided by Reason and Grace. However, conversion could not properly take place without the exercise of God's double-edged gift to the human race: free will. Thanks to the freedom to choose between good and evil, it was entirely possible for an individual or a community to reject both reason and grace and refuse conversion. Both in Christian tradition and in Calderonian dramaturgy, the paradigmatic case was that of the Jews, but addressing the Jews' (lack of) conversion was not as straightforward as it might seem. The pogroms and forced conversions of the previous centuries, the long arm of the Inquisition, and the doubts and questions that could arise about one's own genealogy or that of close relatives and friends made dealing with the conversion of the Jews and/or the *converso* predicament an uncomfortable topic that many authors either avoided altogether or addressed from an orthodox perspective, even when they were of *converso* origin themselves. Not doing so could have tragic consequences, as illustrated by the case of Fernando de Zárate, the best-known alias of Antonio Enríquez Gómez (1600–63).[57]

Born in Cuenca around 1600 in a family of strong *converso* background (his father was a *converso* and his mother an Old Christian), Enríquez Gómez settled in Seville where he worked in his paternal uncle's shop and married an Old Christian before moving to Madrid in 1619.[58] Once there, Enríquez Gómez became acquainted with Lope de Vega's literary circle and soon became a successful playwright himself. As Cayetano Alberto de la Barrera y Leirado points out, 'during this time [Gómez] wrote several comedies that, performed in the theatres of the capital, were very well received, particularly *El Cardenal de Albornoz (The Cardinal Albornoz)* and the two on *Fernán Méndez Pinto*'.[59] Despite his success as a dramatic author, Enríquez Gómez moved to France in 1636. Whether his departure was due to being suspected of crypto-Judaism, to his attacks on the Count Duke of Oliviares or to the debts accumulated by his family in the wool and silk trading business is still a matter of conjecture. He joined the exiled Jewish and *converso* community and some of the texts that he wrote during this period were clearly influenced by this renewed contact with his roots.[60] In 1647, he published the work *Política angelica (Angelic Politics)*, whose criticism of the Holy Office caused it to be placed in the Index. Also during this time, he wrote his *Romance al divin mártir, Juda Creyente (The Ballad to the Divine Martyr, Judah the Believer)*, where he explicitly declared his religious convictions. Then, in 1649, he took the fateful decision to return to Spain, apparently for financial reasons connected with the family business and properties. He did so under several assumed names, including the one that would give him literary fame and public success: Fernando de Zárate. More

than thirty plays were published under this alias and at least twenty-seven can be linked to Enríquez Gómez with certainty.

He addressed the problem of conversion in several of these works but did so (at least superficially) in a highly orthodox way. Having settled in Seville, one of his first plays of this period was *Mártir and Rey de Sevilla* (*Martyr and King of Seville*) (1651), a piece on the conversion and martyrdom of none other than Saint Hermenegild. Writing a play on a popular local saint of legendary status whose life had already been adapted by the Jesuits more than fifty years earlier was a clever way for Fernando de Zárate to (re)introduce himself in the literary cultural life of the city while demonstrating (his) impeccable Old Christian credentials at the same time.[61] Other plays followed that extolled the conversional project of Spanish Catholicism. In *La Conquista de México* (*The Conquest of Mexico*), Zárate presented Hernán Cortés as a hero who takes on vastly superior armies of pagan enemies heralding the final triumph of the Christian faith. Perhaps more significant, in light of his family background, was *La Conversión de la Magdalena* (*The Conversion of Mary Magdalene*), an adaptation of the biblical story of Mary Magdalene, a Jewish woman and a renowned sinner who converted to the new Christian faith. However, rather than a reflection on the *converso* predicament, Zárate's take on Mary Magdalene's story focuses on the rejection of her former libertine life. So safe was the text from the point of view of Catholic orthodoxy that aside from some minor details that were dutifully expunged from the text, the censors did not find anything contrary to accepted Christian doctrine.[62] Nevertheless, some contemporary critics have argued that Zárate left textual clues interspersed in his plays readily identifiable by crypto-Jewish spectators and readers that allowed for more ironic and tragic readings of the apparently undeniable triumph of the Catholic faith. This interpretation is open to debate, but there is no doubt that he had not forgotten his Jewish heritage.[63]

Unfortunately, the Inquisition was already on his trail. His father and paternal uncle had been burned in effigy in 1651, having been accused of Judaising. In 1660, the same charges were levelled against the 'Captain Enrique Enríquez de Paz, also known as Antonio Enríquez Gómez',[64] and he too was burned in effigy in Seville. Enríquez Gómez was finally discovered and sent to prison in 1661 where he died in 1663. His fate is a bleak reminder that the polemics of conversion in seventeenth-century Spain were not just a subject for plays and make-believe, but also a serious affair with potentially deadly consequences.

Enríquez Gómez was not only acquainted with Calderón's dramaturgy. He was, in fact, influenced by him. Given his considerable fame and the limited size of the Spanish literary world at the time, it is likely that Calderón also knew who Fernando de Zárate was, although there is no indication that Calderón was aware of his true identity, origins and fate.[65] In any case, Calderón did not concern himself directly with the tragic predicament of the Spanish *conversos*.

In his works, Jews were mostly historical figures or allegorical ones. They played a key role in Calderón's theatrical exploration of grace, reason and personal freedom as the ultimate embodiment of Man's right to reject truth and conversion. Calderón even 'allowed' them to argue their case on stage, but only so that their arguments could be exposed as sophisms by Catholic Religion and its allies (Faith and Reason).

Calderón's sacramental *auto*, *El orden de Melquisedec* (*The order of Melchizedek*), written between 1652 and 1657,[66] illustrates the way in which he dramatised the polemics of conversion between Christians and Jews. King of Salem and priest of El Elyon ('God most high'),[67] Melchizedek is taken as a prefiguration of Christ and the Eucharist in the Christian tradition as a result of having used bread and wine during his blessing of Abraham. Taking the notion of prefiguration as its organising principle, Calderón's *El orden de Melquisedec* consists of a series of biblical scenes that allegorically anticipate the new priesthood embodied by Christ. One by one, these prefigurations are rejected by the Synagogue on spurious grounds and against all evidence. After having Christ die on the cross in a vain attempt to prevent the foretold coming of the new order, a frightful earthquake rocks the stage. Only at this point will the Synagogue acknowledge that the Old Testament scenes that had been enacted in the play were in fact a prefiguration of Christ. However, it is already too late. The exercise of freedom brings with it the possibility of punishment. For their conscious decision to reject truth and their collective failure to convert, the Jews are forever expelled from the Holy Land and cursed to roam the Earth suffering the wrath and persecution of the Gentiles, who declare themselves their eternal enemies.

Now, the fact that Calderón upheld the theological and metaphysical doctrine of free will does not mean that he endorsed the idea that conversion should, as a rule, be a purely private affair best left to an individual's conscience. As he illustrates in his aptly titled sacramental *auto*, *A Dios por Razón de Estado* (*To God by Reason of the State*), a pun against Niccolò Machiavelli, human thought is indeed free to wander from one corner of the imagination to the other. Humankind has adopted throughout history all kinds of 'false' beliefs, including those that led to the death of Christ on the cross, in order to satisfy specific social and political interests. However, in typically neo-scholastic fashion, Calderón argues that, if reason and natural law are strictly followed, they necessarily lead to the truth revealed in Catholic doctrine even in the absence of Grace. Taking this axiom to be self-evident, the social and political imposition of the Christian religion, and more specifically of Catholicism, is fully justified, and not on relativistic terms, as Machiavelli would have argued, but on theological and epistemological ones. For Calderón, Catholic doctrine and the obligation to convert is the only true *raison d'état*. As Human Ingenuity, one of the play's allegorical characters, aptly puts it:

love and belief in Christ may legitimately be imposed on the basis of [the true] Reason of State when faith falters, or as he says in Spanish, 'llegando a amar y creer por Razón de Estado cuando faltara la fe'.[68]

Despite Calderón's orthodox position in matters of faith and politics, his plays were not always free of controversy. In 1662, more than a decade after he had been ordained priest and with his literary fame already firmly established, two of his sacramental plays, *Las órdenes militares* (*The Military Orders*) and *Mística y Real Babilonia* (*Royal and Mystic Babylon*), also fell under the scrutinising gaze of the Inquisition. While in the case of *Mística y Real Babilonia*, the Inquisition limited itself to eliminate a mere two verses,[69] the work *Las órdenes militares*, an *auto* that celebrated the dogma of the pure conception of Mary, was not as lucky. The Holy Office found that the ideas against Mary's Immaculate Conception contained in the play were heretical and could lead to the dissemination of a false doctrine in spite of the fact that Calderón had placed them in the mouth of none other than the Devil. The sequestration of the work has been linked to the fall of the Count-Duke of Olivares and the designation of a new Inquisitor General contrary to Olivares' court circle, including Calderón.[70] However, the Inquisition was also painfully aware that, purposely or not, 'hurtful' doctrines had in fact been able to spread under the cover of being laid out for criticism. As a result, Calderón was forced to surrender all manuscript copies, and the play would remain condemned until 1671.

The controversy surrounding *Las órdenes militares* is representative of the sometimes-paradoxical nature of Calderón's plays. While there is no doubt that Calderón's theatre was in line with the positions defended by the Spanish monarchy and its understanding of the role of global Catholicism, modern critics have also pointed out that his plays brought forth the many political, theological and philosophical debates on kingship, faith and conversion of his age to a wider public. The process of argumentation, self-doubt and discovery, and not necessarily the resolution of those debates – always invariably supportive of the status quo – is what made Calderón's plays into much more than simple instruments of religious and political propaganda. They became true political and theological conversional dramas, and their influence was felt well beyond the walls of the royal palace and the narrow streets of Madrid, eventually reaching America.

In the New World, the evangelical theatre of the Franciscans had long disappeared by the end of the sixteenth century, but the rapid expansion of the Jesuit order made theatre a permanent fixture of cultural life in Spanish America up to the expulsion of the Society in 1767. The Jesuits succeeded in adapting their Counter-Reformation theatre to the American environment through their missions, schools and universities, encouraging the participation of different sectors of the population, and especially that of the colonial elite. Their dominance of the colonial stage was strengthened by the laws and

decrees prohibiting the introduction in the colonies of fictional works that were secular in nature, the limited development of the printing press at the local level, and the lack of access to public spaces and resources not directly supervised by religious institutions. All things considered, these factors contributed to make Jesuit theatre a formidable ideological force on a continental scale. Its influence reached authors who were not affiliated with the Society, such as Sor Juana Inés de la Cruz, who would herself devote one of her plays to the conversion and martyrdom of Saint Hermenegild. Eventually, the plays of Spanish dramatists of the sixteenth and seventeenth centuries also made it to the New World. Plays by Lope de Vega, Calderón and Mira de Amescua were even available in Indigenous languages for their use in the conversion process, as illustrated by Bartolomé de Alva Ixtlixóchil's translation of some of their works into Nahuatl.

It is far less clear, and surely unlikely, that black and Indigenous communities fully endorsed the triumphal narrative of conversion in the plays emanating from these Golden Age authors and their Jesuit counterparts. In the case of the Andes, the extirpation of idolatry campaigns of the late sixteenth century and early seventeenth century made the authorities realise that the process of conversion had been fundamentally flawed.[71] Whatever the degree of support Indigenous theatre might have enjoyed during the early phases of colonialisation, it came to be viewed with suspicion by colonial authorities, who considered it an obstacle for the effective evangelisation and subjugation of the King's Andean subjects.[72] Some plays continued to be written and performed in Quechua, as illustrated by the case of *Usca Paucar*, which was probably written between 1600 and 1640. However, there was very little space for an Indigenous exploration of the polemics of conversion like the sort found in the theatres of Madrid. In fact, it was not through theatre per se, but through paratheatrical performances in civil ceremonies and religious festivities that Indigenous peoples and Afro-descendants were able to re-enact part of their own cultural heritage and challenge, if not the dominant narratives of conversion, at least the place that these same narratives had assigned them.

The obvious limitations to free speech in both America and the Iberian Peninsula were intrinsic to these cultural productions and should not obscure the significance and often paradoxical nature of what was performed on stage in the period considered above. Regardless of whether it was a tool at the service of absolutism and Catholic dogma or a vehicle for more radical yet hidden ideologies, Spanish theatre during this period was a dramaturgy of conversion. There is little doubt that the army of Crown and Church officials ensured that all or most of the plays that were published or staged conformed to the limits marked by orthodoxy, at least superficially. There is also little doubt that most authors subscribed to the main ideological and religious tenets expressed in the imperial project of Counter-Reformation Spain. Within those

limits however, theatre offered a space for a reinterpretation and reinvention of the self as well as for religious and para-religious experiences. In fact, it often bridged accepted religious orthodoxy and the vast realm of legend, popular religion, and social and political anxieties and revindications. What happened on stage was often viewed with distrust by religious authorities who, in no small part, tolerated the many 'errors' and questionable morals they found in plays not simply because the populace enjoyed them, but because they were a fundamental source of revenue for local religious institutions and helped their proselytising efforts. However, plays meant different things for different people, and theatre was appropriated in diverse ways by the vastly different subjects of the Spanish monarchy. And so, despite all limitations and the ever present gaze of religious and state officials, theatre became one of the few spaces where the conversional potentialities of the early modern period could be discussed, re-enacted and experimented within the Spanish Atlantic world.

NOTES

1. The *moriscos* were the Spanish Muslims who converted or were forced to convert to Christianity following the fall of the Muslim Kingdom of Granada. King Philip III signed the Edict of Expulsion on 9 April 1609. For a history of the Spanish Muslims after the *Reconquista*, see Harvey, *Muslims in Spain, 1500 to 1614*, pp. 291–331; Domínguez Ortiz and Vincent, *Historia de los moriscos*, pp. 160–5.
2. Born in Guadix (Granada) around 1577, Mira de Amescua became one of the most important dramatists of the Spanish Golden Age, having written over sixty plays. *El esclavo del demonio*, his most famous work, is an exploration of the topic of free will in which the protagonist signs a pact with the devil in order to satisfy his sexual appetites before recognising his mistake and being redeemed by the intercession of his guardian angel. The attribution of *Vida y muerte del falso profeta Mahoma* to Mira de Amescua has been suggested by – among others – Ferrero Hernández, 'Mahoma como personaje teatral', pp. 237–54. For more information about the controversy surrounding this play, see Mami, Alvar and López Baralt, *El poeta morisco*, pp. 595–8. For a study on Antonio Mira de Amescua's theatre, see Muñoz Palomares, *El teatro de Mira de Amescua: para una lectura política y social de la comedia áurea*.
3. González Muñoz, 'Apuntes sobre el tratamiento del profeta Mahoma en Occidente', p. 97.
4. For a discussion on the Spanish Inquisition and the practice of censorship, see Márquez, *Literatura e Inquisición en España (1478–1834)*, pp. 159–200.
5. For the attribution of this text to Juan Alonso, see Castro, *Poetas líricos de los siglos XVI y XVII*, pp. xiv–vi.
6. Quoted in Granja, 'Comedias del Siglo de Oro censuradas por la Inquisición', p. 442. The text is found in the Biblioteca Nacional de España in Madrid with signature Códice CC 169. For more information about Morisco authors writing after the expulsion, see Wiegers, 'Las obras de polémica religiosa escritas por los moriscos fuera de España', pp. 391–413.
7. Motolinía, *Motolinía's History*, p. 110.
8. Ibid., p. 110.
9. For a discussion of the transformation of Tlaxcalla from Indigenous settlement to colonial city see Ybarra, *Performing Conquest*, pp. 45–51.

10. Motolinía, *Motolinía's* History, p. 117.

11. Harris, *The Dialogical Theatre*, p. 92.

12. For more information on Franciscan theatre and the conversion effort, see Surtz, 'Judíos y Reyes Magos gentiles', pp. 333–44; Ybarra, *Performing Conquest*, pp. 68–104; Harris, *Aztecs, Moors, and Christians*, pp. 132–47; Arróniz, *Teatro de evangelización en Nueva España*, pp. 82–91.

13. Wetmore, 'Jesuit Theater and Drama', n.p.

14. Anon., *The Jesuit Ratio Studiorum of 1599*, p. 17.

15. Ibid., p. 17.

16. González Montañés, 'El teatro en los colegios de los jesuitas', n.p.

17. Fülöp-Miller, *The Power and the Secret of the Jesuits*, p. 410.

18. For an in-depth analysis of this work and its relation to Spanish theatre and contemporary conceptions of sainthood see Muneroni, *Hermenegildo and the Jesuits*, pp. 85–163.

19. Quoted in Alonso Asenjo, *La tragedia de San Hermenegildo*, p. 38 (my translation).

20. See the classic study by Menéndez Pelayo, *Historia de los heterodoxos españoles*, pp. 431–50. See also Kagan and Dyer, *Inquisitorial Inquiries*, pp. 37–42, 180–93; and Hauben, *Three Spanish Heretics and the Reformation*, pp. 6–9; Gil, *Los conversos y la Inquisición sevillana*, vol. 1, pp. 337–80 and vol. 2, pp. 7–98; and Boeglin, *Entre la cruz y el Corán*, pp. 69–104.

21. Alonso Asenjo, *La tragedia de San Hermenegildo*, pp. 10–16.

22. According to other historical sources, the situation was far more complicated and nuanced. The confrontation between father and son had less to do with religion than with the control of resources and territories. According to Ruggerio ('History and Invention in "La tragedia de San Hermenegildo"', p. 198), Hermenegild's actions were more political than religious and Leovigild did not see his son's religious conversion as a political problem nor even one requiring the use of arms. Instead, Leovigild tried to contribute to a solution of the religious difficulties which divided Arians and Catholics. It was Hermenegild himself who complicated matters in a political way by arranging an alliance with the Byzantines and proclaiming himself king (in 582?). Given this situation, Leovigild had no choice but to march against him in 583, finally conquering him the following year.

23. See González Gutiérrez, 'Tragedia de San Hermenegildo', pp. 288–9.

24. Alonso Asenjo, *La tragedia de San Hermenegildo*, p. 36.

25. García Soriano, *El teatro universitario y humanístico en España*, p. 113.

26. Wetmore, 'Jesuit Theater and Drama', p. 9.

27. Lope must have written *La mayor corona* at the end of the first decade of the 1600s. As Stefano Muneroni has argued, 'it is quite possible that Lope had heard about the saint through his friend and colleague Juan de Arguijo, one of the three playwrights working on the 1590 representation of *La tragedia de San Hermenegildo* in Seville. Arguijo and Lope became close friends during one of Lope's many stays in Seville' (*Hermenegildo and the Jesuits*, p. 141).

28. Ingunda is not the only female character of relevance in the play, which contains other romantic subplots. As Muneroni points out, 'the main dramaturgical function of Bada and Lísipa is to reveal to the king that Ingunda is Catholic, but they also fuel the play with their jealousy, catty comments on Ingunda, and perfidious plan to seduce Hermenegildo. They are carriers of dangerous female seduction, and with their mere presence allude to the possibility, though remote, that Hermenegildo might fall from grace and betray his wife and religion' (*Hermenegildo and the Jesuits*, p. 160).

29. Canning, *Lope de Vega's 'Comedias de tema religioso'*, p. 84.

30. For the importance of Lope's works on Saint Isidore and the patronage circuits in the Spanish court of King Philip III, see Wright, 'Virtuous Labor, Courtly Laborer', pp. 223–40.

31. Lee, 'Lope de Vega and *The Martyrs of Japan*', pp. 229–30.

32. For a discussion of these and other texts of Lope de Vega on Japan, see Carreño, ' "... También sé yo escribir prosa historial cuando quiero" ', pp. 43–59.

33. According to Griswold Morley and Bruerton, the work was written between 1593 and 1603. A manuscript copy of the work was included in Anon., *Onzena parte de las comedias de Lope de Vega Carpio*.

34. Jenkins, *The Muslim Diaspora*, p. 110.

35. See Torres Martínez, 'La Virgen de la Cabeza y Andújar', pp. 239–64.

36. Ohanna, '*Los cautivos de Argel*', pp. 361–79. See also Ohanna, 'Introducción'.

37. Lope must have written *El prodigio de Etiopía* around 1600, but it was not published until 1645. For a discussion on the question of Lope's authorship of *El prodigio de Etiopía*, see Beusterien, *Lope de Vega*. As for *El santo negro Rosambuco*, it appeared for the first time in 1613 in Anon., *Tercera parte de las comedias de Lope de Vega*.

38. For the representation of blacks and blackness in the theatre of this period, see Fra Molinero, *La imagen de los negros en el teatro del Siglo de Oro*, and Barrios, 'Entre la esclavitud y el ensalzamiento', pp. 287–311.

39. Menéndez Pelayo, 'Observaciones preliminares', p. 19 (my translation).

40. For a discussion on the problem of conversion and metatheatricality in this play, see Álvarez Lobato, 'Lo sagrado y lo profano en lo fingido verdadero', pp. 133–53, as well as Fischer, 'Lope's "Lo fingido verdadero" and the Dramatization of the Theatrical Experience', pp. 156–66. Lope also dealt with the problem of conversion in early Christianity in his play *Los locos por el cielo* published in Madrid in 1617 in Anon., *El fénix de España Lope de Vega Carpio, familiar del Santo Oficio*, but probably written between 1598 and 1603. The play's protagonists, Indes and Dona, are part of the 20,000 martyrs of Nicomedia who were persecuted by Emperor Maximilian, and who pretended to be crazy in order to escape from the Emperor's men charged with apprehending them. As Borrego Gutiérrez points out ('Espacios de santidad y puesta en escena', p. 35), Lope's *Los locos por el cielo* is a choral work of collective exaltation and conversion that works its way through a veritable 'accumulation of conversions, sought-after martyrdoms, deaths, and humiliations in defense of the faith'.

41. Ribadeneyra, 'De la tribulación', p. 712.

42. Urzáiz Tortajada, 'Hagiografía y censura en el teatro clásico', p. 48. See also Granja, 'Comedias del Siglo de Oro censuradas por la Inquisición', pp. 435–48.

43. For the importance of the figure of Saint Augustine in Lope de Vega, see Lezcano Tosca, 'San Agustín en la literatura religiosa de Lope', pp. 137–50.

44. Lope de Vega was not the only famous writer to be a member of the Holy Office. Others, such as Antonio de Guevara, were also associated with this institution at some point in their careers. For more information about their relationship, see Márquez, *Literatura e Inquisición en España (1478–1834)*, pp. 121–39.

45. The version from 1608 was not returned to Lope, and there is no copy in the archives. Therefore, it is impossible to know whether *El divino africano* and *La conversión de San Agustín* are indeed the same work. For more information about this play and Lope de Vega's attempt at having it returned for correction, see Castro, 'Una comedia de Lope de Vega condenada por la Inquisición', pp. 311–13. A contemporary discussion of the controversy surrounding *La conversión de San Agustín* and *El divino africano* can be found in Florit Durán, 'Las censuras previas de representación en el Teatro Áureo', pp. 628–9. On the topic of censorship and

theatre, see Roldán Pérez, 'Censura Civil y censura inquisitorial en el teatro del siglo XVIII'.

46. For a biographical approach to Calderón de la Barca, see Cruickshank, *Calderón De La Barca: Su Carrera Secular*, and *Don Pedro Calderón*.

47. Quoted in Buckley, *Christina, Queen of Sweden*, p. 30.

48. For a discussion of the role of dreams in this *auto*, see Gibert, 'La dramatización de una conversión al catolicismo en el auto de Calderón *La protestación de la fe* (1656)', pp. 123–52.

49. Aszyk et al., *Teatro como espejo del teatro*, p. 37.

50. Ramírez de Villaurrutia, 'La reina Cristina de Suecia y los españoles', p. 421.

51. As Colombo and Sacconaghi have pointed out ('Telling the Untellable', pp. 286–7), Baldassarre is 'the only muslim prince who became a Jesuit, one of the few exceptions to the decree *De genere* (1593) that prevented new Christians from joining the Society'. His life is richly documented through first-person accounts (letters, an unpublished autobiography and a spiritual journal) in addition to other sources, including a biography by Domenico Brunacci, Baldassarre's spiritual director.

52. See González Muñoz, 'Apuntes sobre el tratamiento del profeta Mahoma en Occidente', pp. 93–106.

53. Lewis Smith, 'La Gran Sultana Doña Catalina de Oviedo', p. 68.

54. For a discussion of this work and the controversy about its authorship, see Cerezo Soler, 'La Conquista de Jerusalén', pp. 33–49. Cervantes' depiction of the consequences of the expulsion of the *moriscos* is famously presented in Chapter LIV of the second part of Don Quixote, when Sancho meets his old friend Ricote, a formerly wealthy *morisco* who informs him of his fate after the expulsion. Earlier in the first part, Chapter XXXVII, Cervantes had recounted Zoraida's extraordinary story of conversion, a Moorish woman educated by a Christian prisoner who flees to Christian lands longing for baptism. See Fine, 'On Conversion in "Don Quixote", or, the Cry of Hajji Murad', pp. 297–315.

55. It is useful to reproduce at least part of Baldassarre's account since he himself made no secret of it and a version of this account might have been known by Calderón: 'I had a vision: I was in the middle of the sea; half of the sea was black and the other half was aflame; I was treading water in the black half, but I was pulled to the flames. When I was almost in the fire, I began to cry loudly: "Help me, help me, Lord." Then I saw a marvellous thing: a mountain in that immense sea and on it a man dressed in white, who stretched a hand towards me. He pulled me out, and I found myself out of danger. I asked him, "for the love of God, who are you who freed me from this sea?" and he answered: "I am Holy Baptism. . . ."' (as quoted by Colombo and Sacconaghi, 'Telling the Untellable', p. 288).

56. Among the supernatural events recreated by Calderón – which include earthquakes, lightning and other frightful occurrences – there is also a version of the famous sea of flames present in Baldassare's account of his own conversion. This overstimulation of the senses plays a fundamental role in the inner transformation of the protagonist. See Romanos, 'Teatro histórico y evangelización en "El gran Príncipe de Fez"', p. 1149.

57. The biographical information about Enríquez Gómez comes mainly from two sources: González Cañal, 'Biografía de Antonio Enríquez Gómez', and Révah and Wilke, *Antonio Enríquez Gómez*.

58. His paternal uncle, Antonio Enríquez de Mora (or Villanueva) was prosecuted by the Inquisition in 1616 and fled to Burdeos in 1619. Three years later it was his father's turn, who after being condemned for Judaising and losing all his properties to the Holy Office, sought refuge in Nantes. Despite the persecution, Enríquez Gómez remained closely connected with the Holy Office by blood. Both

the brother of his wife and the husband of one of her daughters, who became his commercial partner, were *familiares* of the Inquisition.

59. Barrera y Leirado, *Catálogo bibliográfico y biográfico*, p. 135. For a discussion of the plays on Fernando Mendes Pinto, see Trías Folch, 'La traducción española de la *Peregrinaçao*', pp. 48–54.

60. In his poem, *Sansón Nazareno*, Enríquez Gómez himself gives us a list of the works that he wrote during this first stay in Madrid and during his years in France: 'I wrote twenty-two plays, whose titles I will put here, so that they will be known as mine, since all of them, especially those that printed in Seville, were given by the printers the title they wished and assigned the author of their choosing. *El Cardenal de Albornoz*, first and second part; *Engañar para reinar*; *Diego de Camas, El Capitán Chinchilla*; *Fernán Méndez Pinto*, first and second part; *Celos no ofenden al Sol*; *El rayo de Palestina*; *Las soberbias de Nembrot*; *A lo que obligan los celos*; *Lo que pasa en media noche*; *El Caballero de Gracia*; *La prudente Abigail*; *A lo que obliga el honor*; *Contra el amor no hay engaños*; *Amor con vista y cordura*; *La fuerza del heredero*; *La Casa de Austria en España*; *El Sol parado*; and *El Trono de Salomon*, first and second part. All these plays were born from my intellect and will shortly be given to the printing press in two volumes. In addition to this, the books that I have published, to let all be known, are *Academias morales*; *Culpa del primer peregrino*; *Política angélica*, first and second part; *Luis dado de Dios*; *La Torre de Babilonia*, and this poem about *Samson*. In all, they make nine volumes in prose and verse, all written from 1640 to 1649: one book per year, or one year per book. Arrange them as you think best. I promise my friends and readers that, if God grants me life, I shall write *Torre de Babilonia*; *Amán y Mardocheo*; *Caballero del Milagro, Josué*, an heroic poem; and *Los triunfos inmortales* in rhyme, being this one the book that shall be printed first. I know that I promise much given my weak forces, but I cannot stop writing, nor those who envy me can stop censoring me . . . If one is to enter in *Torre de Babilonia* it is to get into a world of confusion; if you wish to see me as a moral philosopher, read my *Academias*; if as politician, then consult *La Política Angélica*; if as a theologian, take *Peregrino*; if as a statesman, see *Luis dado de Dios*; if as a poet, read this poem (*Samson*): if as a comic author, take my plays; and if you love texts that mock and tell the truth at the same time, then go no further than *Siglo pitagórico*, and you will see why it has been loved by those who have read it, with or without passion' (Antonio Enríquez Gómez, *Sansón Nazareno, poema épico*, pp. 60–1; my translation).

61. For a discussion of this work and Enríquez Gómez's role as a dramatic author in Seville during the 1650s, see Galbarro García, '*San Hermenegildo* de Fernando de Zárate: contexto y lecturas de una comedia de santos', pp. 241–56.

62. See Domínguez de Paz, Elisa, 'La polémica Zárate/Enríquez Gómez', pp. 45–66; and Urzáiz Tortejada, 'Hagiografía y censura en el teatro clásico', p. 52.

63. Among those who argue in favour of a crypto-Jewish interpretation of his texts, see the introductory study of Oelman and Hubbard Rose to *Loa Sacramental de los siete planetas* and, of course, Révah and Wilke, *Antonio Enríquez Gómez*. A good summary of the arguments questioning this interpretation can be found in Salomon, 'Was Antonio Enríquez Gómez (1600–1663) a Crypto-Jew?'

64. González Cañal, 'Las máscaras de un converso', p. 296.

65. Although his plays were performed in Madrid, Fernando de Zárate/Antonio Enríquez Gómez had been residing in Seville for over a decade before he was apprehended by the Holy Office. While it is possible that news that Fernando de Zárate was in fact the *converso* Antonio Enríquez Gómez circulated in Seville and beyond, the only written proof remained locked in the archives of the Inquisition. In fact, most nineteenth-century Spanish critics and commentators, such as Ramón

Mesonero Romanos or Marcelino Menéndez Pelayo, rejected the hypothesis, formulated in 1848 by Adolfo de Castro, that Antonio Enríquez Gómez and Fernando de Zárate were in fact the same person. It was not until 1962 that Révah's 'Un pamphlet contre l'Inquisicion d'Antoni Enríquez Gómez' convincingly showed that this was the case. For more information see Domínguez de Paz, 'La polémica Zárate/Enríquez Gómez', pp. 45–66; Galbarro García, 'San Hermenegildo de Fernando de Zárate: contexto y lecturas de una comedia de santos', pp. 243–4.

66. Tortejada, *El Orden de Melquisedec*, p. 12.
67. *Genesis* 14: 18–20.
68. For a study of this *auto* and of Calderón's rejection of Machiavelli, see Rupp, *Allegories of Kingship*, pp. 33–76.
69. See Uppendahl, 'Einleitung', pp. 7–8.
70. Kurtz, 'Calderón de la Barca contra la Inquisición', pp. 149–50. Permission to perform the play was granted in 1671 after the death of Diego de Arce y Reinoso. By that time, Calderón's status in the Spanish court was at its peak after having been named Royal Chaplain in 1663 and Chaplain of the Congregación de Presbíteros Naturales in 1666.
71. Mills, *Idolatry and its Enemies*, pp. 211–42; Tavárez, *The Invisible War*, pp. 62–158.
72. Salazar Zagazeta, 'El teatro "evangelizador" y urbano en los Andes', p. 776.

WORKS CITED

Alonso Asenjo, J., *La tragedia de San Hermenegildo y otras obras del teatro español de colegio*, vol. 2 (Valencia: Universitat de València, 1995).
Álvarez Lobato, C., 'Lo sagrado y lo profano en *Lo fingido verdadero*', in A. González (ed.), *Texto, espacio y movimiento en el teatro del Siglo de Oro* (México: Colegio de México, 2000), pp. 133–53.
Anon., *Tercera parte de las comedias de Lope de Vega y otros autores* (Madrid: En casa de Miguel Serrano de Vargas, 1613).
Anon., *El fénix de España Lope de Vega Carpio, familiar del Santo Oficio. Octava parte de sus comedias, con loas entremeses y bayles* (Barcelona: Por Sebastián de Cormellas, 1617).
Anon., *Onzena parte de las comedias de Lope de Vega Carpio* (Madrid: Por la viuda de Alonso Martín de Balboa, 1618).
Anon., *The Jesuit Ratio Studiorum of 1599*, trans. A. P. Farrel (Washington, DC: Conference of Major Superiors of Jesuits, 1970), <http://www.bc.edu/sites/libraries/ratio/ratio1599.pdf> (last accessed 3 August 2018).
Arróniz, O., *Teatro de evangelización en Nueva España* (México: Universidad Nacional Autónoma de México, 1979).
Aszyk, U., J. Romera Castillo, K. Kumor and K. Seruga, *Teatro como espejo del teatro* (Madrid: Verbum, 2017).
Barrera y Leirado, C. A., *Catálogo bibliográfico y biográfico del teatro antiguo español*, facsimile edition (London: Tamesis, 1968 [Madrid, 1860]).
Barrios, O., 'Entre la esclavitud y el ensalzamiento: la presencia africana en la sociedad y en el teatro del Siglo de Oro español', *Bulletin of the Comediantes* 54:2 (2002), pp. 287–311.
Beusterien, J. (ed.), *Lope de Vega: El prodigio de Etiopía* (Pontevedra: Mirabel, 2005).
Boeglin, M., *Entre la cruz y el Corán: los moriscos en Sevilla (1570–1613)* (Sevilla: Ayuntamiento de Sevilla, 2010).
Borrego Gutiérrez, E., 'Espacios de santidad y puesta en escena: las primeras comedias

hagiográficas de Lope (1594–1609)', *Tintas. Quaderni di letterature iberiche e iberoamericane* 5 (2015), pp. 31–46.

Buckley, V., *Christina, Queen of Sweden: The Restless Life of a European Eccentric* (New York: Fourth Estate, 2004).

Canning, E., *Lope de Vega's 'Comedias de tema religioso'* (Woodbridge: Tamesis, 2004).

Carreño, A., ' ". . . También sé yo escribir prosa historial cuando quiero": "El triunfo de la fe en los reinos de Japón" de Lope de Vega', *eHumanista: Journal of Iberian Studies* 24 (2013), pp. 43–59.

Castro, A., *Poetas líricos de los siglos XVI y XVII*, 2 vols (Madrid: Rivadeneyra, 1857).

Castro, A., 'Una comedia de Lope de Vega condenada por la Inquisición', *Revista de filología española* 9 (122), pp. 311–13.

Cerezo Soler, J., ' "La Conquista de Jerusalén" en su contexto: sobre el personaje colectivo y una vuelta más a la atribución cervantina', *Dicenda. Cuadernos de filología hispánica* 32 (2014), pp. 33–49.

Cervantes Saavedra, M. de. *Ocho comedias y ocho entremeses nuevos nunca representados* (Madrid: Por la viuda de Alonso Martín, 1615).

Colombo, E. and R. Sacconaghi, 'Telling the Untellable: The Geography of Conversion of a Muslim Jesuit', in Giuseppe Marcocci, Wietse de Boer, Aliocha Maldavsky, and Ilaria Pavan (eds), *Space and Conversion in Global Perspective* (Leiden: Brill, 2015), pp. 285–307.

Cruickshank, D. W., *Calderón de la Barca: su carrera secular* (Madrid: Editorial Gredos, 2011).

Cruickshank, D. W., *Don Pedro Calderón* (London: Cambridge University Press, 2013).

Domínguez de Paz, E., 'La polémica Zárate/Enríquez Gómez', *Cincinnati Romance Review* 37 (2014), pp. 45–66.

Domínguez Ortiz, A. and B. Vincent, *Historia de los moriscos: vida y tragedia de una minoría* (Madrid: Alianza Editorial, 1985).

Ferrero Hernández, C. 'Mahoma como personaje teatral de una comedia prohibida del Siglo de Oro, "Vida y muerte del falso profeta Mahoma" ', in C. Ferrero Hernández and O. Cruz Palma (eds), *Vitae Mahometi: reescritura e invención en la literatura cristiana de controversia* (Madrid: CSIC, 2014), pp. 237–54.

Fine, R., 'On Conversion in "Don Quixote", or, the Cry of Hajji Murad', *Journal of Iberian Studies* 2 (2013), pp. 297–315.

Fischer, S. L., 'Lope's "Lo fingido verdadero" and the Dramatization of the Theatrical Experience', *Revista Hispánica Moderna* 39:4 (1976), pp. 156–66.

Florit Durán, F., 'Las censuras previas de representación en el teatro áureo', in *Cuatro triunfos áureos y otros dramaturgos del Siglo de Oro* (México: El Colegio de México, 2010), pp. 615–37.

Fra Molinero, B., *La imagen de los negros en el teatro del Siglo de Oro* (Madrid: Siglo XXI de España, 1995).

Fülöp-Miller, R., *The Power and the Secret of the Jesuits* (New York: Viking, 1930).

Galbarro García, J., '*San Hermenegildo* de Fernando de Zárate: contexto y lecturas de una comedia de santos', in F. B. Pedraza Jiménez, R. González Cañal and E. E. Marcelo (eds), *Judaísmo y criptojudaísmo en la comedia española. XXXV Jornadas de teatro clásico de Almagro* (Cuenca: Universidad de Castilla-La Mancha, 2014), pp. 241–56.

García Soriano, J., *El teatro universitario y humanístico en España. Estudios sobre el origen de nuestro arte dramático, con documentos, textos inéditos y un catálogo de antiguas comedias escolares* (Toledo, Talleres tipográficos de R. Gómez, 1945).

Gibert, F., 'La dramatización de una conversión al catolicismo en el auto de Calderón

La protestación de la fe (1656): el sueño como espacio de transmisión del dogma', *Criticón* 102 (2008), pp. 123–52.

Gil, J., *Los conversos y la Inquisición sevillana*, 6 vols (Sevilla: Universidad de Sevilla, 2000).

González Cañal, R., 'Biografía de Antonio Enríquez Gómez', *Biblioteca Virtual Miguel de Cervantes*, <http://www.cervantesvirtual.com/portales/antonio_ enriquez_ gomez/autor_biografia> (last accessed 10 August 2017).

González Cañal, R., 'Las máscaras de un converso: el caso de Antonio Enríquez Gómez', *Hipogrifo* 6:1 (2018), pp. 291–396.

González Gutiérrez, C., 'Tragedia de San Hermenegildo', *Epos: Revista de Filología* 8 (1992), pp. 261–89.

González Montañés, J., 'El teatro en los colegios de los jesuitas', *Teatro en Galicia* <http://www.teatroengalicia.es/jesuitas.htm> (last accessed 11 August 2018).

González Muñoz, F., 'Apuntes sobre el tratamiento del profeta Mahoma en Occidente', in J. P. Monferrer-Sala and M. Rodríguez-Pantoja Márquez (eds), *La cultura clásica y su evolución a través de la Edad Media* (Córdoba: Servicio de Publicaciones de la Universidad de Córdoba, 2014), pp. 93–106.

Granja, A., 'Comedias del Siglo de Oro censuradas por la Inquisición', in O. Gorsse and F. Serralta (eds), *El Siglo de Oro en escena: homenaje a Marc Vitse*, special issue of *Anejos de Criticón*, vol. 17 (2006), pp. 435–48.

Griswold Morley, S. and C. Bruerton (eds), *The Chronology of Lope de Vega's Comedias* (New York: The Modern Language Association of America, 1940).

Harris, M., *The Dialogical Theatre: Dramatizations of the Conquest of Mexico and the Question of the Other* (New York: St. Martin's Press, 1993).

Harris, M., *Aztecs, Moors, and Christians: Festivals of Reconquest in Mexico and Spain* (Austin: University of Texas Press, 2000).

Harvey, L. P., *Muslims in Spain, 1500 to 1614* (Chicago: University of Chicago Press, 2005).

Hauben, P. J., *Three Spanish Heretics and the Reformation: Antonio Del Corro, Cassiodoro De Reina, Cypriano De Valera* (Geneva: Droz, 1967).

Jenkins, E., *The Muslim Diaspora (Volume 2, 1500–1799): A Comprehensive Chronology* (New York: McFarland, 2000).

Kagan, R. L. and A. Dyer, *Inquisitorial Inquiries: Brief Lives of Secret Jews and Other Heretics* (Baltimore: Johns Hopkins University Press, 2011).

Kurtz, B. E., 'Calderón de la Barca contra la Inquisición: *las órdenes militares* como proceso y como pieza', in J. Villegas (ed.), *Encuentros y desencuentros de culturas: desde la Edad Media al siglo XVIII. Actas del undécimo congreso de la Asociación Internacional de Hispanistas*, vol. 3 (Irvine: University of California Press, 1994), pp. 146–54.

Lee, C. H., 'Lope de Vega and *The Martyrs of Japan*', in H. Kallendorf (ed.), *A Companion to Early Modern Hispanic Theatre* (Leiden: Brill, 2014), pp. 229–46.

Lewis Smith, P., ' "La Gran Sultana Doña Catalina de Oviedo": A Cervantine Practical Joke', *Forum for Modern Language Studies* 17:1 (1981), pp. 68–82.

Lezcano Tosca, H., 'San Agustín en la literatura religiosa de Lope', *Criticón* 107 (2009), pp. 137–50.

Mami, R., C. Alvar and L. López Baralt (eds), *El poeta morisco: de Rojas Zorrilla al autor secreto de una comedia sobre Mahoma* (Madrid: Pigmalión Edypro, 2010).

Márquez, A., *Literatura e Inquisición en España (1478–1834)* (Madrid: Taurus, 1980).

Menéndez Pelayo, M., *Historia de los heterodoxos españoles* (Madrid: Librería Católica de San José, 1880).

Menéndez Pelayo, M., 'Observaciones preliminares', in *Obras de Lope de Vega*

publicadas por la Real Academia Española. Comedias de vidas de santos y leyendas piadosas, vol. 5 (Madrid: Rivadeneyra, 1895), pp. ix–lxxiv.

Mills, K., *Idolatry and Its Enemies: Colonial Andean Religion and Extirpation, 1640–1750* (Princeton: Princeton University Press, 1997).

Morales, Ambrosio de, *Coronica General de España*, Volume II, Book XI (Alcalá de Henares: Juan Íñiguez de Lequerica, 1577), Chapters 64–70.

Motolinía, T., *Motolinía's History of the Indians of New Spain*, trans. E. A. Foster (Berkeley: The Cortes Society, 1950).

Muneroni, S., *Hermenegildo and the Jesuits: Staging Sainthood in the Early Modern Period* (Cham: Palgrave Macmillan, 2017).

Muñoz Palomares, A., *El teatro de Mira de Amescua: para una lectura política y social de la comedia áurea* (Madrid: Iberoamericana, 2007).

Oelman, T. and C. Hubbard Rose, *Loa sacramental de los siete planetas* (Exeter: University of Exeter/Exeter Hispanic Text, 1987).

Ohanna, N., ' "Los cautivos de Argel" de Lope de Vega y la expulsión de los moriscos', *Hispanic Review* 84:4 (2016), pp. 361–79.

Ohanna, N. (ed.), 'Introducción', in L. de Vega, *Los Cautivos De Argel* (Madrid: Castalia, 2017), pp. 13–62.

Ramírez de Villaurrutia, W., 'La reina Cristina de Suecia y los españoles', *Boletín de la Real Academia de la Historia*, Tomo 100 (1932), pp. 411–22.

Révah, I. S., 'Un pamphlet contre l'Inquisicion d'Antoni Enríquez Gómez: la seconde partie de la *Política Angélica* (Ruan, 1647)', *Revue des Études Juives* 131 (1962), pp. 81–168.

Révah, I. S. and C. Wilke, *Antonio Enríquez Gómez: Un Écrivain Marrane, v. 1600–1663* (Paris: Chandeigne, 2003).

Ribadeneyra, P., 'De la tribulación', in *Las obras del P. Pedro de Ribadeneyra de la Compañia de Iesus* (Madrid: En casa de la viuda de Pedro Madrigal, 1595).

Roldán Pérez, A., 'Censura Civil y censura inquisitorial en el teatro del siglo XVIII', *Revista de la Inquisición* 7 (1998), pp. 119–36.

Romanos, M., 'Teatro histórico y evangelización en "El gran príncipe de Fez", de Calderón de la Barca', in C. Strosetzki (ed.), *Actas del V Congreso de la Asociación Internacional Siglo de Oro* (Madrid and Frankfurt am Main: Iberoamericana-Vervuert, 2001), pp. 1142–50.

Ruggerio, M. J., 'History and Invention in "La tragedia de San Hermenegildo" ', *Bulletin of the Comediantes* 41:2 (1989), pp. 197–209.

Rupp, S. J., *Allegories of Kingship: Calderón and the Anti-Machiavellian Tradition* (University Park, PA: Penn State University Press, 1996).

Salazar Zagazeta, C. M., 'El teatro "evangelizador" y urbano en los Andes: encuentros y desencuentros', *Criticón* 87–89 (2003), pp. 775–86.

Salomon, H. P., 'Was Antonio Enríquez Gómez (1600–1663) a Crypto-Jew?' *Bulletin of Spanish Studies* 88:4 (2011), pp. 397–422.

Surtz, P., 'Judíos y Reyes Magos gentiles: teatro franciscano y milenarismo', in *Nueva España* (1988), pp. 333–44.

Tavárez, D. E., *The Invisible War: Indigenous Devotions, Discipline, and Dissent in Colonial Mexico* (Stanford: Stanford University Press, 2011).

Torres Martínez, J. C., 'La Virgen de la Cabeza y Andújar en una comedia de Lope de Vega', *Boletín del Instituto de Estudios Giennenses* 209 (2014), pp. 239–64.

Tortejada, U., ' "El orden de Melquisedech", de Calderón de la Barca: estudio y edición', MA thesis (Ottawa: University of Ottawa, 2001).

Trías Folch, L., 'La traducción española de la *Peregrinaçao*', in M. R. Álvarez Sellers (ed.), *Literatura portuguesa y literatura española: influencias y relaciones* (Valencia: Universitad de Valencia, 1999), pp. 37–54.

Uppendahl, K., 'Einleitung', in Uppendal, K. (ed.), *Pedro Calderón de la Barca. Mística y Real Babilonia* (Berlin: De Gruyter, 1978), pp. 1–78.

Urzáiz Tortejada, H., 'Hagiografía y censura en el teatro clásico', *Revista de Literatura*, *2015* 153 (2015), pp. 47–73.

Wetmore Jr., K. J., 'Jesuit Theater and Drama', *Oxford Handbooks Online*, 2016, <http://www.oxfordhandbooks.com/view/10.1093/oxfordhb/9780199935420.001.0001/oxfordhb-9780199935420-e-55> (last accessed 8 July 2018).

Wiegers, G. A., 'Las obras de polémica religiosa escritas por los moriscos fuera de España', in M. García-Arenal and G. A. Wiegers (eds), *Los moriscos, expulsión y diáspora: una perspectiva internacional* (Valencia: Publicaciones de la Universidad de Valencia, 2016), pp. 391–413.

Wright, E. R., 'Virtuous Labor, Courtly Laborer: Canonization and a Literary Career in Lope De Vega's Isidro', *MLN* 114:2 (1999), pp. 223–40.

Ybarra, P. A., *Performing Conquest: Five Centuries of Theater, History, and Identity in Tlaxcala, Mexico* (Ann Arbor: University of Michigan Press, 2009).

6

THEATRE AND CONVERSION IN EARLY MODERN ZÜRICH, BERNE AND LUCERNE

Elke Huwiler

Strictly speaking, Switzerland does not have a 'national' theatrical tradition, a peculiarity that derives from the complex history of the Swiss Confederation, and is indicative of the special conditions that characterise the relationship between conversion and theatre in early modern Swiss culture.[1] Although the state we know as Switzerland today was founded relatively recently (in 1848), its origins go back to the Middle Ages. In 1291, the cantons of Uri, Schwyz and Unterwalden united, forming the basis of the Old Swiss Confederacy. Other cantons and city states, such as Zürich, Bern and Lucerne, joined in the fourteenth century. By the sixteenth century, the Confederacy had grown to include thirteen cantons, with the last one, Appenzell, joining in 1513. As in other parts of Europe, the Reformation had a profound impact on the life of the Swiss Confederacy, dividing cities and cantons according to confessional lines. Starting in the early 1520s under the leadership of figures such as Huldrych Zwingli, some major cantons, including Zürich, Berne and Basel, joined the Reform movement, but the example they set did not determine the course for the entire country. Key holdouts included Fribourg, Schwyz and Lucerne, which all maintained allegiance to Catholicism. As the Reform movement advanced, the situation deteriorated rapidly, culminating in a series of conflicts and wars known as the Kappelerkriege (1529–31). Peace was restored in 1531 with the decision to allow each individual canton to decide whether to stay Reformed or Catholic, and prohibitions against confessional defamation were instituted in order to ensure peaceful coexistence amongst cantons

of differing religious affiliations.[2] Although the status quo that emerged after the Kappel Wars put an end to military conflict, it did not settle the problem of confessional division. On the contrary, matters of religion remained a prominent, vexed issue for many years after the war was over.

The political, social and religious changes introduced by the Reformation are the background against which this chapter approaches the interplay of theatre and conversion in the Swiss cities of Zürich, Berne and Lucerne. These changes forced citizens to confront new structures for self-definition, new ideologies and new power formations. In the cities that joined the Reformation, conversion – in the sense of a complete 'changement d'ordre mental' of the entire population[3] – was the declared goal of political and ecclesiastical elites. In response to this example, the cantons that remained Catholic embarked on an equally sweeping, parallel process of introspection and reaffirmation. On both sides of the confessional divide, city councils saw in early modern theatrical practices an opportunity to advance their conversional agenda. By the same token, however, both sides also struggled to manage theatre's potential to subvert official orthodoxy. Typically, as soon as conversion had been achieved, or was institutionally declared to have been achieved, authorities began to exert strict controls, such as censorship or outright bans on theatre altogether.

The theatrical cultures of Zürich, Berne and Lucerne had a number of aspects in common, notwithstanding the significant influence exerted by local particularities. This general affinity can be attributed to geographical proximity and a shared cultural heritage. All three cities belonged to the German-speaking part of Switzerland, which had a history of theatrical practice dating back to the Middle Ages.[4] As in other European countries in the late medieval period, Swiss theatre originated with religious drama in churches, and gradually expanded in terms of content, while also spreading out to a variety of other public spaces.[5] In contrast to other European states, however, the lack of a centralised royal authority in Switzerland prevented the development of theatrical activities linked to a royal court. Moreover, Swiss cities did not develop purpose-built, commercial venues for theatrical representation, such as the Spanish *corrales* or the English playhouses. With the notable exception of performances in schools, theatrical productions almost always took place outdoors, in the town square or a marketplace, with local residents serving as both actors and spectators.[6] This use of public spaces, combined with the lack of professional theatrical companies, had major implications for theatre and conversional representation in the Swiss cantons, as the analysis in the following sections will show.

Another common aspect of theatrical culture in the three cities pertains to the politics of the drama and the dramatists. Because the Old Swiss Confederacy was organised federally, political power resided primarily in city councils and other local institutions. Responsibilities for promotion, authorisation and

supervision of all performances therefore fell to these authorities. This close relationship to local governance gave sixteenth-century Swiss theatre a notably institutional character.[7] For example, in contrast to the theatrical cultures of countries such as England or Spain, the authors of Swiss drama tended to be distinguished, well-connected elites, rather than full-time professional dramatic producers. Regardless of the author, however, all dramatic texts had to be submitted to the city council for approval. Given these circumstances, it is not surprising to note the frequency with which Swiss drama tended to convey messages that echoed the official position.

But despite a very high degree of government influence, theatrical production in Switzerland was nevertheless a genuinely collective affair that worked, not by official fiat, but because it summoned the talent and enthusiasm of individuals from every level of society. All citizens, rich and poor, male and female, old and young, noble and ignoble, were eligible to attend, and many members of the community made direct contributions in terms of logistics. As Glenn Ehrstine has noted, the 'grand scale' of productions would not have been possible without contributions from a wide range of service providers and skilled craftsmen: carpenters to build scenery, seamstresses to design costumes, bailiffs to provide security and innkeepers to provide accommodation.[8] On a similar note, among the massive casts of performers that typically involved somewhere between ten and fifty individuals, it was not uncommon to see members of the nobility (typically in the central roles), priests (typically in religious roles) and the sons of high-ranking political officials.[9] In this sense, theatre carried an implicit ideological message: it asserted social hierarchies by linking social prestige with privileges of visibility. On the other hand, however, it also helped to soften social boundaries (without necessarily erasing them) because it brought the entire community together in a playful, good-spirited endeavour that was generally seen as beneficial to the entire city.

Getting closer to the specific focus of this particular volume, it is also important to note the ways in which public theatre was generally conducive to conversional thinking. As Hildegard Elisabeth Keller has noted, urban performances in public spaces facilitated opportunities for individual and group reflexivity that enabled the inhabitants of Swiss cities to 'come to an understanding of themselves as citizens of a city-state within an Empire, as allies within a Confederation, and as avant-garde reformers of ecclesiastical, social and civic institutions'.[10] The following analysis will track the development of this dynamic in three of the Confederation's most prominent centres of cultural production, beginning with Zürich.

ZÜRICH

In the early sixteenth century, Zürich became the centre of the Swiss Reformation under the leadership of Urlich Zwingli, a charismatic pastor who

became the city's first 'Antistes', or synodal church head, an office appointed by the city council. Although Zwingli died before the cessation of military conflict – he fell in the second Kappel War – he had a long-lasting influence on the post-war development of Zürich and the Old Swiss Confederacy overall. Following his initiatives, the Zürich City Council introduced sweeping, fundamental changes to marriage law, the organisation of the clergy, practices in church services and various other structures governing the everyday lives of the canton's citizens. Theatre and conversion were central factors in this process of transformation.

According to a body of historical evidence that includes official records and printed playtexts, there were at least forty-five theatrical productions in Zürich in the sixteenth century, a figure that suggests substantial growth in a theatrical tradition that seems to have been present since the late Middle Ages, but was not well-documented.[11] Especially important examples of pre-Reform drama from the first decades of the century include a 1504 passion play in honour of the city saints Felix and Regula (performed at the Münsterhof, Zürich's central marketplace) and *Von den alten und jungen Eidgenossen* (1514), a political play by Balthasar Spross that celebrated the simplicity and nobility of the mythical founders of the Swiss Confederacy.[12] For the most part however, drama in sixteenth-century Zürich was entirely dominated by the Reformed elite, who viewed theatrical representation as a uniquely effective mechanism for promoting a Reformed value system.[13] In fact, certain Reformers, including the dramatists Paul Rebhun and Sixtus Birck, even went as far as to suggest that theatrical instruction was superior to preaching, due to its capacity to facilitate visual, as well as aural, engagement.[14] Under strictures endorsed by the Lutheran and Zwinglian schools alike, productions in Zürich from the 1520s onwards were not permitted to depict the suffering of Christ (a former staple of Easter drama), and plots tended to derive from Old Testament sources. As these features suggest, Zürichian drama was, for the most part, a drama of moral instruction – and a drama that was emphatically non-Catholic.

On this point, it is important to note that all of the major playwrights and theatrical producers in Reformation Zürich were closely connected to church governance in one way or another. Throughout his term as Antistes, Zwingli took a close personal interest in the organisation and composition of theatrical productions. Tellingly, his close friend, Georg Binder, became one of the city's most productive and celebrated playwrights. Following Zwingli's hands-on example, the city's second and third Antistes, Heinrich Bullinger and Rudolf Gwalther, both composed entire plays. In Gwalther's view, which is characteristic of church officials during the period, Reformers had a responsibility to take the message of the Reformation to individuals at all social ranks by reaching out to them, not only through sermons in churches, but also through theatrical

performances in the city's squares and streets.[15] The official purpose of theatre, in other words, was not just to provide entertainment, but – more importantly – to advance the conversion effort, and to reshape moral behaviour.

As a result of these directives, Zürichian drama overall is notable for an unambiguous emphasis on touchstones of Reformed identity such as sobriety, chastity, modesty and godliness. In this respect, one might retrospectively posit two key biblical productions from Zwingli's era as prototypes for an approach to theatrical presentation that would come to characterise the entire century: the Lazarus play, *Das Zürcher Spiel vom reichen Mann und vom armen Lazarus* (1529) – which featured music composed by Zwingli himself – and the Prodigal Son play, *Acolastus* (1529), a translation by Georg Binder of a Latin drama that was widely adapted and performed on stages throughout Europe.[16] In these productions, biblical figures became living, breathing examples of the Reformed identity, either by modelling idealised behaviour, or by demonstrating the consequences that resulted from behaviour that fell outside Reformed convention.[17]

But despite an unmistakably Reformist tone and overall character, the drama of early modern Zürich is most accurately viewed in terms of a gradual transition toward Reformed culture, rather than the product of an abrupt break with the past. With this transitionary function in mind, it is instructive to take stock of the numerous medieval conventions that carried over into the sixteenth century, such as the prominent incorporation of music, the use of a herald to introduce the production, and the coordination of action across multiple sections of a large stage ('Simultanbühne').[18] On a similar note, despite express injunctions against carnival by leaders, including Luther and Zwingli, many plays featured a brand of raunchy, raucous humour highly reminiscent of the carnival plays of the late medieval tradition.[19] For especially flagrant examples of this tendency, consider Jakob Ruf's *Etter Heini* (1538), Hans Rudolf Manuel's *Weinspiel* (1548) and *Bacchus* (anonymous, 1548), which all incorporate a wide range of scatological and obscene representations. Presumably, official approval of these plays hinged on the slight, sanctimonious gestures they made toward condemnation of the behaviours they enacted. Moral pretension notwithstanding, however, it seems clear that the productions were simply delivering a tried-and-true form of entertainment that had delighted the citizens of Zürich for centuries.

The racy-yet-condemnatory nature of the plays by Ruf, Manuel and others provides a reminder that one of the central governing impulses of Zürichian drama was to sharpen division by denigrating the markers of Catholic identity, an impulse that is especially apparent in Ruf's *Etter Heini*, which makes an explicit connection between Catholicism and the various forms of moral depravity enacted onstage.[20] Straightforward attacks along these lines mostly disappeared, however, with the establishment of the 1531 peace treaty, which

prohibited confessional defamation and the stirring of religious hatred. In the new era of peace, dramatic productions shifted focus – at least superficially – from the advancement of religious acrimony to the promotion of a unified Swiss identity.

In the entire corpus of extant Zürichian drama, no play better exemplifies the tension between religious factionalism and national identity-making than Jakob Ruf's *Wilhelm Tell* (1545), an adaptation of an earlier play about the mythical Swiss marksman that was originally performed in Altdorf in 1512 or 1513. As Andrea Kauer has noted, Tell was the ideal representative for a new concept of Swiss self-identification that sought to traverse 'regional and confessional borders' by placing emphasis on national allegiance.[21] In the course of elevating Tell to the level of national symbol, however, Ruf also introduced a number of features that tacitly positioned his persona in alignment with Reformed ideals pertaining to family life and the role of women in society. Thus, in addition to inserting speaking roles for several of Tell's children, the dramatist created a major role for Tell's wife, a paragon of motherhood and feminine virtue who does not appear in any forgoing versions of the story. By the same token, Ruf also took care to eliminate women characters with any sort of political function, such as the wife of Werner Stauffacher. In their overall effect, these adjustments both reflected and promoted the Reformers' vision of an ideal society, where marriage and the nuclear family were at the centre of social life, and women served the community in an exclusively domestic role, always subject to male authority.[22] Ultimately, although Ruf makes gestures toward the prospect of a nation-based ideological framework that could bridge the division among cantons, it is clear that his vision for that framework offers very little in terms of practical compromise, and is entirely consistent with Reformed ideals.

Around the time of Ruf's death in 1558, theatrical productions in Zürich fell into decline and began to focus on biblical subjects exclusively, a development that coincided with growing suspicion of theatre among civil and religious authorities throughout the Protestant world. Finally, in 1624, the seventh Antistes of Zürich, Johann Jakob Breitinger, issued a prohibition on theatrical performances in all public spaces.[23] In Breitinger's view, theatrical representations of unruly behaviour would inevitably lead to unruly behaviour in real life. In contrast to his forebears, he saw the affective and persuasive capacities of theatre as a threat, dangerously subject to interpretation and resistant to ideological control. Although his complete ban on theatre was relatively extreme, the anxieties behind it were consistent with the anxieties of authorities throughout the Confederacy, as the following discussions of theatre in early modern Berne and Lucerne will show.

BERNE

Theatrical productions were a prominent aspect of public culture in sixteenth-century Berne, but in contrast to the comparatively rich dramatic archive from Zürich, the corpus of extant Bernese drama includes only ten plays: three by the painter-poet Niklaus Manuel (c.1484–1530), six by Berne City Councillor, Hans von Rüte (?–1558), and one – *Elsli Tragdenknaben* (1530) – by an anonymous author.[24] Everything in this archive by Manuel and the anonymous author is carnival drama deriving from the years between 1520 and 1531, a period dominated by public discussion over the prospect of breaking with the Catholic Church.[25] By presenting a festive, but radical, perspective on questions of faith, the Bernese carnival plays served a key function in the consolidation of Reformist ideology.[26]

The polemical and experimental nature of Bernese carnival drama is particularly well illustrated in Manuel's *Von Papsts und Christi Gegensatz* (*Of the Contrast between the Pope and Christ*, 1523), a daring production that transposed Christ and the Pope to the streets of Berne in order to develop a sharp, damning contrast between Papal extravagance and Christian humility. In the opening scene, this contrast is made visually manifest in two simultaneous processions, each entering from different sides of the performance area:

> On one side of the street there came Jesus Christ, our sweet lord, riding on a poor donkey, on his head a thorn crown, with him his disciples, the poor blind, lame and many crippled. On the other side rode the Pope in his armor and with a great military procession, as will be understood through the dialogue of the two peasants Ruede Vogelnäst and Cläywe Pfluog.[27]

Manuel's double-staging of these processions adapts a convention from medieval drama known as 'Simultanbühne' (multiple setting), which positioned simultaneous representations of Heaven and Hell on opposite sides of the stage. In addition to slyly repurposing a familiar dramatic technique, his scenographic arrangement also invoked a common motif from Reformation visual culture that many Bernese spectators would have known from texts such as Lucas Cranach's *Passional Christ and Anti-Christ* (1521), a series of thirteen paired woodcuts that juxtaposed images of Christ against the Pope (or Anti-Christ). In similar fashion, *Von Papsts und Christi Gegensatz* sets Christ and the Pope side by side, but within separate zones of a bifurcated field of action, so they could not engage with each other directly. As the foregoing quotation suggests, a pair of peasant characters – Ruede Vogelnäst and Cläywe Pfluog – provided an ongoing interpretive commentary that made the critique of Papal corruption explicit. By positioning these familiar everyman characters as audience surrogates, Manuel found a way to accommodate Reformers' insistence

on ideological clarity in a manner that made the message accessible and relatable.[28] Adding yet another layer of local significance, the production was staged at the *Kreuzgasse*, a central intersection featuring a platform and a pillory for the proclamation and execution of judicial punishment.[29] Intentionally or not, these prominent symbols of mortal consequence would have provided *Von Papsts und Christi Gegensatz* with an ominous analogue for the spiritual consequences that Manuel forecasted for the Pope and his followers.

There is a remarkable diversity of imaginative critical speculation centred on the mystery of how, or why, officials saw fit to present Manuel's virulently anti-papal drama to the public in 1523, five full years before Berne officially broke ties with the Catholic Church.[30] According to a theory suggested by Barbara Könneker, for example, the city council may have deployed the production as a sort-of trial balloon, hoping to gauge the amenability of Bernese citizens to Reformation ideology.[31] Flipping Könneker's premise on its head, other critics have suggested the possibility that, despite its obvious slant, *Von Papsts und Christi Gegensatz* somehow managed to slip through the cracks of official oversight, catching the authorities by surprise. Pushing this premise a step further, Richard Feller has proposed that Manuel's promotion to Steward of Erlach in 1523 was a subtle form of forced exile imposed as punishment for stirring the pot – a possibility that seems remote, given the prestige attached to the position in Erlach.[32] Taking a step back from the conversation, Glenn Ehrstine argues that the production was unlikely to have been as incendiary as most critics have assumed.[33] In a detailed study of theatre in Reformation Berne, he notes that, in 1525, anti-papal sentiment was not necessarily the same thing as anti-Catholic sentiment.[34] Moreover, at this point in Swiss history, the political implications of religious reform were not fully apparent.[35] In Ehrstine's view, the drama's fuzzy politics may have provided Manuel with enough latitude to 'agitate for change' without openly appearing to 'foment insurrection'.[36] In an eyewitness account that seems to support this theory, Valerius Anselm enthusiastically reports that the production was a massive success and that a 'great mass of people were moved to consider and distinguish Christian freedom and papal servitude'.[37] To put Anselm's report in perspective, however, it is important to note that he was a vehement advocate for the Reform movement, so his comments must be regarded with a certain degree of reservation. Nevertheless, even if the likelihood of positive bias is taken into consideration, the glowing eyewitness account offers some indication of how the citizens of Berne – or at least some of the citizens of Berne – understood and talked about the ideological purpose of Manuel's production. Incendiary or not, *Von Papsts und Christi Gegensatz* was a prolegomenon for conversion.

In 1528, Berne became the second Swiss city (after Zürich) to join the Reformation. Three years later, in 1531, the peace treaty that brought an

end to the Kappel Wars also brought a number of changes in Bernese public culture, including a prohibition on carnival celebrations and the end of carnival plays such as *Von Papsts und Christi Gegensatz*. Notably, the death of Bernese carnival drama coincided with the death of the city's premier carnival dramatist, Niklaus Manuel. It was truly the end of an era. In the new post-war, post-carnival era that followed, the task of composing theatrical productions fell primarily to Hans von Rüte, a city councillor who wrote biblical plays that addressed contemporary social issues with the typical Reformed emphasis on family, modesty and moral clarity. As noted above in regard to the post-war, biblical drama of Zürich, Von Rüte's productions were massive, communal affairs that aimed to build ideological unity out of cooperative effort, mutual experience and shared identity.[38] In contrast to Zürich, however, the Bernese City Council did not institute an outright prohibition on theatrical productions when the hold of Reformed ideology solidified. Although there seems to have been some level of concern over the capacity of theatre to undermine moral discipline – an anxiety demonstrated by a ban on jugglers and foreign acting troupes – theatrical culture in Berne was permitted to continue under heavily supervised conditions.

LUCERNE

Engagement with conversional thinking was also a defining feature of theatrical cultures on the other side of the confessional divide, an affinity exemplified by the case of Lucerne, one of the three main cities to maintain allegiance to the Catholic Church (along with Fribourg and Solothurn). In contrast to their Reformed neighbours, Lucernian officials continued to sponsor Easter plays and Passion plays in the medieval tradition, a practice that lasted throughout most of the sixteenth century.[39] At the same time, the city also saw the emergence of a more didactic style of drama that took Reformers' critiques seriously without supporting the political goals of the Reformation, a trend that became especially prominent with the Counter-Reformation efforts that followed the Council of Trent (1545–63).

For an example of a production that repositions Reformed critique from a Catholic-friendly perspective, consider the case of Renward Cysat's *Convivii Process* (*Mirror of Abundance and Abuse*, 1593), a morality play that was staged in Lucerne's market square. As is typical of the morality genre, Cysat's drama features the exhibition and punishment of allegorical figures representing vices such as gluttony and drunkenness. Notably however, the moral failings held up for rebuke are consistent with the vices that Reformers typically pointed to in their critique of the Catholic clergy, an association that was apparent enough to attract the attention and censure of political and religious leaders alike.[40] To grasp the dynamics at play in this example, it is helpful to recall the fuzzy politics surrounding *Von Papsts und Christi Gegensatz*

(noted in the section on Berne), and the distinction made by Glenn Ehrstine between anti-papal sentiment versus anti-Catholic sentiment.[41] By borrowing the Reformation critique of church governance, Cysat was not proposing a renunciation of Catholicism. In a sense, his production converted the discourse of conversion itself.

The case of *Von Papsts und Christi Gegensatz* provides an illuminating example of how the discourses of conversion could pertain, not only to spiritual transformation, but also to social transformation – and not only to relations between individuals and God, but also to relations between individuals and each other. With this point in mind, it is instructive to note how the impulses of Reformation and Counter-Reformation social protest become manifest in Zacharias Bletz's carnival play, *Marcolfus* (1546), a reworking of a late medieval folktale about a wise fool (Marcolfus) who gains an audience with King Solomon, thereby setting the stage for an exchange that pits the putative wisdom of the King against the fool's superior cleverness and improvisatory ability. Notably, in Bletz's version of the story, Marcolfus visits the court because he is starving and in desperate need of relief, a motivation that does not appear in the dramatist's medieval sources. Following from this fundamental modification, King Solomon becomes an analogue for the elite handful of Lucernian families who saw themselves as noble (by merit, if not by birth) and were anxious to maintain religious, political and economic control over the surrounding countryside. By the same token, the fool Marcolfus becomes an analogue for the rural, impoverished peasantry, who resented the authority and lavish lifestyles of their supposed betters in the city. As Heidy Greco-Kaufmann has noted, the production is typical of carnival drama insofar as Marcolfus' subversive exposé of the King's failings ultimately yields to a conciliatory ending and a return to the status quo.[42] However, even though the fictional peasant is eventually mollified, it would be a mistake to assume that the Reformation-inspired arguments that Bletz made available for the real-world Lucernian peasantry could not be compelling. Irrespective of the outrageousness and absurdity characteristic of carnival drama, *Marcolfus* brought some very serious thinking about social transformation onto the public stage.

As noted above in regard to Niklaus Manuel's *Von Papsts und Christi Gegensatz* (Berne), the production of theatrical meaning in Lucernian public drama was a palimpsestic process that built on a foundation of previous productions and topographical features of the urban environment. For example, consider the case of *Weltgerichtsspiel* (*Last Judgement Play*, 1549), another production by Zacharias Bletz. As the title suggests, *Weltgerichtsspiel* dramatises the final judgement of mankind foretold by St John in the Book of Revelation. In accordance with a long-established scenographic practice, biblical productions of this sort traditionally staged Heaven on the east side of the

market square, where a building popularly known as 'house of the sun' was located. For purposes of contrast, Hell was traditionally staged on the west side of the square, opposite Heaven. In a remarkable break with these traditions, however, Bletz staged Hell on the north end of the square, directly in front of the courthouse. With this move, the dramatist brought the city's most prominent symbol of institutional judgement into alignment with the thematic structure of his dramatic production. For citizens accustomed to public spectacles in Lucerne – theatrical and judicial alike – the implication was clear: just as criminals were judged in the city's courts, God would be sure to judge all men in the world beyond.

Overall, support for theatrical culture lasted much longer in Lucerne and the Catholic cantons than in the cantons that joined the Reformation. Eventually however, officials determined that the inherent risks of public drama outweighed the potential benefits. By the beginning of the seventeenth century, the only productions permitted within the city limits were the heavily didactic, heavily regulated plays written and organised by Jesuit priests. The golden age of dramatists such as Renward Cysat and Zacharias Bletz was definitely over.

Stepping back, one can see that the theatrical cultures of Zürich, Berne and Lucerne developed along similar trajectories over the course of the sixteenth century, despite differences of confessional allegiance, and despite a confederate style of governance that left the regulation of theatrical productions entirely in the hands of local authorities. In all three cities, officials enthusiastically promoted ideological instruction by way of dramatic representation, a trend that led to a wave of outrageous, radically provocative productions around the time of the Kappel Wars. Following the peace treaty of 1531, however, dramatic productions began to take a subtler, less openly antagonistic tone, and to promote an emergent ideology of Swiss national unity (at least in theory). However, as the century progressed and the Confederacy began to settle into a new status quo, Reformists and Catholics alike became increasingly uncertain about the ability of theatre to reliably promote ideological correctness. In Zürich, theatre was eventually banned entirely, and in Berne and Lucerne, it was subjected to strict controls that effectively curtailed the very elements that had made it engaging and attractive in the first place. To characterise these developments in a single stroke, one might say that, by the beginning of the seventeenth century, officials feared theatre for the same reason they had embraced it eighty years earlier: because it had a unique, unparalleled power to change hearts and minds. Ultimately, this ability proved to be too potent to be left unchecked.

NOTES

1. Nagy and Rouyer, *World Encyclopedia of Contemporary Theatre*, p. 828.
2. Ehrstine, *Theater, Culture, and Community*, p. 52.

3. Hadot, 'Conversion', p. 979.
4. Nagy and Rouyer, *World Encyclopedia of Contemporary Theatre*, p. 828.
5. Schulze, *Geistliche Spiele*.
6. The first permanent theatre house opened in Baden in 1675. See Gojan, *Spielstätten der Schweiz*, p. 11.
7. Huwiler, 'Theater, Politik und Identität'.
8. Ehrstine, *Theater, Culture, and Community*, p. 294.
9. See for example the extensive list of dramatis personae with the corresponding actor's names and their ranks in Greco-Kaufmann and Huwile, *Das Sarner Bruderklausenspiel von Johann Zurflüe*.
10. Keller, 'God's Plan', p. 154. Swiss cities in the sixteenth century were still technically part of the Holy Roman Empire, yet they had already gained a high level of independence and saw themselves as belonging to the Swiss Confederation.
11. Stucki, 'Das 16. Jahrhundert', p. 265; Brunnschweiler, *Johann Jakob Breitinger*, p. 125; Evidence of a play performed in Zürich as early as 1397 is unfortunately without precise source: 'There seems to have been performed a play of Herodes in 1397 in the Stephans Church in Zürich'. Müller, *Schweizer Theatergeschichte*, p. 17.
12. Brunnschweiler, *Johann Jakob Breitinger*, p. 125; Christ-Kutter, *Das Spiel von den alten und jungen Eidgenossen*.
13. See Tschopp, 'Reformationsdrama'; Meier, 'Symbolische Kommunikation'.
14. Ehrstine, *Theater, Culture, and Community*, p. 291.
15. Gwalther, *'Nabal'*, p. 11.
16. Delcorno, *In the Mirror of the Prodigal Son*, p. 391.
17. See Washof, *Die Bibel auf der Bühne*.
18. The use of music and singing in church was banned by Zwingli in sixteenth-century Reformation Zürich, though it was still used in plays. Ehrstine, *Theater, Culture, and Community*, p. 63.
19. A 'carnival play' is the 'dominating type of worldly play in late medieval times, which is mainly shaped by its connection to the situation of carnival in an urban context'. Ragotzky, 'Fasnachtspiel', p. 568. See also Simon, 'Shrovedite Plays'.
20. Kauer, 'Einleitung zum Etter Heini'.
21. Kauer, 'Wilhelm Tell', p. 121.
22. Maschwitz, *Die Form der Eheschließung*, pp. 70–4.
23. Brunnschweiler, *Johann Jakob Breitinger*.
24. Ehrstine, *Theater, Culture, and Community*, p. 7. *Elsli Tragdenknaben* is often attributed to Niklaus Manuel, see Schiendorfer, 'Vigil Rabers', pp. 193–211.
25. Ehrstine, *Theater, Culture, and Community*, p. 47.
26. Ibid., p. 6.
27. Manuel, 'Fasnachtsspiel', p. 181.
28. Weishaupt, *Bauern, Hirten und 'frumme edle puren'*, p. 150.
29. Dörk, 'Der verwilderte Raum', p. 129.
30. For an overview of opinion, see Ehrstine, *Theater, Culture, and Community*, p. 83.
31. Könneker, *Die deutsche Literatur der Reformationszeit*, p. 125.
32. Feller, *Geschichte Berns*, vol. 2, p. 139. On the unlikeliness of Feller's theory, see Greco-Kaufmann, 'Niklaus Manuel', p. 76.
33. Ehrstine, *Theater, Culture, and Community*, p. 83.
34. Ibid.
35. Ibid.
36. Ibid.
37. Valerius Anselm, cited in Ehrstine, *Theater, Culture, and Community*, p. 79.
38. Gamiz-Brunner, 'Königseinzüge, Stadtnarren, Schauspiele', pp. 90–4.

39. Greco-Kaufmann, *Zuo der Eere Gottes.*
40. Greco-Kaufmann, *Spiegel des vberflusses*, p. 73.
41. Ehrstine, *Theater, Culture, and Community*, p. 83.
42. Greco-Kaufmann, *Spiegel des vberflusses*, p. 73.

WORKS CITED

Brunnschweiler, T., *Johann Jakob Breitingers 'Bedencken von Comoedien oder Spilen'. Die Theaterfeindlichkeit im Alten Zürich*. Edition – Kommentar – Monographie (Bern: Verlag Peter Lang, 1989).
Christ-Kutter, F. (ed.), *Das Spiel von den alten und jungen Eidgenossen*, Altdeutsche Übungstexte, Bd. 18 (Berlin: Francke Verlag, 1963).
Delcorno, P. *In the Mirror of the Prodigal Son: The Pastoral Uses of a Biblical Narrative (c. 1200–1550)* (Leiden, Boston and Köln: Brill, 2017).
Dörk, U., 'Der verwilderte Raum. Zum Strukturwandel von Öffentlichkeit in der frühneuzeitlichen Stadt am Beispiel Berns', in S. Rau and G. Schwerhoff (eds), *Zwischen Gotteshaus und Taverne. Öffentliche Räume in Spätmittelalter und früher Neuzeit* (Köln, Weimar and Wien: Böhlau Verlag, 2004), pp. 119–54.
Ehrstine, G., *Theater, Culture, and Community in Reformation Berne, 1523–1555* (Leiden, Boston and Köln: Brill, 2002).
Feller, R. *Geschichte Berns*, 2nd edn, 4 vols (Bern: Herbert Lang, 1974).
Gamiz-Brunner, R., 'Königseinzüge, Stadtnarren, Schauspiele. Theater in Bern im Spätmittelalter und in der Frühen Neuzeit', in H. Greco Kaufmann (ed.), *Stadtnarren, Festspiele, Kellerbühnen. Einblicke in die Berner Theatergeschichte vom Mittelalter bis zur Gegenwart* (Zürich: Chronos, 2017), pp. 17–140.
Gojan, S., *Spielstätten der Schweiz. Historisches Handbuch* (Zürich: Chronos Verlag, 1998).
Greco-Kaufmann, H., *Spiegel des vberflusses vnd missbruchs. Renward Cysats 'Convivii Process'*. Kommentierte Erstausgabe der Tragicocomedi von 1593 (Zürich: Chronos, 2001).
Greco-Kaufmann, H., *Zuo der Eere Gottes, vfferbuwung dess mentschen vund der statt Lucern lob. Theater und szenische Vorgänge in der Stadt Luzern im Spätmittelalter und in der Frühen Neuzeit. Historischer Abriss* (Zürich: Chronos, 2009).
Greco-Kaufmann, H., 'Niklaus Manuel, der Fasnachtspieldichter', in Susanne Marti (ed.), *Söldner, Bilderstürmer, Totentänzer. Mit Niklaus Manuel durch die Zeit er Reformation* (Zürich: NZZ, 2016), pp. 70–7.
Greco-Kaufmann, H. and E. Huwiler (eds), *Das Sarner Bruderklausenspiel von Johann Zurflüe (1601)*. Kommentierte Erstausgabe (Zürich: Chronos, 2017).
Gwalther, R., *'Nabal'. Ein Zürcher Drama aus dem 16. Jahrhundert*, ed. and trans. S. Giovaloni (Bonn: Bouvier Verlag Herbert Grundmann, 1979).
Hadot, P., 'Conversion', *Encyclopaedia Universalis*, vol. 4 (Paris: Encyclopaedia Universalis France, 1968), pp. 979–81.
Huwiler, E., 'Theater, Politik und Identität: Das Schweizer Schauspiel des 16. Jahrhunderts', in P. Hanenberg and F. Clara (eds), *Aufbrüche: Kulturwissenschaftliche Studien zu Performanz und Performativität* (Würzburg: Königshausen & Neumann, 2012).
Kauer, A., 'Einleitung zum Etter Heini', in H. E. Keller (ed.), *Jakob Ruf. Werke bis 1544. Kritische Gesamtausgabe, Teil 1* (Zürich: Verlag NZZ, 2008), pp. 43–62.
Kauer, A., Wilhelm Tell', in H. E. Keller (ed.), *Jakob Ruf. Werke 1545–1549. Kritische Gesamtausgabe, Teil 2* (Zürich: Verlag NZZ, 2008), pp. 121–225.
Keller, H. E., 'God's Plan for the Swiss Confederation: Heinrich Bullinger, Jakob Ruf and their Uses of Historical Myth in Reformation Zürich', in R. C. Head and D. Christensen (eds), *Orthodoxies and Heterodoxies in Early Modern German*

Culture. Order and Creativity 1500–1750 (Leiden and Boston: Brill, 2007), pp. 139–67.

Könneker, B., *Die deutsche Literatur der Reformationszeit: Kommentar z.e. Epoche* (München: Winkler, 1975).

Manuel, N., 'Fasnachtsspiel', in P. Zinsli and T. Hengartner (eds), Niklaus Manuel, *Werke und Briefe. Vollständige Neuedition* (Bern: Stämpfli Verlag AG, 1999), pp. 181–8.

Maschwitz, A., *Die Form der Eheschließung. Ehe im Zentrum der Interessen von Staat und Religion – eine rechtsvergleichende Untersuchung der obligatorischen und fakultativen Zivileheschließung am Beispiel Deutschlands und Schwedens* (Bonn: V&R unipress, 2014).

Meier, C., 'Symbolische Kommunikation und gesellschaftliche Werte im vormodernen Theater. Eine Einführung', in C. Meier, H. Meier and C. Spanily (eds), *Das Theater des Mittelalters und der frühen Neuzeit als Ort und Medium sozialer und symbolischer Kommunikation* (Münster: Rhema, 2004), pp. 7–22.

Müller, E., *Schweizer Theatergeschichte. Ein Beitrag zur Schweizer Kulturgeschichte* (Zürich: Verlag Oprecht, 1944).

Nagy, P. and P. Rouyer, *World Encyclopedia of Contemporary Theatre*, vol. 1 (Hoboken: Taylor & Francis, 2014).

Ragotzky, H., 'Fasnachtspiel', in K. Weimar et al. (eds), *Reallexikon der deutschen Literaturwissenschaft*, vol. 1 (Berlin and New York: Walter de Gruyter, 1997), pp. 568–72.

Schiendorfer, M., 'Vigil Rabers "Consistory Rumpoldi" und das in Bern 1530 aufgeführte "Elsli Tragdenknaben" ', in M. Gebhardt et al. (eds), *Vigil Raber. Zur 450. Wiederkehr seines Todesjahres. Akten des 4. Symposiums der Sterzinger Osterspiele* (Innsbruck: Universitätsverlag Wagner, 2004), pp. 193–211.

Schulze, U., *Geistliche Spiele im Mittelalter und in der Frühen Neuzeit. Von der liturgischen Feier zum Schauspiel. Eine Einführung* (Berlin: Erich Schmidt Verlag, 2012).

Simon, E., 'Shrovedite Plays in Late-Medieval Switzerland: An Appraisal', *Modern Language Notes* 85 (1970), pp. 323–31.

Stucki, H., 'Das 16. Jahrhundert', in M. Flüeler-Grauwiler and N. Flüeler (eds), *Geschichte des Kantons Zürich, Bd. 2, Frühe Neuzeit – 16. bis 18. Jahrhundert* (Zürich: Werd Verlag, 1996), pp. 172–281.

Tschopp, S. S., 'Reformationsdrama', in J. D. Müller (ed.), *Reallexikon der deutschen Literaturwissenschaft*, vol. 3 (Berlin and New York: De Gruyter, 2003), pp. 247–9.

Washof, W., *Die Bibel auf der Bühne. Exempelfiguren und Protestantische Theologie im lateinischen und deutschen Bibeldrama der Reformationszeit* (Münster: Rhema, 2007).

Weishaupt, M., *Bauern, Hirten und 'frumme edle puren'. Bauern- und Bauernstaatsideologie in der spätmittelalterlichen Eidgenossenschaft und der nationalen Geschichtsschreibung der Schweiz* (Basel and Frankfurt: Helbing & Lichtenhahn, 1992).

7

CONVERSIONAL ECONOMIES: THOMAS MIDDLETON'S *CHASTE MAID IN CHEAPSIDE*

Paul Yachnin

There is a moment in Middleton's 1613 city comedy, *A Chaste Maid in Cheapside*, that seems to resonate with the darkest moment in the greatest tragedy of the early modern English drama. In Middleton's comedy, Moll Yellowhammer, the daughter of a rich London goldsmith, conspires to marry a poor young gentleman, Touchwood Junior. Her father is dead set against the marriage. He has decided that his daughter will marry a man named Sir Walter Whorehound. It is extraordinary that he seems unable to grasp the meaning of Sir Walter's baldly allegorical name (he is indeed a 'whorehound'); in any case, Moll's father thinks the marriage will raise the status of the rich but commoner Yellowhammer family into the ranks of gentlemen and gentlewomen and will enable the flowering of their connections with the Court. The young lovers try a couple of times to escape the watchfulness of Moll's parents so that they can be wed. Their final, and successful, plan is for Moll and her beloved to feign death; once she has died, her lifeless body will be carried to the church; Touchwood Junior (seemingly dead too) will be carried in mourning to the same church; and then, once safely inside the church, the two dead lovers will rise miraculously from their coffins and be wed.

That is indeed what happens in the end. But first Moll has to die. Her death-directed playacting is well set in motion by a dunking in the Thames, which she suffers at the hands of her enraged mother. Her mother pulls her out of a boat – she grabs her by the hair to boot! – as Moll is trying to escape so she can marry Touchwood. Moll seems to sicken, she grows pale, she sings

a sorrowful song for the loss of her beloved. When her lover's brother brings the (false) news of Touchwood Junior's death ('Faith, feels no pain at all: he's dead, sweet mistress'),[1] she collapses, and her parents' hearts seem also to be breaking from grief:

MOLL [*swooning*]
Peace close mine eyes!
YELLOWHAMMER
The girl! Look to the girl, wife!
MAUDLINE
Moll, daughter, sweet girl, speak! Look but once up,
Thou shalt have all the wishes of thy heart
That wealth can purchase!
YELLOWHAMMER
O, she's gone for ever! That letter broke her heart.
(V, ii, 84–8)

I hear a remarkable echo at this moment. Could it be, I want to ask, that there is a recollection here of the broken-hearted King Lear as he is moved inexorably toward his own death over the body of his daughter, Cordelia? He carries her dead body onto the stage. In the space of sixteen lines, he says 'she's gone for ever' twice.[2] Note also that Middleton designs the action so that the audience does not know for certain that Moll is feigning death; as far as we know, she might have actually died, so the scene could be played seriously and tragically.

But surely, it might be objected, the echo of *King Lear* is merely the work of my imagination. Shakespeareans like me tend to see Shakespeare everywhere they look, even in the most unlikely places. And after all, 'she's gone for ever' is not such an unusual thing to say over the body of your newly deceased daughter. I should add, by the way, that I am not absolutely wed to the idea that there is a recollection of *King Lear* in Yellowhammer's mourning for his daughter. I won't even try to draw into my claim the fact that Moll's swan song includes the word 'never' as a triple refrain ('O, I shall see thee never, never, never!'); Lear, of course, says something similar: 'Thou'lt come no more, / Never, never, never, never, never' (V, ii, 41; V, iii, 308–9).

In any case, my argument is larger than a claim about a shared line or two between two very different plays. My starting point in this rethinking of *Chaste Maid*, for which the possible echo of *Lear* is only a hint, has to do with the remarkable tonal and thematic complexity or even contradictoriness of the play. Middleton's play is scandalously funny and savage as a satire of London social climbing and social falling, and it is also seriously invested in the possibilities of individual and collective conversion toward a good and worthy life. It is remarkable, for example, that the play is set during Lent and concludes

with the Christological death and resurrection of the two lovers. This complexity is of a piece with how the play might have worked for early modern audiences, how it might have spoken – critically, creatively and entertainingly – to the challenges the playgoers faced in their social, political and religious lives.

My title, 'conversional economies', suggests something about how Middleton binds together these two opposed and the mutually exclusive master metaphors of human living and valuation. Their boundedness together in the play is restless, frictional and productive – like tectonic plates whose collision turns everything upside down and alters the character of the lives of the people in the city and the whole shape of the urban landscape.

Economy is a fundamentally transactional domain. It depends on a logic of commensurability. For an economy to work, things of all kinds, including human labour (and in slave economies or in Middleton's Cheapside, human beings themselves), must be reducible to a common value with other things, reducible to a common currency, so that they can be traded, bought and sold. Of course in one sense, 'conversion' is key to how economies work. Currencies, forms of labour and goods of all kinds need to be convertible one to another, usually by way of the medium of currency, so that economic activity can go forward in more or less equitable and transparent ways.

But the particular meaning of 'conversion' that I want to bring forward here connects with the Latin *convert re*: 'to turn about, turn in character or nature, transform, translate, etc.' (*OED*). This 'conversion' represents a transformational rather than a transactional domain of human living. Conversion in this sense is informed by a logic of incommensurability – the idea that there are some ways of being, some kinds of knowledge and some forms of identity that are immeasurably higher, better and truer than other ways of being, kinds of knowledge and forms of identity. They belong to different worlds; in Augustine's phrasing, they belong to two cities: the City of Man and the City of God.

So Saul on the road to Damascus, Augustine in the garden or Martin Luther in his study in Wittenberg find themselves turning or being turned toward an incommensurably higher level of being and knowing. None of them would for a moment countenance the idea that their conversions could be measured in terms of cash value, increased social capital or career advancement. Conversion in this sense is transcendent over material wealth, social status and sometimes even life itself.

That is why the history of the early modern period features many people who were willing to suffer torture and even death rather than change from one form of Christianity to another. A convert to Protestantism at a doctrinally touchy time in the reign of Henry VIII, Anne Askew was racked and then burned at the stake for her outspoken new faith and her refusal to countenance the Catholic doctrine of transubstantiation.[3] Hundreds died for their Protestant faith under

the reign of Henry's daughter, the Catholic Mary, including Thomas Cranmer, former Archbishop of Canterbury. And Catholics were not spared. Under Elizabeth, Catholic priests and those that sheltered them were subject to arrest and to ghastly forms of corporal and capital punishment.[4]

In much criticism of the play, not surprisingly, the economy–conversion binary breaks into two pieces and takes the form of opposite and irreconcilable frames of reference.[5] On the side of what I am calling economy, the play emerges as something like a carpet-bombing satire of early modern London. 'The reduction of all relations to economic ones is typical of Middleton', says Joanne Altieri in a 1988 essay on the play.[6] In her introduction to the recent Oxford edition, Linda Woodbridge provides a definitive version of this view:

> [I]n a superficial world of materialism, sensuality, self-serving and cheap intrigue, horror lies in recognizing that this ugly surface *is* the world: there is nothing underneath. Life's farcicality . . . is offset not even by human dignity; such recognitions are savage. Yet *Chaste Maid's* very savagery crackles with vitality and a spirit of play.[7]

Woodbridge's approach finds a great deal of traction in the text. Consider the scene where Allwit counsels Yellowhammer not to marry his daughter to Sir Walter Whorehound. He tells him what should have been obvious from Sir Walter's name itself – that '[h]e's an arrant whoremaster' (IV, iii, 227). Allwit undertakes this seeming mission of moral counsel for a remarkable, mercenary reason: Allwit's wife is one of Whorehound's mistresses, the Allwit children were fathered by him, and the Allwit household is funded entirely by Sir Walter's money. It's bad enough that Allwit is in fact protecting his income and living arrangements by seeking to prevent Whorehound from marrying Moll, but Moll's father's response to the news is even worse. Yellowhammer reasons that marriage with his daughter might help Whorehound reform, that sexual profligacy is commonplace, that in any case Whorehound is rich, and that he, Yellowhammer, will see to it that the groom is treated for venereal disease in advance of the wedding. Here is Yellowhammer, left alone on stage, the most scandalously bad father anyone could imagine. Basically, he decides to sell his daughter and endanger her health for money and socially advantageous connections:

> Well, grant all this, say now his deeds are black,
> Pray, what serves marriage but to call him back?
> I have kept a whore myself, and had a bastard
> . . . The knight is rich, he shall be my son-in-law.
> No matter, so the whore he keeps be wholesome –
> My daughter takes no hurt then. So let them wed;
> I'll have him sweat well ere they go to bed.
> (IV, iii, 260–70)

A very different way of seeing the play comes from Herbert Jack Heller's book, *Penitent Brothellers*. Heller doesn't ignore the gritty social satire in the play, but for him that is finally not what the play is about. It's not what the play is. Here he describes how the play turns toward what he says is its conversional character as a 'comedy of grace':

> The hope of a penitent for his or her own salvation and resurrection, however, is always based on the resurrection of Christ. The grace which was omitted in his repentance now comes to Sir Walter – that in the feigned resurrection of Touchwood Jr and Moll, his life is more literally saved from the hanging which up to that moment was his possible fate . . . Resurrection is the basis of hope, and with Sir Walter's life saved, and with the lovers married, the play returns to comedy.[8]

Heller is reaching here. After all, Sir Walter exits the play, never to return, before the concluding scenes with their Christological deaths and resurrections and with the wedding of Moll and Touchwood. In the scene that features his final exit, he comes on grievously wounded, facing (as the scene develops) financial ruin and a possible murder charge, raging against the Allwits, and blaming others for his own bad life. He curses the children he has fathered. He curses Mistress Allwit, wishing misery and damnation on her ('In French and Dutch' means infected with venereal disease):

> Next I bequeath to that foul whore his wife
> All barrenness of joy, a drought of virtue,
> And dearth of all repentance; for her end,
> The common misery of an English strumpet,
> In French and Dutch; beholding ere she dies
> Confusion of her brats before her eyes,
> And never shed a tear for it.
> (V, i, 104–9)

Whorehound's story illustrates the complexity and even the naturalism of Middleton's thinking about religion. Heller says that resurrection is the basis of hope, but there is no sign of hope for Sir Walter. At the end of his time in the play, he is a figure of despair rather than a penitent or a convert. He is someone who sees his 'adulterous guilt' hovering over him like a harpy, 'with her black wings beat[ing] down all [his] prayers / Ere they be half way up' (V, i, 75–7). He feels himself 'o'ergrown with sin', feels death coming toward him, and tastes only bitter gall in his mouth (V, i, 72, 78–9). He cannot on this account be a protagonist in a comedy of grace, but his story nevertheless is far more at home in a conversional than in an economic domain, especially since it resonates powerfully with what Puritans such as William Perkins and Robert Bolton (in their rethinking of the apostate Francis Spira) had argued about

despair, which was that while despair is usually the sin against the holy spirit, it can also be a formative stage on the path to salvation.[9]

In light of the purchase that both economy and religion have on *Chaste Maid*, my claim in this chapter is that we have to push the boundaries of our understanding in order to grasp how the play operates and signifies in a domain that is both economic and conversional. To a remarkable degree, I want to suggest, the theatre opened new pathways between the City of God and the Earthly City, between the domains of conversion and economy, so that playgoers might begin to think in far more complex ways about their lives in the metropolis of London, a city that was a centre of religious controversy and change and also a centre of bustling commerce that happened to feature a newborn entertainment industry, a burgeoning field of the creation and consumption of print and performance that was at once artistically and socially creative.

1.

It is hardly surprising that conversion features so prominently in Middleton's drama.[10] From the late fifteenth century until long after Middleton's death, England, Europe and much of the Americas were undergoing what might be called a crisis of conversion. The forced conversion of Iberian Jews and Muslims in the wake of the *Reconquista*, the establishment of the Inquisition in Spain under royal authority, the European mission of conquest and conversion in the Americas, the emergence of the Reformation in Germany and its spread across northern Europe and Britain, the terrible wars of religion in France –all this moved conversion to the centre of early modern culture, religion and politics.

Not only did conversion become the centrepiece of early modernity, it also became highly problematised. How could Spanish Catholic authorities be sure that the conversions they had compelled their Jewish subjects to undergo would stick over the long run? The same kinds of interpretive challenges dogged the conversional programmes in the Americas and also through the sixteenth century in Britain as the population was harried by major shifts in the confessional identity, practices and theology of the national Church.[11] The problematisation of conversion did not allow early moderns to grasp conversion wholly and objectify it as if it were an instrument that they could easily put to other uses, but it did open a critical space around conversion that enabled them to redescribe it in other terms. The myriad redescriptions of religious conversion that Middleton and other playwrights generated enabled playgoers of all kinds to think together about their religious and social lives. The playhouse became on this account what Steven Mullaney has characterised as 'a new forum within which . . . collective thinking could take place':

The open air amphitheaters of early modern London . . . introduced new dimensions, in a quite literal sense, to an already extensive early modern performative sphere, producing a complex cognitive space for play-wrights, players and audiences to occupy and experience – an inhabited affective technology . . . designed to resonate with an audience newly uncertain of its individual or collective identities, and thus to sound out the gaps that had opened up in the heart of the Elizabethan social body.[12]

Conversion was surely the principal gap in the early modern English social body, a feature of the individual, interior lives of people of all ranks and walks of life and a central 'policing' concern of State and Church. Not surprisingly, conversions were very often regarded with suspicion. Historian Michael Questier has documented a great many cases of conversion that were thought to be more or as much a matter of worldly advancement as heartfelt turnings toward the true Church.[13] John Donne, one of the most high-profile cases among hundreds cited by Questier, converted from Catholicism to the Protestant Church (and eventually became one of its greatest preachers). Donne was a member of an eminent Catholic recusant family. His mother's great-uncle was the Catholic martyr, Thomas More. Donne's younger brother Henry died in prison after having been arrested for sheltering a Catholic priest. In his first published work, *Pseudo-Martyr*, Donne defended himself against those who accused him of apostasy and careerism. In the following passage, he enjoins his reader not to side automatically with those Catholics who have denounced him but to read the whole book before rendering judgement on his conversion or on his conversional argument:

And for my selfe, (because I have already received some light, that some of the Romane profession, having onely seene the Heads and Grounds handled in this Booke, have traduced me, as an impious and profane under-valuer of Martyrdome,) I most humbly beseech him [the reader], (till the reading of the Booke, may guide his Reason) to beleeve, that I have a just and Christianly estimation, and reverence, of that devout and acceptable Sacrifice of our lifes, for the glory of our blessed Saviour. For, as my fortune hath never beene so nattering nor abundant, as should make this present life sweet and precious to me, as I am a Moral man: so, as I am a Christian, I have beene ever kept awake in a meditation of Martyrdome, by being derived from such a stocke and race, as, I beleeve, no family, (which is not of farre larger extent, and greater branches,) hath endured and suffered more in their persons and fortunes, for obeying the Teachers of Romane Doctrine, then it hath done. I did not therefore enter into this, as a carnall or over-indulgent favourer of this life, but out of such reasons, as may arise to his knowledge, who shall be pleased to read the whole worke.[14]

Just as Donne asked his reader to undertake the hard work of reading and thinking, so he reported that he had read everything that had been written between the Catholic and Protestant adversaries and had reflected deeply on their arguments. On Donne's account, his was an entirely scholarly and rational conversion, with no trace of social or political influence or aspiration:

> And although I apprehended well enough, that this irresolution not onely retarded my fortune, but also bred some scandall, and endangered my spirituall reputation, by laying me open to many mis-interpretations; yet all these respects did not transport me to any violent and sudden determination, till I had, to the measure of my poore wit and judgement, survayed and digested the whole body of Divinity, controverted betweene ours and the Romane Church.[15]

If the case of Donne can illustrate how early modern English people had become, to quote Mullaney, 'newly uncertain of [their] individual or collective identities', then we can see how Middleton's drama could help playgoers, to quote again, '[to] sound out the gaps that had opened up in the heart of the Elizabethan social body'.[16] From beginning to end, Middleton's dramatic canon is keenly interested in questions around religious conversion. Characters such as Penitent Brothel in *Mad World My Masters* (*c.*1606), Francisco in *The Widow* (*c.*1616), the Duke of Florence in *Women Beware Women* (1621) and a number of characters in *Game at Chess* (1624), as well as Sir Walter Whorehound and other characters in *Chaste Maid* move, not unlike Donne, within the liminal space between Christian conversion and the worldly, self-interested or self-deluding performance of Christian conversion.

The Duke's conversion to virtuous married life in *Women Beware Women* is something like a parody version of Donne's apparently rational turn to the Church of England. The Duke's brother, the Cardinal of Florence, upbraids him for his adulterous relationship with the beautiful Bianca. The Duke seems to take this Christian counsel to heart. In soliloquy, he says he will honour the vow he just made '[n]ever to know her as a strumpet more' (IV, i, 270). He then looks forward to the murder of her husband, which he has instigated; once she is a new-made widow, he will 'make her lawfully [his] own' (IV, i, 274). He concludes by celebrating his conversion to chastity and to lawful marriage: ''Tis but a while, / Live like a hopeful bridegroom, chaste from flesh, / And pleasure then will seem new, fair and fresh' (IV, i, 277–9).

2.

Chaste Maid in Cheapside is Middleton's most experimental conversional comedy. Here religious conversion is fully itself, especially for the despairing Whorehound, whose conversion must remain in question. However,

conversion also takes other forms: the quasi-sacrament of marriage; trans-formations of social rank; the death and resurrection of the two lovers; an ethics of care that takes hold of two unscrupulous con artists; and the master-metaphor of the play – the triadic relationship of humans, animals and meat.[17] Bear in mind that conversion not only makes the convert new, but also reveals what the convert most authentically is. Augustine is transformed entirely and also becomes what he was always meant to be: a devout Christian. So humans transformed into animals are made new and also revealed as what they really are. If we can look again at *King Lear* for a moment, we will remember how the King must take on his own animality – what he truly is – by taking off his clothes. 'Thou art the thing itself', he says as his understanding is wrenched open by the spectacle of Edgar's nearly naked body, 'unaccommodated man is no more but such a poor, bare, fork'd animal as thou art. Off, off, you lend-ings!' (III, iv, 106–8). If anything, Middleton's triadic conversional pathway is even more pessimistic than the moment of unbuttoning in Shakespeare's play. Middleton's men, women and infants are converted into animals; but then – this is ghastly and darkly ironic – they are made into meat, undergoing a transformation into something new and enacting a revelation of their true character. This dimension of the play gives us the transactional domain of economy equipped with a full set of sharp teeth.

Taken together, however, from religious conversion to zoomorphism, the fast-moving, intersecting forms of conversion that populate the play give us a metropolis that is nothing like the zero-sum competition for wealth and status described by so many of the play's critics. On the contrary, the conversional traffic of people, things, money, social status and forms of language issues in a hyperactive field of possibilities. Turn up the speed of all that conversional traffic far enough, which is what the play does, and London itself is trans-formed into a new city.

It's important to remember that the emergence of a new city does not mean that conversion supplants economy. The new London is not transcendent over the material and social stuff, money and people that have driven the trans-formation in the first place. The picture of London that issues from the play remains both economic and conversional all the way down.

For the persistence of both economy and conversion, consider how humans can turn into animals, which of course they already are, and how animals, including the human animals, are transformed into meat. At the start of the play, Touchwood Junior spots his rival Whorehound. Somehow he knows that the supposedly landed Welsh gentlewoman on stage is Sir Walter's mistress, brought to the city to be offloaded onto some naïve Londoner. Touchwood speaks in an aside ('ewe-mutton' neatly yokes together the animal and the meat that the animal is made into by butchery):

My knight, with a brace of footmen,
Is come, and brought up his ewe-mutton
To find a ram at London.
(I, i, 143–5)[18]

The triad of human, animal and meat is everywhere in this Lenten comedy. Allwit himself (in disguise as someone else) says that Allwit sells his wife to Whorehound '[a]s other trades thrive, butchers by selling flesh, / Poulters by vending conies' (IV, i, 235–6). The conversion of humans into meat lines up with the play's depiction of a world where people are instrumentalised by others, where even children have exchange value rather than intrinsic value and where they are particularly serviceable to bolster the social and financial standing of their parents. We have already seen how Yellowhammer is bent on marrying his daughter to Whorehound for the sake of social advancement. When he catches her trying to marry Touchwood, he reiterates her cash value by declaring that he will 'lock up this baggage / As carefully as my gold' (III, i, 41–2). The downfall of Whorehound, and his sudden plummet as an eligible mate for Moll, is precipitated when his kin, Sir Oliver and Lady Kix, at last conceive a child (more about that in a moment), which is the legal requirement for them to inherit the fortune otherwise willed to Sir Walter. 'The child is coming', says the jubilant Sir Oliver, 'and the land comes after' (V, iii, 14).

The play features a remarkably large population of children and infants. 'Children are blessings' (III, ii, 34) says one of the Puritan women at the drunken celebration of the birth and christening of Whorehound and Mistress Allwit's daughter. Babies are indeed blessings, but they are also legal instruments of a kind, as when Lady Kix's pregnancy overturns Whorehound's right to inherit. And they are, naturally enough, dynamically related to domestic economies. Yellowhammer invests in his children's education and 'finishing' so that their marriages will yield a greater social and material profit. Touchwood Senior, who is the man that impregnated Lady Kix and thereby brought her and her husband a fortune, mourns the fact that he and his wife must live apart because their hyper-fertility has impoverished them; he simply cannot afford another legitimate conception. 'Some only can get riches and no children', he complains, 'We only can get children and no riches' (I, ii, 11–12).[19]

When one of his many bastard offspring is brought to him by the baby's mother, Touchwood Senior, himself impoverished by his fecundity in wedlock, refuses to provide support. Once she exits, he makes explicit the cannibalistic current that flows beneath so many of the parent–child relationships in the play. 'What shift', he says, 'she'll make now with this piece of flesh [that is, the infant] / In this strict time of Lent, I cannot imagine; / Flesh dare not peep abroad now' (II, i, 107–9).

The idea of economy as a kind of cannibalism takes a turn when Middleton revives and resets the comic climax of *The Second Shepherd's Play*, part of the Catholic Wakefield Cycle, which was suppressed by the Elizabethan authorities in 1576. In the Cycle play, the shepherds find their sheep, which was stolen by Mak, swaddled as an infant in a cradle in Mak's dwelling. At first, the shepherds are convinced it is a newborn baby, in spite of the ovine noises coming from the cradle. They ask to be allowed to kiss the baby; when they reach in to lift the infant out, they discover the fraud:

> 3RD SHEPHERD
> Give me leave him to kiss, and once lift him out.
> What devil is this? He has a long snout!
> 1ST SHEPHERD
> He is marked amiss. Let's not wait about!
> 2ND SHEPHERD
> The ill-spun weft always comes foully out.
> Aye, so!
> He is like to our sheep.[20]

After recovering their property and punishing Mak, they return to their flocks and prepare themselves for sleep when the angel of the Lord appears to them, singing 'Gloria in excelsis' and announcing the birth of Christ. The sheep–infant of the parodic comic scenes with Mak becomes the Christ child–Lamb of God in the follow-up. The conversional relationship of human, animal and meat issues in this Catholic drama in the founding of a salvific community. The extraordinary new dispensation of grace played out in *Second Shepherd's Play* is replayed in earnest and at regular intervals in the central ceremony of the Church (both Catholic and Protestant), when members of the congregation are invited to eat the flesh of the Son of God, take into themselves and so be taken into the deity incarnated as a man and symbolised in scripture and religious art as a lamb.[21]

Middleton's replaying of Mak's trick and its revelatory follow-up is conversional, but not nearly so spectacular or decisive. In *Chaste Maid*, the young woman, who has been rejected by Touchwood Senior, hides her infant in a basket. She comes upon two Promoters – conmen who are fleecing passers-by of the meat they are carrying – meat being forbidden during Lent. The young woman tells them that she has a licence for the meat she is carrying in the basket. She says that she will run and fetch her master and the licence, and she makes them swear to keep the basket and its contents until she returns. She leaves and they dig into the basket, find a fat loin of mutton, dig deeper, think at first they have found a lamb, but find it is a child instead. The scene has no angel in it, of course, but the two thieves tell us they must honour their promise to the young woman and so they begin to make arrangements for the care of the infant:

FIRST PROMOTER
'Swounds, what's here?
SECOND PROMOTER
A child!
FIRST PROMOTER
A pox of all dissembling cunning whores!
SECOND PROMOTER
Here's an unlucky breakfast!
FIRST PROMOTER
What shall's do?
SECOND PROMOTER
The quean made us swear to keep it too.
FIRST PROMOTER
We might leave it else.

. . .

FIRST PROMOTER
Half our gettings must run in sugar-sops
And nurses' wages now, besides many a pound of soap
And tallow; we have need to get loins of mutton still,
To have suet to change for candles.
(II, ii, 167–77)

The Promoters' conversion is not Christian in a doctrinal sense, but they embrace the Christian virtues of promise-keeping and especially charity by honouring their oath to the baby's mother and by deciding to pay for the care of the infant. Their conversion to an ethics of care does not in any way lift them out of their lives as conmen. Indeed, their turn toward faithfulness to their word and care of the helpless is embedded in and enabled by thievery and the illicit trade in meat.

The conversion of the Promoters is of a piece with the scene of Moll and Touchwood's resurrection and marriage that turns the play decisively toward its comedic ending, and of a piece also with the conversion by marriage of the faux Welsh gentlewoman in the play's closing moments. Marriage is a religious and legal kind of conversion whereby two individuals become one flesh. Protestant marriage, as we've noted, is not a sacrament (it is a sacrament in Catholicism), but it retains nevertheless a strong sense of the sacred as a transformative force. So the marriage ceremony in the 1559 *Book of Common Prayer* begins:

DEARELY beloved frendes, we are gathered together here in the sight of God, and in the face of his congregacion, to joyne together this man and this woman in holy matrimony, which is an honorable state, instytuted

of God in Paradise, in the time of manes innocencie, signiflyng [*sic*] unto us the mistical union that is betwixt Christ and his Churche.[22]

Moll's father is more interested in social than in sacral conversion. Her marriage to Whorehound will, he believes, transform Moll's social rank, advancing her to the status of a lady and lifting her above her origins in the gritty commerce of the city. The transformation that her parents envision for her is matched by what they have in store for her brother Tim. His Cambridge degree will make him a gentleman; his marriage to the supposed Welsh gentlewoman will add gentrified landedness to his gentled condition. Of course, none of this is going to happen, at least not the way the Yellowhammers want it to happen. The inevitable failure of the wished-for social conversions lines up with the failure of the young people's material and linguistic transformations. Moll's mother upbraids her for her drossiness and leadenness, especially against the brightness, purity and costliness of gold (I, i, 12–22). Tim's rudimentary linguistic ability stands like a fat block of wood in the way of his hoped-for accomplishment as a Latinist. On the face of it, the merchant class can no more convert to a higher status or escape their city origins than lead can metamorphose into gold or the rough vernacular of *Cheapside* can translate into aureate Latin.

And yet, from the start of the play, the alchemical traffic of people, goods and even words is going on outside and inside the characters. Maudlin Yellowhammer, to take one example, has picked up the word 'errors', her husband says, from some Westminster attorney's clerk seeking ready money. 'Nay', he says, 'the city cannot hold you, wife, / But you must needs fetch words from Westminster' (I, i, 27–8). The single errant word, which seems to have more transformative power than a Cambridge education or an arranged marriage, points to how the fast-moving heterogeneity of city life itself can issue in individual and collective transformation and even in system-level change.

That kind of large-scale transformation is what Moll and Touchwood Junior bring about by staging their illicit wedding as an Easter Sunday-like resurrection, an innovation that connects with Middleton's own adaptation of *Second Shepherd's Play*. The wedding is prefaced by a solemn funeral pageant, led by Touchwood Senior. Once the coffins have been set down in the church and a sad song has been sung, Touchwood Senior recalls the Edenic ideal of marriage, which, as we have seen, opens the wedding ceremony in the *Book of Common Prayer*: 'Never could death boast of a richer prize / From the first parent; let the world bring forth / A pair of truer lovers' (V, iv, 1–3). He goes on to say that Moll's perfection would have been able to redeem Eve from her Fall and restore the world to its prelapsarian perfection.[23] No longer a leaden or a drossy young woman, she is celebrated as a 'jewel so infixed' of '[b]eauty set in goodness' (V, iv, 17–18).

The lead-up to the wedding is thus radiant with the conversional, redemptive sentiments of scripture and the Anglican liturgy, but the wedding is also a socially transformative event. Ironically, it achieves the social advancement that Yellowhammer was so bent on: Moll the commoner is indeed elevated by the gentle rank of the man she marries. That fact is possibly part of the reason that Yellowhammer, who suddenly breaks into the wedding scene, surprises everyone, including the playhouse audience, by celebrating rather than denouncing the marriage and, finally, by inviting everyone to a feast in celebration of the marriages of his children – Moll with Touchwood Junior and Tim with the unnamed Welsh woman. By the way, Tim's rank is also elevated by his marriage, since his bride, whatever her past life has been, is designated in the text as a gentlewoman.

In spite of his bride's social rank, Tim himself is disconsolate when he discovers that the woman he has just married is Sir Walter's cast-off mistress, what he and the others call a whore. What happens to Tim is both an early modern dirty joke and also something deeper and more transformative than jokes usually are. At the start of the exchange among the characters, Tim brings back the human–animal form of conversion, vowing to rent his wife out as if she were a horse, which means to prostitute his wife (as Allwit did up until the fall of Sir Walter). But at the prompting of his mother, Tim undertakes instead to prove by logic that his bride is an honest woman. When that fails – as it must, given Tim's minimal capacity for logical thinking – his bride takes matters into her own hands. She brings forward the conversional power of marriage, she inadvertently promotes the value of the vernacular over Latin and she seems to succeed in expunging what would usually be the indelible stain of whoredom:

> MAUDLIN
> I think you have married her in logic, Tim.
> You told me once by logic you would prove
> A whore an honest woman; prove her so, Tim,
> And take her for thy labour.
> . . .
> TIM
> Why then my tutor and I will about her,
> As well as we can.
> *Uxor non est meretrix, ergo falacis.*[24]
> WELSH GENTLEWOMAN
> Sir, if your logic cannot prove me honest,
> There's a thing called marriage, and that makes me honest.
> MAUDLIN
> O there's a trick beyond your logic Tim.

TIM

I perceive then a woman may be honest according to the English print,
when she is a whore in Latin. So much for marriage and logic! I'll love
her for her wit . . .
(V, iv, 100–15)

At the very end, Yellowhammer invites everyone gathered on the stage
(everyone is there except Sir Walter) to a celebration of the two weddings. The
gesture is perfectly in keeping with the complexity of the play's representation
of London life. It is a genuine and generous invitation, but Yellowhammer,
as the Oxford editor comments, is a 'businessman to the end', and so he is
pleased to be able to enhance his social standing by throwing a big party,
contribute to the crystallisation of the new community that has formed around
the Christological death, resurrection and marriage of Moll and Touchwood
Junior, and save money by having two weddings for the price of one:

So Fortune seldom deals two marriages
With one hand, and both lucky. The best is,
One feast will serve them both! Marry, for room,
I'll have the dinner kept in Goldsmiths' Hall,
To which, kind gallants, I invite you all.
(V, iv, 118–22)

Chaste Maid in Cheapside on this account is neither a 'comedy of grace' nor
a wall-to-wall satire of early modern London. As a comedy of conversional
economy, it is something far more original and socially creative – a form of
collective theatrical action that involved the players and the members of the
audience in thinking and feeling their way toward a new understanding of their
social, religious and commercial world. It was an understanding that included
both the contest for wealth and status and also the capacity for transformative
change for individuals and collectivities that issued from the heterogeneity and
the fast-moving traffic, along with the inevitable collisions, of city life. *Chaste
Maid* is also, as I have been arguing, a play that rethinks and thinks with conver-
sion, moving out from the model of religious conversion, which was at the centre
of the earlier Catholic drama, into multiple related forms of transformation. All
those forms of conversion, including the religious one, do not at any moment in
the course of play cast off their necessary and enabling entanglements with the
economic life of the city; they never transcend the economic to rise into some
kind of pure, superlunary zone of sacred being. In Middleton's play, as in the
real lives of the players and the playgoers (someone like Donne for example),
conversion really happens, but it is something that always happens right here in
the world. Middleton's play invites us to see how the world we live in is, through
and through, a space for the dynamic interplay of conversion and economy.

NOTES

1. This and all following quotes from *Chaste Maid* are from the edition by Woodbridge, *The Chaste Maid in Cheapside*.
2. All Shakespeare quotes are from Evans, *The Riverside Shakespeare*.
3. See Askew and Beilin, *The Examinations of Anne Askew*; for an account that sets Askew's martyrdom in its political context, see Marshall, *Heretics and Believers*, pp. 296–302.
4. For a brief, reliable survey, see Collinson, *The Reformation*, pp. 123–43.
5. Studies that see the play operating and signifying within an economic frame of reference include Leinwand, *The City Staged*, pp. 76–9; and Newman, 'Goldsmiths Ware'. Studies of the play that take religion as foundational include Heller, *Penitent Brothellers*, pp. 76–88; and Brunning, 'O, how my offences wrestle with my repentance!'
6. Altieri, 'Against Moralizing Jacobean Comedy', p. 176.
7. Woodbridge, 'Introduction', p. 907.
8. Heller, *Penitent Brothellers*, pp. 87–8. Note that an 'economic' reading, like Rowe's in *Thomas Middleton and the New Comedy Tradition*, pp. 130–49, discusses the religious elements in the play, but sees them as 'meaningless forms' – pious gestures or formulaic ways of speaking that are emptied of all religious significance.
9. See MacDonald, 'The Fearefull Estate of Francis Spira', especially pp. 47–8. We find similar thinking about despair in Book 1, Canto 8 of Spenser's *Faerie Queene*, where Red Cross Knight begins his long pilgrimage from abject despair, wishing only to die, to salvation and sainthood. Shakespeare's Duke in *Measure for Measure* uses what he calls 'heavenly comforts of despair' (IV, iii, 110) to move Isabella toward what the Duke thinks will be forgiveness, gratitude and grace.
10. For a discussion of 'the conversional theatre' with a Shakespearean focus, see my essay, 'Shakespeare's Theatre of Conversion'.
11. For the growing need to 'pass' as a member of the established Church – an existential need for Jews and Muslims in Spain and Catholics in Elizabeth's England – and for the challenges it created for the authorities in both countries, see Zagorin, *Ways of Lying*, pp. 38–62 and pp. 131–52 respectively.
12. Mullaney, 'Affective Technologies', pp. 73–4.
13. Questier, *Conversion, Politics and Religion in England*, pp. 40–75.
14. Donne, *Pseudo-Martyr*, p. 8.
15. Ibid., p. 13.
16. Mullaney, 'Affective Technologies', p. 74.
17. I call marriage a quasi-sacrament since the Protestants demoted it from its place as one of the seven Catholic sacraments.
18. For a brilliant discussion of ideas about the insufficiency of the human animal and *King Lear*, see Shannon, 'Poor, Bare Forked', pp. 127–73.
19. Happily, at the end of the play, the delighted and even more wealthy Oliver Kix promises to provide life-long support to Touchwood Senior, his wife and their many offspring.
20. The Wakefield Master, *The Second Shepherd's Play*, p. 21.
21. For the competing understandings of the sacrament of Holy Communion and for its continuing centrality, see Wandel, *The Eucharist in the Reformation*.
22. Anon., 'The Fourme of the Solempnizacion of Matrimonye'.
23. See V, iv, 15–17: 'What nature could there shine that might redeem / Perfection home to woman, but in her / Was fully glorious?' The Oxford editor glosses, 'whatever natural goodness could exist to redeem womankind from the sin of Eve, restoring Woman to perfection, shone fully in Moll'.

24. The literal translation is 'a wife is not a whore; therefore you utter a fallacy'. It's not easy to understand just what Tim means to say. Given the exchange that follows, he seems to mean, 'a whore cannot be a wife; therefore you are wrong to think that she could be an honest woman'.

Works Cited

Altieri, Joanne, 'Against Moralizing Jacobean Comedy: Middleton's *Chaste Maid*', *Criticism* 30 (1988), pp. 171–87.

Anon., 'The Fourme of the Solempnizacion of Matrimonye', *Book of Common Prayer – 1559*, <http://justus.anglican.org/resources/bcp/1559/Marriage_1559.htm> (last accessed 24 July 2018).

Askew, Anne and Elaine V. Beilin (eds), *The Examinations of Anne Askew* (Oxford: Oxford University Press, 1996).

Brunning, Alizon, ' "O, how my offences wrestle with my repentance!": The Protestant Poetics of Redemption in Thomas Middleton's *A Chaste Maid in Cheapside*', *Early Modern Literary Studies* 8 (2003), pp. 41–51.

Collinson, Patrick, *The Reformation: A History* (New York: Modern Library, 2006).

Donne, John, *Pseudo-Martyr*, ed. Anthony Raspa (Montreal: McGill-Queen's University Press, [1610] 1993).

Evans, G. Blakemore (general ed.), *The Riverside Shakespeare*, 2nd edn (Boston: Houghton Mifflin, 1997).

Heller, Herbert J., *Penitent Brothellers: Grace, Sexuality, and Genre in Thomas Middleton's City Comedies* (Newark, DE: University of Delaware Press, 2000).

Leinwand, Theodore B., *The City Staged: Jacobean Comedy, 1603–1613* (Madison: University of Wisconsin Press, 1986).

MacDonald, Michael, 'The Fearefull Estate of Francis Spira: Narrative, Identity, and Emotion in Early Modern England', *Journal of British Studies* 31 (1992), pp. 32–61.

Marshall, Peter, *Heretics and Believers: A History of the English Reformation* (New Haven: Yale University Press, 2017).

Mullaney, Steven, 'Affective Technologies: Toward an Emotional Logic of the Elizabethan Stage', in Mary Floyd-Wilson and Garrett Sullivan (eds), *Environment and Embodiment in Early Modern England* (London: Palgrave Macmillan, 2006), pp. 71–89.

Newman, Karen, ' "Goldsmiths Ware": Equivalence in *A Chaste Maid in Cheapside*', *Huntington Library Quarterly* 71 (2008), pp. 97–113.

Questier, Michael C., *Conversion, Politics and Religion in England, 1580–1625* (Cambridge: Cambridge University Press, 1996).

Rowe, George E., *Thomas Middleton and the New Comedy Tradition* (Lincoln: University of Nebraska Press, 1979).

Shannon, Laurie, 'Poor, Bare Forked: Animal Happiness and the Zoographic Critique of Humanity', in *The Accommodated Animal: Cosmopolity in Shakespearean Locales* (Chicago: University of Chicago Press, 2013).

The Wakefield Master, *The Second Shepherd's Play*, in Adrian Guthrie (ed.), *The Second Shepherd's Play from the cycle of the Wakefield Mystery Plays*, [c.1500] 1987, <http://seas3.elte.hu/coursematerial/PikliNatalia/AGuthrieSecondShP.pdf> (last accessed 24 July 2018).

Wandel, Lee Palmer, *The Eucharist in the Reformation: Incarnation and Liturgy* (New York: Cambridge University Press, 2006).

Woodbridge, Linda (ed.), *The Chaste Maid in Cheapside*, in Gary Taylor and John

Lavagnino (general eds), *Thomas Middleton: The Collected Works* (Oxford: Clarendon Press, [*c*.1613] 2007), pp. 912–58.

Woodbridge, Linda, 'Introduction, *A Chaste Maid in Cheapside*', in Gary Taylor and John Lavagnino (general eds), *Thomas Middleton: The Collected Works* (Oxford: Clarendon Press, 2007), pp. 907–11.

Yachnin, Paul, 'Shakespeare's Theatre of Conversion', *The Immanent Frame*, 7 May 2018, <https://tif.ssrc.org/2018/05/07/shakespeares-theatre-of-conversion> (last accessed 17 July 2020).

Zagorin, Perez, *Ways of Lying: Dissimulation, Persecution, and Conformity in Early Modern Europe* (Cambridge, MA: Harvard University Press, 1990).

CODA: PERFORMING CONVERSION IN AN EARLY MODERN FUTURE

Stephen Wittek

My thoughts turn to the *moriscos* as I take my first sip of espresso and look over a damp copy of the morning's *New York Times*. In the foreground of the cover photo, a handful of human figures stand with their backs to the camera, looking toward a stout, grey building that sits commandingly at the end of a sandy courtyard. The women in the photo all wear colourful headscarves and long jackets that extend past their knees. One of them has her head slightly tilted, gold necklace sparkling in the sunlight. Another holds a clamshell cell phone to her ear. A boy on the right has his arms folded across his chest, revealing a skinny elbow that peeks out from a saffron-coloured polo shirt. Near the centre of the photo, the Chinese national flag flies above the building's entrance, providing a splash of colour to match a pair of messages emblazoned in red across the building's facade. Looking closer, I notice that the message on the left is in Mandarin and the message on the right is in Arabic. The headline provides further details. 'Anti-Islam Detention Camps in China. Minority Swept Up in Biggest Internment Program Since Mao Era'.[1]

The article underneath explains that the building is a centre for conversion.[2] Over the past year, the Chinese government has built a number of similar facilities throughout the Xinjiang region for the express purpose of turning hundreds of thousands of Chinese Muslims into model Chinese citizens. As detainees enter, the gigantic red messages in Mandarin and Arabic command them to 'Learn the language, study law and acquire job skills'.[3] Once inside, they must adjust to a life stripped of beards, headscarves and prayer mats and

work through a daily regimen of lectures, patriotic hymns and exercises in self-criticism. A former detainee reports that, after two months in the facility, he certified his new identity by publicly renouncing his former life, an obligatory performance managed in spite of seething private resentment.

I wonder if the detainee's resentment makes any difference. My first thought is that, as long as he speaks, dresses, eats, writes and sings according to script, the authorities will consider his conversion a fait accompli. But if the primary objective is outward conformity, why bother with the prolonged lecturing and self-examination?

I reach into my pocket for my phone and forward the article to my friend Stephanie. 'Hey there. Just saw this article in the Sunday paper and thought it might be of interest. Hope all is well'. Stephanie is a historian of early modern Spain.[4] Her scholarship focuses on legal and political documents pertaining to the *moriscos*, a socially distinct group that emerged in the early sixteenth century following the introduction of laws forcing hundreds of thousands of Spanish Muslims to convert to Catholicism. Like their twenty-first-century counterparts in China, the *moriscos* found themselves obliged to perform according to the script for a dramatically new identity.[5] With the threat of mortal consequence constantly hanging overhead, they systematically adapted to new codes of behaviour, new cuisine, new apparel, new books, new songs, new prayers and a new god. Their story does not have a happy ending. Following a century of assimilative policy, the Spanish government eventually concluded that the converts were not performing as expected. Between 1609 and 1614, approximately 300,000 *moriscos* left Spain on threat of death, abandoning properties they had inhabited for generations.[6] In a contemporary painting of the port at Dénia, Vicente Mostre depicts Spanish Christians triumphantly dancing, wrestling and enjoying other festivities while hundreds of Morisco families board ships bound for North Africa, victims of what was at that point, in the words of historian Matthew Carr, the largest 'ethnic-cleansing' campaign in European history.[7]

Readers of *Don Quixote* may recall Cervantes' characteristically sensitive, but politically cautious, treatment of the *moriscos* in a brief episode from Part II, Chapter LIV, where Sancho Panza encounters his old neighbour Ricote, an exiled *morisco* who has returned to Spain in disguise to recover a stash of buried gold. After treating Sancho to a picnic of caviar and a half dozen botas of wine, Ricote delivers a surprising defence of the expulsion, candidly admitting that he was never much of a Christian, but not really a Moor either. As a counterpoint to this justification, however, he also offers a sympathetic description of his wife and daughter, who were sincere Christians, and have had difficulty adapting to life among the Moors in Algiers. 'It is not a good idea to nurture a snake in your bosom or shelter enemies in your house', he tells Sancho.

In short, it was just and reasonable for us to be chastised with the punishment of exile: lenient and mild, according to some, but for us it was the most terrible we could have received. No matter where we are we weep for Spain, for, after all, we were born here and it is our native country.[8]

The story of the *moriscos* is historically significant because it signals the arrival of an era where conversion became a world-making phenomenon, an era invigorated by the theory that the innermost dimension of selfhood could undergo radical, categorical change. When historians attempt to describe early modernity from a wide-angle perspective, they typically list developments such as the discovery of the New World, the growth of cities and states, new networks for trade, growing interaction between peoples and cultures, and other advancements toward a global marketplace. In addition to these broad structural features, however, one might also note the emergence of another, more conceptual, marketplace, a space that made the free-flowing exchange of identities, faiths and allegiances seem readily possible. Operating under the affordances of this new regime, the people of early modernity converted at an unprecedented rate, sometimes by the thousands, but also on an individual basis, sometimes by force, but also as a result of volition or persuasion. As the conversion camps in Xinjiang and myriad similar examples demonstrate, the influence of early modern conversional theory continues to resonate in our own age.

Laying my newspaper aside, I lean back and focus on bringing my thoughts into order. At some point in the twenty-first century, an Islamic detainee at the Xinjiang conversion centre proclaimed his commitment to a wholly new identity, secretly burning with resentment, perhaps making a conscious effort to avoid clenching his fists or grinding his teeth. At another point approximately 500 years and 7,000 kilometres away, *moriscos* such as Cervantes' Ricote endeavoured to reinvent themselves as Christians, only to face expulsion to a society where their new identity was a damning liability. What patterns emerge when one considers the conversions of the sixteenth and twenty-first centuries side by side?

Three ideas come immediately to mind. My first observation is that conversion is always political. Whether it is sincere or feigned, forced or volitional, conversional change will always involve a turn away from one social category toward another, and will play out in terms of alliances, schisms, recruitment, defection, persuasion, coercion, sovereignty, subjugation, loyalty and betrayal. Second, because it can only become manifest in modes of self-presentation, conversion is always performative. Saul of Tarsus and Cassius Clay both got a new name. The detainee in Xinjiang shaved his beard and learned new songs. The *moriscos* ate ham. Augustine abandoned his mistress. Whatever form they may take, articulations along these lines are constitutive of conversional

performance. They are the ground that makes the figure of conversion knowable for others and oneself.

However, conversion is never really knowable, at least not from the outside. A convert who appears to have become a model Chinese citizen may in fact be a deep well of resentment, framed by a model citizen-shaped outline. One can never really know for sure. Thus, my third and most important observation is that, although conversion is always political and always performative, it is only nominally interior. A key similarity between Ricote and the Xinjiang detainee is that, while both were able to successfully perform according to script, neither was in fact sincere. Conversion is putatively about a change on the inside, somewhere deep in the heart, or the soul, or the mind, but an interior change does not actually have to occur in order for a conversional performance to be effective. Rather, it merely has to *seem* as though it has occurred. Performance trumps spiritual sincerity.

I should note that I have been using the term 'performance' as it pertains to practices of identity and self-presentation. Writing in a similar mode, Judith Butler famously argued that gender is performative because it inheres in practices of acculturation, and is therefore distinct from anatomy, which has a purely biological basis.[9] In order to bring the legacy of early modern conversional culture into better focus, I want to draw a line connecting this notion of 'performance' to the sort of performance that takes place in a theatre, that is to say, the sort of performance that an actor delivers by conveying a representational artwork through the medium of a body to a group of other bodies gathered around a stage.

The early modern conversional marketplace arose on the crest of a tremendous outpouring of cultural production, drama in particular. In music, philosophy, literature and the visual arts, thinkers and makers of all stripes applied their talents to the subject of conversion for purposes of persuasion, but also for purposes of critical enquiry, providing a rich seedbed where conversional tropes, norms, images, attitudes and ideas could proliferate and evolve. Above all other media, drama was uniquely able to bring the dynamics of conversion into focus because it could replicate the subtle nuances of conversional performance in fine-grained, bodily detail.

In the theatre, one could examine a living example of conversion from various angles, compare it against similar examples and evaluate it in terms of veracity and sincerity. For example, consider Shakespeare's masterpiece of conversional drama, *The Merchant of Venice*, which invites spectators to consider the forced conversion of the Jewish moneylender, Shylock, alongside the voluntary conversion of his daughter, Jessica. Representations of a similar nature abound in the drama of early modernity. Notably, in even the simplest examples, a theatrical conversion will force an implicitly critical perspective. After all, if an actor on a stage can convincingly simulate the outward signs

of conversional experience, then it must be possible to simulate conversion in other contexts as well. Even the most passionate, credible convert could be a secret dissembler, like Ricote or the Xinjiang detainee. One can never really know for sure.

In what follows, I will track the legacy of early modern conversional theory through the lens of twenty-first-century dramatic performance. My goal is not to provide a comprehensive summary, but, more modestly, to simply observe the great variety of conversions in the present age, and to assert the continued centrality of dramatic and social performance to the ongoing evolution of conversional phenomena. I have three examples.

1.

A solitary man sits on a chair on a stage, hands folded between his legs. He glances to the side and smiles sheepishly into the light, accentuating a dimple on his upper right cheekbone.

> Yeah . . . Um, I guess the first thing I want to tell you is, my name's not Nick. It's Dave. And I don't work at Office Depot. I work at a gay-friendly newspaper on Capitol Hill. And I frequently have sex with other men. I lied because when I first started coming here, I had no idea how much I wanted to open up to you guys. I mean, I heard your stories about the desperate gay lifestyle, and how your homosexuality resulted from abandonment by your father, and I was threatened. I mean, you guys saw me . . . coming in here, and arguing, and intellectualizing everything. Uggh! All my life, my intellect has gotten in the way of my happiness, but now I know it is time to give myself to something bigger than intellect. And that something is Jesus Christ.[10]

Hands still folded, he bows his head and closes his eyes. 'Does anybody have any chips?'[11]

The moment comes at a critical juncture approximately halfway through David Schmader's one-man show, *Straight: A Conversion Comedy*, which premiered in Seattle in 1999. Alone on a stage with a desk and a few chairs, Schmader narrates and re-enacts his experiences as an undercover journalist in the nebulous world of conversion therapy. Frustrated by his inability to present himself 'as both rational queer and would-be former homosexual', he eventually arrives at the realisation that in order to genuinely understand the subjects of his investigation, he will have to drop his combative posture, swallow his pride and play the conversion game according to script.[12] 'I would have to take the plunge', he explains. 'Or, at least, you know . . . at least look like I was taking the plunge, which meant acting.'[13]

His investigation ultimately leads him to the True Hope Retreat in Arlington, Texas, where he spends a weekend immersed in counselling and testimonial

lectures by putative converts. Included amongst the speakers is 'Ex-Gay Phil', a character who claims to have transitioned to a heterosexual identity over a period of five years, during which time he has remained completely celibate. Adopting a peppy Texan drawl, Schmader re-creates Phil's lecture with a strained intensity, bringing the horror and humour of conversion therapy into stark relief. 'Our gender is not an accident', Phil proclaims:

> God planned our gender before we were born. To become whole, we must answer the call of gender, without fear. Men, read the sports page! When I spend time on the sports page, I feel more informed about what other men are talking about. And when I sense their approval and enjoyment of being around me, I feel affirmed as a man. I feel more masculine. Women, indulge your feminine side, take pride in your appearance, and feminine clothes, and combining colors and accessories. And all of you, thank God every day for making you who you are. Stand before the mirror and say it. Say it out loud: God, thank you for making me a man! God, thank you for making me a woman![14]

As Phil's lecture suggests, the upshot of *Straight* is that conversion therapy amounts to nothing more than conditioning subjects to perform in accordance with social conventions that gradually distort almost every aspect of their personal and public lives, including their behaviour, choice of reading materials, style of dress and leisure activities. Like Schmader himself, Phil has simply been playing the conversion game according to script, but for a much longer time, and at the cost of profound personal sacrifice. At the end of the play, spectators must evaluate a blunt accusation of abuse, and acknowledge the possibility that any success the treatment may achieve is simply the result of repression, rather than genuine transformation. 'Yeah, it works', Schmader says. 'If you make it work. There's no cure, just sacrifice, day after day, after day, after day, for the rest of your life.'[15]

In *Psychoanalysis and Male Homosexuality*, Kenneth Lewes tracks the origins of conversion therapy to the late nineteenth century, the same period when psychologists coined the term 'homosexual' and began to view same-sex attraction as an innate aspect of personhood, rather than mere deviancy. His research shows that, as the twentieth century progressed, 'homosexual' and 'heterosexual' became prominent categories for organising human identity, and a long series of methods for making gay people straight correspondingly emerged.[16] Freud experimented with a treatment based in hypnosis, but ultimately concluded that his efforts were futile and mistaken.[17] Various other attempts ranged from psychotherapy and spiritual counselling, to ice-pick lobotomisation, chemical castration, electroshock therapy and testicle transplant surgery.[18]

Schmader's pioneering work for *Straight* seems especially relevant twenty

years later. Following the release of two conversion therapy films and a major study from the UCLA School of Law, the prospect of reversing sexual preference has become the subject of widespread discussion and condemnation in the public sphere. At the same time, however, organisations such as True Hope continue to operate unabated. Despite legal restrictions in select jurisdictions and numerous denouncements from politicians and mental health professionals, any of the scenes presented in *Straight* could happen today.[19] In the study from UCLA, researchers estimate that 20,000 LGBTQ youths between the ages of 13 and 17 will receive conversion therapy from a licensed health care professional before they turn 18, while an additional 57,000 will receive the treatment from a religious adviser.[20] The report also estimates that 698,000 LGBTQ Americans between the ages of 18 and 59 have undergone conversion therapy at some point in their lives.[21] Of that group, 350,000 subjects received the therapy during adolescence.[22]

Schmader's investigation corresponded to a moment when the notion of a 'cure' for same-sex attraction was making a bold push into the mainstream. In 1998, a coalition of religious organisations known as 'Exodus International' spent $600,000 to place full-page conversion therapy ads in *The New York Times*, *USA Today*, *The Wall Street Journal*, *The Los Angeles Times* and other publications, an effort Robert Knight of the Family Research Council described as 'the Normandy landing in the culture war'.[23] In a description of this moment, Schmader recalls that, like many others, he initially regarded the Exodus ad blitz as a joke, and assumed it would only appeal to a slim minority of gullible hopefuls within the LGBTQ community.[24] His assessment changed, however, when he began to consider the larger impact on public discourse. 'A very smart friend pointed out that gullible queers weren't the problem', he says.

> Gullible straight people were the problem, because the basic message of these ads was that, thanks to the miracle of conversion therapy, gays no longer have to exist, which is a short jump from saying gays shouldn't exist. And, if people think we shouldn't exist, then what's to stop anyone from denying our existence, either in the voting booth or by beating us to death with tire irons?[25]

In a *Washington Post* editorial, entitled 'Why We Still Haven't Banished Conversion Therapy in 2018', Seth Anderson echoes Schmader's argument and makes an important connection between the prospect of a 'cure' and the rights of American citizenship.[26]

> Mid-twentieth-century conversion therapy advocates insisted that a person could in fact modify his or her sexual orientation – which offered a justification for the state to extend benefits to heterosexuals while

denying them to so-called sexual deviants. Even today, as LGBTQ Americans have made significant strides toward equality, the idea that therapy can change a homosexual orientation or gender identity to mirror heterosexual ideals lingers on, with a toxic impact on the lives of thousands of LGBTQ people.[27]

By his own admission, Schmader was not the first person to think of infiltrating the conversion movement. 'After the Exodus boom, every gay magazine on the rack had an Exodus exposé', he says.[28] 'But exposing the conversionists as merely deluded freaks is nothing, and no different than the conversionists exposing gays as merely promiscuous sociopaths.'[29] In an effort to rise beyond mere caricature, Schmader set out to engage with his subjects as fellow human beings, with as much emotional honesty as possible.

A similar attention to human particularity guided the approach he adopted for *Straight*. In addition to Ex-Gay Phil, Schmader's dramatic adaptation of his experiences features a colourful ensemble of characters, each one sketched with a few carefully chosen strokes of personal detail. Dr Craft is a stocky therapist with white hair, a white beard and a 'soulful gaze'.[30] In a curt conversation, he explains that same-sex desire derives from irregular glandular secretions, which he claims he can correct with yoga. 'Never-Gay Ted' is Schmader's heterosexual mentor at True Hope. Talkative and hopelessly dense, he provides a model of generic masculinity and a steady stream of tone-deaf encouragement. 'Buddy, what you are doing is very brave, and I love you for it.'[31] Allison is a lesbian attendee at True Hope, and one of the only proto-converts who seems 'normal' to Schmader. In a candid conversation following Ex-Gay Phil's lecture, she confesses that she knows in her heart that she will never lose her desire for women, which she regards as a 'cross to bear'.[32] In her view, voluntary repression is the 'sacrifice' she must make in order to enter 'the kingdom of heaven'.[33]

Of course, there is also a good deal of mockery. *Straight* is *A Conversion Comedy*, after all. But Schmader is equally unsparing in his self-deprecating, hyper-awareness of his own absurdity. In addition to democratising the humour, his over-thinking, neurotic persona enables him to represent the genuine complexity of a subject that requires feeling engagement and attention to human detail. His various performances – and performances of performances – bring the social dimension of conversion into a critical perspective, demonstrating the unique power of drama to make conversion visible.

2.

Two men with umbrellas stand onstage at the Aldwych Theatre in London's West End. A violent storm is raging. The men have to shout in order to make themselves heard above the wind and rumbling thunder.

MAHLER
What will I lose? Being a Jew means nothing to me.
SIEGFRIED
You say that just to reassure yourself.
Thunder and lightning.
It's not true –
MAHLER
What? I didn't hear –
Another terrific thunderclap.
SIEGFRIED
Just imagine that your very being is in some dark and arcane way the product of a million years of –
Another thunderclap but not as close.
What if your creativity will slowly wither? What if the few drops of holy water on the crown of your head drowns your genius?
Nothing from Mahler. They fall silent. The storm is moving away. Thunder again, but further off.
SIEGFRIED
Gustav, listen carefully to what I have to say. We must never betray who we are.[34]

The scene occurs near the beginning of *Mahler's Conversion*, a drama in two acts by Ronald Harwood. As its title suggests, the play presents a semi-biographical portrait of Austro-Bohemian composer, Gustav Mahler, with particular focus on his decision to convert from Judaism to Catholicism in 1897, a move that facilitated an appointment to the directorship of the Vienna Court Opera. It opened at the Aldwych in October 2001, with Anthony Sher as Mahler and Nickolas Grace as his friend, Siegfried Lipiner. The director was Gregory Doran.

Mahler was a natural subject for Harwood, whose drama for the stage and screen has repeatedly engaged with issues pertaining to Jewishness and the lives of artists, especially musicians. Important works in a similar mode include *The Dresser*, *Taking Sides*, *Another Time*, *The Quartet*, *Collaboration* and *The Pianist*, which won the 2003 Academy Award for Best Adapted Screenplay. There are also some general affinities between the dramatist and the composer in terms of biographical detail. Most notably, they both grew up in relatively humble Jewish families, and they both became artists. Although he didn't ever convert, Harwood did feel compelled to modify his original surname, Horwitz, when he moved from Cape Town to London in pursuit of a theatrical career.[35]

On a similar note, the actor who played Mahler, Anthony Sher, was South African, Jewish and also gay. In a *Guardian* interview for *Mahler's Conversion*, he explained how issues of identity and repression factored into

his own struggle to establish an artistic career, drawing explicit connections to Mahler's biography. 'This is not a biopic in the Hollywood tradition', Sher explained.[36]

> It's not the historical Mahler. It's Ronnie Harwood's Mahler. It's about an artist struggling with questions of identity, with the conflict between ambition and personal integrity. It's a personal play, both for Ronnie and for me, and that's why I'm doing it.[37]

To Harwood's great disappointment, *Mahler's Conversion* failed to impress the critics and the public at large.[38] Judging from the reviews, a certain measure of the dissatisfaction derived from the dramatist's unconventional approach to presenting conversion narratives. Writing for *The London Theatre Guide*, Darren Dalglish complained,

> The lack of any characters to try and persuade [Mahler] not to convert leaves us with no effective drama. He abandons Judaism with little resistance from his own conscience or from his closest friends. There is some debate but it contains very little drama! In fact, the drama comes in the second act in short swift scenes outlining the composer's problems in marriage, with infidelities and with his impotence! But this also adds to the shallowness of the play, as we are not fully conversed on any reasons or underlying causes to these problems.[39]

To be fair, I should note that the opening act of *Mahler's Conversion* does in fact feature a few scenes where friends and other advisors endeavour to dissuade the composer from abandoning Judaism. But Dalglish's more general observation is correct. In contrast to conventional conversion narratives, the decision to convert is not a matter of interpersonal conflict or psychological struggle, at least not in the first act. What Dalglish fails to acknowledge, however, is that the lack of conflict is precisely the point. Harwood's Mahler does not perform according to the script of traditional conversion narratives. His conversion is a matter of mere formality and professional convenience. Judaism and Catholicism both mean very little to him, so there is very little in the way of dramatic conflict. He shifts from one category to another as though he is replacing an old pair of shoes.

For these reasons, it may be helpful to think of *Mahler's Conversion* as an *anti*-conversion narrative. Harwood turns the traditional conversion narrative inside out, revealing an inverse view of the structures that make conversion work. Lightning and thunder notwithstanding, the scene excerpted above is in fact the exact opposite of Saul's experience of blinding transformation on the road to Damascus, or Augustine's sequence of bibliomancy and epiphany in the garden, or Luther's moment of revelation in the storm. Mahler actually makes this exact point himself in a scene with his prospective convertor, Father Swider.

FATHER SWIDER
And may I ask your reasons for wanting to become a Catholic?
MAHLER
Was all this not explained to you?
FATHER SWIDER
No. I'm afraid not. So, I should like to know have you, over the years, from childhood perhaps, been in search of the truth which has finally led you to our Lord Jesus Christ? Your 'Resurrection' Symphony seems to suggest that was the path you followed.
Mahler hesitates.
MAHLER
Not exactly.
FATHER SWIDER
Excellent. Then it must have been a sudden moment of inspiration, like St Paul blinded on the road to Damascus.
Mahler hesitates again.
MAHLER
Not exactly.
FATHER SWIDER
What then?
MAHLER
I want to be honest with you, Father.
FATHER SWIDER
I very much hope so.
After a moment:
MAHLER
There is a movement afoot to have me appointed to the Court Opera in Vienna.
FATHER SWIDER
Splendid, congratulations – *(then, realising)* Oh, I see.
MAHLER
It is likely that first I will be invited only as a conductor, and later, be confirmed as director. I have no guarantees but as you know better than I, such a position can only be filled by a Catholic.
FATHER SWIDER
Dr. Mahler, this is not a good reason for conversion.[40]

As the scene continues, Swider asks Mahler, point-blank, if he believes in God. Rather than answering directly, Mahler haltingly describes an oblique 'Creator' along the same lines of the impersonal creative force proposed by Einstein and Spinoza.[41] Horrified, Swider *'puts a hand to his head as if in pain'*, and brings the interview to a swift conclusion.[42] As he exits, he makes

a candid admission of shock and consternation, and offers to put Mahler in contact with a Jesuit priest in Vienna who 'does nothing but convert Jews, rather quickly, I believe'.[43]

Crucially, Swider's shock is a reaction, not only to Mahler's tacit admission of religious disbelief, but also to his frank indifference and disinclination to perform according to script. As the priest's leading questions suggest, there are certain things converts must do and say in order to make an interior change plausible, and Mahler is unwilling to do or say any of them. By offering an image of what conversion does not look like, Harwood puts the performative dimension of conversional experience in sharp relief.

In a recent study entitled *Strange Gods: A Secular History of Conversion*, Susan Jacoby sets out to de-mystify conversional experience by highlighting the ordinary, human motivations that play into a survey of conversion stories from the past 2,000 years. In case after case, she demonstrates how factors such as convenience, ambition, mortal necessity, a desire to escape, a desire for acceptance or a desire to recover from an addiction might direct a person toward conversional performance, sincere or otherwise. Gustav Mahler does not figure among the converts in Jacoby's survey, but he certainly would have fit comfortably within the theory of conversion she develops. Although the composer's attitude toward his conversion is fundamentally unknowable, anecdotal evidence suggests that he embraced Catholicism perfunctorily, as a means to an end, and did not regard the decision as a matter of profound seriousness or spiritual awakening.[44]

Harwood's Mahler is similar, but also different. Tracing the same arc as tragic protagonists such as Macbeth, Dr Faustus and Michael Corleone, he gets what he wants, only to discover that the price he paid for his success has robbed him of a quality essential to his humanity. In a psychoanalytical scene with no less an analyst than Sigmund Freud himself, Mahler expresses a fear that his conversion has had a spiritual profundity that he had somehow failed to realise.

> FREUD
> I must warn you that in the short time available to us this afternoon, I cannot possibly effect anything like a cure. At best, I may be able to guide you on the right path, but little more than that.
> *Silence.*
> MAHLER
> I have become impotent.
> *Silence.*
> My wife is having an affair. A young man. An architect.
> *Silence.*
> In the last three years, my entire life has collapsed. First, there was a

vicious anti-Semitic press campaign against me and I was forced to resign from the Court Opera. Then – (*Fights tears*). I had two children. Daughters. But the elder one, my beautiful little Maria, died of diphtheria. Not yet five years old. We called her Putzi – (*Cries recovers*). Such a beautiful, loving child. That same month, July 1907, the doctors found I had this serious heart complaint.
Silence.
I'm lost to the world.
Silence.
I cannot rid myself of the feeling that I'm being punished.
FREUD.
By whom?
Silence.
MAHLER
Jehovah.[45]

In this moment, *Mahler's Conversion* suddenly seems as though it might end up on the path of traditional conversion narratives after all. Like the Prodigal Son, Mahler has hit bottom, recognised the error of his ways, and now seems penitent and ready to reaffirm his authentic identity. But Harwood is unrelenting in his commitments. Freud responds to the composer's admission as follows:

FREUD
All religion is an illusion, Dr. Mahler. All religion suppresses the universal essence of humanity. But being a Jew has nothing to do with religious belief. Being a Jew is to possess a common mental construction, radical rather than religious. Which is why, in your case, for example, your conversion of convenience, as one might call it, has not, cannot change your essential Jewishness, which is the inheritance of all the obstinacy, defiance and passion with which our ancestors defended their temple. In your case, your conversion was essentially dishonest. The society in which you lived unfairly demanded that you deny your origins and beliefs in order to rise through its ranks. And you succumbed to what must have seemed to you an intolerable pressure, as great as though you were being raped. Your conversion was psychopathological, a neurotic impulse bordering on the hysterical. Hysterical, because you, like so many other patients of this kind, were made to feel ashamed of being a Jew, then ashamed of being ashamed, and as a result reacted to this mass suggestion of your unjust society and allowed it to seduce you. But the common mental construction of the Jews is immutable and that is why you suffer guilt.[46]

The interview draws to a close after this diagnosis, and the play itself ends soon thereafter. In the final scene, Mahler is on his deathbed, still struggling with uncertainty and regret, a victim of repression and internalised anti-Semitism, not unlike the self-sacrificing 'converts' described by David Schmader. The ending is tragic. There is no redemption. The fictional Freud's quasi-mystical theory of an immutable 'mental construction' hangs in the air as the curtain closes.[47]

I do not think the point of the ending is that Mahler's conversion led to his downfall. Harwood has not set out to warn his audience about the moral dangers of betrayal, artistic ambition or religious indifference. Rather, his play is about the psychology of hatred, particularly anti-Semitic hatred, and how the systemic pressures of a prejudiced society can slowly grind a human being into nothing. On this point, it is important to note that the play depicts turn-of-the-century Vienna from a vantage point of 100 years, with the horrors of the Holocaust looming menacingly on the horizon. Ultimately, the culture that obliged Mahler to convert did not really want Jews to become Catholics. The goal was for Jews to become nothing at all. For comparison, consider David Schmader's observance on the argument implicit in the rhetoric of conversion therapy: if gays (or Jews) can convert, then there is no reason for them to exist, nor is there any reason to acknowledge their claim to the legal rights of citizenship. In certain cases, the politics of conversion is also a politics of erasure.

<div align="center">3.</div>

A young woman stands onstage at Factory Theatre, Toronto, delivering an oral report for an aboriginal studies course. She is wringing her hands compulsively.

> JOSIE
> Stats Canada figures indicate our country's Aboriginal population experiences life expectancies five years shorter than all other Canadians. The United Nations definition of genocide: 'killing members of the group; causing serious bodily or mental harm to . . .' Did I already . . .?
> *Beat.*
> Assimilate: 'to absorb; to make part of oneself; to be absorbed'. I'm not feeling well. This is not who I am. I get As. But am I . . . What if I'm the successful product of this?[48]

Josie's question – 'What if I'm the successful product of this?' – strikes the keynote for *A Very Polite Genocide or The Girl Who Fell to Earth*, a 2006 play by Melanie J. Murray that assesses the impact of residential schools on Canadian Aboriginals. Falen Johnson played Josie. The director was Yvette Nolan.

The term 'residential schools' refers to a national system of church-run institutions set up by the Canadian government for the express purpose of converting Aboriginal children to Christianity and assimilating them into mainstream Canadian society. Over the course of an era that lasted from the 1880s until the 1980s, the government forcibly removed some 150,000 children from their families and resituated them in residential schools across the country.[49] The rudimentary education they received focused primarily on manual labour and service industry training.[50]

Upon arrival at a residential school, incoming students received a haircut, a uniform and in many cases a new name, or a number instead of a name.[51] Contact with their families was minimal, if not entirely off-limits.[52] The same was true for any practices or behaviours deriving from Aboriginal culture. Language rules were especially strict. Students could receive a severe beating or even a needle through the tongue as punishment for speaking their native language, even if it was the only language they knew.[53] In addition to these threats, the schools also subjected students to sexual abuse, malnutrition, unsanitary living conditions and coercive sterilisation. 'We had to stand like soldiers while singing the national anthem, otherwise, we would be beaten up', recalled Sue Caribou, a residential school survivor who entered the Guy Hill institution in Manitoba at age seven. 'I was thrown into a cold shower every night, sometimes after being raped.'[54]

In 2005, the Canadian government announced a $1.9 billion compensation package for survivors of the residential school system.[55] To receive payment, claimants had to sign settlement agreements by the end of 2006, the same year *A Very Polite Genocide* premiered. The compensation package ultimately paid $1.62 billion to 78,750 former students, the largest class action settlement in Canadian history.[56] It also provided funds to establish a Truth and Reconciliation Commission mandated to collect testimonies and other documentation. In a six-volume report, investigators for the commission found that at least 3,201 students died in Canadian residential schools, primarily as a result of disease.[57] The true number of deaths is likely much higher, however, because the government stopped collecting statistics in the 1920s. Conservative estimates put the total death toll at somewhere around 6,000.[58]

The report also connected the schools to endemic trauma, poverty, incarceration, alcoholism, drug abuse and domestic abuse among Aboriginal people.[59] In the executive summary, investigators concluded that the residential school programme amounted to 'cultural genocide',[60] a careful turn of phrase that prompted widespread reproof from critics, who argued that 'genocide proper',[61] without qualifications, would have been more accurate.

On 11 June 2008, Prime Minister Stephen Harper invited five Indigenous leaders and six residential school survivors to the House of Commons,

where he delivered the following public apology on behalf of the Canadian government:

> Two primary objectives of the residential school system were to remove and isolate children from the influence of their homes, families, traditions and cultures, and to assimilate them into the dominant culture. These objectives were based on the assumption that Aboriginal cultures and spiritual beliefs were inferior and unequal. Indeed, some sought, as it was infamously said, 'to kill the Indian in the child'. Today, we recognize that this policy of assimilation was wrong, has caused great harm, and has no place in our country.[62]

The government's handling of issues related to residential schools received widespread criticism. In a 2013 article for the C2C *Journal*, Paul Bunner, a former speechwriter in the Prime Minister's Office, wrote that the response was an exercise in damage control and public relations, rather than a genuine gesture of remorse and reparation. 'The best that can be said of Harper's apology is that it was a strategic attempt to kill the story and move on to a better relationship between Natives and Non-Natives', he wrote.[63] 'Unfortunately, it only appears to have deepened the conviction that Church and State conspired not only to "kill the Indian in the child", but also to physically exterminate the whole race'.[64]

Other critics protested that the government response had gone much too far, rather than not far enough. In a speech to the Senate in 2013, Senator Lynn Beyak insisted that the Truth and Reconciliation Commission report unfairly tarnished the reputations of residential school administrators. 'I want to present a somewhat different side of the residential school story', she said.[65]

> I speak partly for the record, but mostly in memory of the kindly and well-intentioned men and women and their descendants – perhaps some of us here in this chamber – whose remarkable works, good deeds and historical tales in the residential schools go unacknowledged.[66]

In *A Very Polite Genocide*, Melanie J. Murray stepped directly into the middle of the residential school debate. As one might surmise from the title, she does not shy away from making her position abundantly clear. But despite a strong clarity of purpose, the drama itself develops a nuanced and morally complex perspective on the issue, rather than focusing on polemics or accusations. Consider the following scene from the beginning of the play, which flashes back to the 1950s to show the moment that Josie's grandmother, Mary, gave over custody of her son and daughter (Josie's mother) to a residential school official.

GERTRUDE

They'll be taken care of, which is every mother's want. You want the best for your children, so you're agreeing to their care. It's a gift. You're giving them a gift!

MARY

Do you have children, Mrs. Lett?

GERTRUDE

How is that relevant?

MARY

You come here like you're omnipotent – which the church teaches belongs only to God – and tell me what my wishes are. You say nothing of my rights should I not fit in the tidy package of what your form dictates 'my' wishes to be. That's how it's relevant.

GERTRUDE

Whether it's relevant or not, it's none of your business. It's personal.

MARY

It's been personal for me from the start! You come into my home. I'm here, making lace I learned to make at the government school so I can decorate my baby's clothes the way *your* people's ancestors admired. In return, I'm asking you to spare me the courtesy. I want to know if you're a woman or a machine, so please be so kind as to tell me, personally, what you think of this situation? Then – then – we can talk.

GERTRUDE

I'm a mother, I am. All right? I walk in here, and think, 'Is this what you would want?' I would never want my child to set foot in this. My children? All children! I want to keep all children a million miles away from this life.

MARY

This life?

GERTRUDE

This life. You have no family. I stepped over animal or human waste just down the hallway from your apartment. It's the circumstances, dear. No one would blame you for leaving this life behind. Sign here. Then I'll go. Here! Would you like help to write it? If you would prefer, you're free to mark an 'x'. Mark an 'x', please. That's simple. Here – on this line. This line. Right here. Please. Or if you aren't able then let me. Let me do it for you. Let me help you. Help them. Here.

She marks an 'x'.

There. There![67]

Murray's artful rendering of this exchange shows how a more-or-less well-intentioned impulse to convert and educate can work in alignment with

systemic white supremacy and processes of 'very polite' erasure. In a similarly even-handed manner, the dramatist also invites spectators to consider the relative success that residential schools may have potentially achieved, if any. A substantial part of the play focuses on documenting the violence experienced by Josie's family, but Josie's own story is different. Her life would have likely been entirely different if her mother had not attended a residential school. She is a university student. She gets good grades. She has integrated herself into mainstream society. By all appearances, she is a walking advertisement for the benefits of conversional policy. The horror of this realisation creeps up on her during her presentation for her aboriginal studies class, and underlies the question quoted above: 'What if I'm the successful product of this?'[68] As she struggles to move forward, the horror becomes overwhelming:

> JOSIE
> If I'm one of them, not one of us, and they don't sit in these classrooms, do I belong here? When I'm lost in it? What if . . . What if all this is an equation, that's logically solved . . . that all adds up . . . to me? *She starts over.* My project's title is 'The Devastation of the Metis: A Very Polite Genocide'. The United Nations definition of genocide: 'the following acts committed with . . . with . . . with . . .'[69]
> *She falls to the floor in a full-fledged seizure.*

The second part of Murray's title, '*The Girl Who Fell to Earth*', refers to Josie's seizure-inducing realisation. It also hints at a connection to the 1976 David Bowie film, *The Man Who Fell to Earth*, a cult classic about an alien who integrates himself into human society following an unexpected crash-landing in New Mexico. Although he is able to use his superior technological skill to acquire tremendous wealth and all the trappings of a successful life, the alien ultimately succumbs to an all-consuming depression, unable to forget the people he left behind on his home planet. Josie's situation has a similar quality. She cannot separate the comfort of her life from the sacrifices that made it possible. She feels isolated, as though she is marooned on a foreign planet, not a fully-fledged member of mainstream society, but not entirely Aboriginal either.

This unsettling sense of stuck-in-betweeness appears repeatedly in stories of conversion. The Xinjiang detainee performed a public declaration of conversion despite private resentment and a lingering commitment to Islam. Ricote the *morisco* told Sancho that he was never much of a Christian, but not really a Moor either. Ex-Gay Phil foreswore romantic relationships with men, but was also unable to have romantic relationships with women. Gustav Mahler became a Catholic in order to rise in a society that would always condemn him for his Judaic origins. Josie felt like an alien in a society that created her through a long process of erasure.

In all these scenarios, tension arises from an incomplete transition from

one identity to another. 'Ex-gay' is not quite the same thing as 'straight', just as 'converted Jew' is not quite the same thing as 'Catholic', and 'assimilated Aboriginal' is not quite the same thing as 'white Canadian'. Every convert is a palimpsest. Every conversion implicitly points toward a former identity. Every conversional performance falls short of interior proof. Drama has a profound capacity to bring these dynamics into relief. For more than 500 years, the special affordances of theatre have made the political and performative dimensions of conversion uniquely visible, and have helped to cultivate a culture of conversion that has had a tremendous influence on how we conceptualise identity in the present age.

NOTES

1. Buckley, 'China Is Detaining Muslims in Vast Numbers', p. A1.
2. Ibid.
3. Ibid.
4. For information on the scholarship of Stephanie Cavanaugh, see <http://early-modernconversions.com/people/postdoctoral-fellows/stephanie-cavanaugh> (last accessed 17 July 2020).
5. For an accessible introduction to the historical context surrounding the expulsion of the *moriscos*, see Carr, *Blood and Faith*, pp. 1–3.
6. The number of *moriscos* expelled from Spain is a matter of scholarly debate. For further background, see the essays by Tueller, 'The Moriscos Who Stayed Behind or Returned'; and Vincent, 'The Geography of the Morisco Expulsion'.
7. Carr, *Blood and Faith*, contends that 'The removal of *moriscos* contains many of the ingredients that we have come to associate with the phenomenon of ethnic cleansing', p. 9.
8. Cervantes, *Don Quixote*, p. 131.
9. Butler, *Gender Trouble*, p. 179.
10. Schmader, *Straight* (transcribed by author from video recording).
11. Ibid.
12. Ibid.
13. Ibid.
14. Ibid.
15. Ibid.
16. See Lewes, *Psychoanalysis*, especially pp. 3–11.
17. Freud, *The Penguin Freud Library*, p. 51.
18. Day, 'He was bad, so they put an ice pick in his brain . . .', reports that the neurologist Walter Freeman Haldeman performed more than 3,000 ice-pick lobotomies for the purposes of sexual conversion. For reviews of other therapies see Haldeman, 'Sexual Orientation Conversion Therapy for Gay Men and Lesbians', pp. 149–56; Anderson, 'Why We Still Haven't Banned Conversion Therapy in 2018', paragraphs 3–5; Mallory et al., *Conversion Therapy and LGBT Youth*, pp. 1–2.
19. Mallory et al., *Conversion Therapy and LGBT Youth*, pp. 1–2.
20. Ibid.
21. Ibid.
22. Ibid.
23. Quoted in Merritt, 'How Christians Turned against Gay Conversion Therapy', paragraph 12.
24. Schmader, *Straight*.

25. Ibid.
26. Anderson, 'Why We Still Haven't Banned Conversion Therapy in 2018'.
27. Ibid., paragraph 3.
28. Schmader, *Straight*.
29. Ibid.
30. Ibid.
31. Ibid.
32. Ibid.
33. Ibid.
34. Harwood, *Mahler's Conversion*, p. 18.
35. Rees, 'Writer Sir Ronald Harwood', paragraphs 3–5.
36. Quoted in Smith, 'The Great Pretender', paragraph 3.
37. Ibid.
38. In an interview for *The Jewish Chronicle*, Harwood told John Nathan that the failure of *Mahler's Conversion* 'was a crushing moment for me' (Nathan, 'Interview', paragraph 14). For examples of the play's critical reception, see the reviews by Wolf, 'Mahler's Conversion', Spencer, 'Theatre Review Mahler's Conversion Aldwych' and Dalglish, 'Mahler's Conversion'.
39. Dalglish, 'Mahler's Conversion', paragraph 2.
40. Harwood, *Mahler's Conversion*, pp. 26–7.
41. Ibid., pp. 29–31.
42. Ibid., p. 30.
43. Ibid., pp. 31–2.
44. Carr, *Mahler*, p. 84.
45. Harwood, *Mahler's Conversion*, pp. 70–1.
46. Ibid., pp. 77–8.
47. Ibid., p. 77.
48. Murray, *A Very Polite Genocide*, p. 256.
49. CBC News, 'A History of Residential Schools in Canada', paragraph 5; Paquin, 'Canada Confronts Its Dark History of Abuse in Residential Schools', paragraph 5.
50. Indigenous Foundations, 'The Residential School System', paragraph 9.
51. Ibid., paragraph 8.
52. Ibid., paragraph 7.
53. Ibid., paragraph 10.
54. Quoted in Paquin, 'Canada Confronts Its Dark History of Abuse in Residential Schools', paragraph 2.
55. CBC News, 'A History of Residential Schools in Canada', paragraph 11.
56. Ibid.
57. Truth and Reconciliation Commission of Canada, *Final Report of the Truth and Reconciliation Commission of Canada*, pp. 1–6.
58. Ibid.
59. Ibid.
60. Ibid., p. 1.
61. Parker, 'An Act of Genocide', paragraph 14.
62. Harper, 'Statement of Apology on Behalf of Canadians for the Indian Residential Schools System', paragraph 2.
63. Bunner, 'The "Genocide" That Failed', paragraph 9.
64. Ibid.
65. Senate of Canada, 1st Session, 42nd Parliament, paragraph 2, in the section entitled 'Increasing Over-representation of Indigenous Women in Canadian Prisons'.
66. Ibid.
67. Murray, *A Very Polite Genocide*, pp. 239–40.

68. Ibid., p. 256.
69. Ibid., p. 263.

WORKS CITED

Anderson, Seth, 'Why We Still Haven't Banned Conversion Therapy in 2018', *The Washington Post*, 5 August 2018, <https://www.washingtonpost.com/news/made-by-history/wp/2018/08/05/why-we-still-havent-banished-conversion-therapy-in-2018/?utm_term=.323a86ec49fc> (last accessed 26 July 2020).
Buckley, Chris, 'China Is Detaining Muslims in Vast Numbers. The Goal: Transformation', *The New York Times*, 8 September 2018, p. A1.
Bunner, Paul, 'The "Genocide" That Failed', *C2C Journal*, 26 October 2013, <https://www.c2cjournal.ca/2013/10/the-genocide-that-failed> (last accessed 17 July 2020).
Butler, Judith, *Gender Trouble: Feminism and the Subversion of Identity* (New York: Routledge, 1990).
Carr, Jonathan, *Mahler: A Biography* (New York: The Overlook Press, 1999).
Carr, Matthew, *Blood and Faith: The Purging of Muslim Spain* (New York: New Press, 2009).
CBC News, 'A History of Residential Schools in Canada', 16 May 2008, <https://www.cbc.ca/news/canada/a-history-of-residential-schools-in-canada-1.702280> (last accessed 17 July 2020).
Cervantes, Miguel de, *Don Quixote*, trans. Edith Grossman (New York: Ecco, 2003).
Dalglish, Darren, 'Mahler's Conversion [review]', *London Theatre Guide*, 11 October 2001, <https://www.londontheatre.co.uk/reviews/mahlers-conversion> (last accessed 17 July 2020).
Day, Elizabeth, 'He was bad, so they put an ice pick in his brain . . .', *The Guardian*, 13 January 2008, <https://www.theguardian.com/science/2008/jan/13/neuroscience.medicalscience> (last accessed 17 July 2020).
Freud, Sigmund, *The Penguin Freud Library, Vol. 7: On Sexuality* (London: Penguin, 1991).
Haldeman, Douglas C., 'Sexual Orientation Conversion Therapy for Gay Men and Lesbians: A Scientific Examination', in John Gonsiorek and James Weinrich (eds), *Homosexuality: Research Implications for Public Policy* (Newbury Park, California: Sage Publications, 1991), pp. 149–60.
Harper, Stephen, 'Statement of Apology on Behalf of Canadians for the Indian Residential Schools System', 11 June 2008, <https://www.aadnc-aandc.gc.ca/DAM/DAM-INTER-HQ/STAGING/texte-text/rqpi_apo_pdf_1322167347706_eng.pdf> (last accessed 17 July 2020).
Harwood, Ronald, *Mahler's Conversion* (London: Faber and Faber, 2001).
Indigenous Foundations, 'The Residential School System' (2009), <https://indigenousfoundations.arts.ubc.ca/the_residential_school_system> (last accessed 17 July 2020).
Jacoby, Susan, *Strange Gods: A Secular History of Conversion* (New York: Pantheon Books, 2016).
La Expulsión en el Puerto de Denia, painting, Vicente Mostre, 1613, Colección Bancaja, València.
Lewes, Kenneth, *Psychoanalysis and Male Homosexuality* (Lanham, MD: Jason Aronson, 1977).
Mallory, Christy, Taylor N. T. Brown and Kerith J. Conron, *Conversion Therapy and LGBT Youth* (Los Angeles: The Williams Institute, UCLA School of Law, 2018), <https://williamsinstitute.law.ucla.edu/publications/conversion-therapy-and-lgbt-youth/> (last accessed 17 July 2020).

Merritt, Jonathan, 'How Christians Turned against Gay Conversion Therapy', *The Atlantic*, 15 April 2015, <https://www.theatlantic.com/politics/archive/2015/04/how-christians-turned-against-gay-conversion-therapy/390570> (last accessed 17 July 2020).

Murray, Melanie J., *A Very Polite Genocide or The Girl Who Fell to Earth*, in St. Donna-Michelle Bernard (ed.), *Indian Act: Residential School Plays* (Toronto: Playwrights Canada Press, 2018), pp. 229–86.

Nathan, John, 'Interview: Ronald Harwood: Why the Hottest Screenwriter in the World Keeps Smoking', *The Jewish Chronicle*, 14 May 2009, <https://www.thejc.com/culture/film/interview-ronald-harwood-1.9279> (last accessed 17 July 2020).

Paquin, Mali Ilse, 'Canada Confronts Its Dark History of Abuse in Residential Schools', *The Guardian*, 6 June 2015, <https://www.theguardian.com/world/2015/jun/06/canada-dark-of-history-residential-schools> (last accessed 17 July 2020).

Parker, Courtenay, 'An Act of Genocide: Canada's Coerced Sterilization of First Nations Women', *Intercontinental Cry*, 15 November 2018, <https://intercontinentalcry.org/canadas-coerced-sterilization-of-first-nations-women> (last accessed 17 July 2020).

Rees, Jasper, 'Theartsdesk Q&A: Writer Sir Ronald Harwood', *Theartsdesk*, 30 December 2012, <https://theartsdesk.com/film/theartsdesk-qa-writer-sir-ronald-harwood> (last accessed 17 July 2020).

Schmader, David, *Straight: A Conversion Comedy*, video recording of a theatrical performance, Amazon Prime, 2007, <https://www.amazon.com/STRAIGHT-Conversion-Comedy-Createspace/dp/B005IF1VYG> (last accessed 17 July 2020).

Senate of Canada, 1st Session, 42nd Parliament, 150:102, 7 March 2017, <https://sencanada.ca/en/content/sen/chamber/421/debates/102db_2017-03-07-e> (last accessed 17 July 2020).

Shakespeare, William, *The Most Excellent History of the Merchant of Venice* (London, 1600).

Smith, Rupert, 'The Great Pretender', *The Guardian*, 20 September 2001, <https://www.theguardian.com/culture/2001/sep/20/artsfeatures> (last accessed 17 July 2020).

Spencer, Charles, 'Theatre Review Mahler's Conversion Aldwych', *The Telegraph*, 5 October 2001, <https://www.telegraph.co.uk/expat/4179762/Theatre-Review-Mahlers-Conversion-ALDWYCH.html> (last accessed 17 July 2020).

The Man Who Fell to Earth, film, directed by Nicholas Roeg (British Lion Film Corporation and Cinema 5, 1976).

Truth and Reconciliation Commission of Canada, *Final Report of the Truth and Reconciliation Commission of Canada, Volume One: Summary* (Toronto: James Lorimer & Company, 2015).

Tueller, J., 'The Moriscos Who Stayed Behind or Returned: Post-1609', in M. G. Rodriquez and G. A. Wiegers (eds), *The Expulsion of the Moriscos from Spain: A Mediterranean Diaspora* (Leiden: Brill Online Publishing, 2014), pp. 197–215.

Vincent, Bernard, 'The Geography of the Morisco Expulsion: A Quantitative Study', in M. G. Rodriquez and G. A. Wiegers (eds), *The Expulsion of the Moriscos from Spain: A Mediterranean Diaspora* (Leiden: Brill Online Publishing, 2014), pp. 17–36.

Wolf, Matt, 'Mahler's Conversion [review]', *Variety*, 5 October 2001, <https://variety.com/2001/legit/reviews/mahler-s-conversion-1200553498> (last accessed 17 July 2020).

INDEX

Page numbers in *italics* are illustrations, those followed by 'n' refer to notes.